HOUSES AND MONUMENTS OF
POMPEII

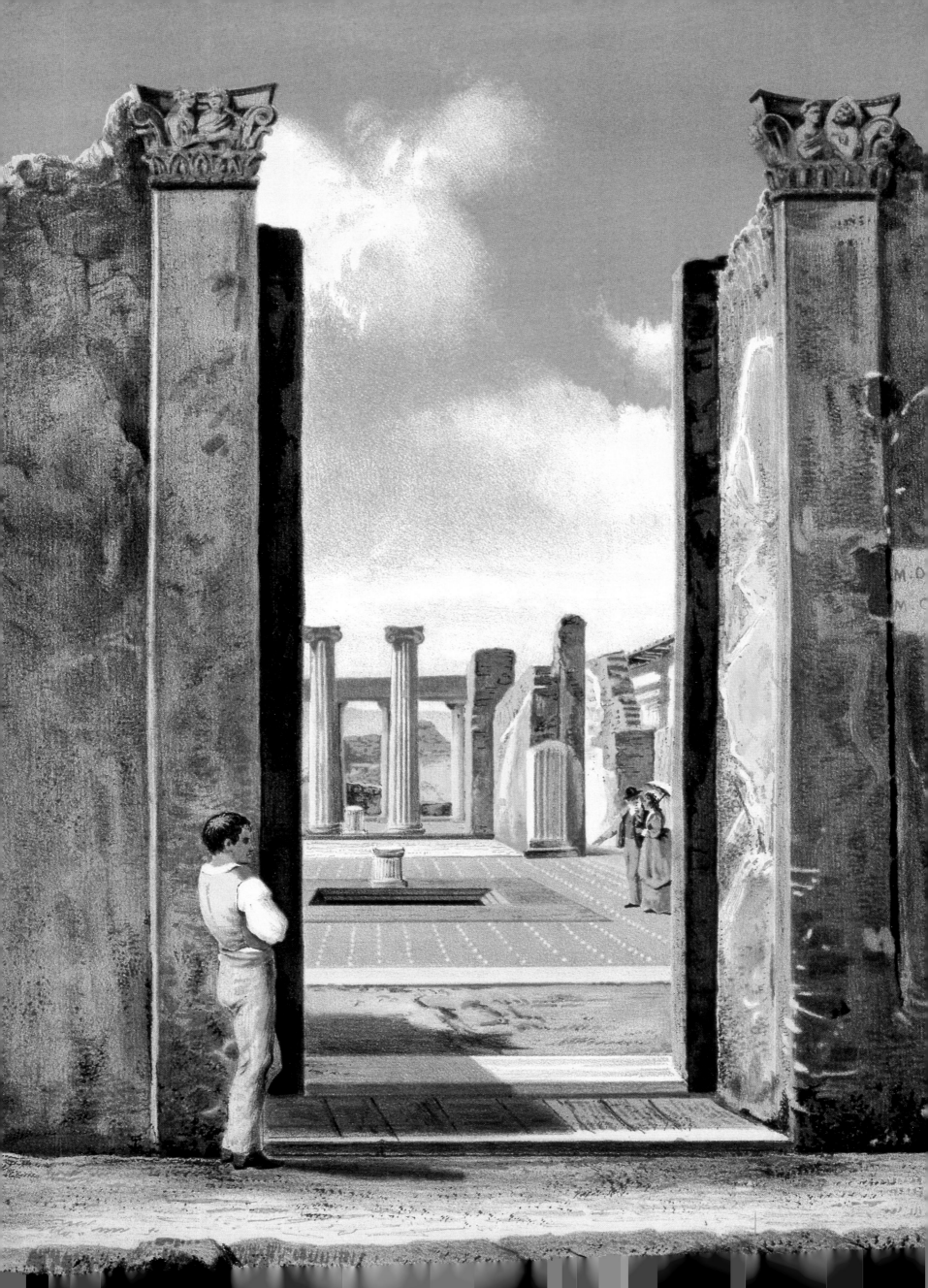

HOUSES AND MONUMENTS OF
POMPEII

The Works of

Fausto and Felice Niccolini

By

ROBERTO CASSANELLI, PIER LUIGI CIAPPARELLI,
ENRICO COLLE, AND MASSIMILIANO DAVID

Introduction by
STEFANO DE CARO

Translation by
THOMAS M. HARTMANN

THE J. PAUL GETTY MUSEUM
LOS ANGELES

©1997 Instituto GeograWco De Agostini S.p.A.

English translation ©2002 J. Paul Getty Trust

First published in the United States of America in 2002 by the J. Paul Getty Museum

Getty Publications
1200 Getty Center Drive, Suite 500
Los Angeles, California 90049–1682
www.getty.edu

Christopher Hudson, *Publisher*
Mark Greenberg, *Editor in Chief*

Thomas M. Hartmann, *Translator and Editor*
Hespenheide Design, *Compositor and Designer*

Library of Congress Control Number: 2002106116

ISBN: 0-89236-684-2

Printed and bound in Italy

On the slipcase: Guiseppe Abbate, *Nymphaeum in the West Wall of the Peristyle at the House of the Small Fountain* (VI, 8, 23–24; see pl. 73, pp. 124–125)
Endpapers: De Stefano, *A General View of the Excavations* (see p. 61).
On page 2: Vincenzo Mollamei, *A View of the Entrance of the House of the Sculpted Capitals* (VII, 4, 57)
On pages 8–9: E. Colonna, *A View Toward the Pompeian Forum from Vicolo dei Soprastanti*

Photography Credits
The photos for the first part of this book were generously provided by the authors and:
Alinari: p. 44 (*bottom left* and *right*)
Archivio IGDA: pp. 29, 31, 47
Archivio M. R.: p. 34
IGDA/A. Dagli Orti: pp. 28, 35 (*top right* and *below*)
IGDA/G. Dagli Orti: pp. 2, 8–9, 10 (*bottom*), 14–15, 32, 42, 44 (*top*)
IGDA/Lensini: p. 45
IGDA/E. Lessing: p. 30
IGDA/L. O'Rain: p. 43
IGDA/L. Romano: p. 36
IGDA/Tass: p. 41
Massimo Velo: pp. 10 (*top*), 11–12, 52 (*top*), 53–54
Soprintendenza Archeologica di Napoli e Caserta: p. 52 (*bottom*)

The plates of *Le case ed i monumenti di Pompei* were photographed at the Bibliothèque des arts décoratifs in Paris.

Graphics on pages 56, 58–59 are by Renata Besola and Elena Caglio.

In 1861 the great Giuseppe Fiorelli, the illustrious Pompeian scholar, described the architect Fausto Niccolini as someone "whose work gave Pompeii such splendor and dignity that we can take pride in his marvelous publication, which has no equal in all of Europe."[1]

Le case ed i monumenti di Pompei disegnati e descritti (Drawings and descriptions of the houses and monuments of Pompeii) was published beginning in 1854 through the initiative and editing of Fausto and his brother, Felice Niccolini. It was the first publication since François Mazois's *Les ruines de Pompei* to attempt presenting the entire collection of public and private monuments that had been uncovered at the time in an organized way. Since the complete work was meant to appear the year after Italy's unification (1870), it featured a number of collaborations with national high-ranking scholars and a team of the most accomplished artists of the time. The generous use of chromolithographs for the exquisite folio volumes was quite innovative. Although this technique had already been used in foreign publications, it was being introduced in Naples for the first time in this well-executed work.

The Niccolinis were not new to great and important editorial undertakings. Their father, the renowned architect Antonio Niccolini, was director of the Accademia di Belle Arti and designer at the San Carlo Theater in Naples. The two brothers had even taken part in publishing the massive *Real Museo Borbonico*, which had been their father's idea, and eventually completed it after he died. *Le case ed i monumenti* was directly within the tradition of their father's important work, in line with the ancient institution of court publications. These included the inaccessible eighteenth-century precedent, *Antichità di Ercolano esposte* (The antiquities of Herculaneum displayed), and were characterized by lush and precise illustrations. However, court publications were still too elitist for new needs brought on by widespread knowledge that had fully matured in mid-nineteenth-century Naples. Scientific correctness, lively texts, and pleasant graphics began to take leading roles in the search for faithfulness and exactness surpassing any existing gouaches of Pompeii. These goals would be achieved using foreign techniques. The objective was to describe all of Pompeii, including large areas that had remained hidden because of administrative jealousy by the Napoleonic court regarding excavations there.

All of this makes the Niccolinis' work one of the most modern cultural expressions of that period. Thanks to the young Fiorelli, who was a colleague and great friend to Fausto and Felice, this culture focused on definitive historical improvements over previous Pompeian studies in a learned and academic manner. The Niccolinis' work can also be credited with having kept alive, whether they knew it or not, the idea of presenting the houses of Pompeii in their completely decorated and furnished state. This idea had run through Pompeian literature since the end of the eighteenth century, but was only partly achieved for a monument a century later, when the House of the Vettii was restored.

The idea of presenting *Le case ed i monumenti* here once again is quite admirable.

Seen at the distance of more than a century, Pompeii, on one hand, has now reached the peak of its popularity. Millions of tourists of every nationality visit it, placing it among the second or third most frequented sites in all of Italy. On the other hand, the city shows the limitations of this process, and

there are urgent needs for restoration in the heavy tourist traffic areas. Excessive enlargements to the excavation areas in order to boost national prestige and yet again, tourism, lead to questions as to whether these will be able to be effectively maintained.

At the very moment that creating a "virtual" Pompeii in the interests of conserving the ancient city has been put forward, here is an opportunity to present *Le case ed i monumenti*, which in its own way was the first virtual Pompeii. It also represents one of the most captivating stages in the history of study and publishing on the Vesuvian city.

Being face to face with antiquity in Pompeii and Herculaneum led our modern world to invent archaeology and learn to directly touch the past in a previously unimaginable global dimension. Works like this one taught us to wonder at the cities, to be moved by them, and hopefully to understand and benefit from them in a more complete way, respecting their integrity.

Stefano de Caro
Archaeological Superintendent of the Provinces of
Naples and Caserta

CONTENTS

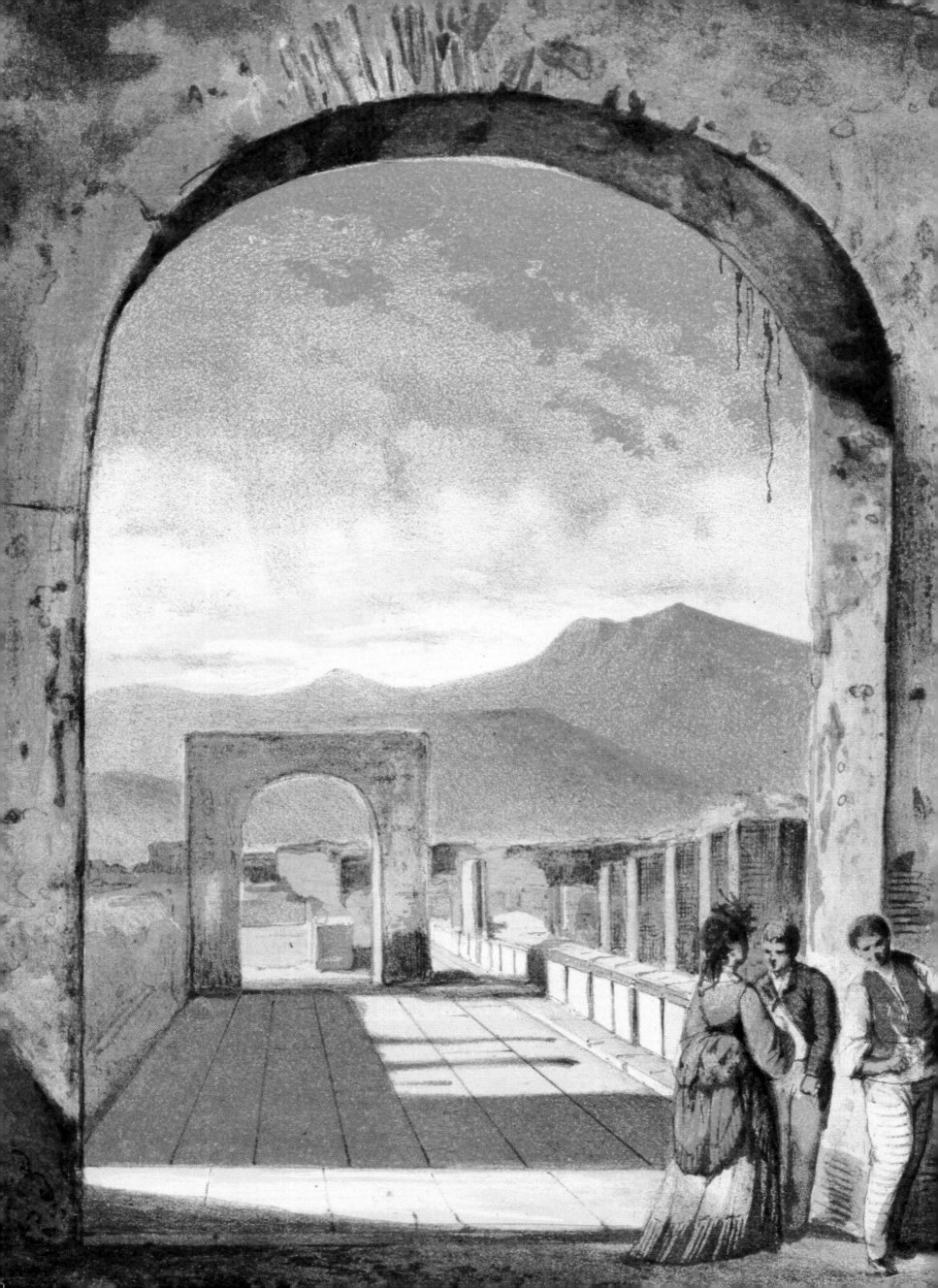

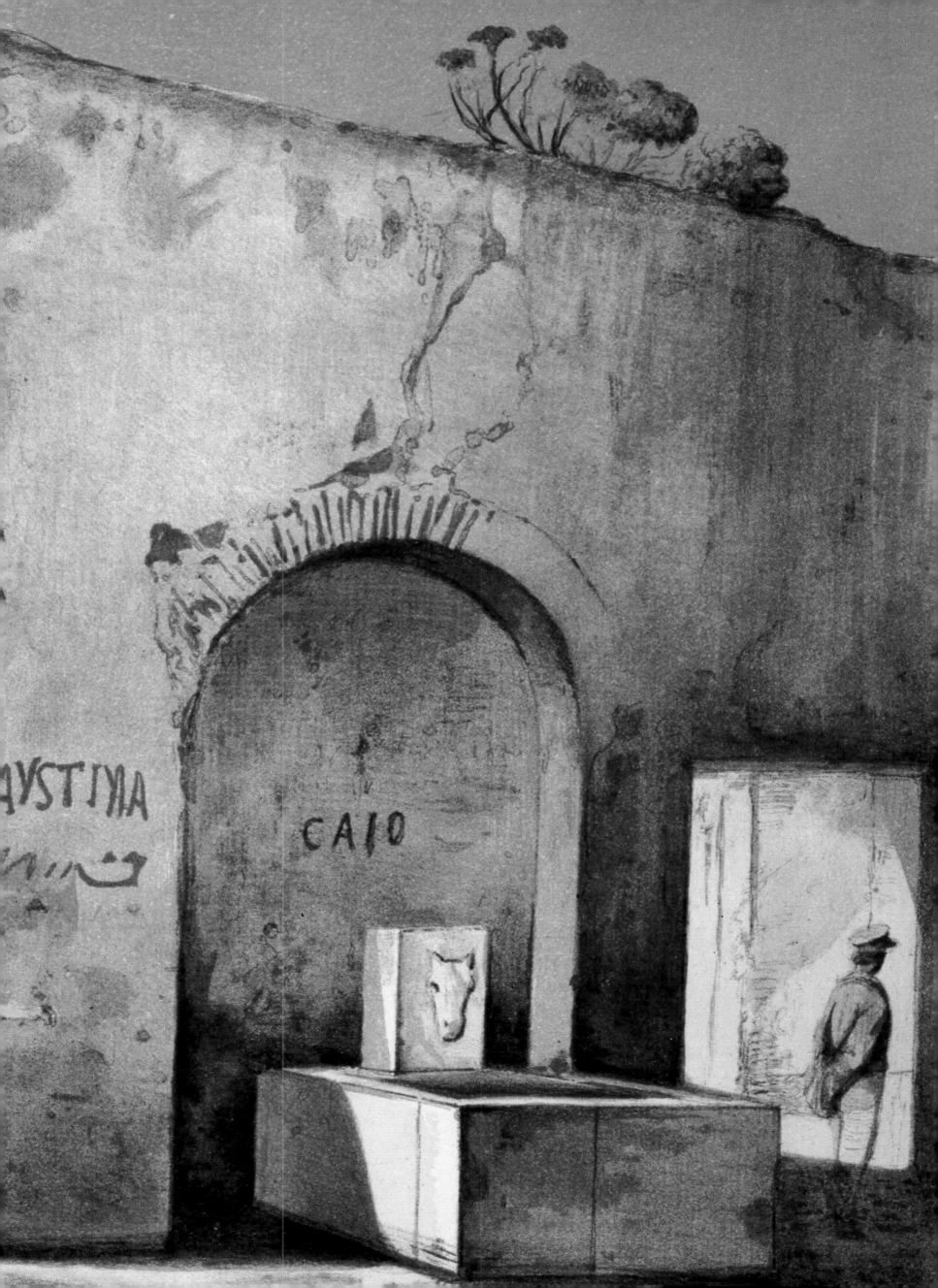

THE EDITORIAL ADVENTURES OF THE NICCOLINI BROTHERS

By Pier Luigi Ciapparelli

A portrait of Antonio Niccolini (1772–1859), the architect and set designer who played a leading role during the Neoclassical period in Naples. At the same time he carried out editorial activity that capitalized on his archaeological experience.

The frontispiece of the work by Fausto and Felice Niccolini published in Naples in four volumes (1854–96). It was intended to be a complete catalogue of the entire city of Pompeii, "from colossal public monuments to the humblest furnishings buried within domestic walls," as the introduction to the first volume indicated.

On November 19, 1825, the opera *L'ultimo giorno di Pompei* (Pompeii's last day) opened at the San Carlo Theater in Naples. The show's music was written by Giovanni Pacini, the libretto by Andrea Leone Tottola, and the sumptuous set was signed by Antonio Niccolini.[1] Niccolini was a leader during Naples's Neoclassical period in the fields of set design, architecture, and urban planning. The *Giornale delle Due Sicilie* reported that the production was enthusiastically received, praising the exceptional realism of the scenes and underlining the "highest level of conformity between various parts of Pompeii that were portrayed and the original, which moved the audience to general surprise and approval."[2]

The success of the set design surely must have resulted from the architect's knowledge of antiquity, which in 1824 had matured while printing the first volume of *Real Museo Borbonico* (Bourbon royal museum), an epic sixteen volumes whose publication Niccolini directed. The tomes were completely dedicated to the Naples museum, which besides the Farnese collections, held materials uncovered during the excavation of the ancient Campanian cities destroyed by the eruption of Mount Vesuvius on August 24, A.D. 79.[3] Niccolini's professional luck and achievements at the Accademia di Belle Arti in Naples would eventually lead him to participate as an expert in different organizations that guided the Pompeii excavations.[4] It should also be mentioned that an 1832 pamphlet published by this Tuscan master was dedicated to the famous *Battle of Issus* mosaic, which had been discovered the previous year in the House of the Faun[5] and described by Niccolini in volume eight of *Real Museo* (1832).

The architect's two sons, Fausto and Felice, helped edit the work. The first assumed the direction of the publication following his father's death[6] and designed a number of plates of architectural drawings for it; the second authored many charts for the final volume (1857). Three years before the conclusion of *Real Museo*, the two brothers continued their archaeological and editorial activity by beginning one of the most exhaustive publications of the nineteenth century on the subject, the first volume of *Le case ed i monumenti di Pompei disegnati e descritti* (Drawings and descriptions of the houses and monuments of Pompeii).

The original idea of assembling an exact replica and up-to-date description of Pompeii can most likely be attributed to the elder Niccolini himself, not just because of the precedent of *Real Museo*. In 1843 he had ordered renderings of the most representative buildings that had emerged from the excavations from Pasquale Maria Veneri.[7]

In any case, the succession of events did not occur casually, especially if one considers the interest in antiquity that all three Niccolinis had in common. This was fundamental for Antonio in understanding how to develop an architectural and theatrical language,[8] while for Fausto and Felice it was more linked to professional positions at the Naples museum.

The two brothers' training and activity are not equally on record. They were both born from Antonio's marriage to Anna Quériau in the second decade of the nineteenth century.[9] Fausto's facts are more known; he had a brilliant career as an architect. Records regarding Felice point to his important administrative positions at the Museo Nazionale di Napoli, which will be described further here, and his charge as governmental commissioner at the Brancacciana Library in Naples.[10] Felice alternated these activities with publishing. Besides his previously mentioned efforts, he was the author of a pamphlet dedicated to one of Raphael's drawings at the museum.[11]

Having finished his studies in Florence,[12] Fausto returned to Naples and collaborated with his father to design sets for Reali Teatri (Royal theaters), substituting for him in 1839 in the twofold position of "architect of Reali Teatri and the Reale Soprintendenza."[13] He would cover the latter position again between 1854 and 1855, and in 1857 together with Pasquale Francesconi.[14] Following his father's example, Fausto became especially involved in the field of theater architecture. In Naples he designed the Filarmonico Theater (1870),[15] the Sannazaro Theater (1874), and in 1878 he completed the Comunale Theater (later the Verdi Theater) in Cava dei Tirreni.[16]

He was also active in urban planning, such as enlarging and straightening Via Chiaia in Naples;[17] civil architecture, including the Piscione building project (1855)[18] and modernizing the Miranda-Ottajano building (1842)[19] in the Chiaia neighborhood in Naples; and religious architecture, such as the church of San Ferdinando in Bari (1843–49).[20]

Fausto's work in the archaeological sector is less known. Besides his previously mentioned editorial work, he also created a guidebook for the Naples museum (1870).[21] He directed the excavation of the Necropolis of Cumae, which was discovered in 1853[22] during explorations between 1852 and 1857 that had been ordered by Count Leopold of Syracuse, the brother of Ferdinando II of Bourbon.

It seems that meeting the count had a determining factor in Fausto's career. The first contact between the young architect and his future patron is already on record in 1838, when Leopold commissioned him to modernize his Naples residence on the Chiaia Riviera.[23] Their association would also strengthen through an artistic initiative together, the funerary monument for Antonio Niccolini (1850) that Fausto designed. Count Leopold provided statues for the work, and Bernardo Quaranta wrote the text for the commemorative stone.[24]

It is interesting to note that Fausto introduced the young archaeologist Giuseppe Fiorelli[25] to the count in 1853. Fiorelli would be Leopold's special secretary until the count's death in 1860.[26]

Today Fiorelli's importance as a scholar and his role in the history of the excavations at Pompeii are largely known.[27] His positions at Pompeii should be mentioned here, first as inspector beginning in 1860 and then superintendent in 1863. In 1875 his Pompeian experience concluded when he was named director of Servizio di Antichità e Belle Arti.

During the years of his term, Fiorelli founded the Scuola Archeologica di Pompei (1866)[28] and contributed decisively to renewing excavation methods by introducing new techniques. These included the strategy of digging from above, bylaws that assured the restoration of the city's urban fabric, and removing earth that had accumulated between the lots and single buildings. The plaster process that he promoted during his term was just as significant. Besides providing the dramatic images of the victims of Pompeii, it also allowed organic elements to be recorded, including wooden beams, furnishings, and even gardens and orchards.

Fiorelli's archaeological work was accompanied by his scholarly activity—his competence was already modern—and his ample bibliographic output.[29] The theoretical reconstruction of Pompeii's topography that he proposed in 1858 is particularly significant because of the influence it had on the Niccolinis' work. This booklet, dedicated to Count Leopold,[30] supported the theory of subdividing the city into nine regions (*regiones*), which in turn were partitioned into housing blocks (*insulae*). The regions resulted from four main roads intersecting; each connected the nine city gates. Relying on an Oscan inscription, the scholar identified the oldest city quarter—the area around the Stabiae Gate—and starting from there he proposed that each region and block be assigned a progressive number. He even defined a name system for architectural and urban types of constructions: "houses (*domus*), shops (*tabernae*), bake houses (*pistrina*), streets (*viae*), lanes (*vici*), pools (*lacus*), fountains (*fontes*) . . ."[31]

A large-dimension map of the city was closely connected to the booklet's publication and came out that same year. Edited by the engineer Giacomo Tascone, the map was divided into forty-two plates, grouped in six sections that were called "segments."[32] In the archaeologist's mind, these were meant to become a valid instrument for planning future excavations and precisely describe the city.

Despite the fact that they were published four years after the first volume of *Le case ed i monumenti* appeared, we dwell on Fiorelli's projects here because they still constituted the premise and methodological support for the Niccolinis' census work.

Orazio Angelini, a detail from the mosaic *Battle of Issus*. It was uncovered in 1831 in the House of the Faun (*Real Museo Borbonico*, vol. 8, pl. 61).

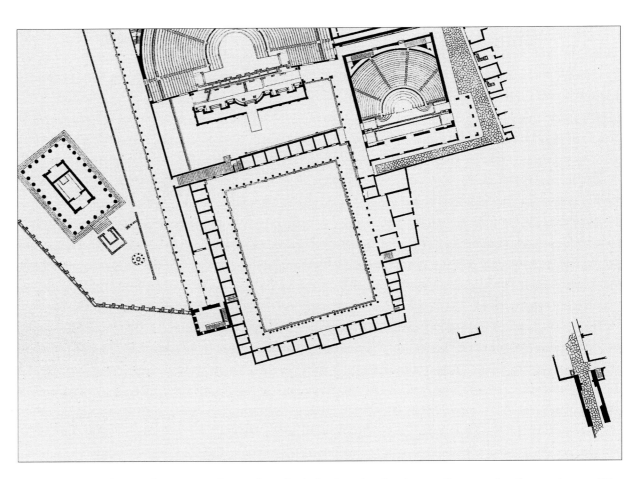

Giacomo Tascone, *Detail of the Theater District from a General Map of Pompeii* (*Tabulae Coloniae Veneriae*, segment 6, pl. D6)

There is a clear reference to the archaeologist's theories in the preface to the first volume. The authors affirm that they "coordinated the work thanks to a general index placed at the end of the work. By tracing the map of the city that is divided into regions and described in blocks of houses for the first time, it topographically displays the public and private buildings as they were laid out in ancient Pompeii."[33] In addition, the Niccolinis claimed being the first to incorporate an inventory of Pompeii's architectural heritage with topographic criteria, foreshadowing methodology that would later take root in all of Europe.

Other examples of the Niccolinis' affinity with Fiorelli include using Tascone's map, which was skillfully updated for plates that illustrate the chapter *Pompeii Topography*. They also utilized the urban system that the archaeologist had developed—including building types—in the chapters under *General Description* and the appendix. These sections included an itinerary among the "lesser" Pompeian buildings.

Archival records also highlight the favorable exchange between the two brothers and the illustrious architect, which furthered their careers.

Felice was secretary at the Soprintendenza agli Scavi di Napoli as early as 1861, and when Fiorelli was named general director of the Musei e Scavi di Antichità in 1875, Felice took on the role of head secretary at the Naples museum the same year.[34] Felice quickly rose within the institution in the years that followed, and in 1878 he was charged with the position of vice director.[35] Four years later he was named director.[36]

Fausto's first contact with the museum, in contrast, is on record as 1866, when he was commissioned to modernize the building.[37] In 1882, possibly because work there had extended through to the 1880s, his professional task was changed into a permanent position with a salary to match, and he was given the title "First-Class, Exceptional Architect in Charge of Decorating the Museum."[38]

Fiorelli had already supported Fausto's candidacy to be "Architect of the Excavations at Capua and Pesto" in 1861, but without results. In a list of Niccolini's professional merits for Superintendent S. Spinelli that Fiorelli compiled, he especially emphasized the publication on Pompeii, "for which there is no comparison in Europe."[39]

This flattering judgment by Fiorelli was presumably hiding a vengeful spirit toward foreign works on the subject, which had been especially prolific in France and Germany. Finally these had been faced with an important local scientific contribution.

Putting aside that question for the moment, the original structure of *Le case ed i monumenti* was initially presented as an edition without original texts that featured a selection of plates.

According to Friedrich Furchheim, the work was initially sold in booklets, each composed of three plates and two pages of text. These would eventually be bound in four volumes.[40] The volumes, despite being different in shape and graphics, would resemble the same brief chapters that had been used in *Real Museo*; each chapter was dedicated to a building or subject.[41]

The authors' intended goals for the work were quite ambitious, especially when the descriptions extended beyond the city buildings and architectural projections to record, together with the usual repertory of wall decorations and mosaics, furnishings and a range of objects from private life. "From colossal public monuments to the humblest furnishings buried within domestic walls," the Niccolinis wrote.

The idea was certainly not new. From the moment the noteworthy volumes of *Le antichità di Ercolano esposte* (The antiquities of Herculaneum displayed) were published from 1757 to 1792, others were also to include domestic instruments (*instrumentum domesticum*)—following the example of Fougeroux de Bondaroy's *Recherches sur les ruines d'Herculanum* (Research on the ruins of Herculaneum) in 1770—as a number of unpublished designs and engravings attest.[42] More recent publications, such as Paul Fumagalli's *Traité pittoresque . . .* (Pictorial treatise),[43] also presented reproductions of utensils and objects from everyday use. However, the novelty of adapting inventory work to Fiorelli's line of action should still be stressed, as should the Niccolinis' wider interpretation that aimed at uniting knowledge from diverse disciplines in order to re-create an image of a complete Pompeian house, accenting the comprehensive environment over particular facts. The attempt to describe the various aspects of social life, religious worship, festivals, and theater should also be emphasized.

The descriptions of the buildings were documented with scientific rigor, and they were enriched by information about their place of origin and the circumstances of the excavations.[44] The sources that were utilized—from François Mazois, to *Real Museo*, to William Gell, Johannes Overbeck, Earnest Breton, and of course Fiorelli—demonstrate a deep knowledge of an accurate bibliography of Pompeian studies.

Beyond the precision of the texts, however, the work's value above all resides in the rich iconographic elements of the plates. For these the brothers relied on an eminent group of collaborators. Among them, the names of noted representatives from the artistic environment in Naples can be recognized: from Gaetano Genovese,[45] the directing architect of the excavations from 1852 to 1860, to Giuseppe Abbate[46] and Vincenzo Loria, representatives of a long line of artists who were involved with drawing ornamentation, to famous painters like Giacinto Gigante and Teodoro Duclère. These last two signed some of the panoramic views[47] that were inserted in the booklets, intended as a part of the scientific documentation made up of diagrams, architectural details, and objects.

When the first volume of the work came out in 1854, Gigante was enjoying recognition, fame, and had created a large line of pictorial works on Pompeii.

These included his collaborations on *Real Museo* and, beginning in 1829, two volumes of *Viaggio pittorico nel regno delle Due Sicilie* (Picturesque voyage in the Kingdom of the Two Sicilies), which had seventeen perspectives of Pompeii.[48]

On the following pages: Vincenzo Loria, *A View of the House of Orpheus or Vesonius Primus* (VI, 14, 20)

Paul Fumagalli, *Utensils and Objects from Everyday Use Uncovered in Pompeii* (Fumagalli, *Pompeia*, pl. 12). The reproduction of domestic items was a subject already explored in other archaeological writings, and the Niccolini brothers gave this special attention in their work.

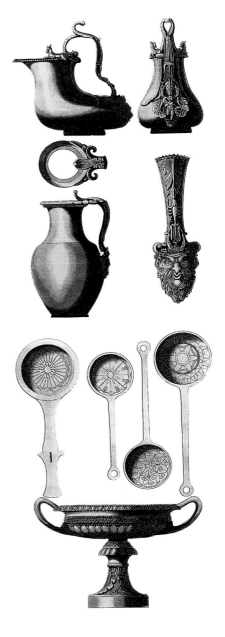

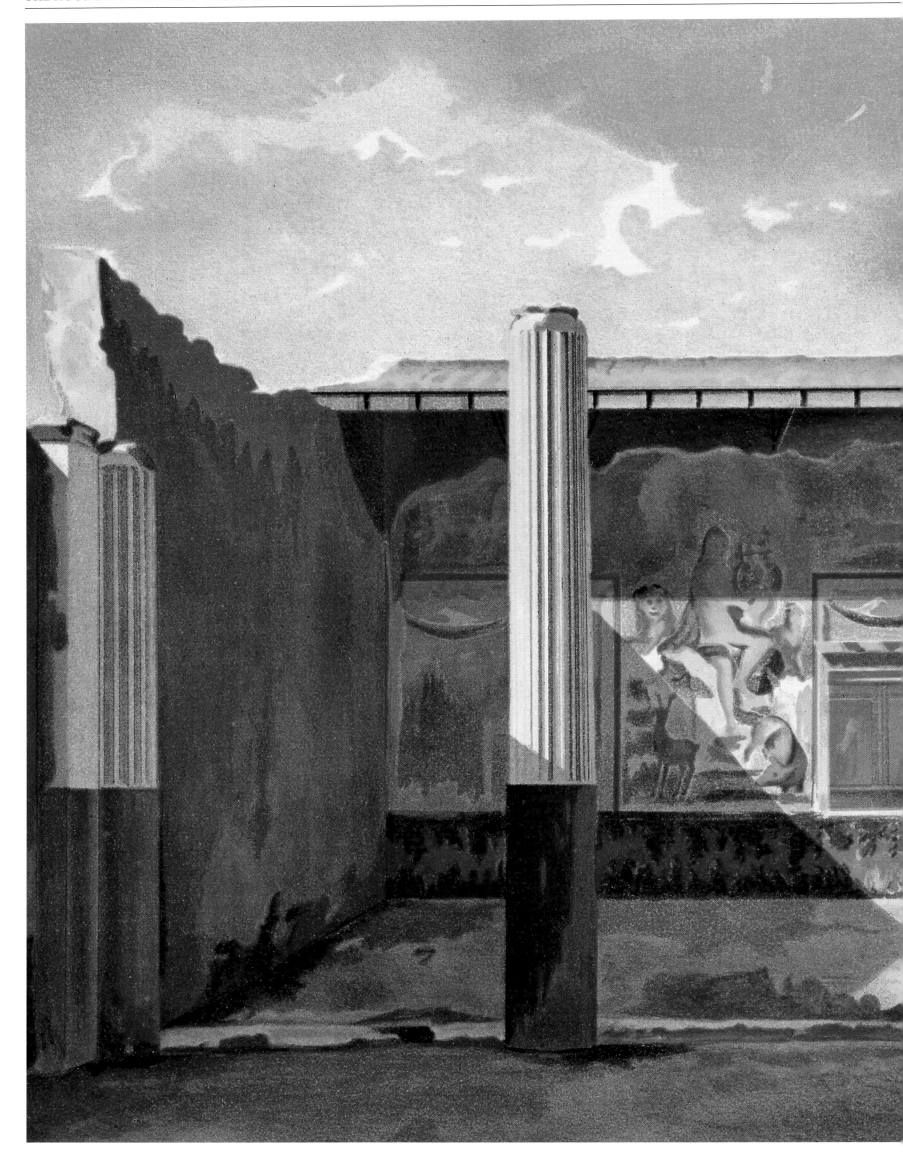

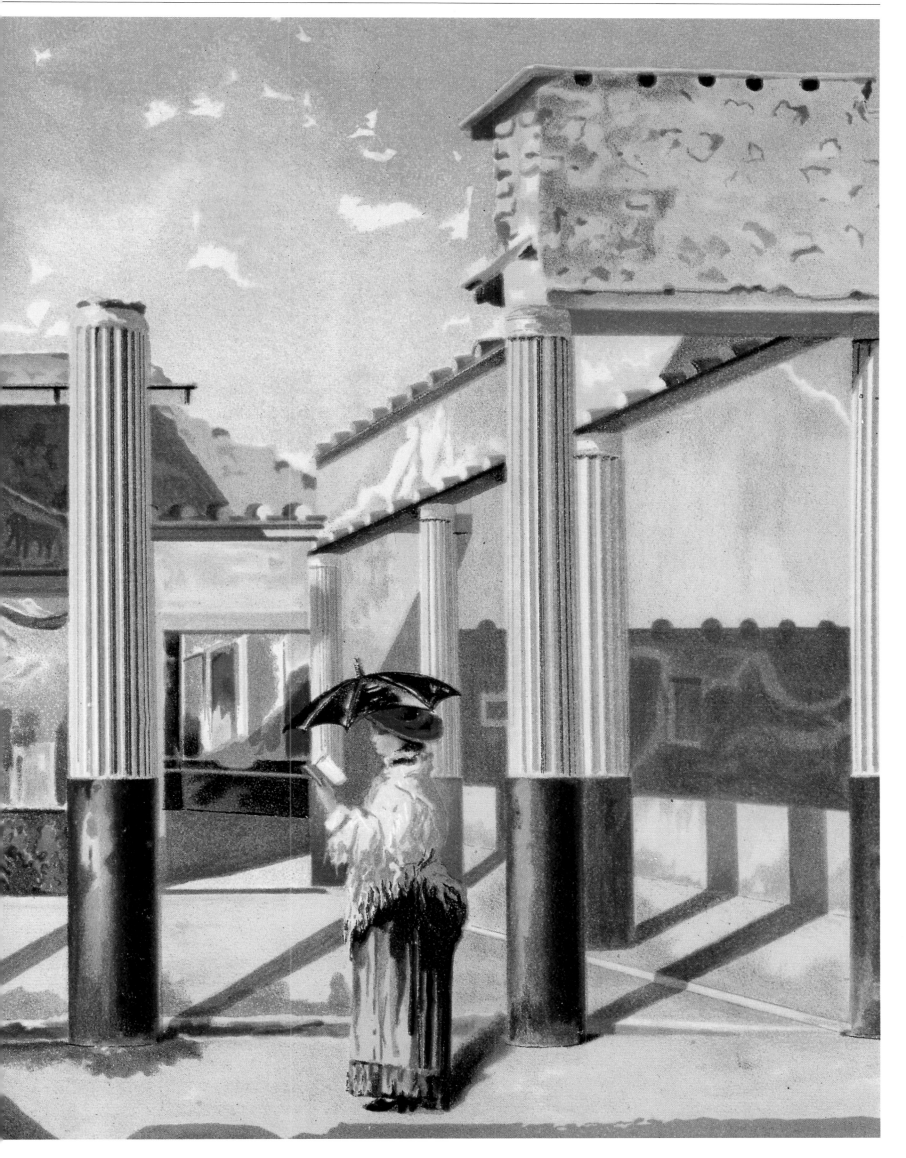

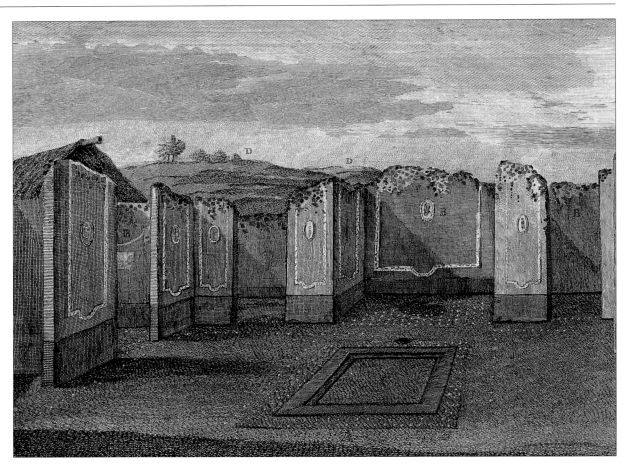

A view of a house in Pompeii from one of the plates featured in the book by the English collector Lord William Hamilton, *Account of the Discoveries at Pompeii* (1777). The book begins a long line of published works dedicated to ancient Pompeii during the second half of the eighteenth century, after reports from foreign travelers on their Italian tours.

Visitors and artists drawing the ruins were featured in Gigante's lithographs. The lithographs went beyond just simple documentation and acquired a value all their own, continuing the established tradition of Pompeian iconography with poetic motifs and pictorial taste.

The third volume, which was published in 1890, saw substantial changes in editorial direction. Fausto died on March 22, 1886,[49] and even though the exact date is unknown, Felice also died that same year.[50] *Le case ed i monumenti* was completed by Antonio Niccolini the Younger, the grandson of the illustrious Tuscan architect, who also published a number of extracts.[51] At the same time the work passed from the Richter printing company, which had overseen the printing of the first two volumes and a part of the third, to Lithografia Artistica (Artistic lithography). Zucchi and De Luca's firm would carry the work to its conclusion[52] together with the Officina Lithografica (Lithography shop) of the Casa Editrice Fausto Niccolini (Fausto Niccolini publishing house).[53]

When the first volume was published, the excavations of Pompeii had been open and on record for more than a century. Today the Campanian city's burial and rediscovery are well known,[54] beginning with the casual circumstances that saw the first discoveries: the digs conducted on the hill that Domenico Fontana (1592)[55] had called "Civita." Francesco Antonio Picchiatti (1689)[56] soon followed suit and uncovered ruins and inscriptions.

Although Lucas Holstein identified Civita as the site of ancient Pompeii in 1666,[57] it was only in 1748, ten years after the official sites at Herculaneum were opened, that digging began under the guidance of the Spanish engineer Roque Joachim de Alcubierre. This resulted in a large amount of the removal and destruction that characterized the first pioneering explorations.

The establishment of the Regia Accademia Ercolanese (Royal Academy of Herculaneum) in 1755, initiated by Minister Bernardo Tanucci, must have been a decisive moment for the study and discovery of archaeological heritage. Until that time, the sites had been jealously guarded by the Bourbon authorities. The academy was composed of fifteen scholars who had the task of studying Herculaneum. The resulting publication of eight of the forty volumes of *Le antichità di Ercolano esposte* between 1757 and 1792 offered material that had emerged from the excavations to European culture. In its way it contributed to the rise of antiquarian tastes, especially in the field of applied arts.[58] The work was edited with scarce care in authenticating items, not only grouping objects from Herculaneum, Pompeii, and Stabiae under the title *Le antichità di Ercolano esposte* but also interpreting the works recorded in the plates according to the period's tastes.

Other than a small view of the excavations at Pompeii and three plates showing projections of an oil factory (*fattojo*) and an oil press (*frantojo*) found at Stabiae that were inserted in the sixth and last vol-

ume,[59] the work did not provide space for architecture. It primarily illustrated wall decorations, statues, and bronze objects such as candelabras, vases, and lamps.

The first records of buildings of ancient Pompeii were perspectives included in volumes dedicated to the excavations or reports from travelers on their Italian tours. Often altered in dimension and placement, the Pompeian structures appeared quite changed in these graphic works from how they must have been really. Either the public's explicit request for free interpretations instead of scientific projections, the difficulty accessing the excavations, or the precarious conditions of the buildings themselves led to replacing the actual state with picturesque sketches or imaginary re-creations.

Starting with the thirteen plates that accompany Lord William Hamilton's 1777 volume containing the illustrious English collector's 1775 report to the Society of Antiquaries in London,[60] a line of publications dedicated to Pompeian antiquities began to develop[61] and featured artists and "antiquaries" such as Paul Fumagalli, Henry Wilkins,[62] Jacob Wilhelm Hüber,[63] and the Italian Luigi Rossini.[64] Among the

Jacob Wilhelm Hüber, *View of the Odeon* (Hüber, *Vues pittoresques les plus remarquables*, pl. 21)

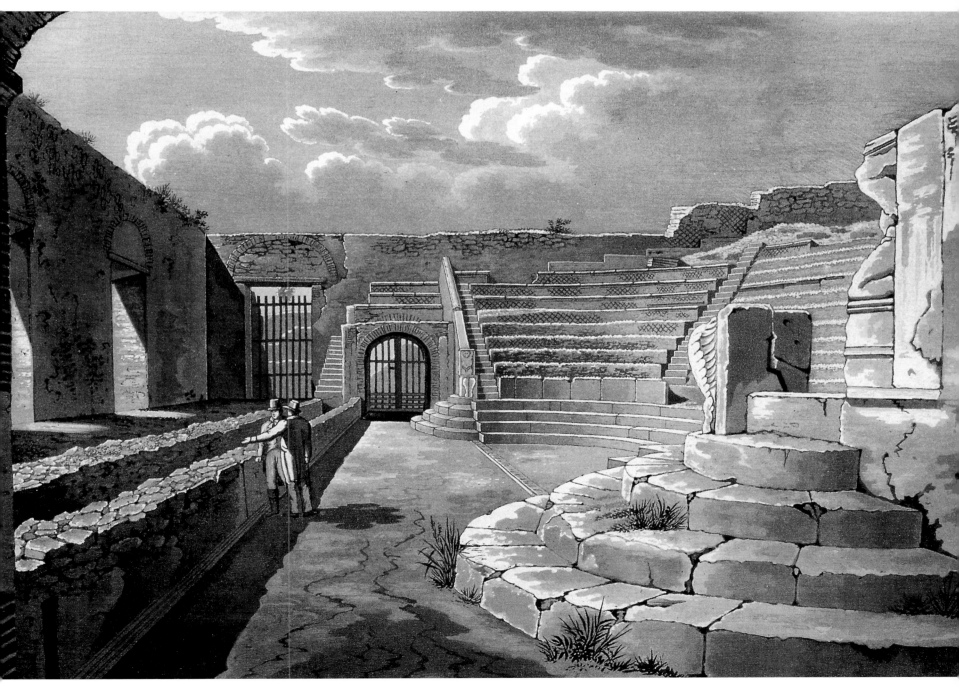

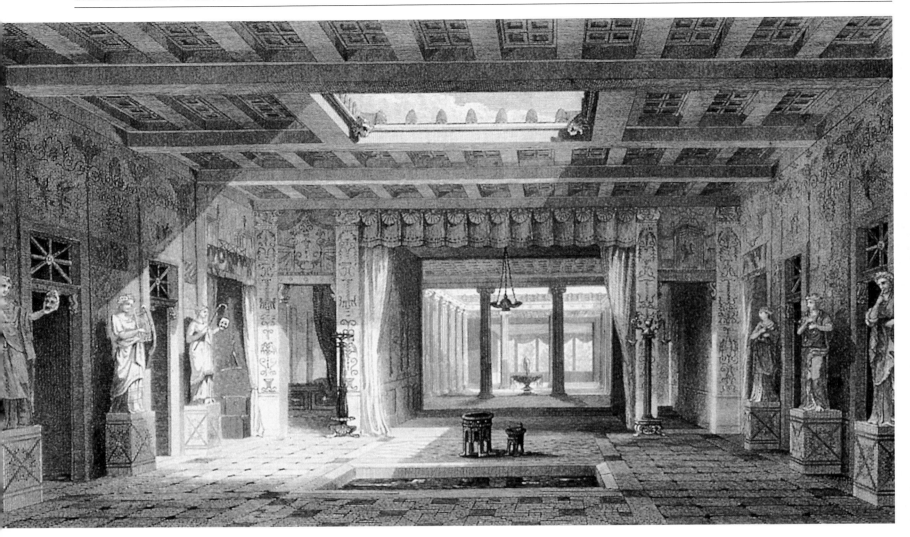

first attempts were sixteen views of Pompeii created by the French architect Jean-Louis Desprez that were part of the second volume of *Voyage pittoresque* (Picturesque journey) by Abbot Richard De Saint-Non.[65] These offered a number of imaginary reconstructions of buildings and an exact examination of the ruins, inaugurating a line of restorations or graphic reconstructions that followed the example of Fischer von Erlach's "marvels" of antiquity in his *History of Architecture* (1721). One typical example was the plate portraying the Temple of Isis by night amid a ritual celebration, which was compared with the actual state of the monument presented on previous pages. (See opposite.)

The practice of "restoring" would be taken up again, among others, by Giovan Battista Piranesi, who had produced a reconstruction of the same temple and integrated certain missing parts.[66] This would become widespread in the nineteenth century, as shown, for example, in the debated reconstructions that Gell published together with the architect John Paul Gandy in his two works on Pompeii,[67] and in drawings by French *pensionnaires* (resident architects) who were on study trips to the excavation sites.[68]

In the fourth volume of *Le case ed i monumenti* (1896), Antonio Niccolini the Younger reconnected with the reconstructive tradition by inserting twenty-one restoration sketches that were placed in comparison, just as Desprez had done, with the actual state of the subjects. Created by certain collaborating artists who were evidently not familiar with ancient architecture, the restorations seem completely simplistic, not always at a high level of graphics, and quite distant from the clever reconstructions by other contemporary architects. The latter were characterized by their extensive repertory of illustrated subjects that included, along with the most representative buildings, examples of lesser-known architecture. The original, yet improbable reconstruction of a shop near the fountain of Mercury, for example, was filled with Pompeians preparing food. Perhaps this was inspired by a similar construction by Mazois. The need to feature the society of the time along with the monuments must have determined the recurring costumed characters within the buildings and the tendency to include scenes of everyday life within the architecture.

This taste was quite similar—with obvious qualitative differences—to the Campanian revival of paintings of Pompeian settings that occurred during the second half of the nineteenth century.

If the restoration theme was inspired by a specific line of research, the idea of documenting the entire city through projections, from domestic dimensions to an urban scale, found an illuminating

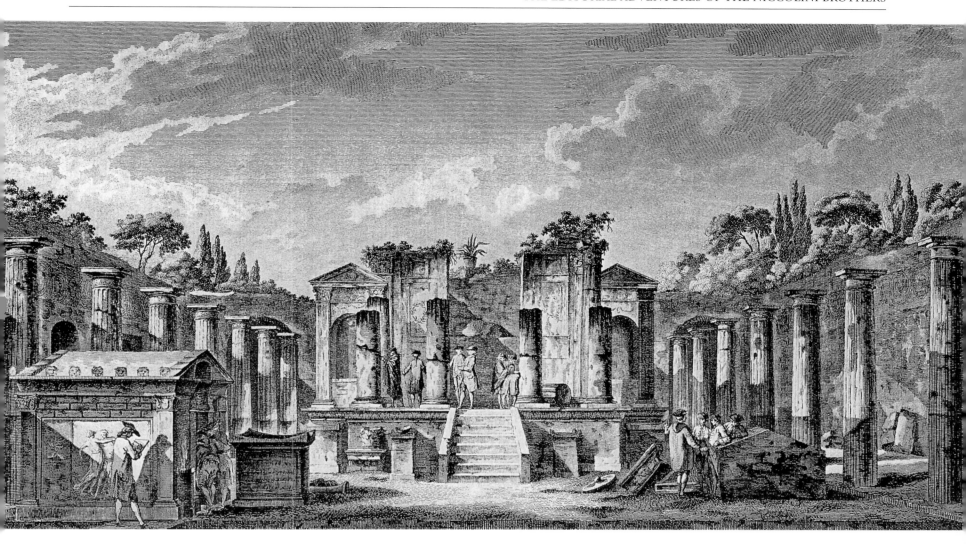

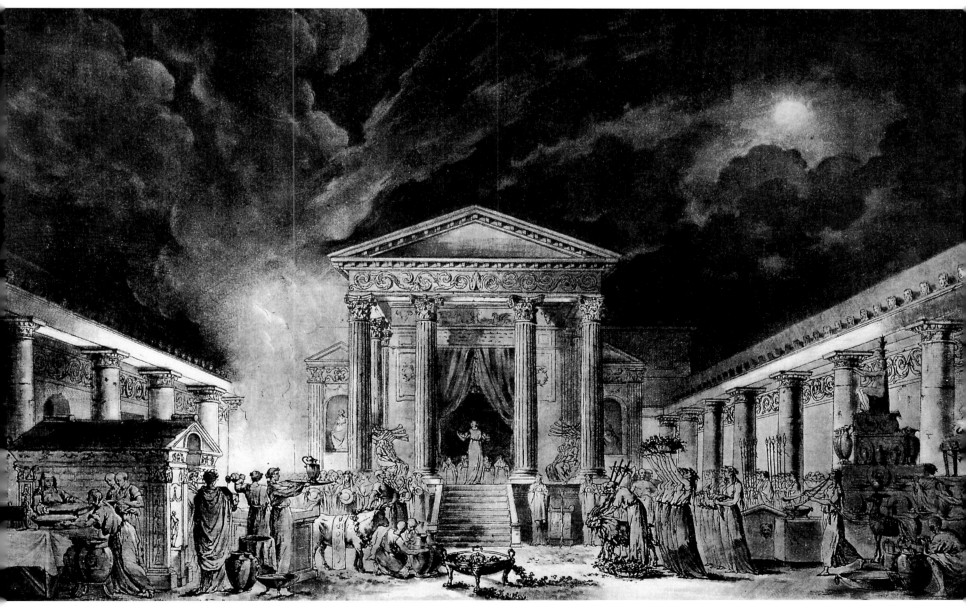

Above, Francesco De Cesare, *Details of the Architectural Orders of the Basilica* (De Cesare, *Le più belle ruine di Pompei*, pl. 32)

precedent in work on Pompeii by the French architects Mazois and François Chrétien Gau.[69] The plates illustrating their four volumes, the results of years of surveys and drawings conducted by a extensive team of designers, offered refined scientific projections along with views and moderate reconstructions. The depictions not only featured buildings but entire sections of the urban fabric, and these became premises for the research of architects and scholars who later followed.

In this light the contribution of the Neapolitan architect Francesco De Cesare can also be mentioned. In 1835 he published a volume[70] that featured forty-four plates with maps and details of Pompeian monuments, where the commitment to rigorously and accurately document architecture prevailed over rendering the environment or atmosphere; this was dominant, instead, in the work of the *vedutisti* painters. It is interesting to know that De Cesare, like other architects who were working in the excavations of Pompeii such as Pietro Bianchi[71] and Genovese, did not miss incorporating his experience as an archaeologist into architectural language. The modernization of the church of San Carlo all'Arena in Naples is one example, where he created a Classical façade that was certainly inspired by his direct knowledge of antiquity.[72]

The panorama of editorial work about Pompeii during the first half of the nineteenth century is naturally too extensive to be outlined here[73] and would have to include guides and scientific dissertations along with the *vedutisti* works and graphic records on the buildings.

It remains useful to underline here that when *Le case ed i monumenti* was published, there had never been a scholarly monograph on the ancient city in Italian that included a systematic layout of the

François Mazois, *Map of Via dei Sepolcri* (Mazois, *Les ruines de Pompéi*, pl. 3). Mazois's immense work, published between 1813 and 1824, provides perspectives of entire sections of the urban fabric.

numerous monuments and archaeological evidence. As mentioned, the situation had been aggravated by foreign editorial competition. In this regard, the writings of Raffaele D'Ambra in his report on the Pompeii excavations that he sent to Minister Bozzelli in 1848 should be cited. He lamented "the pain of seeing Pompeian paintings come from Berlin and Paris, drawn, painted, and giftedly illustrated in the work of Gerhard, Panofka, Zahn, Raoul-Rochette, and many others, while here we were suffering from their cost, which even inhibited us from seeing them."[74] D'Ambra was referring to some of the most renowned studies in the field, such as the seven booklets that Désiré Rochette[75] of France published between 1844 and 1853, which were known under the pseudonym Raoul-Rochette. These were filled with color plates of a number of wall decorations in Pompeii. There was also the massive work (1827–59) by the German W. Zahn,[76] which featured thirty booklets dedicated to Herculaneum and Pompeii. The Niccolinis also referred to these models, especially for their use of colored lithographs and their booklet form. The works of Breton (1855)[77] and H. Roux Aîné and M. L. Barré (1861–62)[78] were also widely acknowledged. The latter was filled with plates that had been chosen for *Le antichità di Ercolano esposte* and included literature that had been written since. In the 1880s famous studies were published by August Mau[79] on the stylistic classifications of the wall decorations and by Johannes Overbeck[80] on the houses of Pompeii, which was in collaboration with Mau. This last contribution featured the entire contents of each residence and seems influenced by the Niccolinis' methods in adopting a topographic model, although it had diverse treatments of the building types. Thus an interesting circle of methods of study and cataloguing can be traced.

Table supports uncovered at the House of Cornelius Rufus described in the work of Johannes Overbeck. In Overbeck's work, the cataloguing of materials from this Pompeian house appears to be inspired by the Niccolini brothers' criteria (Overbeck, *Pompeji in seinen Gebäuden*, 422).

The continual updating of *Giornali degli scavi di Pompeii*, the work that attempted to record the findings like an "excavation news," is also significant within the panorama of European studies. This work documented explorations that were conducted through 1896, including the House of the Tragic Poet (1824–25) and the House of the Vettii (1893–95), and featured a wide range of excavation facts. During the forty years that passed between the printing of the first and last volume, there were Fiorelli's reforms and new orientations brought on by the direction of Michele Ruggiero (1875–93), who had collaborated with Fiorelli since 1864, and Giulio de Petra (1893–1900, 1906–10).[81] It should also be said that the attention that the Niccolinis had given toward incorporating the entire Pompeian house—from architecture, to decoration, to furniture—had influenced the debate on the problem of safeguarding the sites. During the final years of the century, this moved toward renewing the architectural structure and the integral conservation of the on-site decorative elements and furnishings, thus avoiding the looting that had often occurred during nineteenth-century explorations.

One last consideration should be made concerning the links between publications and the artistic culture of the time. The discovery of the ancient Campanian cities had greatly contributed to knowledge of Roman civilization and the spread of antiquarian tastes in Europe,[82] especially through the publication of *Le antichità di Ercolano esposte*. This was also true, to a lesser extent, of the work of the Niccolini brothers and its impact on European culture with respect to its illustrious forerunners.

The analogous positivist process of interpreting recorded evidence should also be indicated. Naturally, this process followed positivist parameters that were totally different from those that had inspired academics at Herculaneum. This time the liveliness of the colored plates was heightened by the lithographic process and quite different from the original tones of the paintings. In the first half of the century, these had been rendered by designers' delicate watercolors; this gives a measure of this noticeable change toward a "modern" taste in antiquity.

For the most part, other attempts at reconstructing the typical Pompeian house were not any different. Especially in Naples, even though there were already valuable anticipations during the 1770s, the Pompeian revival asserted itself during the first half of the 1800s. Guglielmo Bechi elegantly translated

this taste into works such as the San Teodoro Palace (1826) and the modernization of the palace at Ruffo della Scaletta (1832–35), both of which were on the Chiaia Riviera. Being so close to the Vesuvian cities was a determining factor for this style to survive in the Campanian area during the entire nineteenth century and well into the twentieth. The nostalgic restoration of the Pompeian Villa in Sorrento is a good example.

It is significant that Fausto Niccolini himself was an apt interpreter of Pompeian style in his own architecture work. Following the example of his father, who had been inspired by the plates of *Le antichità di Ercolano esposte* for his designs for the bas-reliefs on the San Carlo stage,[83] Fausto designed a Pompeian decoration for the Sannazaro Theater. In using the traditional motif of dancers on the hall's curtain, he referred to reproductions by Vincenzo Mollame that had been published in *Le case ed i monumenti*.[84]

Wall decorations found in the Temple of Augustus in the Pompeian Forum by Raoul-Rochette (Désiré Rochette). This is from the work *Choix de peintures de Pompéi*, one of the most renowned studies regarding ancient Pompeii, seven booklets published between 1844 and 1853 (Raoul-Rochette, *Chois de peintures de Pompéi*, pl. 4).

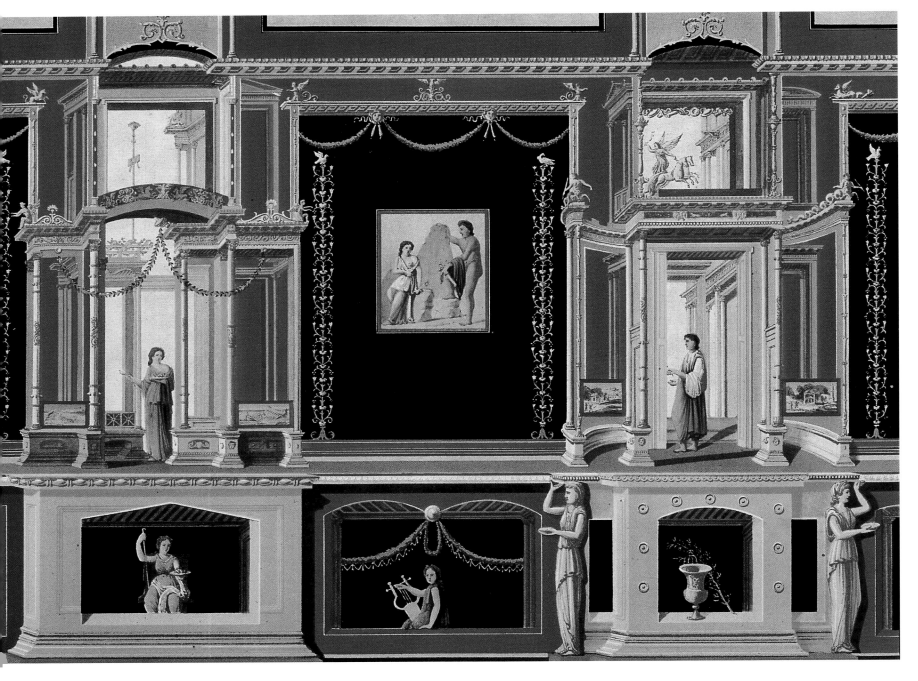

Notes

1. Antonio Niccolini was born in San Miniato al Tedesco in 1772 and lived in Naples for the rest of his life until 1850. Given the obvious space restraints here, for a summary of his work see his notable autobiography published by Franco Mancini: "Un'autobiografia inedita di Antonio Niccolini," in *Napoli Nobilissima*, vol. 3, 5:185–94; the bibliography edited by Antonio Benci and given an account of in Luciano Caruso, "L'inizio di una stagione romantica a Napoli," in *Il Teatro del Re: Il San Carlo da Napoli all'Europa*, G. Cantone and F. C. Greco, eds. (Naples: 1987), 81–111; and the profile of the master by Arnaldo Venditti, *Architettura neoclassica a Napoli* (Naples: 1961), 235–99.

2. From *Giornale delle Due Sicilie*, November 21, 1825, cited in F. Mancini, "Le scene, i costumi," in *Il Teatro di San Carlo, 1737–1987*, vol. 3 (Naples: 1987), 66.

3. See also *Real Museo Borbonico*, 16 vols. (Naples: 1824–57).

4. These ranged from the commissions named in 1827 and 1840, respectively, for the reproduction of a Pompeian house on one of the royal Bourbon sites and for "assembling a general rule for restoring the ancient monuments" (see also M. Pagano, "Metodologia dei restauri borbonici a Pompei ed Ercolano," *Rivista di studi pompeiani* 5 [1991–92], 180–81), to the renowned restoration commission that in 1829 was charged with evaluating the graphic reproductions of the excavations (see also I. Bragantini and M. De Vos, "La storia degli scavi e della documentazione," in *Pompei 1748–1980: I tempi della documentazione*, exhibit catalogue [Rome: 1981], 41, n. 39).

5. See also *Quadro in mosaico scoperto in Pompei a dì 24 ottobre 1831 descritto ed esposto in alcune tavole dimostrative dal Cav. Antonio Niccolini architetto di Casa Reale direttore del Reale Istituto delle Belle Arti* (Naples: 1832).

6. Fausto Niccolini, *Letter from Fausto Niccolini, 26.1.1861*, Cartella "Fausto Niccolini," Fondo Personale, Archivio Storico della Soprintendenza Archeologica di Napoli e Caserta (ASSAN).

7. Bragantini, "La storia degli scavi," p. 38.

8. In his multifaceted activity, Antonio was committed to other archaeological publications and published a number of essays on the so-called Temple of Serapis in Pozzuoli: Antonio Niccolini, *Memoria sulle arti deunta dalla illustrazione dell'antica terma Puteolana volgarmente nomata tempio di Serapide* (Naples: 1800); *Rapporto sulle acque che invadono il pavimento dell'antico edificio detto il tempio di Giove Serapide letto dal presidente della Reale Accademia di Belle Arti Cav. Antonio Niccolini: Nella tornata del dì 25 novembre 1828* (Naples: 1829); "Sunto delle cose avvenute e di quanto è stato recentemente operato nella gran cisterna del tempio di Serapide per restituire e conservare l'acqua salatifera che in essa sorge," in *Rendiconto della R. Accademia delle Scienze* (Naples: 1844), 339–41; *Descrizione della gran terma puteolana volgarmente detta Tempio di Serapide preceduta da taluni cenni storici per servire alla dilucidazione de' fenomeni geologici, e de' problemi architettonici di quel celebre monumento e considerazioni su i laghi maremmani* (Naples: 1846). This last writing had already appeared in 1845, entitled without "*considerazionei su i laghi maremmani.*"

9. Fausto and Felice's birthdates can be deduced from Benci's biography, which states that when the San Carlo theater burned, the Tuscan architect had "a four-year-old child, and his wife was about to give birth" (see also Caruso, "L'inizio di una stagione romantica a Napoli" p. 96). Since C. N. Sasso reports that Antonio had "only two sons, Fausto the first, Felice the second," (C. N. Sasso, *Storia de' monumenti di Napoli e degli architetti che li edificavano dal 1801 al 1851 per l'architetto Camillo Napoleone Sasso*, vol. 2, 1858 [Naples: 1856–58], 51), and if Benci's information is accurate, the two brothers would have been born in 1812 and 1816, respectively.

10. Before being annexed by the Biblioteca Nazionale. Carlo Paglione, *Lettera del Bibliotecario Carlo Paglione al Direttore del Museo Nazionale del 22.6.1886*, Cartella "Fausto Niccolini," Fondo Personale, ASSAN.

11. Felice Niccolini, *Di un cartone di Raffaello Sanzio custodito nel Museo Reale Borbonico e dei tempi in cui venne operato: Memoria diretta alla Reale Accademia di Belle Arti da Felice Niccolini* (Naples: 1859).

12. See also L. Zingarelli, "Note bio-bibliografiche sugli Architetti, Pittori, e Scenografi dei Teatri di Bari (1800–1854)," in *Il Teatro Piccinni di Bari*, V. A. Melchiorre and L. Zingarelli, eds. (Bari: 1983), 204.

13. See also F. Mancini, *Scenografia napoletana dell'Ottocento: Antonio Niccolini e il Neoclassico* (Naples: 1980), 133.

14. See also C. Belli, "Il San Carlo attraverso le fonti documentarie," in Cantone, *Il Teatro del Re*, 188.

15. See also F. Florimo, *La scuola musicale di Napoli e i suoi conservatori, con uno sguardo sulla storia della musica in Italia*, vol. 4 (Naples: 1881–82), xvii.

16. His collaborations in works directed by his father should also be remembered, such as the restoration of the San Carlo theater in 1844 (see also Venditti, *Architettura neoclassica a Napoli*, 246, where he dates the work to 1845, and F. Mancini, "La storia, la struttura," in *Il Teatro di San Carlo, 1737–1987*, vol. 1 (Naples: 1987), 134) and editing a project during a contest (1848) to modernize the Fondo Theater (today the Mercadante Theater) in Naples by Niccolini and Francesco Maria Del Giudice (see also A. Venditti, "L'architettura del Mercadante: dal Teatro del Fondo all'età moderna," in *Il Teatro Mercadante la storia, il restauro*, T. R. Toscano, ed. [Naples: 1989], 12, 28–29).

17. Together with Gaetano Genovese, Bartolomeo Grasso, and Michele Ruggiero. See also Venditti, *Architettura neoclassica a Napoli*, 394, n. 104; B. and G. Gravagnuolo, *Chiaia* (Naples: 1990), 62. For other urban-scale operations, see Venditti, *Architettura neoclassica a Napoli*, 190, 228, n. 143.

18. See also Gravagnuolo, *Chiaia*, 62.

19. See also L. Catalani, *I palazzi di Napoli* (Naples: 1845), 90.

20. See also Venditti, *Architettura neoclassica a Napoli*, 298, 318, n. 139.

21. Fausto Niccolini, *Guida del Museo Archeologico Nazionale di Napoli e suoi principali monumenti illustrati* (Naples: n.d., possibly 1870). A second edition of this guide was published in 1882 and translated into French, English, and German.

22. See also Fausto Niccolini, *Lettera di Fausto Niccolini del 26.1.1861*, Fondo Personale, Cartella "Fausto Niccolini," ASSAN.

23. See also Catalani, *I palazzi di Napoli*, 48; Venditti, *Architettura neoclassica a Napoli*, 190, 228, n. 143.

24. Venditti, *Architettura neoclassica a Napoli*, 320, n. 144.

25. See also G. Fiorelli, *Appunti autobiografici*, A. Avena, ed. (Rome: 1939), 29. This was recently republished with a premise by S. De Caro (Sorrento and Naples: Di Mauro, 1994).

26. See also F. De Angelis, "Giuseppe Fiorelli: la 'vecchia' antiquaria di fronte allo scavo,' in *Recerche di Storia dell'arte* 50 (1993), 6.

27. For a summary of Fiorelli's work in Pompeii, besides De Angelis's essay above, see F. Zevi, "La storia degli scavi e della documentazione," in *Pompei 1748–1980*, 16–18. For his youth, see also A. Milanese, "Il giovane Fiorelli, il riordino del medagliere e il problema della proprietà allodiale del Real Museo Borbonico," in *Musei, tutela, e legislazione dei beni culturali a Napoli tra '700 e '800*, Quaderni del Dipartimento di Discipline Storiche, Università degli studi di Napoli "Federico II," no. 1 (1995), 173–206.

28. This was discontinued in 1875 with the institution of the Scuola Archeologica Italiana.

29. Of which should be remembered at least the *Pompeianarum Antiquitatum Historia*, three vols. (Naples: 1860–64), which includes a history of the excavations based on records dating before the unification of Italy, a publication of the work carried out at the site in Pompeii from *Giornale degli Scavi* (1868–79), and a printed report sent to the Ministro dell'Istruzione Pubblica at the conclusion of the first decade of Fiorelli's mandate in Pompeii (*Gli scavi di Pompei dal 1861 al 1872: Relazione al Ministro della Istruzione Pubblica di Giuseppe Fiorelli Soprintendente Gen. Del Museo e degli scavi di Napoli Senatore del Regno* [Naples: 1873]).

30. See also G. Fiorelli, *Sulle regioni pompeiane e della loro antica distribuzione* (Naples: 1858).

31. Ibid., p. 5.

32. See also *Tabulae Coloniae Veneriae Corneliae Pompeiis, quam denuo recognitam edidit Joseph Fiorelli* (Naples: 1858).

33. Fausto and Felice Niccolini, *Le case ed i monumenti di Pompei disegnati e descritti*, vol. 1 (Naples: 1854–96), i.

34. From a copy of a royal decree extract from May 16, 1875, Fondo Personale, Cartella "Felice Niccolini," ASSAN.

35. Ibid., copy of a royal decree extract from January 3, 1878.

36. Ibid., copy of a royal decree extract from January 15, 1882.

37. From a letter to Fausto Niccolini from April 26, 1866, Cartella "Fausto Niccolini," ASSAN.

38. Ibid., from a letter to Fausto Niccolini from July 12, 1882.

39. Ibid., from a letter by Giuseppe Fiorelli, January 31, 1861.

40. See also Friedrich Furchheim, *Bibliografia di Pompei, Ercolano, e Stabia compilata da Friedrich Furchheim libraio* (Naples: 1891), 65. In 1891 Furchheim published 109 booklets out of the 124 that were initially planned.

41. Here it seems useful to include the contents of the four volumes along with the number of plates in each chapter. Vol. 1: *House of the Tragic Poet*, 6; *House of Castor and Pollux*, 11; *House of the Second Fountain*, 6; *Temple of Fortuna*, 2; *House of the Faun*, 9; *House Number 57*, 3; *House of Siricus*, 2; *Pantheon*, 6; *The Tomb of Umbricius*, 1; *Temple of Mercury*, 1; *House of the Colored Capitals*, 4; *Tomb of Naevoleia Tyche*, 1; *House of Marcus Lucretius*, 9; *Stabiae Gate Baths*, 8; *Gladiator Barracks*, 5; *Theaters*, 3; *Temple of Isis*, 12; vol. 2: *Villa of Diomedes*, 7; *House of the Sculpted Capitals*, 3; *Cenotaph of C. Quieto*, 1; *General Description*, 96; vol. 3: *Topography of Pompeii*, 11; *Amphitheater*, 3; *Baths Near the Arch of Fortuna*, 3; *Temple of the Triangular Forum*, 1; *House of the Banker L. Caecilius Iucundus*, 2; *House of the Centenary*, 4, *House of Block VII in Region IX*, 3; *House of Sallust*, 3; *Trades and Industries of the Pompeians*, 9; *Plaster Forms*, 4; *Art in Pompeii*, 56; vol. 4: *Graffiti*, 7; *Appendix*; *Supplement*, 50; *Restoration Essays*, 32; and *New Excavations*, 33. It should also be noted that not all copies consulted have chapters that are identically distributed within the index, and some of the volumes are subdivided.

42. See also F. Zevi, "Gli scavi di Ercolano," in *Civiltà del '700 a Napoli 1734–1799*, exhibit catalogue, vol. 2 (Florence: 1979–81), 65, fig. 6, 66.

43. See also P. Fumagalli, *Pompeia: Traité pittoresque, historique et géométrique: Ouvrage dessiné sur le lieux: Pendant les années 1834, à 1846, Gravé et Publié Par P. F.* (Florence: n.d.).

44. These were generally followed by the description of objects that were found on site, subdivided by category, and illustrative plates.

45. His contribution was limited to the plate reproducing the tomb of Umbricius Scaurus that was included in the first volume.

46. At the Ufficio Tecnico della Soprintendenza Archeologica di Napoli there are numerous designs by Giuseppe Abbate reproducing decorations at residences on Via di Nola and Via delle Terme Stabiane. See also Bragantini, *La storia degli scavi*, 38–39; and *Pompei pitture e mosaici nell'opera di disengatori e pittori dei secoli XVIII e XIX* (Rome: 1995), 238–431.

47. Gigante signed the following plates: vol. 1, *House of Castor and Pollux*, pl. 1; *House of Castor and Pollux*, pl. 11; *House of the Colored Capitals*, pl. 1; *Temple of Isis*, pl. 1, 4; vol. 2, *General Description*, pl. 11, 16, 25. Duclère participated in the work in three plates: vol. 1, *House of the Faun*, pl. 9; *Theaters*, pl. 3; vol. 2, *General Description*, 2:7. One watercolor by Gigante, which Plate 1 of the *House of the Colored Capitals* is based on, is kept in the collection at the Museo Nazionale di San Martino a Napoli and has been published in L. Fino, *Ercolano e Pompei: Vedute neoclassiche e romantiche* (Naples: 1988), 141. For a general overview of Gigante's designs of Pompeii, see *Pompei pitture e mosaici*, 982–1006. (See note 46.)

48. See also Fino, *Ercolano e Pompei*, 128.

49. Fausto Niccolini, *Lettera al Ministro della Pubblica Istruzione del 23.3.1886*, Fondo Personale, Cartella "Fausto Niccolini," ASSAN. See also the notice published in *Roma*, Anno 25, no. 81, Monday, March 22, 1886, p. 2.

50. Carlo Padiglione, *Lettera del Bibliotecario Carlo Padiglione al Direttore del Museo Nazionale del 22.6.1886*, Fondo Personale, Cartella "Fausto Niccolini," ASSAN.

51. See also A. Niccolini Jr., *Pompei* (Naples: n.d., possibly 1887); *Arte Pompeiana: Monumenti scelti*, (Naples: 1888); *Fouilles de Pompei: Monuments choisis* (Naples: n.d.).

52. The name "A. Niccolini dir" appears on plates for the first time in the chapter entitled *The Trades and Industries of Pompeii*, substituting "F.lli Niccolini, dir." This indicated the new scientific direction of the work. Many plates of the fourth volume, however, still showed "F.lli Niccolini dir" and carried the seal of the Richter printing company.

53. This last detail would seem to indicate that the editor of the work was Fausto himself, which an 1880 payment to "Cav. F. Niccolini" from the Direzione Generale dei Musei e degli Scavi for the acquisition of a number of booklets from the work seems to confirm. Giuseppe Fiorelli, *Lettera di Fiorelli al Direttore dei Musei d'antichità di Napoli del 20.10.1880*, Fondo Personale, Cartella "Fausto Niccolini," ASSAN.

54. For the history of the excavations and their documentation, see Fiorelli, *Pompeianarum Antiquitatum Historia*; L. Mascoli, P. Pinon, G. Valet, and F. Zevi, "Architetti 'antiquari' e viaggiatori francesi a Pompei dalla metà del Settecento alla fine dell'Ottocento," in *Pompei e gli architetti francesi dell'Ottocento*, exhibit catalogue (Naples: 1981), 3–53; Zevi, *La storia degli scavi*, 11–21; E. De Carolis, "Gli sviluppi dell'archeologia pompeiana: 1748–1900," in *Fotografi a Pompei nell'800 dalle collezioni del Museo Alinari*, exhibit catalogue (Florence: 1990), 11–20.

55. See also G. C. Capaccio, *Neapolitanae historiae a Iulio Cesare Capaccio . . . conscriptae*, vol. 1 (Naples: 1607), bk. 1, chap. 9.

56. See also F. Bianchini, *La istoria universale provata con monumenti e figurate con simboli degli antichi* (Rome: 1697), 246; C. Celano, *Notizie del bello, dell'antico, e del curioso che contengono le reali ville di Portici, Resina, lo scavamento di Pompeiano, Capodimonte, Cardito, Caserta, e S. Leucio, che servono di continuazione all'opera del canonico Carlo Celano* (Naples: 1792), 52–53. Concerning Picchiatti's archaeological interests, see G. Cantone, *Napoli barocca* (Naples: 1992), 150–52.

57. Holstein expressed his thesis, which was quite controversial at the time, in the volume *Lucae Holstenii Annotationes in Geographiam sacram Caroli a S. Paulo, Italiam antiquam Cluverii et Thesaurum geographicum Ortelii* (Rome: 1666), 243.

58. A modern reprint including a selection of the plates and essays by Fausto Zevi, Raffaele Ajello, Marcello Gigante, and Ferdinando Bologna has been published by the Banco di Napoli: *Le antichità di Ercolano esposte* (Naples: 1988). Interesting reflections on the effects of *Le antichità di Ercolano* on European culture can be found in M. Praz, *Gusto neoclassico* (1940; reprint, Milan: 1990), 75–86; Praz, "Le antichità di Ercolano," 1:35–39; and Zevi, "Gli scavi di Ercolano," 66–67.

59. See also *Le antichità di Ercolano esposte*, vol. 6 (1771) (Naples: 1757–92), 393; Ibid., vol. 8 (1792), pl. 1–3 from the preface.

60. See also W. Hamilton, *An Account of the Discoveries at Pompeii, Communicated to the Society of Antiquaries of London by the Hon. Sir William Hamilton . . .* (London: 1777). As a sign of his interest in Pompeii, a year earlier the ambassador had published a view of the Temple of Isis in his renowned work on the Campi Flegrei, taken by Pietro Fabris while it was being uncovered. See W. Hamilton, *Campi Phlegraei* (Naples: 1776), vol. 2, pl. 41.

61. For a useful summary of the subject, see Fino, *Ercolano e Pompei*; C. Robotti, *Immagini di Ercolano e Pompei: disegni rilevi, vedute dei secoli 18 e 19* (London: 1987); and *Pompei ed Ercolano attraverso le stampe e gli acquarelli del '700 e dell'800*, exhibit catalogue (Naples: 1958).

62. H. Wilkins, *Suite de vues pittoresques des Ruines de Pompeii et un précis historique de la ville: Avec un plan des fouilles qui ont été faites jusqu'en Février 1819 et une description des objets les plus intéressant* (Rome: 1819).

63. J. W. Hüber, *Vues pittoresques des ruines le plus remarquables de l'ancienne ville de Pompéi: Dessinées et gravées à l'acqua tinta par J. W. Hüber, peintre* (Zurich: 1824).

64. See also L. Rossini, *Le antichità di Pompei delineate su le scoperte fatte sino a tutto l'anno 1830 ed incise dall'architetto Luigi Rossini, Ravennate e dal medesimo brevemente illustrate* (Rome: 1830).

65. R. De Saint-Non, *Voyage pittoresque ou description des Royaumes de Naples et de Sicile*, 5 vols. (Paris: 1781–86; Naples: Società Editrice Napoletana, 1981).

66. His son Francesco published this in 1804 in a posthumous collection. See also F. Piranesi, *Antiquités de la Grande Grèce aujourd'hui Royaume de Naples, . . . d'après les dessins originaux et les observations locales du feu célèbre architecte . . . Jean Baptiste Piranesi: redigées et expliquées par Antoine-Joseph Guattani* (Paris: 1804–7), vol. 2 (1804), pl. 70.

67. See also W. Gell and J. P. Gandy, *Pompeiana: The Topography, Edifices, and Ornaments of Pompeii: By Sir William Gell F.R.S. F.S.A. and John P. Gandy, Architect*, 2 vols. (London: 1817–19); W. Gell, *The Result of Excavations Since 1819: By Sir William Gell, M.A. F.R.S. & F.S.A.*, 2 vols. (London: 1832).

68. See also *Pompei e gli architetti francesi* (see note 54), especially the chapter entitled *I restauri*, pp. 67–79.

69. See also F. Mazois, *Les ruines de Pompéi dessinées et mesurées pendant les années MDCCCIX, MDCCCX, MDCCCXI publiée à Paris en MDCCCXII, Première et secondième parties*, 2 vols. (Paris: 1813–24).

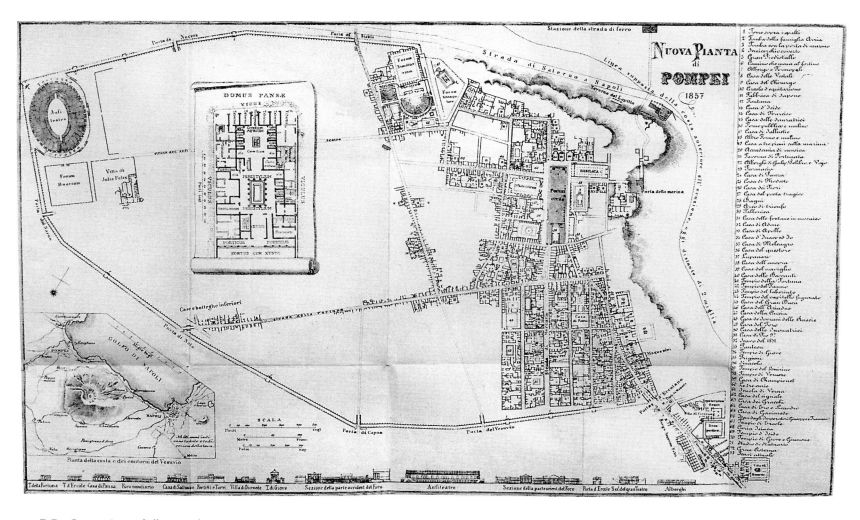

New Map of Pompeii, 1857 (Sasso, *Il Vesuvio, Ercolano e Pompei*, pl. 22)

70. F. De Cesare, *Le più belle ruine di Pompei descritte e misurate, e disegnate da Francesco De Cesare professore di architettura civile, socio corrispondente della Reale Accademia di Belle Arti di Napoli ec. Colle notizie de'scavi da che ebbero principio sino al 1835* (Naples: 1835).

71. On Bianchi's archaeological activity, see M. Pagano, "Pietro Bianchi archeologo: da architetto fiscale a direttore delgi scavi di Pompei," in *Pietro Bianchi 1787–1849 architetto e archeologo*, exhibit catalogue, N. Ossanna Cavadini, ed. (Milan: 1995), 151–60.

72. Fra' Nuvolo built the church between 1623 and 1680. See also Cantone, *Napoli barocca*, 114. On De Cesare's operations, see F. De Cesare, *Sulla origine delle lesioni della Chiesa di San Carlo Borromeo in Napoli e suo progetto di ricostruzione: Memoria di Francesco di Cesare* (Naples: 1837); F. Cibarelli, *La chiesa di San Carlo all'Arena e il Cristo del Naccherino* (Naples: 1926).

73. For a bibliography on Pompeii up to 1891, see Furchheim, *Bibliografia di Pompei, Ercolano, e Stabia*. Interesting indications are also in C. De Seta, *Architettura ambiente e società a Napoli nel'700* (Turin: 1981), 79–109; and *Pompei Ercolano Stabiae Oplontis LXXIX–MCMLXXIX*, exhibit catalogue (Naples: 1984).

74. See also Pagano, *Metodologia dei restauri borbonici*, 186; and *Pietro Bianchi archeologo*, 155.

75. See also Raoul-Rochette (Désiré Rochette), *Chois de peintures de Pompéi la plupart de sujet historique, lithographiées en couleur par M. Roux, et publiées avec l'explication archéologique de chaque peinture et une Introduction sur l'histoire de la peinture chez les Grecs et chez le Romains par M. Raoul-Rochette*, 7 vols. (Paris: 1844–53).

76. W. Zahn, *Die schönsten Ornamente und merkwürdigsten Gemälde aus Pompeji, Herkulanum und Stabiae, nebst einigen Grundrissen und Ansichten: Mit deutschem und französichem Text*, 3 vols. (Berlin: 1827–59).

77. E. Breton, *Pompeia décrite et dessinée par Ernest Breton de la Société Impériale des Antiquaires de France, etc., Suivie d'une notice sur Herculanum* (Paris: 1855).

78. H. Roux Ainé and M. L. Barré, *Herculanum et Pompéi recueil general des peintures, bronzes, mosaïques, etc. découverts jusqu'à ce jour, et reproduits d'après "Le antichità di Ercolano," "Il Museo Borbonico" et tous les ouvrages analogues augmentés de sujets inédits graves au trait sur cuivre par H. Roux Ainé et accompagnés d'un Texte explicatif par M. L. Barré*, 7 vols. (Paris: 1861–62).

79. A. Mau, *Geschichte der decorativen Wandmalerei in Pompei* (Berlin: 1882).

80. J. Overbeck, *Pompeji in seinen Gebäuden: Alterhümern und Kuntswerken dargestellt von Johannes Ovebeck vierte im Vereine mit August Mau durchgearbeitete und vermehrte Auflage* (Leipzig: 1884; Rome: 1968).

81. For a synthesis of Ruggiero's and De Petra's management of the excavations, see A. Maiuri, "Gli scavi di Pompei dal 1879 al 1948," in *Pompeiana: Raccolta di studi per il secondo centenario degli scavi di Pompei* (Naples: 1950), 11. More specifically on Ruggiero's activity, see also A. Sogliano, "Michele Ruggiero e gli scavi di Pompei," in *Atti della Reale Accademia d'Archeologia*, Lettere e Belle Arti, vol. 16 (1891–93), Part 1, pp. 225–34.

82. This question was widely debated by historiographers. For obvious motives of space constraints, we refer here to some of the main contributions to the subject: F. Bologna, "Le scoperte di Ercolano e Pompei nella cultura europea del XVIII secolo," in *La parola del passato*, vol. 33, booklets 188–89 (1979), 377–404; E. Chevallier, "Les peintures découvertes à Herculanum, Pompéi, et Stabies vues par les voyageurs du XVIIIe siècle," in *Gazette des Beaux Arts*, vol. 90 (December 1977), 177–88.

83. C. Garzya, *Interni neoclassici a Napoli* (Naples: 1979), 77.

84. The plan was nonetheless never practically achieved. See also P. L. Ciapparelli, "Il 'teatro pompeiano' di Fausto Niccolini," in *I disegni di archivio negli studi di Storia dell'Architettura*, Atti del Convegno di Studi, Naples, June 1991, G. Alisio, G. Cantone, C. De Seta, and M. L. Scalvini, eds. (Naples: 1995), 178–81.

THE EVOLUTION OF POMPEIAN TASTES IN EUROPE

By Enrico Colle

Robert Adam was one of the proponents of a reawakened interest in antiquity during the second half of the eighteenth century. This brought new rules for conceptualizing architecture and interior design.

"Fashion, that fickle goddess who often calls the past to new life, can hasten the present from her womb in a flash of lightning," wrote the brothers Fausto and Felice Niccolini. They were commenting on the discovery of a valuable armlet in the shape of twisting serpents that was found among the ruins of Pompeii. For almost a century, attention had been focused on the archaeological discoveries at Pompeii and Herculaneum, which had been inexhaustible sources of inspiration.[1] It was exactly for this reason and, above all, to publicize the progress of excavations and archaeological studies in that "antique city" that the Niccolinis published their series of volumes. These were meant to substitute the obsolete pages of *Le antichitá di Ercolano esposte*, which had greatly contributed to the growth of archaeological studies and the diffusion of Neoclassical tastes in Europe.

When the eight huge tomes of *Le antichità di Ercolano esposte* were brought to light between 1757 and 1792, interest in antiquity had already been awakened in artistic and learned circles. In Rome, Giovan Battista Piranesi, followed by Robert Adam, established a basis for a new way of understanding architecture and interior decoration. These were to be modeled after the extravagant works of the ancient Romans. The monumental and scenographic interpretations of antiquity in Piranesi's engravings came to accompany the Alexandrine grace of the decoration and furnishings of Herculaneum. Images of the

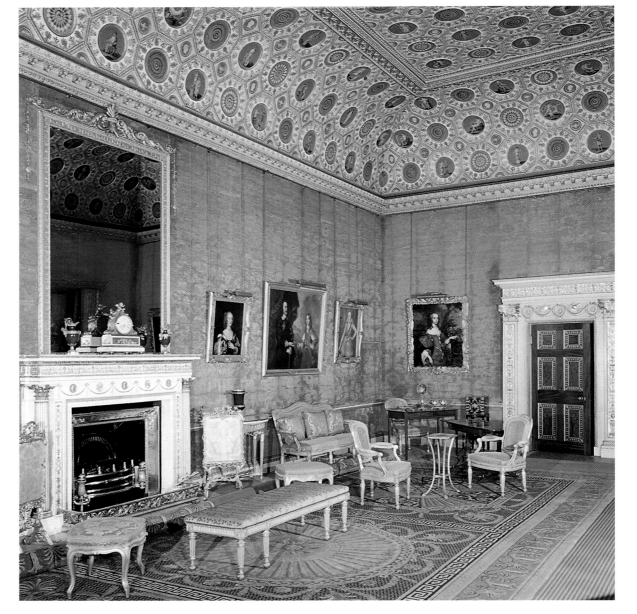

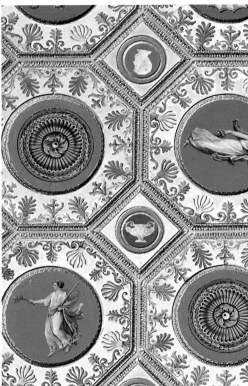

In the Red Hall of Syon House (*left*), with its silk damask walls, the unusual ceiling provides a unifying effect. The ceiling's overlying shell is finely worked with stucco rosettes and tiny round paintings of silhouettes inspired by archaeology (*above*).

city were distributed through printed reproductions filled with "eighteenth-century charm." Reading the frescoes and bronzework in line with the Louis XVI style determined the rapid diffusion of new decorative motifs among decorators. "Eighteenth-century taste found itself through the paintings shown at the Museo di Portici," wrote Mario Praz.[2] A whole line of dancing figures, winged sprites, cherubs, and children joking among themselves took on new life in an infinite variety of paintings on the walls of salons and on furniture made beginning in the 1760s during that "century of light." Examples include the multicolored stucco ceiling in the Red Hall of Syon House, which was designed in 1768 by Adam and painted around 1770 by Angelica Kaufmann, and the slender paintings of candelabras, sphinxes, and medallions that were created by Adam between 1761 and 1777 to decorate the Etruscan Room in Osterley Park.[3] The latter equaled decorations by Richard Mique and Pierre Rousseau, architects of the French court. In 1786 Rousseau built a boudoir in Fountainebleau Castle for Marie Antoinette. Here ancient Classical decoration dissolved into stylized scrolls of acanthus leaves and elegant floral compositions that included simulated cameos.[4]

In Italy the encaustic medallions of feminine figures in various poses among the golden stucco works at the Salotto Rotondo of the Pitti Palace can be considered early examples of allusions to engravings

The Etruscan Room at Osterley Park. Here Adam was inspired by ancient vase painting and the archaeological imagination of Piranesi, coupling red and black grotesque patterns on a cream or light-blue background with silhouettes and tiny multicolor tondi of a variety of scenes.

Marie Antoinette's boudoir in Fontainebleau Castle, built by Pierre Rousseau, one of the queen's favorite architect-decorators. Here refined grotesque patterns in Pompeian style appear with mother-of-pearl furniture.

from Herculaneum. These were completed by 1775,[5] and miniatures were made after 1762 on a porcelain dinner service from the Real Fabbrica di Napoli.[6]

As has been noted many times, the diffusion of models from Herculaneum was slow at first (at the time archaeological discoveries from Pompeii were also grouped under the name of Herculaneum). This was due to the fact that for a number of years, access to the excavation sites was only given to a small number of people who were prohibited from making drawings of what they saw. The publication of *Le antichità di Ercolano esposte*, which was sponsored by the royal court, did not particularly help knowledge to circulate either, since Neapolitan royalty only displayed these volumes as they liked, giving them to whoever was in their graces at the time.[7]

It would only be at the end of the eighteenth century that archaeological discoveries in Naples would enter into and become part of a true decorative vocabulary. This language was applied to wall decorations, furniture, and objects for everyday use. An example can be found in the hall made by artisans in the service of the Bourbon court in Naples between 1796 and 1798, the hall of the second royal apartment in the Favorita Villa in Resina. Here Dionysian worshippers, taken from antiquity, adorn the backs of armchairs and couches. These resembled others that were uncovered in the so-called Villa of Cicero and illustrated in Plate 29 of the third volume of *Le antichità di Ercolano esposte*. In addition, an

armchair is now at the Palazzina Cinese in Palermo[8] whose structure, painted in simulated bronze with gold-plated ornamentation, was the result of freely interpreting ancient prototypes.

Other examples include triclinium supports, reproduced many years later by Fausto and Felice Niccolini in Plate 35 of the second volume of their work. However, in Naples, like Rome, references taken from archaeological sites in Herculaneum and Pompeii were often merged with Piranesi's imaginary inventions. In his 1769 *Diverse maniere d'adornare i camini* (Different methods for decorating fireplaces) he suggested an infinite variety of ornamentation to apply to furniture and interior decoration. At the same time in Florence, beginning in the 1770s, recycled Classicism in the decorative arts occurred when decorative themes from antiquity were rediscovered, as seen in the Medici collections. Grotesque forms were also reelaborated. It was for exactly this reason that Grand Duke Pietro Leopoldo of Tuscany had arranged for the role of "master of the grotesque" at the local academy, which was originally held by the painter Luigi Levrier. Together with Ildebrando Poggi and Carlo Lasinio, Levrier designed and printed a selection of grotesque decorations from Florentine palaces.[9]

During that century's last quarter, the tastes of the French dictatorship melted into Neoclassicism with a Habsburg stamp. This originated from the close dynastic ties that linked the archdukes and archduchesses of Austria with the Italian courts of Florence, Naples, Parma, and Milan. The French found exemplary regimes in the courts of Piedmont and especially Parma, which ranged from the mature style of Louis XV to the beginnings of the Louis XVI style (circa 1750–70). "Good taste" fostered structures and ornamentation that were simpler and rational, and these were accepted and promoted by enlightened aristocrats and other less-official court representatives who were freer from ceremonial norms. They were therefore better suited to welcome the international forms of the new style, where rationality and cultured references to antiquity coexisted under the scientific seal of progress.

At this point, the importance of obtaining "good models" for the new institutes and refounded academies could not be overlooked. These came from plaster and painted copies, or other designs, engravings, books, and anything that was reproducible and meriting to be taken as an example and studied. Besides the volumes by Jean Charles Delafosse (1771), Richard de Lalonde (circa 1780), and Oubert Parent (1786–90), whose decorative inventions were in debt to classical antiquity, or Jacques François Blondel (1771–77), there was the publication between 1766 and 1767 of four folio volumes entitled

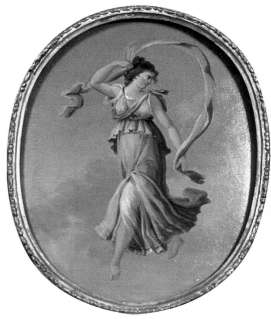

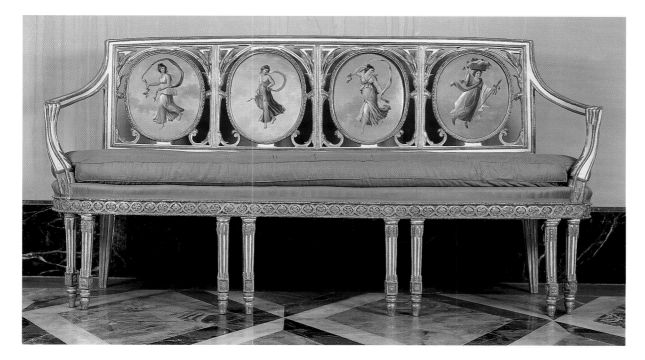

The archaeological discoveries of Herculaneum and Pompeii at the end of the eighteenth century became a part of a true decorative vocabulary that was applied to furniture and other everyday objects. This sofa was part of a Neoclassical finishing trend between 1796 and 1799 and made by artisans in the service of the Bourbon court. It belonged to the hallway of the second royal apartment in the Favorita Villa in Resina, near Naples. In the refined ovals of the backrest (*above*), there are figures of Dionysian worshippers that were vaguely inspired by archaeological examples from Pompeii and Herculaneum. Naples, Museo e Gallerie Nazionali di Capodimonte.

An Imperial tripod in bronze and gold-plated bronze. This is very similar to another example from the Roman era in Pompeii. It was made in the workshop of the brothers Luigi and Francesco Manfredini, bronze workers in Milan. Nizza, Musée Masséna.

Antiquités etrusques et romaines (Etruscan and Roman antiquities), edited by Pierre François Hugues d'Hancarville.

Examples were taken from Apulian vases collected by the English diplomat in Naples, Lord William Hamilton, and other numerous collections that were classified with an enlightenment mindset. The collections held a variety of decorative motifs and everyday objects from antiquity that had begun to be catalogued by type. These include the famous *Recueil d'antiquités égyptiennes, etrusques, romaines, et gauloises* (Collection of Egyptian, Etruscan, Roman, and Gaulish antiquities), seven volumes edited by the Count of Caylus between 1752 and 1767, and *Manuale di vari ornamenti . . .* (Manual of various ornaments), published by Carlo Antonini in 1777. In the latter, the author shunned the "capricious embellishments" of the Baroque and Rococo "to obtain . . . the reflourishing of ancient good taste in decorating works" and advised "professors and amateurs in the fine arts" on imitating the "most noble ancient works." He therefore had shaped this "abundant collection of the most chosen flowers, especially those included under the general name of Rosoni that were found sculpted in the decorations of the ancient factories in Rome and outside of it." Stonecutters and cabinet-makers had accurately copied these at the turn of the century, rivaling models chosen by Domenico Pronti for his collections dedicated to the "religious, civil, and military customs of the ancient Egyptians, Etruscans, Greeks, and Romans that had been found in the ancient monuments."

Giocondo Albertolli's formation was based on the paintings of Herculaneum and Pompeii, the engravings of Piranesi, the grotesque decorations of Raphael (and his school that Volpato had replicated), and the English Neoclassical influence, which was probably known through Adam's works. Albertolli was a decorator originally from Ticino who was the first in Italy to give an autonomous and original interpretation of classical antiquity. His work was publicized through two volumes entitled *Ornamenti diversi . . .* (Various decorations), from 1782, and *Alcune decorazioni di nobili sale ed altri ornamenti . . .* (Some ornamentation from halls of the nobility and other decorations), published in 1787.

The incentive to value the teachings that Classical architecture and ancient ruins provided to new generations of decorators had already been felt in Lombardy for a few years. More precisely, this began in 1769, when the decorator Agostino Gerli moved to Milan. He had been active in Paris since 1764 in Honoré Guilbert's shop.[10] Giuseppe Piermarini also moved to Milan, called there, following Vanvitelli, in order to develop the plans for the new royal palace. The two were soon joined by the "architecture and decoration painter" Giuseppe Levati and Albertolli himself, who had given extraordinary evidence of his decorative ability with his stuccowork in the hall of the Pitti Palace and the Poggio Imperiale Villa in Florence.[11]

Yet Albertolli, who was a teacher of decoration at the Accademia di Brera from 1775 to 1812, established a didactic method based on the study of the ancient Roman reliefs, instead of encaustic works from Herculaneum and Pompeii as Gerli proposed.[12] The method would be followed by successive teachers and would signal critical misfortune—this occurred in the Grand Duchy of Tuscany—for Pompeian decoration during most of the first half of the nineteenth century.[13]

"I can now supply young designers with a large number of examples," Albertolli informed in his preface to *Alcune decorazioni di nobili sale*, "who I hope with these aids will not be easily or inadvertently swayed to the unrealistic, arid painting style found in the caves of the ancient baths in Rome, among the ruins of Herculaneum, and other places, which some would like to introduce among us." The decorator, in fact, was astonished that those "frivolous paintings" of "capricious childishness" would be reproduced and distributed in the main Italian cities. These must have been works "by the most mediocre brushes of that era." Instead, the ones to look to in order to find the prototypes of "good taste" were "masters advanced in Roman grandeur." He held that "whichever decoration we want to

employ for any sort of embellishment, after we have been careful observers of nature, should be drawn from architectural orders."

The artist and man of letters Carlo Maria Giudici had already stated in his 1775 *Riflessioni in punto di Belle Arti…*[14] (Reflections of the moment on the fine arts) that one needed to consult ancient architecture and decorations that the Greeks had created "to give charm and grandeur to Corinthian, Ionic, and Doric orders," not encaustic decorations. The latter were held to be more captivating because of their chromatic colors and variety of subjects, yet some saw them as inhibiting good taste. Since the decorative school of Brera advised its students to use grotesque work as study models,[15] its choice set it apart from other Italian academies since its beginning. The school also valued interpreting Piranesi's ideas, which would only be applied in the decorative arts with the coming of the Imperial style. The light scrolls of acanthus leaves, the meandering friezes woven with ribbons, and the multicolored stucco cameos that were typical of the Louis XVI style were definitively overcome. For the most part, these had only been an update of the Rococo (*rocaille*) style.

Nevertheless, the antiquities of Paestum, Herculaneum, and Pompeii, together with the natural phenomena of Vesuvius and Pozzuoli, continued to draw travelers from every part of Europe to Naples. This contributed to the diffusion of uncovered artistic works, which, as Mario Praz said, acted consistently to inspire new Neoclassical ornamentation. The model of the armchair with armrests supported by sphinxes that was largely used during most of the first half of the nineteenth century originated, for example, from Plate 44 of the fourth volume of *Le Antichità di Ercolano esposte*. The figures of winged caryatids, or the lion heads that often ended with the paws of beasts (these were also reproduced by the Niccolinis in Plate 48 of Volume 3), were transformed into some of the most common supports for Imperial consoles. Similarly, the tripods discovered in Pompeii (Plate 42 of Volume 2 of the Niccolinis' work) became—in the shape of portable washbasins, flower holders, or pedestals (*guéridon*)—one of the indispensable elements of Neoclassical furnishings. This can be seen, for example, in the baptismal font made in 1811 by the Milanese bronze workers Luigi and Francesco Manfredini, which was given to Napoleon for the inauguration of Re di Roma.[16] The bronze and marble items uncovered in the so-called House of the Faun (Plate 2 of Volume 2, Plate 7 of Volume 1 in the Niccolinis' work) resurface in the gold-plated bronze work of a light stand in one of the halls of Neues Schloss in Baden-Baden,[17] and the council chair in Carlton House that was made by English sculptors.[18]

The major Imperial decorators, Charles Percier and Pierre Fontaine, were inspired by *Le antichità di Ercolano esposte* in conceiving their decorations for the Napoleonic court. The famous motif of the young woman standing upright on a globe was adapted into infinite variations to support candles. There were numerous Medusa heads, friezes with sprites that ended in scrolls, cherubs seated on two intertwined seahorse tails, and the motif of Cupid next to a tiny pillar, all of which were used to shape bronze appliqués for furniture.

In Italy too, Pietro Ruga, who published his *Invenzioni diverse di mobili ed utensili sacri e profani* (Different inventions of sacred and profane furniture and utensils) together with Lorenzo Rocchegiani in 1811, demonstrated where to find many decorative cues, just as Percier and Fontaine had done. He gave special attention to Pompeian decorations. Felice Giani had given a refined interpretation of these at the beginning of the nineteenth century with his frescoes for the Gabinetto d'Amore and the Sala dell'Antibagno at the Milzetti Palace in Faenza.[19]

Thanks to Adam and later Cameron from Scotland, the decorative motifs of Herculaneum and Pompeii also spread to the Neoclassical Russia of Catherine II. In her room at the Tsàrskoye Selò Palace, she wanted to re-create the "graceful columns, the airy vaults, the flying garlands, and the wild perspectives of many walls in Herculaneum."[20] Pompeian styles eventually made their way into Germany as

A Neoclassical candelabra in bronze that was made either in Milan or Paris. It is a faithful copy of a Classical original uncovered in Pompeii in the House of the Faun and was represented in the work of the Niccolini brothers together with other marble and bronze objects. Baden-Baden, Neues Schloss.

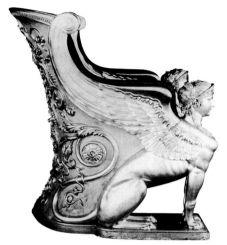

The motif of winged sphinxes in the council chair made in 1813 for Carlton House was inspired by the table supports discovered in the House of Cornelius Rufus at Pompeii (*below*).

well. Inside many of the royal residences, next to a Rococo boudoir, other halls were built and decorated with the recurring figures of dancers and other subjects taken from paintings in Herculaneum.

Karl Friedrich Schinkel, the court architect for Federico Guglielmo IV of Prussia, was among the most sensitive to this archaeological revival. Around 1825 he conceived a sumptuous tearoom in the Berlin Castle for the king, where Classically derived paintings were flanked by gold-plated bronze and statues.[21] Some years later in Munich, when Leo von Klenze decorated the Holfgarten Arcades, he framed exotic panoramas and historical pictures within false architectural motifs that were clearly inspired by Pompeii.[22] On the other hand, the geometric sobriety of Classical ornamentation, cleverly purged of its rough subject matter, matched well with the peaceful Biedermeier tastes from Austria that had even penetrated the Lombard-Venetian Kingdom. On one hand there was the overt refutation of the Pompeii-inspired decorative trend that favored reflecting Classical decoration in a Neo-Renaissance light, and on the other there did exist purchasers in the Venetian area who adopted subjects from Herculaneum to renew the halls of their palaces beginning at the end of the eighteenth century.[23] These included, for example, the Papafava and Lazara families in Padova and the Mangilli, Papadopoli, and Albrizzi families in Venice. The author of this turning point in taste was the architect Giannantonio

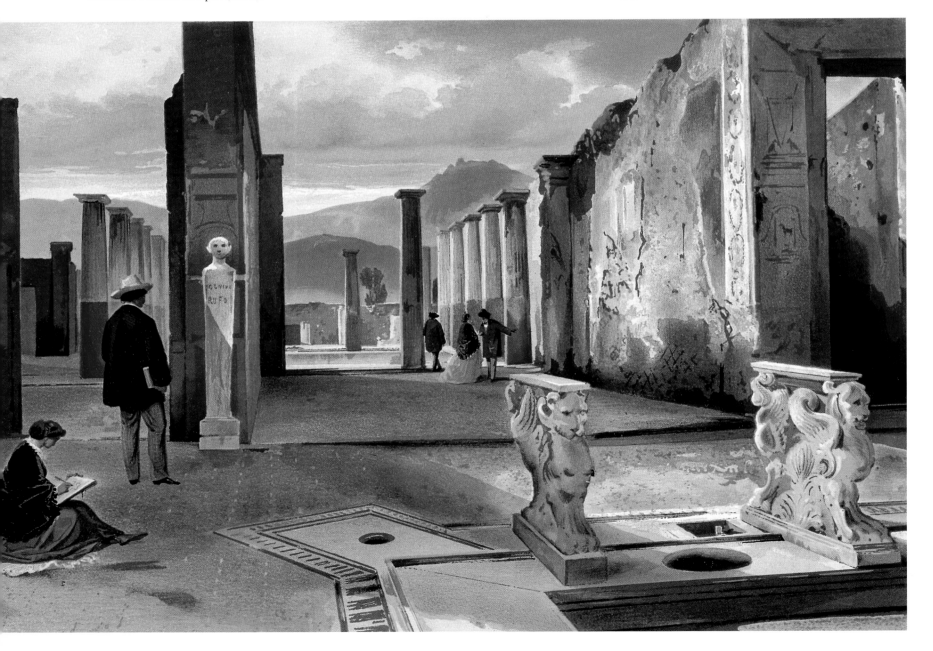

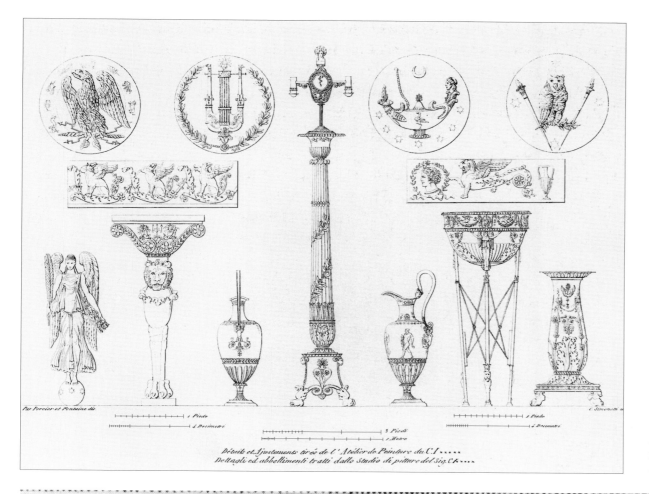

Recueil de decorations intérieures (1801), by the French architects Charles Percier and Pierre Fontaine, provides a rich decorative repertory conceived for Napoleon's court. Percier and Fontaine inspired furniture makers throughout Europe with their work and determined the canons of the Imperial style.

Below, a plan for decorating the Holfgarten Arcades in Munich by Leo von Klenze. He framed exotic landscapes and historical scenes within false architectural motifs that were clearly inspired by Pompeii (1840).

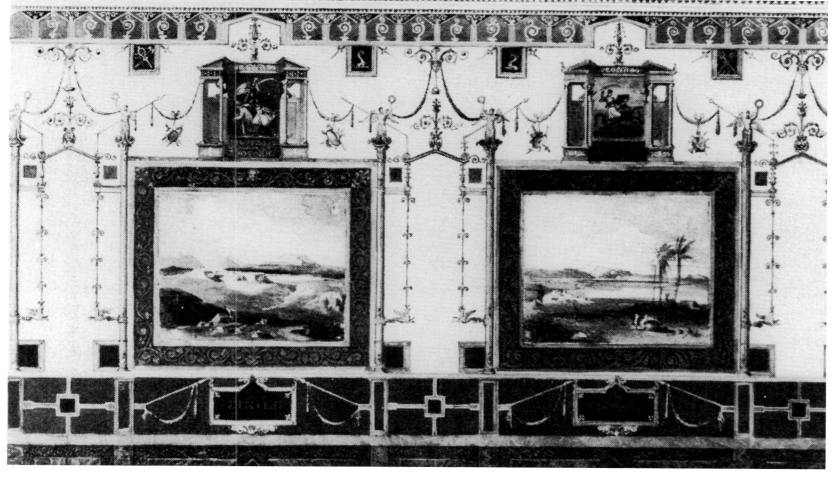

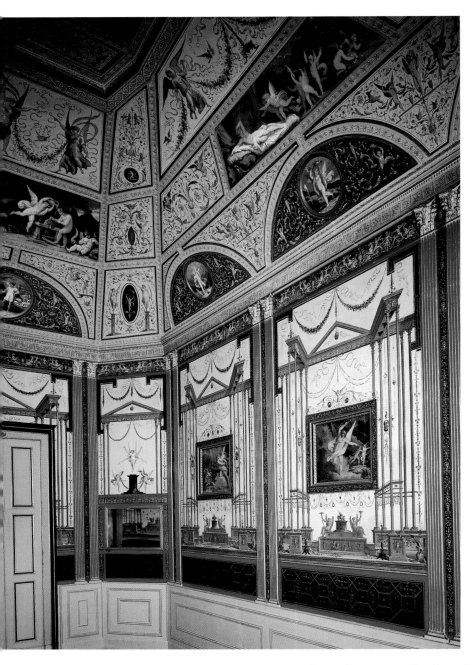

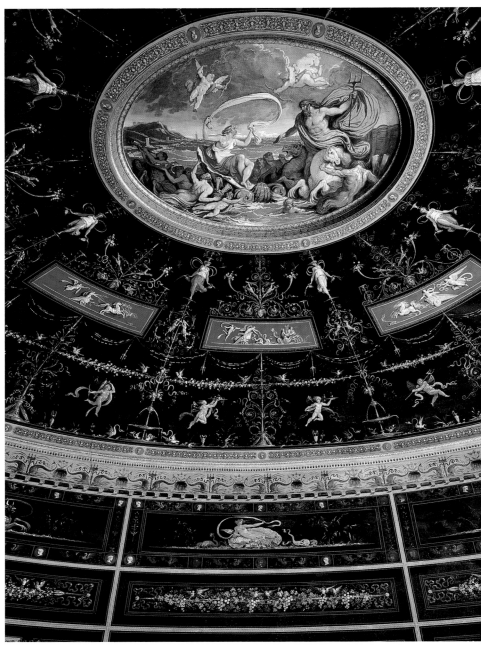

The Gabinetto d'Amore (*above*) and the Sala dell'Antibagno (*above right*)—like one in the Baths of Titus—in the Milzetti Palace in Faenza. These frescoes were made by Felice Giani at the beginning of the nineteenth century and particularly recalled decorations from Pompeii. Giani, one of the most active decorators in Emilia and internationally, was studying antiquity in Rome when he took the inevitable pilgrimage to Naples and Pompeii.

Selva, who, as Diedo described, "reformed and corrected" Venetian interiors. This earned him the praises of Antonio Canova, who considered him "a true artist not just of architecture, but interior decoration as well." During the years of French occupation, Pietro Moro and Giuseppe Borsato decorated the Sala delle Belle Arti in the Royal Palace in Venice with subjects from antiquity.

This technique was taken up again when Giovan Carlo Bevilacqua decorated the walls of the Camera delle Dame and the Stanza delle Udienze dell'Imperatrice in the Villa Nazionale di Stra. Luxurious tastes for complex ornamentation, although always distributed within the geometric partitions of Classical origins, advanced in the wall paintings that Borsato created for the reception areas in the royal palace. Giani was also called in to collaborate there in 1815, followed by Giovanni Demin and Francesco Hayez. The latter was the author of the stylized decorations in tempera on the vaults of the hall and the small rooms (*camerini*) at the palaces of Duse Masin and Sacerdoti in Padova.

In Milan there is a rare example of Pompeian décor. The ceilings of the Saporiti Palace were built from designs by Giovanni Perego in 1812 for Giovanni Belloni. A short time later, in 1818, Belloni sold it to the Marquis Saporiti of Genova.[24]

The ornamental artist Antonio Basoli of Bologna composed two volumes of engravings that included various "paintings to complete on the walls and vaults of palaces" (1827) and models for furnishings (1838). He found diverse decorative cues in *Le antichità di Ercolano esposte* that, wisely reread in the light of the Imperial style, gave rise to a highly esteemed technique in the Emilian and Venetian areas during the Restoration.

The famous *Opera ornamentale* (Ornamental work) that Borsato printed in Venice in 1831 was also part of this line of taste. Inside there is an entire series of references to the ancient everyday objects that had been uncovered in Pompeii, beginning with the various furnishings that are theatrically arranged in the frontispiece engraving.

Above all it was Naples that felt the prevailing influence of the nearby archaeological discoveries, especially regarding interior decoration taken up during the first half of the nineteenth century. The particular rejection of the Imperial style that the court architect Antonio Niccolini proposed revolved around rereading Classical decoration in a Neo-Baroque light.[25] At the same time, there was the tendency to return to the airy, ornamental compositions from Pompeii. This was evident in paintings that decorate the Pompeian hall in the Regia di Capodimonte, which were achieved between 1825 and 1830, and in the areas that Guglielmo Bechi designed in the same period for the local aristocracy, such as the Cabinet de

Below left, the frontispiece of *Opera ornamentale* by Giuseppe Borsato, printed in Venice in 1831 and published by the Accademia delle Belle Arti. This was a collection of designs that were inspired by Neoclassical tastes lined with Parisian influences, and the book was influential far beyond Venetian circles. *Below*, decorative motifs in the Hall of Fine Arts in the Royal Palace of Venice.

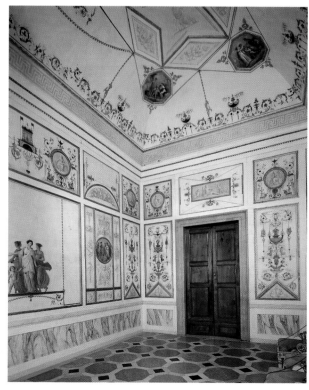

Toilette in the Acton Villa, the hallway in the Doria d'Angri Villa, the vault in the main stairway of the palace of Ruffo della Scaletta, and the stairway and ballroom of the San Teodoro Palace.[26]

The publication of Edward Bulwer-Lytton's 1834 novel, *The Last Days of Pompeii*, translated into Italian in 1871, recorded—as Carlo Sisi revealed[27]—a rebirth of historical and archaeological interest toward that "unforgettable disaster."[28] Excavations were taken up once again, followed by careful scientific studies intended to positivistically reconstruct daily life in the city. It was not by chance that Domenico Morelli exhibited his painting *Pompeian Bath* in 1861, sparking notable interest in the public eye.

At the same time in France, Gustave Boulanger was once again evoking the rehearsal of *The Flute Player* and *The Wife of Diomedes* in his painting for the Pompeian atrium in the house of prince Napoleon, brother of princess Matilde, on rue Montaigne in Paris.[29] The architect Alfred-Nicolas Normand built the Maison Pompeiénne in 1856 to house the prince's art collections and antiquities. It was demolished in 1891 and can be considered one of the last examples of Pompeian ornamentation in nineteenth-century Europe.[30] The stylistic eclecticism of the middle of the century had brought a new interpretation to all the historical styles, including eastern ones. The whimsicalities of the grotesque style no longer aroused the interest of decorators, who were advised to study medieval architecture. Despite this, both Lewis Gruner, the artistic adviser to Prince Albert in London and author of a volume of engravings in 1850 entitled *Specimens of Ornamental Art...*, and Owen Jones, whose *Grammar of Ornament* was published in London in 1856, did not miss inserting a number of reproductions taken from Pompeian painting. These presented, besides originality in composition, a special liveliness in color.

It was precisely this violent chromatic juxtaposition in the red and black walls of the houses of Pompeii that sparked the curiosity of decorators at the end of the century. These decorators completely abandoned the slender, garlanded columns and the dancing figures on light backgrounds that had char-

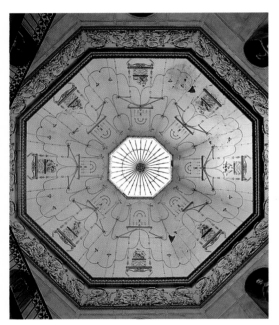

The influence of the archaeological discoveries was felt most of all in nearby Naples, especially in interior decorations created during the first half of the nineteenth century. *Above*, the vault of the main stairs in the palace at Ruffo della Scaletta. *Right*, the ballroom of the San Teodoro Palace.

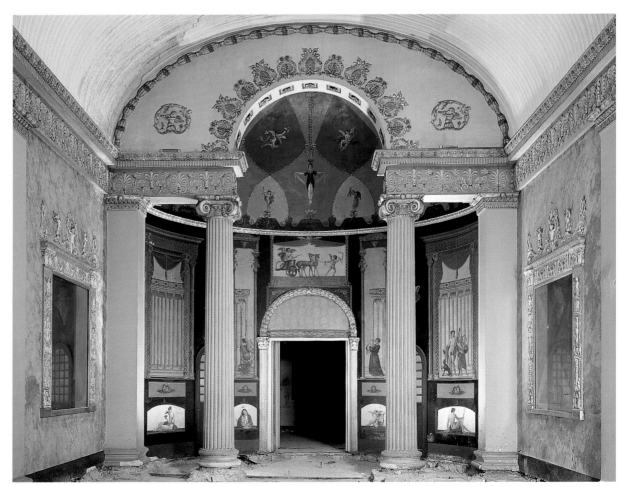

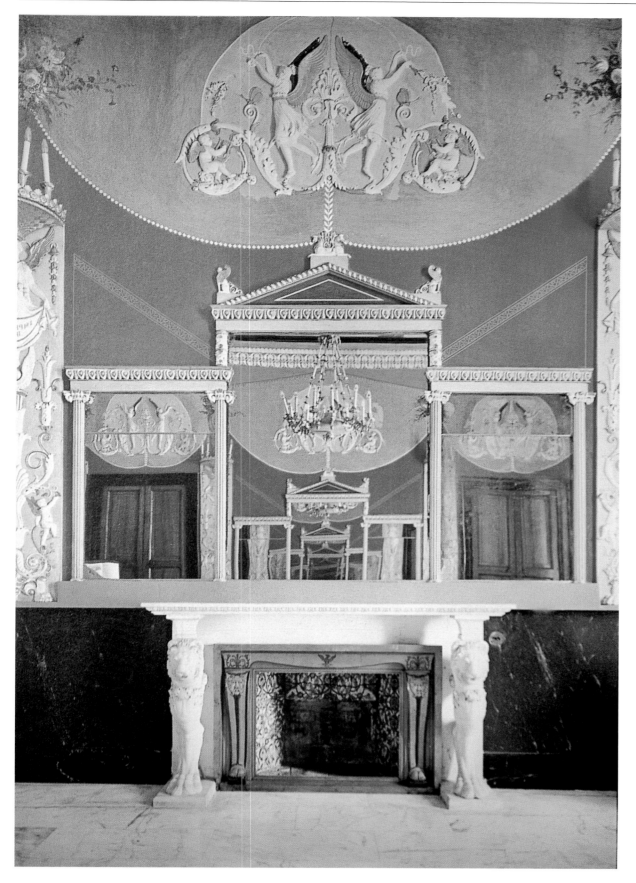

The tendency to allude to ornamental compositions from Pompeii in Naples can be also seen in the hallway of the Doria d'Angri Villa

acterized previous interior decoration. They now displayed embellished friezes above ample ledges that were preferably red and broken up by dark frames, adorned by stylized palmettes or false architecture. Gradually an "archaeologized" style entered in that was more adequate for decorating the walls of public buildings such as ministries, theaters, or museums. Here the members of the bourgeoisie liked to gather during the era of Humbert I, rhetorically comparing themselves with the past greatness of imperial splendor.

The work of the Niccolini brothers can be inserted exactly in this context of reevaluation during one of the major moments of glory for art history and Italian politics. The brothers' intention was to "publicize how much of the antique city had risen, from the colossal ruins of the public monuments to the humblest furnishings within domestic walls," with the goal of reconstructing "the religious rites, customs, uses, military disciplines, industries, commerce, shows, and everything that made up civil life in that ancient town."[31]

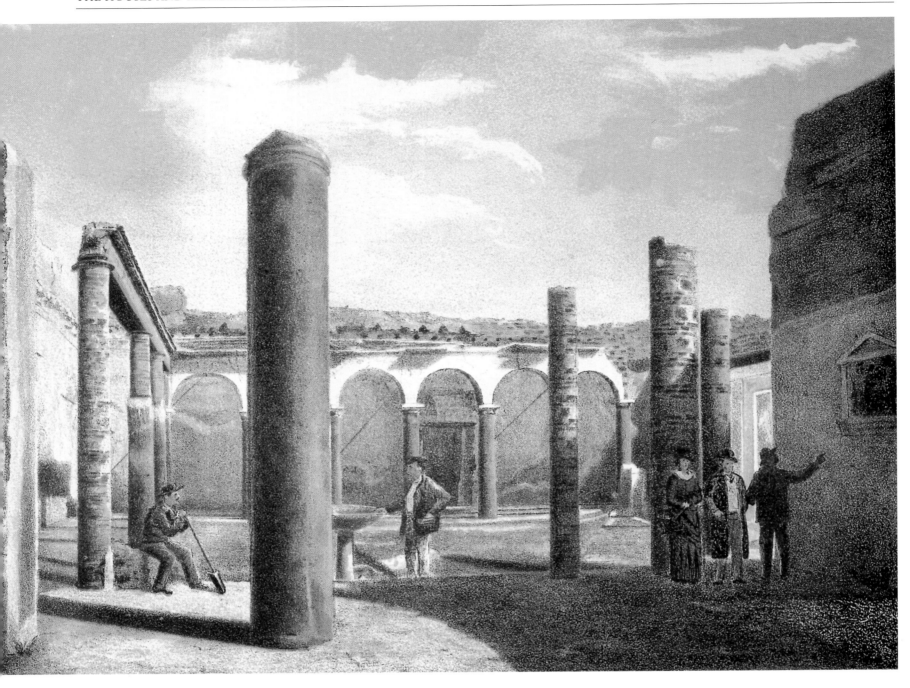

Vincenzo Loria, *The House of Caprasius Felix and Fortunata* (IX, 7, 20). A perspective (*above*) and diagram (*right*).

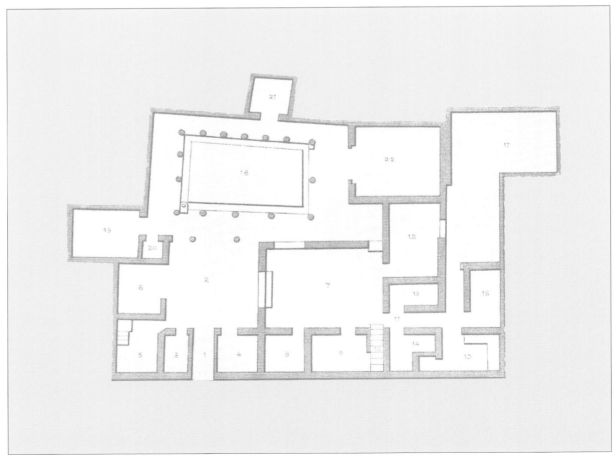

Notes

1. In this regard, see the authors' comment for the illustrations of the House of the Faun in vol. 2, p. 10.
2. One detailed study that examined the influence that antiquities from Herculaneum and Pompeii had on interior decoration and furnishings made in Europe beginning in the eighteenth century was made by Mario Praz in his essay "Le antichità di Ercolano," in *Gusto neoclassico*, (1939; Milan: 1974), 75–86.
3. See also J. Rykwert, *Adam* (Milan: 1984), pp. 132–33, Fig. 133, and p. 87, Fig. 79. Mario Praz (op. cit., p. 80) notes that "the ceiling of the Red Hall in Syon House in Middlesex is completely divided in small octagons and squares, each containing a figurative tondo—closely imitating plaster work in Herculaneum," illustrated in Plate 53 and others that follow in vol. 4 of *Le Antichità di Ercolano esposte*. In 1770, also in Syon House, Angelica Kaufmann painted some figures on the blue area that were taken from *Le Antichità*. These were "colored with bronze tones on a light-green background," continues Praz. "Dancers appear, just a few years after Syon House had been decorated, on the East Hall ceiling in Crichel, Dorsetshire; in the domed ceiling of Heaton Park, Lancashire, that Rebecca Biagio decorated"; and in many other "Georgian" house interiors in London and Dublin. See also the paintings that the Niccolinis published in vol. 1, Plate 4 (a detail from a fresco uncovered in the Stabian Baths) and vol. 4, Plate 8 (a detail from a mosaic). These were probably sources of inspiration, through the engravings of *Le Antichità*, for ornamentation created by Adam.
4. In contrast to claims in J. Feray, *Architecture interieure et decoration en France des origins à 1875* (Paris: 1988), 272, the conservator of Fontainebleau castle reports that Marie Antoinette's boudoir was made by Pierre Rousseau, not Richard Mique.
5. See also E. Colle, *I mobili di Palazzo Pitti: Il primo periodo lorenese, 1737–1799* (Florence: 1992), 28.
6. See also A. Gonzàlez-Palacios, *Civiltà del '700 a Napoli 1734–1799*, exhibit catalogue (Naples: 1979), 131, no. 365.
7. In this regard see the chapter dedicated to the discoveries at Herculaneum in the essay by A. Ottani Cavina, "Il Settecento e l'antico," in *Storia dell'arte italiana*, part 2, vol. 2, *Settecento e Ottocento* (Turin: 1982), 616–18.
8. Both examples were published in Gonzales-Pacios, *Civiltà del '700 a Napoli*, pp. 21–211, no. 457; p. 215, no. 462.
9. See also E. Colle, "Traccia per una storia del mobile in Toscana da Pietro Leopoldo a Ferdinando III," *Antichità Viva* 4–5 (1991), 70–71.
10. See also E. Baccheschi, "Un decoratore italiano 'Compagnon sculpteur' di Honoré Guilbert: disegni di Agostino Gerli," in *Antologia di Belle Arti* (1990), 82–92.
11. Facts about the architects and decorators of Lombardy cited here were mostly taken from G. Mezzanotte, *Architettura neoclassica in Lombardia* (Naples: 1966); and from the catalogue *Mostra dei Maestri di Brera* (Milan: 1975); for Albertolli's activity in Florence for the Lorenese Court, see Colle, "Storia del mobile in Toscana," 26, and the preceding bibliography.
12. Baccheschi, "Disegni di Agostino Gerli," 91.
13. As revealed in Praz, *Le antichità di Ercolano*, 81, Cochin had already judged the wall paintings in Herculaneum as being ridiculous and on the same level as Chinese designs, and the traveler Swinburne found them as barbaric as Gothic constructions. Perhaps this is why they were admired by the eccentric Horace Walpole, who wrote, "at least the discoveries at Herculaneum attest to a light and fantastic architecture that is almost Indian, forming the common decoration of private dwellings."
14. See also C. M. Giudici, *Riflessioni in punto di Belle Arti dirette ai suoi scolari* (Milan: 1775), xii; and E. Colle, "I disegni d'ornato," in *Quaderni di Brera*,

soon to be published. Giudici was a member of the Accademia di Parma, a sculptor for the cathedral, and a painter, and he was one of the most active proponents of the new Neoclassical style he had learned during his stay in Rome and spread in Milan. There, after a long bureaucratic period, he was admitted to the Accademia di Brera as curator of plaster sculpture and bursar.
15. See also Praz, *Le antichità di Ercolano*, 81, where he writes that the "arabesques favored by the neoclassicists were those Rafael had created in the loggias, imitating the Baths of Titus."
16. See also A. Gonzàlez-Palacios, *Il tempio del gusto: Le arti decorative in Italia fra classicismi e barocco: La Toscana e l'Italia Settentrionale* (Milan: 1986), fig. 564. The Manfredinis copied the font, which is now kept in Vienna, many times.
17. The lamp was published in A. Ponte, *Il bello "ritrovato": Gusto, ambienti, mobili dell'Ottocento* (Novara: 1990), 31.
18. This was displayed in the exhibit and its catalogue entitled, *The Age of Neoclassism* (London: 1972), 768, no. 1640, pl. 130. The carvings on two pieces of furniture that are still held in the Reggia di Caserta were derived from the Pompeian model cited here; these were the throne and two winged lions decorating the bed of Francesco II.
19. See also A. Colombi Ferretti, E. Golfieri, and A. Ottani Cavina, *Il Museo Nazionale dell'Età Neoclassica di Palazzo Milzetti in Faenza* (Bologna: 1983).
20. See also Praz, *Le antichità di Ercolano*, 81.
21. See also Praz, *Le antichità di Ercolano*, 82. In Fig. 15 the critic illustrates a detail from the Pompeian Hall in Gotha Castle (as it appeared before World War II). Other examples of Pompeian taste in Germany can be found, according to Praz, in the Celebration Hall at Neu-Hardenberg Castle, a ceiling at Worlitz Castle (1773), and in the Princess Maria Pavlovna's music hall in Weimar Castle, which was created by Heinrich Gentz in 1803.
22. See also *The Age of Neoclassicism*, 722, no. 1551, Fig. 129b.
23. Regarding the development of ornamentation in Venezia during the Neoclassical period, see the studies by Giuseppe Pavanello: "La decorazione neoclassica a Padova," *Antologia di Belle Arti* 13–14 (1980), 55–73; and "La decorazione neoclassica nei palazzi Veneziani," in *Venezia nell'età di Canova 1780–1830*, exhibit catalogue (Venice: 1978), 281–300.
24. See also G. C. Bascapè, *I palazzi della vecchia Milano* (1945; Milan: 1986), 294. The ceiling is also reproduced in Praz, *Le antichità di Ercolano*, Fig. 16.
25. See also E. Colle, "La culla del principe di Napoli e alcune note sull'intaglio napoletano dell'800," in *Antichità Viva* 1 (1987), 49–50.
26. All these places have been published in C. Garzya, *Interni neoclassici a Napoli* (Naples: 1978), which can also be referred to for facts about architects and interior decorators who were active in the Neapolitan capital during the Restoration.
27. See also C. Sisi, "Umbertini in toga," *Arista* (1993), 174–76.
28. See also Ottani Cavina, "Il Settecento e l'antico," 608.
29. See also C. Sisi, "Le 'Contemplations' di Gustave Moreau," in *Gustave Moreau 1826–1898*, exhibit catalogue (Florence: 1989), 27.
30. See also C. Gere, *Interni ottocento: Stili, arredi, oggetti* (Milan: 1989), 256–57, nos. 295–96, and pp. 25–27, where besides illustrating a Pompeian decorative design dating to 1880 (Fig. 20), it is also written that Sir William Gell published two volumes between 1816 and 1817 that were dedicated to the buildings and decorations of Pompeii. Here architectural examples were reproduced in color for the first time. At the time this roused an irresistible fascination in society, so much so that Prince Albert had a Pompeian Hall painted in the Garden Pavillion of Buckingham Palace in 1843 by Agostino Aglio.
31. For the amount of material covered by Fausto and Felice Niccolini, see the preface (pp. i–ii) of their *Le case ed i monumenti di Pompeii*. (Or see p. 60 of this edition.)

POMPEII IN NINETEENTH-CENTURY PAINTING

By Roberto Cassanelli

Karl Pavlovic' Brjullov, *The Last Day of Pompeii*. This painting was made between 1828 and 1834 and was impressive for its new subject matter. Inspired by the writings of Pliny the Younger, the painting represents the moment of Mount Vesuvius's eruption using highly dramatic tones, and it includes a small group of people who attempt to carry and save Pliny the Elder from an onslaught of volcanic ash and crumbling monuments (*right*). Saint Petersburg, Russian Museum.

On Sunday morning, March 11, 1787, Johann Wolfgang von Goethe visited the excavations at Pompeii accompanied by his friend Johann Tischbein and the engraver George Hackert, the brother of Philipp. The three had an authoritative guide, Marquis Domenico Venuti, the director of the Reale Fabbrica di Porcellane (royal porcelain factory). "Pompeii surprises everyone," Goethe observed in *Italian Journey*, "by its compactness and its smallness of scale," adding that "we saw on every hand many views which we knew well from drawings, but now they were all fitted together into one splendid landscape."[1] Some years later in 1824, the architect Karl Friedrich Schinkel recalled in the pages of his travel journal—by that time a trip to Pompeii was expected—how he had already been excitedly studying the monuments in the pages of François Mazois's work.[2] Pompeii was also featured at the Countess of Albany's Florence residence in a passage of Massimo d'Azeglio's *Ricordi* (Memories): "If I close my eyes I can see, as if it were right now, the fireplace facing the windows, and next to it an armchair, with the Countess of Albany in her usual attire and Marie Antoinette. There are two pictures by Fabre on the walls; one is Samuel with the fortuneteller and Saul; the other portrays someone near the excavations at Pompeii."[3]

Karl Pavlovic' Brjullov, *Study for the Last Day of Pompeii.* This was an immediate critical and popular success.

At the end of the eighteenth and beginning of the nineteenth centuries, admirers, learned observers, and scholars enjoyed a number of ways to view the monuments at Pompeii. These ranged from paintings by *vedutisti* artists to work by French architects who created *envois*.[4] Pompeian themes in the vast panorama of painting history would soon unexpectedly indicate another path. This would be marked by a work that was long in the making during the 1820s and conceived by Karl Pavlovic' Brjullov (1799–1852), a Russian painter who was active in Italy for a long period. Influenced by an opera by Giovanni Pacini (1825) and especially Pliny the Younger's story in his letter to Tacitus, Brjullov created a vast painting between 1828 and 1834 entitled *The Last Day of Pompeii* (Saint Petersburg, Russian Museum). Prince Anatolij Demidov had commissioned it. Using highly dramatic colors, the work captures the moment when a small group tries to save Pliny the Elder on Via dei Sepolcri. They are overcome by an eruption of volcanic ash and collapsing monuments. The painting received immediate public acclaim from the moment it was exhibited as a model in the artist's studio in Rome, and then during the European tour of the definitive version, which was shown in various Italian cities and finally in Paris in 1834.[5]

Even though it was not entirely unique (the English painter John Martin had addressed similar themes just a few years before), Brjullov's work was attractive because of its power, and critics from Walter Scott to Nikolai Gogol praised it for the newness of its conception. That same year in 1834, the year the painting triumphed, the auspicious novel by Edward Bulwer-Lytton was published, *The Last Days of Pompeii.* The excavation sites were being enlarged during those same years, uncovering an extraordinary variety of residences, interior decorations, and household goods. The House of the Tragic Poet, which had just been discovered, served as a model for the house of Glaucus, the lead character in Bulwer-Lytton's novel.[6]

Although they were inserted within a rich series of works that also reinvented the classical past, Pompeian themes in painting were characterized by a strong adhesion to objective fact, whether topographic or archaeological. This was especially true for interiors and urban foreshortening, as well as the lively scenarios of exchanges that animated the paintings to become more akin to literature and theater. They also did not exclude their hidden vein of sensuality, which then became particularly explicit in the bombastic (*pompier*) style of the second half of the nineteenth century.

These themes assumed new visibility during the second empire. Six years after Thomas Couture's *Les Romains de la decadence*, Théodore Chassériau (1819–56) exhibited a large painting in the Salon of 1853, *Tepidarium of the Baths in Pompeii* (*Tepidarium, sale où les femmes de Pompéi venaient se reposer et se sécher en sortant du bain*), which the state immediately bought (Paris, Musée du Louvre). Antonio Bonucci's discovery of the Forum Baths (or Baths of Fortuna) in 1824 had been immediately incorporated into Mazois's

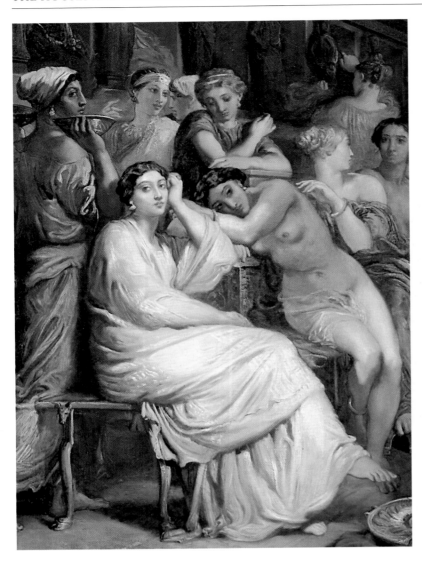

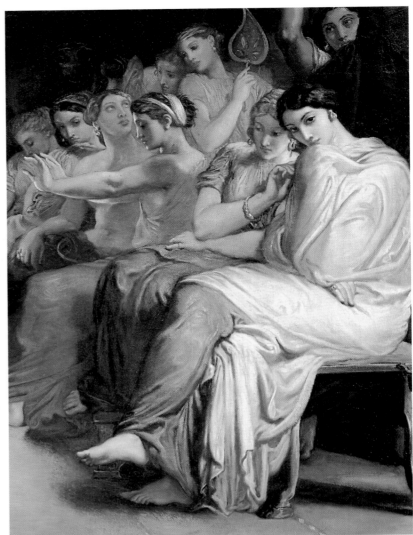

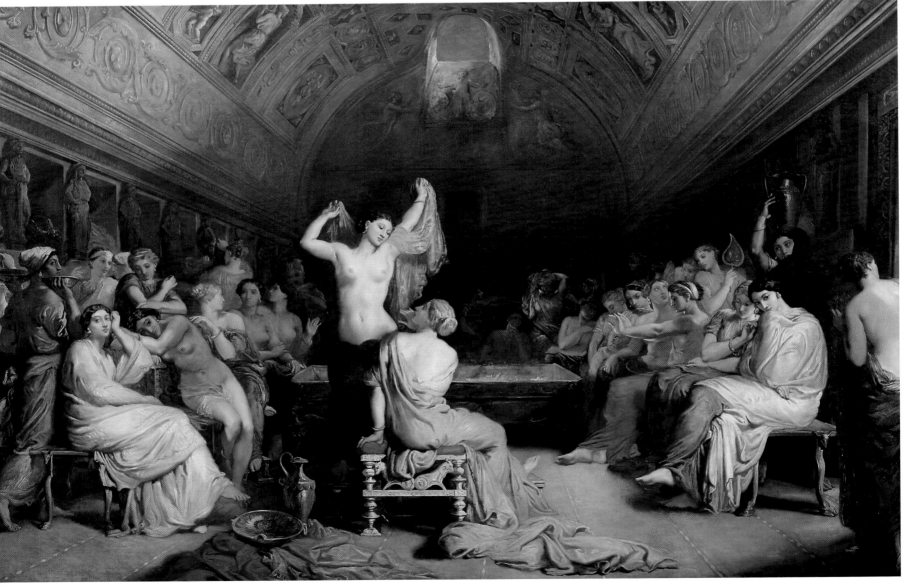

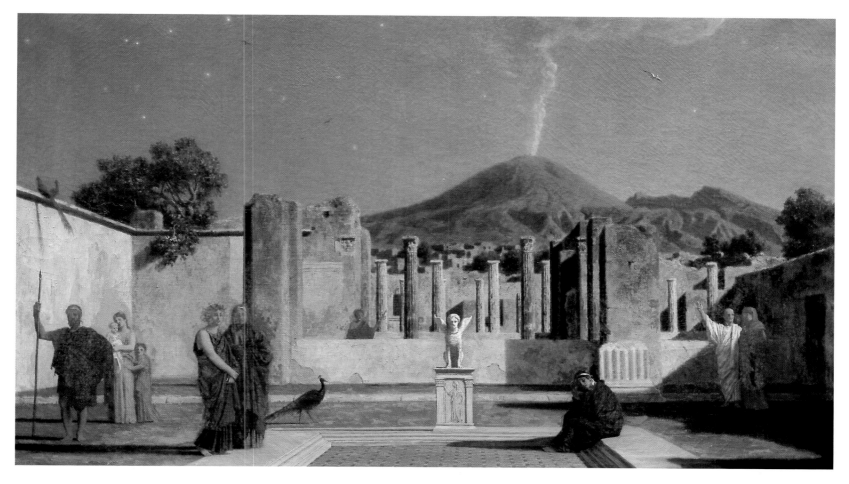

repertory (*Les ruines de Pompéi*, vol. 3, 1824–38), and became the inspiration for the architectural setting of Chassériau's painting. This had such an impact of immediate truth that Théophile Gautier exclaimed that he was standing in front of an ancient fresco that had been detached from a wall in Pompeii.[7]

A few years later Paul-Alfred de Curzon (1820–95), a friend of Chassériau's who accompanied him to Pompeii, painted *A Dream Among the Ruins of Pompeii* (*Un rêve dans les ruines de Pompéi: Les ombres des anciens habitants reviennent visiter leurs demeurs*, Bagnères-de-Bigorre, Musée Municipal, 1866). This gave a sample of an approach to painting that was suggestively visionary, although it was not especially followed afterward. The scene opens onto the ruins of the House of the Faun just as it emerged from the excavations, yet still populated by the ghosts of the house's ancient inhabitants.[8]

A taste for Pompeian decorations rapidly overcame the French aristocracy. Gerolamo Napoleon ordered Alfred-Nicolas Normand to build a house on rue Montaigne, the famous Maison Pompeiénne, whose walls were appropriately frescoed by Jean-Léon Gérôme. Valuable iconographic evidence from the house has survived in the form of a painting by Gustave Boulanger (1824–88), *Rehearsal of the "Flute Player" and the "Wife of Diomedes"* (Musée Nationale du Château de Versailles, 1861).[9] The characters are all in ancient costumes, but in the center of the atrium, a huge statue of Napoleon I towers reassuringly.

Since at the time Italy was busy revisiting its past in a political light, it was late to join the Pompeian trend. The first convincing attempt was Domenico Morelli's (1826–1901) *Pompeian Bath* (private collection). He had certainly seen Chassériau's *Tepidarium* during his stay in Paris in 1855. Morelli's painting was exhibited in 1861 at the Esposizione di Firenze and can still be appreciated through the photograph Pietro Simplicini took on that occasion. In the painting Pompeii is the setting for contemporary feelings, and authenticity steps aside to allow emotions to dominate. This is especially evident in Morelli's second work with a Pompeian theme, *The Triclinium After the Orgy* (Rome, Galleria Nazionale d'Arte

Above, Paul-Alfred de Curzon, *A Dream Among the Ruins of Pompeii*. Created in 1866, this painting represents the House of the Faun as it emerged from the excavations, populated by the figures of its ancient inhabitants. Bagnères-de-Bigorre, Musée Municipal.

Opposite, Théodore Chassériau, *Tepidarium of the Baths in Pompeii*, with details. Exhibited at the Salon of 1853, this painting re-creates the architectural environment of the Baths of Fortuna, discovered in 1824 by Antonio Bonucci. Paris, Musée du Louvre.

43

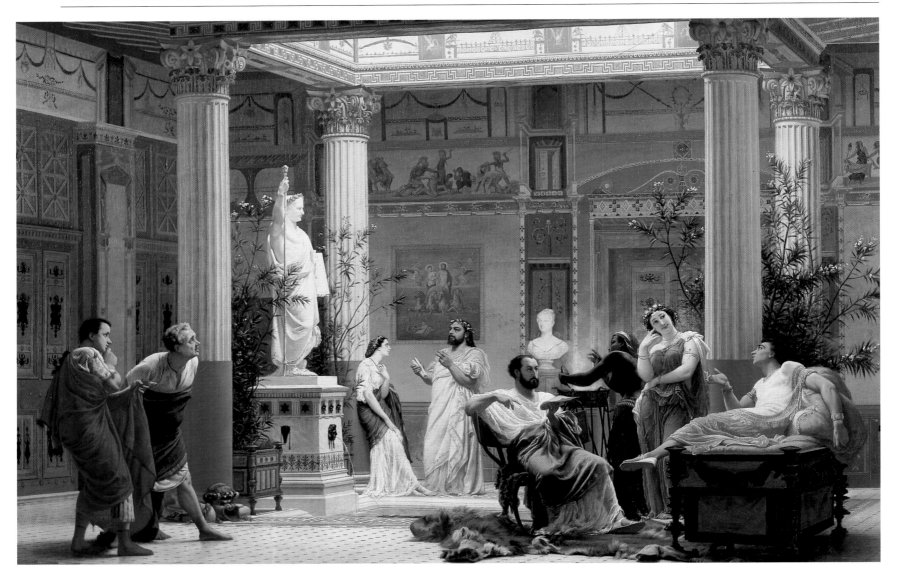

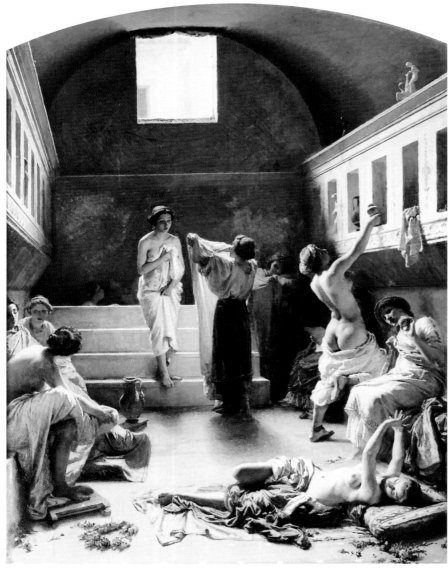

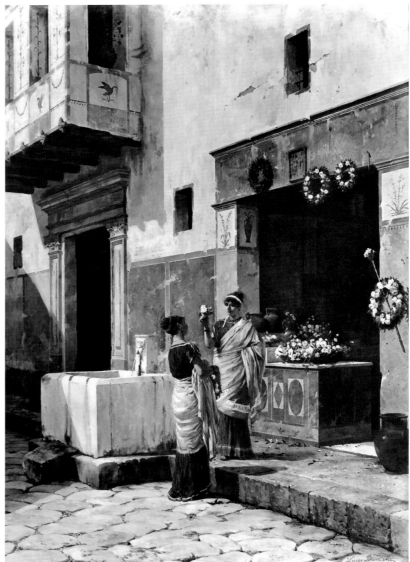

Moderna), which was consistent with literary sources such as Bulwer-Lytton's novel. The presence of Pompeian themes in national expositions continued to increase until 1877, the height of this trend.

The Roman painter Luigi Bazzani used a happy, sketchy tone to portray a house with a *thermopolium* (a stall where warm drinks were sold) on a Pompeii street in *The House with the Overhanging Balcony* (location unknown). Although the piece has a photographic quality, it does not depict a real location but rather a general revisitation.[10] Aspects of Pompeii also appear out of context, such the setting for *An Episode in the Life of Fabiola* (1870, Siena, The Chigi-Saracini Collection) by Cesare Maccari (1840–1919). The story has a Christian subject taken from a novel by Cardinal Wiseman.[11]

Pompeian themes played a prominent role in painting during the Victorian period, especially in the work of Sir Lawrence Alma-Tadema (1832–1912).[12] Having visited Naples on his honeymoon, he frequently returned there because of a close friendship with Morelli and other artists, such as the sculptor Giovan Battista Amendola, who sculpted his portrait (Naples, Museo di San Martino; a bust of Alma-Tadema that was made from this sculpture is at the Royal Society in London). In *Opus LXII* (this was how Alma-Tadema categorized his paintings), *A Roman Flower Market* (Manchester, Manchester City Art Gallery, 1868) transfers a subject that originated in Holland into a Pompeian environment (the artist was Dutch).

Opposite, top, Gustave Boulanger, *Rehearsal of the "Flute Player" and the "Wife of Diomedes."* The atrium of prince Napoleon's Maison Pompeiénne, designed by the architect Alfred-Nicolas Normand in Pompeian style, provides the background for this painting. Versailles, Musée national du Chateau de Versailles.

Opposite, bottom, Domenico Morelli, *Pompeian Bath.* In terms of Italian painting revisiting the Classical past, this painting is quite impressive; it is reproduced here in a photograph by Pietro Simplicini (*bottom left*). *Bottom right,* Luigi Bazzani's *House with the Overhanging Balcony.*

Below, hints of Pompeii also appear in *An Episode in the Life of Fabiola* by Cesare Maccari. It was inspired by Cardinal Wiseman's historical novel.

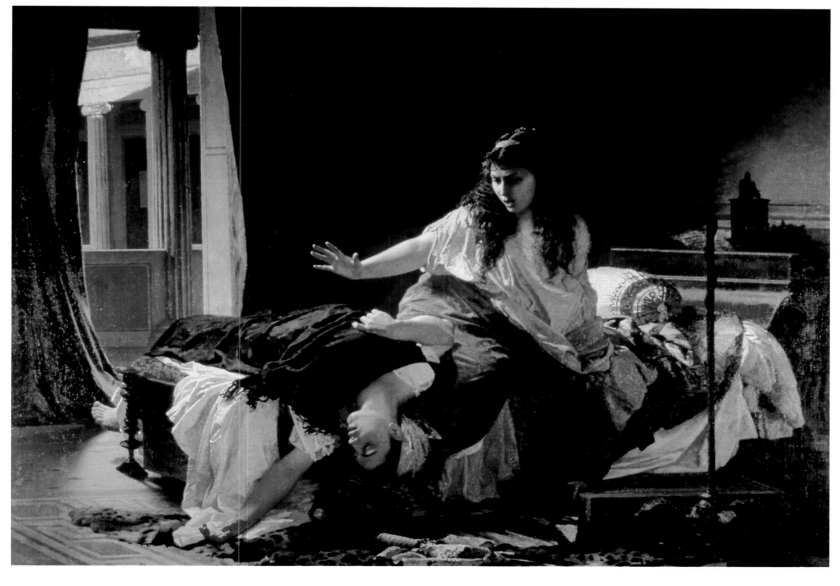

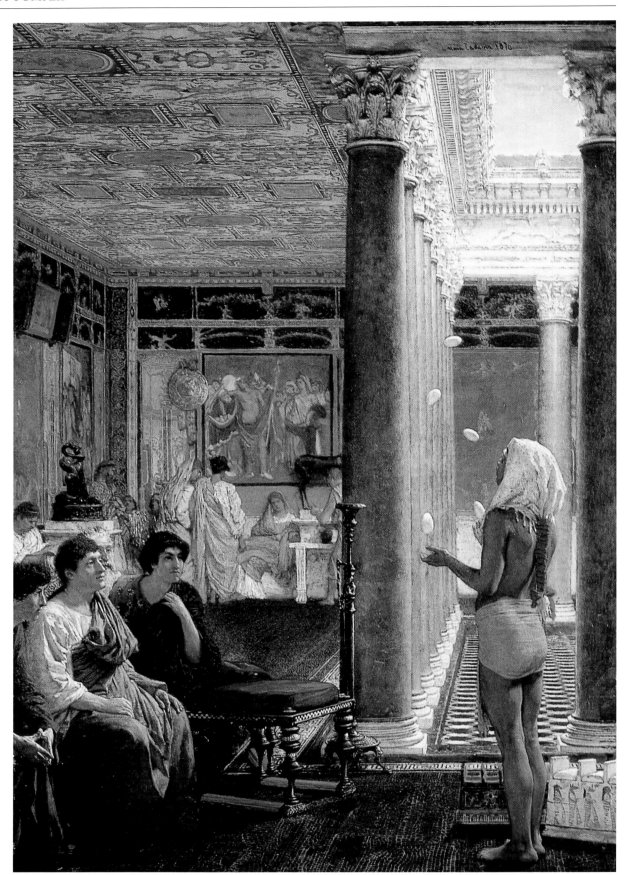

Right, in this painting by Lawrence Alma-Tadema, *A Juggler*, the scene unfolds in the House of Marcus Lucretius and reproduces objects taken exactly from Pompeian examples.
Opposite, also by Alma-Tadema, *A Roman Flower Market* transfers a subject that originated in Holland (the painter was Dutch) into a Pompeian environment.

To be faithful to the scene, Alma-Tadema also included two painted inscriptions on the walls to the sides of the tavern (*caupona*) that were from election campaigns, perfectly imitating the letters (the more visible one reads *Marcus Epidius Sabinus*). In the soon-to-follow *A Juggler* (*Un jongleur*, *Opus LXXVII*, Stanley G. Allen Collection, 1870), Alma-Tadema portrayed another real place—the House of Marcus Lucretius—filled with a selection of real objects that were deftly taken from examples in Pompeii or other sources (such as Pliny the Elder). This combination game became continually more refined, serving an especially generous clientele who loved classical remembrances and were opportunely informed by cultural reviews. The reviews entertained correspondence from Italy and especially Pompeii, where Giuseppe Fiorelli was excavating intensely. The trend would enthusiastically last for many decades to the end of the century and beyond. However, the climate had already profoundly changed and was open to experiments that were completely different, with a conception of modern that was no longer reconcilable with the past.

Notes

1. Johann Wolfgang von Goethe, *Italian Journey*, W. H. Auden and Elizabeth Mayer, trans. (San Francisco: North Point Press, 1982), 189. The same visit is also recorded in parallel by J. H. W. Tischbein, *Dalla mia vita: Viaggi e soggiorno a Napoli*, M. Novelli Radice, ed. (Naples: Edizioni Scientifiche Italiane, 1993), 210.

2. K. F. Schinkel, *Reisen nach Italien: Tagebücher, Briefe, Zeichnungen, Aquarelle*, G. Riemann, ed., third edition 1988 (Berlin: Rütten u. Lening, 1979), 193.

3. M. d'Azeglio, *I miei ricordi*, A. M. Ghisalberti, ed. (Turin: Einaudi, 1971), 45.

4. For the *vedutisti*, see L. Fino, *Ercolano e Pompei: Vedute neoclassiche e romantiche* (Naples: Electa Napoli, 1988); for the activity of French architects in the nineteenth century, this exhibit catalogue remains fundamental: *Pompéi: Travaux et envois des architectes française au XIXe siècle* (Paris and Naples: École nationale supérieure des beaux-arts, 1981).

5. A. Bird, *A History of Russian Painting*, Italian translation, *Storia della pittura russa* (Turin: Allemandi, 1987), 73–74; M. Allenov, N. Dimitrieva, and O. Medve'kova, *L'arte russa* (Milan: Garzanti, 1993), 343–45. It should also be mentioned that Brjullov's brother, an architect, was also drawing Pompeii's monuments for the Academy of Fine Arts in Saint Petersburg (see also *Pompéi: Travaux et envois*).

6. For this aspect, I refer to the chronology of excavations, pp. 218–19.

7. *The Second Empire (1852–1870): Art in France Under Napoleon III*, catalogue from the exhibits in Philadelphia, Detroit, and Paris, 1978–79 (Philadelphia: Philadelphia Museum of Art, 1978), 268–69, Table VI-22.

8. Ibid., p. 283–84, Table VI-37.

9. For a bibliography on Normand and his painting, refer to my contribution on nineteenth-century photography in Pompeii, pp. 48–51.

10. Such as *Venditori di anfore a Pompei* by Enrico Salfi (Milan, Galleria d'Arte Moderna), where incongruous Greek vases and black figures are sold next to the amphorae, or Camillo Miola's *I fatti di Virginia* (Naples, Gallerie Nazionali di Capodimonte).

11. Regarding the wealth of Pompeian themes in nineteenth-century Italian painting, see also C. Sisi, "Umbertini in toga," in *L'artista* (1993); keep in mind the picture given by S. Pinto, "La promozione delle arti negli Stati italiani dall'età delle riforme all'Unità," in *Storia dell'arte italiana* (Turin: Einaudi, 1982), 2:791; and the contributions contained in *La pittura in Italia: L'Ottocento* (Milan: Electa, 1991).

12. On Alma-Tadema, see the catalogue from the monographic exhibition in Amsterdam and Liverpool, E. Becker, ed., *Sir Lawrence Alma-Tadema* (Zwolle: Waanders Uitgevers, 1996); his works with classical and Pompeian subjects were studied in M. Liversidge and C. Edwards, eds., *Imagining Rome: British Artists and Rome in the Nineteenth Century* (London: Merrell Holbertson, 1996). Guido Rey's photographs on Pompeii seem to depend on Alma-Tadema's paintings (see also M. Miraglia [Turin: Allemandi, 1990], ad loc.).

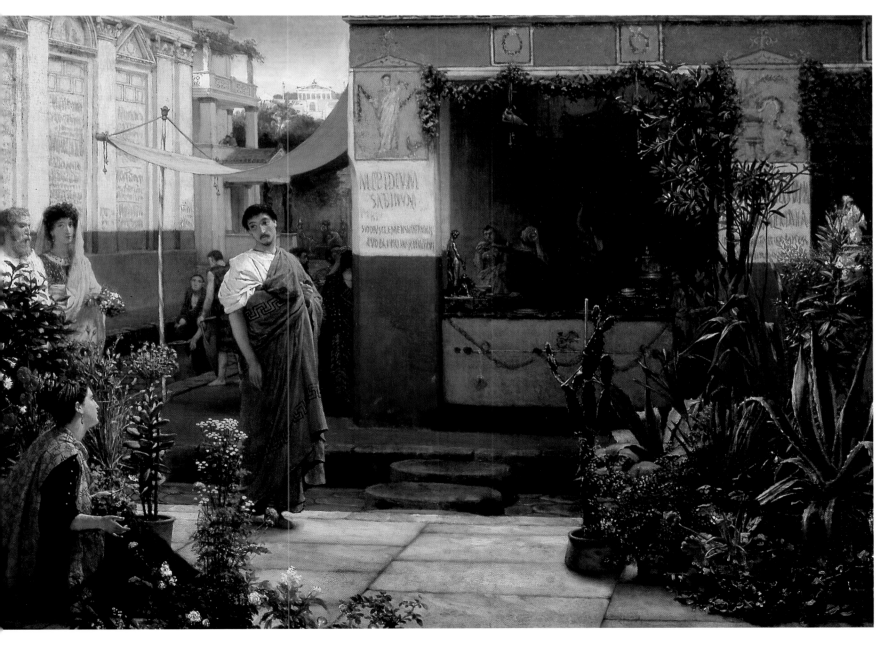

IMAGES OF POMPEII: FROM ENGRAVING TO PHOTOGRAPHY

By Roberto Cassanelli

Top, during the nineteenth century, Pompeii appeared in the earliest photographic experiments, as this daguerreotype demonstrates. It portrays the Pompeian Forum and belongs to a series by the philologist Alexander John Ellis. London, Science Museum.
Bottom, a Pompeii street in a salt print from 1852 by Paul Jeuffrain

Beginning in the mid-1850s and continuing for more than forty years, Fausto and Felice Niccolini's *Le case ed i monumenti di Pompeii*[1] (1854–96) followed the rise, spread, and transformation of photography as it documented one of the most symbolic locations of antiquity.[2] Although Pompeii's visual richness—beyond the simple chronological coverage of the discovery—emerged late in engravings with respect to Herculaneum, which remained the preferred subject during the 1700s,[3] the next century brought a reversal. Pompeii became the favorite gymnasium for artists and young architects, especially from France, to exercise in.[4]

The city was not included in Lerebur's *Excursions daguériennes,* one of the first editorial undertakings to take advantage of photography in its daguerreotype form. Contrary to what has been thought,[5] however, Pompeii was not overlooked in early photographic experimentation.[6] One small series of daguerreotypes on Pompeii is now held at London's Science Museum and was achieved by the English philologist Alexander John Ellis, who was committed to carrying out a series of panoramic daguerreotypes in Italian cities. These were meant to be distributed in a periodical that unfortunately was never published (*Italy in Daguerreotypes*). Eight of the series portray Pompeii. One daguerreotype in particular, an entire plate, shows a view of the Basilica in the Pompeian Forum in a somewhat uncertain composite style, although it is totally coherent with the preceding *vedutisti* tradition.[7] We still owe the first series of views of the Vesuvian city to another English traveler, Reverend Calvert Jones, who used salt paper and paper negatives.[8]

William Fox Talbot's methods, which were perfected in the 1850s, notably simplified the process, allowing photographs to be executed more rapidly and, most importantly, provided the possibility of making numerous copies.[9] The Société Française de Photographie holds an interesting series of calotypes from 1852 by Paul Jeuffrain (1808–96), a passionate amateur, naval official, and wool merchant in Louviers.[10] In the footsteps of Abbot Richard de Saint-Non, he was attracted to the south of Italy (he did push as far as North Africa and the recently French Algeria) to portray the countryside and monuments of antiquity (Cumae, Pompeii, and Paestum). His eye was engrossed and attentive to the quality of the backgrounds. He recorded the intersections of Pompeii and its most famous buildings (the House of the Faun and the Amphitheater), and he even took some animated shots as well.

Another Frenchman, the architect Alfred-Nicolas Normand (1822–1909), traveled Italy with a sketchbook and camera on his way to Greece and Constantinople, stopping for a while in Pompeii.[11] "As soon as I finish the sketches I want at the museum," he wrote in a letter from Naples on May 5, 1849, "I will go to Pompeii, which is a half-hour from here by rail." "I was delighted with my visit. I had dreamt of this city, yet this is the first time since I have been in Italy that I find something that is no less than what my imagination had me perceive."[12] The visit turned out to be quite significant, for both the quality of the photographs taken and the role these surely played in spreading the Pompeian style in the second empire. Normand was in fact responsible for the Maison Pompeiénne on rue Montaigne in Paris, built between 1856 and 1860 for prince Gerolamo Napoleon. The atrium was decorated with Gustave Boulanger's painting, *Rehearsal of the "Flute Player" and the "Wife of Diomedes."*[13] (See page 44.)

At this point reproductions of the Pompeian monuments began to infiltrate commercial circles, and besides being valuable for their designs or engravings, they became a vehicle for knowledge. This turn of events was mainly caused by the work of a German photographer, Giorgio Sommer (1834–1914), among the most illustrious representatives of a lively colony of foreign photographers who were mostly French (Bernoud, Grillet, Conrad, Rive, de la Rumine). These were active in Naples around the middle of that century.[14]

A paragraph that appeared in *Il Pugnolo* on December 21, 1860 reads, "On September 25, 1860 Garibaldi came to Pompeii with his son, wife, General Türr, and other high-ranking state officials. The

Below, a watercolor by Giacinto Gigante, *Dinner in the House of Sallust at Pompeii*. Sorrento, Museo Correale.
Right, from top to bottom: the atrium of the House of the Faun in a photograph taken in 1852 by the French architect Alfred-Nicolas Normand; a panoramic view of Pompeii in a print by photographer Giorgio Sommer (circa 1870–80); the House of the Tragic Poet (circa 1870), also by Sommer; and the Nola Gate in a print by Rive (circa 1880).

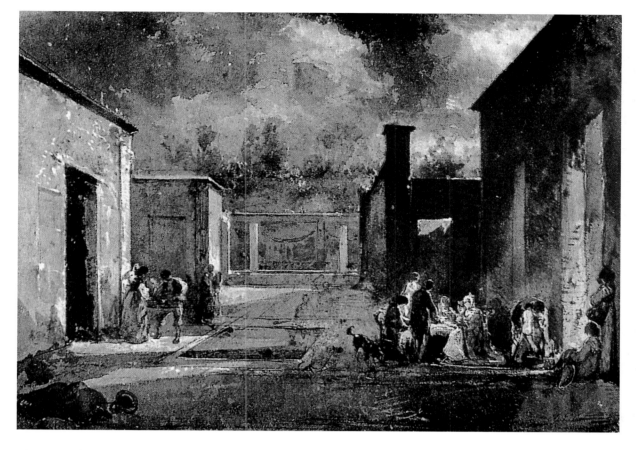

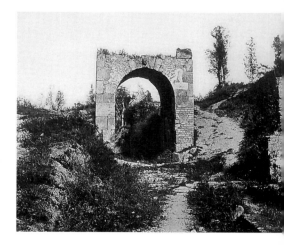

photographer Sommer, who was on the scene for work, asked Türr to see if Garibaldi wanted to stop for a photograph. Garibaldi consented. They were at the Pantheon. 'I am ready,' said the photographer. 'Then go ahead,' said Garibaldi. In a moment, the group was taken."[15] Sommer (sometimes associated with Edmondo Behles) photographed a large amount of material, from Pompeii itself to the many materials kept at the Museo Nazionale di Napoli. This was the first reliable repertory of panoramic views, monuments, and objects.[16] Besides the usual landscapes and detailed shots, for the first time his photographs appeared in direct relationship with the excavation activity that Giuseppe Fiorelli was directing in the 1860s.[17] In fact it was Sommer who captured the first plaster casts of buried animals and people, a technique that Fiorelli himself had developed.[18] The photographer's emotion at these appears in the unusually eloquent photo captions. There are 77 shots of Pompeii in the catalogue that Sommer edited in 1886, 61 concerning "frescoes taken from the work of Fausto Niccolini." In 1891 the new catalogue counted 88, with a wide variety of formats (from large format to business-card size). In 1900 the number rose to 172 due to new efforts at uncovering the House of the Vettii.

The difficulty of printing photographic material, which was usually separately distributed or collected in albums, left a large amount of room for lithographs and engravings. These translated the memories of Pompeii, as the Niccolinis did, transposing them into simplified formulas that could be immediately converted into the designs of the time.

Among the reproduced albums (*Souvenirs of Pompeii*) that were assembled for learned travelers, those by the Neapolitan photographer Michele Amodio deserve special mention. These were presented in the Paris Exposition of 1878. The fact that photography was only beginning to take on a pictorial orientation reserved Pompeii for *vedutisti* painters, and photographers preferred other evocative locations such as Baron Wilhelm von Gloeden's Taormina (Sicily). Thanks to the talent of Giacinto Gigante, Pompeii would attract a number of *vedutisti* painters who would also benefit the Niccolini brothers.

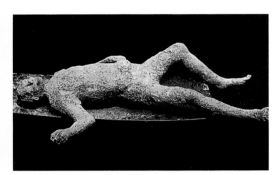

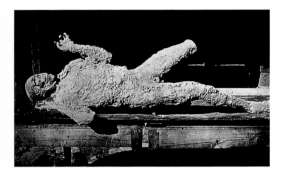

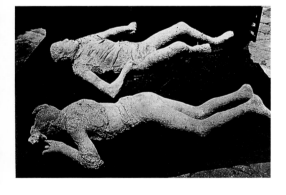

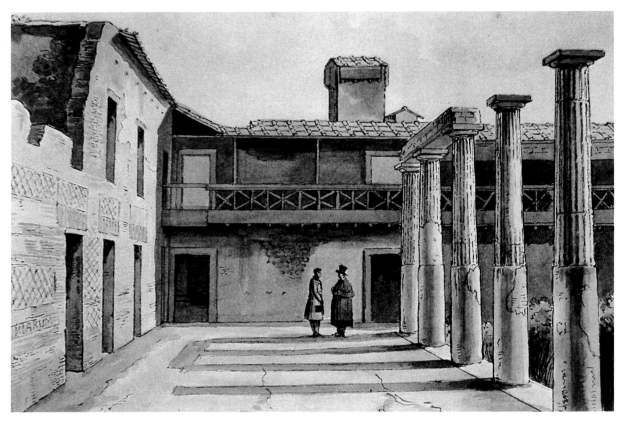

The organized efforts of Alinari began at the end of the 1870s, followed by Brogi some years later. These were especially attentive to the life and needs of the time, such as excavations, study visits, and learned walks.[19] However, only a film series by Domenico Anderson in the 1920s—while *The Last Days of Pompeii* was being shot—was able to provide a documentary and archaeological image of the Vesuvian city.

Above, three prints by Sommer that display plaster casts of people, which were made using methods developed by Fiorelli.
Top right, a watercolor lithograph by A. Vianelli portraying the Pompeian Forum. *Bottom right*, by the same author, *Shop with an Oven at Pompeii.*

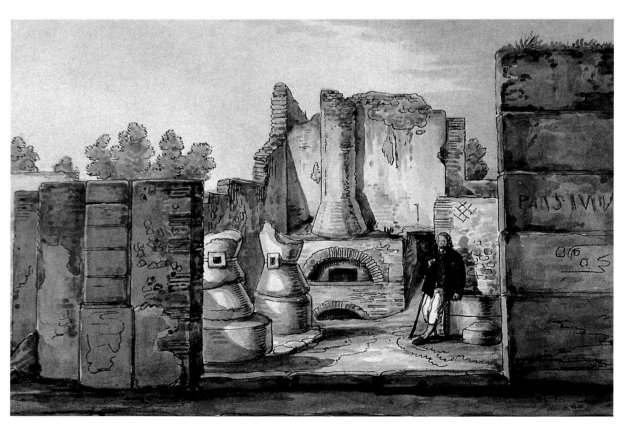

Notes

1. For all information regarding the editorial undertaking of *Le case ed i monumenti di Pompei* by Fausto and Felice Niccolini, I refer to P. Ciapparelli's contribution in this same volume (p. 10).

2. A comprehensive study on photography in Pompeii is in *Fotografi a Pompei nell'800 dalle collezioni del Museo Alinari*, an exhibit catalogue from Pompeii, 1990–91 (Florence: Alinari, 1990); see the contributions of M. Falzone del Barbarò, "Guida all'iconografia fotografica di Pompei," p. 31–32; G. C. Ascione, "Tra vedutismo e fotografia: la rappresentazione di Pompei nella seconda metà dell'Ottocento," pp. 21–29; M. Maffioli, "Il 'corpus' fotografico pompeiano nel Museo di Storia della fotografia Fratelli Alinari," pp. 33–36; E. Sesti, "Le campagne fotografiche a Pompei presenti negli Archivi Alinari," pp. 37–38. The essays in the volume *Pompei 1748–1980: I tempi della documentazione*, catalogue for the 1981 exhibits in Rome and Pompeii (Rome: Multigrafica, 1981) are still important, especially I. Bragantini and M. De Vos, "La documentazione della decorazione pompeiana nel Settecento e Ottocento," pp. 34–42; T. Martinelli Coco, "La prima documentazione della decorazione pompeiana nel Settecento e Ottocento," pp. 49–56; and F. Parise Badoni, "La campagna fotografica dell'Istituto Centrale per il catalogo e la documentazione," pp. 57–80. This last scholar returned to the same subject in the essay "Tempi e modi della documentazione a Pompei" in *Un impegno per Pompei: Studi e contrbuti* (Milan: Total-T.C.I., 1983), 12–17.

3. L. Fino, *Ercolano e Pompei: Vedute neoclassiche e romantiche* (Naples: Electa, 1988). For the history of excavations in Herculaneum, see F. Zevi, "Gli scavi di Ercolano," in *Civiltà del '700 a Napoli*, catalogue from the exhibit in Naples, December 1979 to October 1980 (Florence: Centro Di, 1980), 2:58–68. The extravagant preparation work for the engravings of *Voyage pittoresque ou description des Royaumes de Naples et de Sicile* by the Abbot of Saint-Non was recently studied by P. Lamers, *Il viaggio nel Sud dell'abbé de Saint-Non*, with an introduction by P. Rosenberg (Naples: Electa Napoli, 1995). See also V. Sampaolo, "Dessins, aquarelles, et gouaches," in *A l'ombre du Vesuve*, catalogue from the exhibit in Paris, 1995–96 (Paris: Paris-Musées, 1995), 184–95. One indispensable working text is the ample repertory edited by I. Baldassare, *Pompei pitture e mosaici: La documentazione nell'opera di disegnatori e pittori dei secoli XVIII e XIX* (Rome: Istituto dell'Enciclopedia Italiana, 1995), which completely charts the vast wealth of designs from the Ufficio Scavi di Pompei (now at the Museo Archeologico Nazionale di Napoli).

4. *Pompéi: Travaux et envois des architectes française au XIXe siècle*, catalogue from the exhibit in Paris, Naples, and Pompeii, 1981 (Paris: École nationale des beaux-arts, 1981).

5. Falzone del Barbarò, "Guida all'iconografia." See note 2 above.

6. On daguerreotypes in Italy, besides the fundamental contributions in the catalogue edited by M. Miraglia, D. Palazzoli, and I. Zannier, *Fotografia italiana dell'800* (Milan and Florence: Electa-Alinari, 1979), see also the recent precisions by P. Costantini, "'Occhio artificiale': Sull'Italia riflessa nelle lamine di Daguerre," in *Segni di luce: Alle origini della fotografia in Italia*, vol. 1, I. Zannier, ed. (Ravenna: Longo, 1991), 57–64.

7. P. Becchetti, "Fotografia e archeologia alle origini della fotografia Italiana," in Zannier, *Segni di luce*, 75–84.

8. On photographic activity by English travelers in Italy, see R. E. Lassam and M. Gray, *The Romantic Era (La calotipia in Italia 1845–1860)* (Florence: Alinari, 1988); on Calvert Jones in particular see the catalogue of his works that are held in London's Science Museum: R. Buckman, *The Photographic Work of Calvert Richard Jones*, introduction by J. Ward (London: Science Museum, 1990). "Yesterday I was in Pompeii," notes Jones, "and I photographed beautiful subjects, but unfortunately I ruined some photos because of the inevitable imprecision that comes from hurrying." (This was cited in Lassam and Gray, *The Romantic Era*, p. 16, and again in Falzone del Barbarò, "Guida all'iconografia," p. 31.) The Museo di Storia della Fotografia Alinari in Florence holds a photo album (printed from a tiny album of paper negatives) of a little-known Scottish traveler, James Graham (1806–69), thirty-three of which feature Pompeii.

9. We know from Piero Becchetti that the great calotypist Giacomo Caneva also went to Pompeii to photograph: Becchetti, "Fotografia e archeologia."

10. *I calotipi della Società francese di fotografia 1840–1860* (Venice: Marsilio, 1981). One calotype, dating to 1845 or 1846, portrays the House of Sallust and was published in W. M. Watson, *Images of Italy: Photography in the Nineteenth Century* (South Hadley, Mass.: Mount Holyoke College, 1980), p. 52, no. 45.

11. P. Néagu and A. Cayla, *Alfred Normand: Calotypes 1851–52: Photographies d'Italie, de Grèce, et de Constantinople* (Gorle, Bergamo: Grafica Gutenberg, 1978).

12. Néagu and Cayla, *Alfred Normand*, letter 58. An attentive study of Normand's work in Pompeii can be found in M. Miraglia, "Regno delle Due Sicilie," in Miraglia, Palazzoli, and Zannier, *Fotografia italiana dell'800*, 133–34.

13. *The Second Empire 1852–1870: Art in France Under Napoleon III*, catalogue from exhibits in Philadelphia, Detroit, and Paris, 1978–79 (Philadelphia, Philadelphia Museum of Art, 1978); see chart I-22, pp. 63–64; for the interior decoration see chart I-9, p. 47. For a depiction of the atrium see *Der Traum vom Glück: Die Kunst der Historismus in Europa*, herausgegeben von H. Fillitz, catalogue from the exhibit in Vienna, 1996–97 (Vienna, Künslerhaus, 1996), chart 12.10, 2:468.

14. The following volume is fundamental concerning Giorgio Sommer: M. Miraglia and U. Pohlmann, eds., *Un viaggio fra mito e realtà: Giorgio Sommer fotografo in Italia 1857–1891*, catalogue from the exhibit in Rome, 1992–93 (Rome: Carte Segrete, 1992). See also M. Miraglia, "Bernoud, Alinari, Sommer, und die Anderen: Die Ausbreitung der Photographie in Mittel-und Sünditalien," in *Italien shen und sterben: Photographien der Zeit des Risorgimento (1845–1870)*, herausgegeben von B. Von Dewitz, D. Seigert, u. K. Schuller-Procopovici, catalogue from the exhibit in Cologne, 1994 (Heidelberg, Edition Braus, 1994), 47–56. A large amount of material is collected in *Immagine e città: Napoli nelle collezioni Alinari e nei fotografi napoletani fra Ottocento e Novecento*, with important writings by G. Galasso, M. Picone Pertusa, and D. del Pesco (Naples: Macchiaroli, 1981).

15. M. Miraglia, "I luoghi dell'epopea garibaldina: reportage bellico e 'veduta' nella fotografia dell'Ottocento," in S. Pinto, ed., *Garibaldi, Arte e storia*, catalogue from the exhibit in Rome, 1982 (Florence, Centro Di, 1982), 2:273, chart 82, p. 325.

16. Thanks to the courtesy of Marina Miraglia, I was able to consult the following sales catalogues from the Sommer establishment: *Giorgio Sommer: Catalogo di fotografie d'Italia, Malta, e ferrovie del Gottardo* (Naples: Tipografia Trani, 1886); *G. Sommer & Figlio: Catalogo di fotografie*, a copy from the University Library of Michigan in Ann Arbor, Michigan (Naples: Tipografia A. Trani, 1891); *G. Sommer & Figlio: Catalogo di bronzi & terracotta* (Naples: Tipografia Trani, n.d., after 1889–before 1899); *G. Sommer & Figlio . . . : Catalogo di fotografie: Svizzera e Tirolo* (Naples: Tipografia Scarpati, 1899); *Catalogo di fotografie & diapositive: Italia, escluso Napoli, contorno e museo* (Naples: Piazza Vittoria Palazzo Sommer, n.d., before 1899); *G. Sommer & Figlio: Catalogo di fotografie & diapositive (lantern slides) contorni, museo etc. di Napoli* (Naples: Piazza Vittoria Palazzo Sommer, n.d., after 1908), 37–42.

17. For Fiorelli, refer to Massimiliano David's contribution to this volume (see pp. 52–57). For the relationship between archaeology and photographic documentation, see M. Necci, *La fotografia archeologica* (Rome: NIS, 1992). The English archaeologist John H. Parker relied on Sommer to provide images of Pompeii for his extremely rich photographic collection, *Un inglese a Roma 1854–1877: La Raccolta Parker nell'Archivio fotografico comunale* (Rome: Artemide, 1990), 35.

18. Bonetti, *Viaggio fra mito e realtà*, charts 127–29, pp. 225–26. The subjects were available in diverse formats, such as middle-sized, albums, stereoscope, or business-card size (up until 1886).

19. See also the essays in *Fotografi a Pompei nell'800* (note 2 above). Guido Rey's photographic activity in Pompeii (for this see M. Miraglia, *Culture fotografiche e società a Torino 1839–1911* (Turin: Allemandi, 1990)) was evidently influenced by the painting of Lawrence Alma-Tadema, who himself relied on photographic material (for this subject see U. Pohlmann, "Alma-Tadema and Photography," in *Sir Lawrence Alma-Tadema*, E. Becker et al, eds. (Zwolle Waanders Uitgevers, 1996), 111–24, which especially studies Wilhelm Plüschow's works).

FIORELLI AND DOCUMENTATION METHODS IN ARCHAEOLOGY

By Massimiliano David

A portrait of the archaeologist Giuseppe Fiorelli (1823–96). Fiorelli relaunched the excavation of Pompeii and promoted new strategies for record keeping. *Below*, a general view of a model before the restorations of 1989 and 1993. Naples, Museo Archeologico Nazionale.

"I started frequenting the Museo di Napoli to get closer to Giuseppe Fiorelli. Fiorelli was able to free the Museo di Napoli building from the various schools of the Istituto di Belle Arti, which at the time took up the whole floor where the museum directors now are. The room where Fiorelli had his studio was one of the last on the building's face toward Forìa, and Giulio de Petra and Domenico Salazar took the last room on that side. A bit further, on the opposite side, the administration secretary Felice Niccolini had his office."[1]

These were the words that the archaeologist Felice Barnabei used to describe his esteem for Fiorelli's character in his 1865 memoirs.[2] The floor of the Museo Nazionale di Napoli held the offices of Fiorelli's closest colleagues. Among these was Felice Niccolini, who together with his brother Fausto had already published two volumes of their monumental work on Pompeii. Here the work's diligent editorial quality is once again being presented to the public.[3]

Fiorelli found himself directing the excavations of the Vesuvian city after the decline of the Bourbon court, when the new Sabaudian state intended on—although Garibaldi himself had already planned to—opening research once again. The excavation sites had already been open since the end of the 1860s, but Fiorelli went beyond simple activism and earned his merited fame by restructuring strategies and techniques, essentially rethinking the entire documentation methodology.

Above all, he promoted the creation of a new general map of the uncovered structures, charging Giacomo Tascone with creating it.[4] Excavations were then carried out "no longer following the directions of the roadways, but penetrating the buildings from above in order to further understand their structure and re-create how they had crumbled."[5] The practice of creating plaster casts was approved with great success. These not only allowed the traits of the victims who had been buried in the ashes of

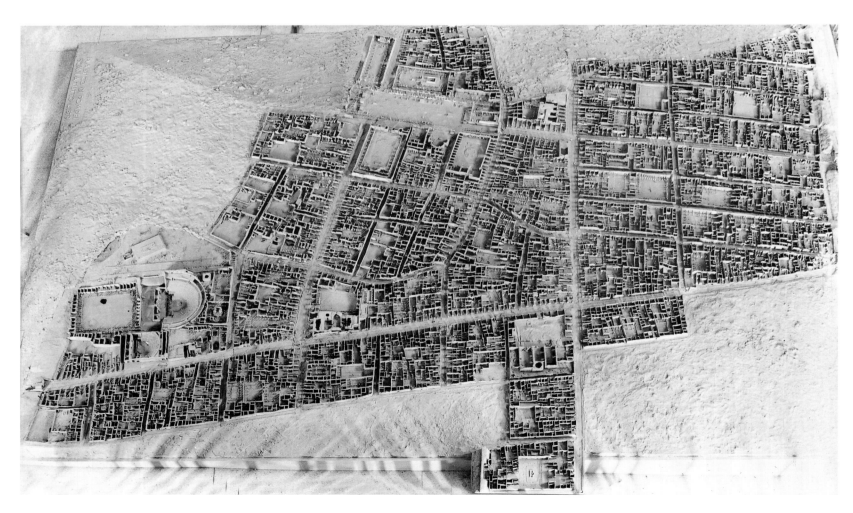

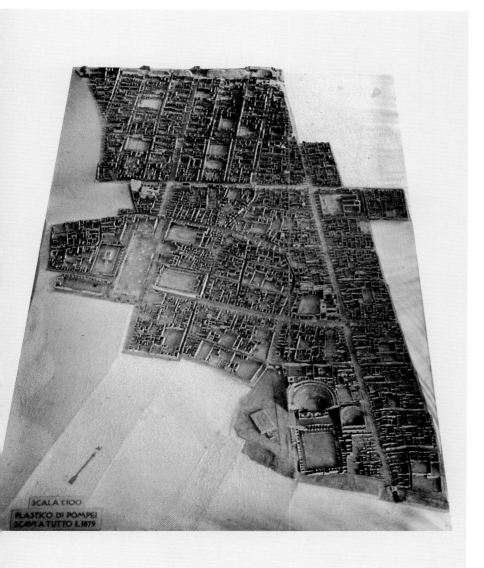

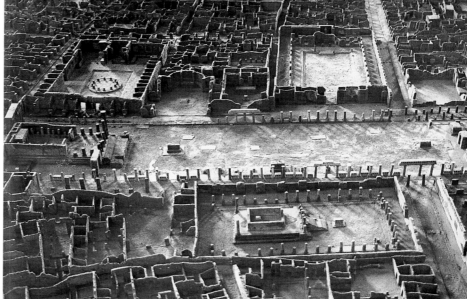

Vesuvius to be recovered but also recuperated the shapes of rafters, fixtures, and furniture. By recovering the traces of their roots, the process was even able to identify the vegetation of entire gardens and orchards.[6] Thus Fiorelli aimed at enlarging the spectrum of documentation techniques in the field.

The archaeologist is also credited with opening new frontiers by moving toward completely recording the results of past and continuing excavations. He recorded data on excavations between 1748 and 1860 in *Pompeianarum antiquitatum historia,*[7] and he reported on his own studies in "Giornali degli scavi di Pompei."[8] His goal was to achieve a continual, up-to-date, and detailed picture of the excavations. To do this, Fiorelli launched another huge project: a model of Pompeii in a scale of 1:100.[9]

Model making had a long tradition in the Kingdom of the Two Sicilies.[10] In 1860 the Museo Archeologico di Napoli displayed at least fifteen models of ancient monuments, some of which even dated to the eighteenth century. Five of these reproduced some of the most important buildings at Pompeii.[11] These models were authentic masterpieces and can be considered the forerunners of didactic models that still take leading roles in museum exhibits, such as the Römisch-Germanisches Zentralmuseum in Magonza or the Museo della Civiltà Romana in Rome's EUR district.[12] This last museum (long looked down upon by an Italian archaeological culture that is unable to come to terms with anything achieved during the twenty years of Fascism) boasts one of the best examples of archaeological models. This re-

Left, a general view of a model of Pompeii after the restoration. Naples, Museo Archeologico Nazionale. *Above, top*, a detail of the model featuring a view of the Pompeian Forum. *Above, bottom*, a detail of the floor mosaic from the House of the Faun. While the raised areas of the buildings were made of cork and the walls were painted, the meticulous imitation of the ancient floor pavements—mosaics and other types—were made of paper.

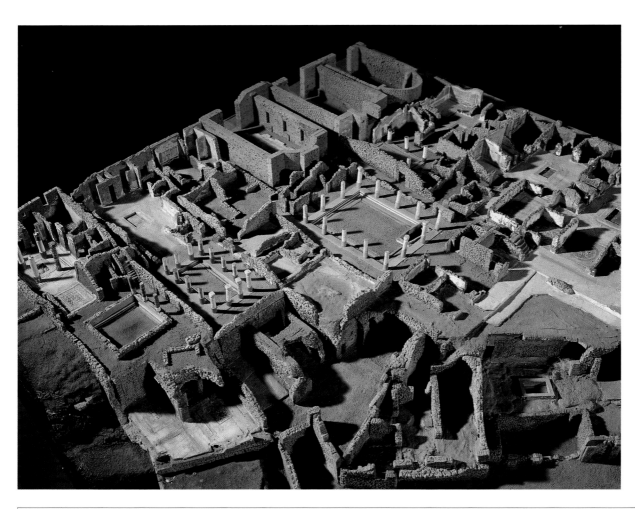

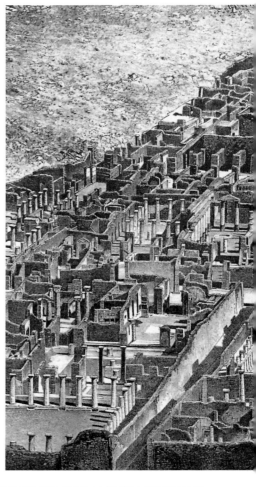

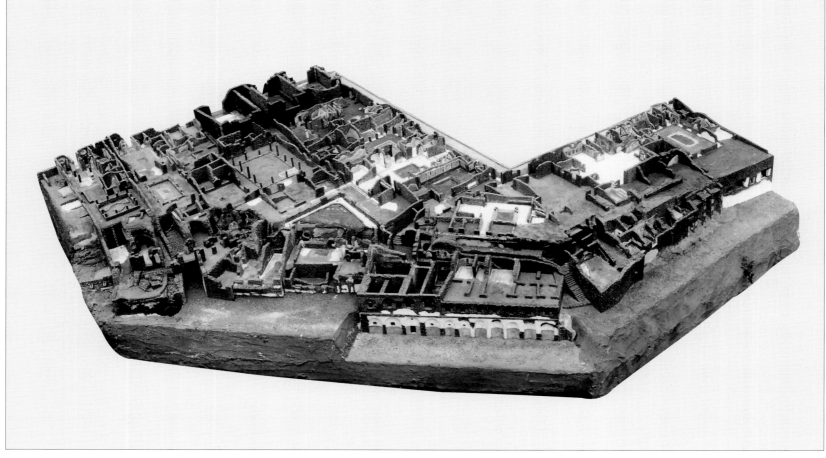

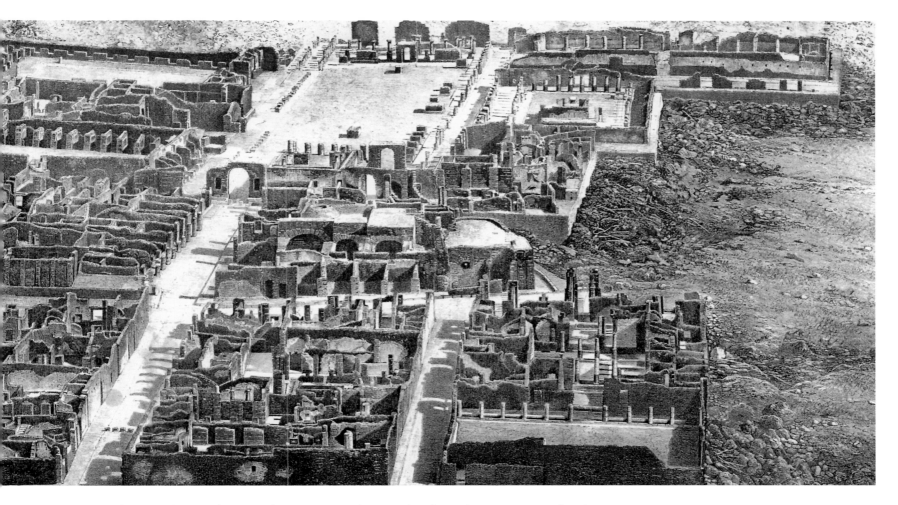

creation of Rome during the age of Constantine (in a scale of 1:250) is unsurpassed today in recon-structing an entire environment.[13]

Archaeological models were invented to demonstrate the value and beauty of the ancient monu-ments. At first they brightened the gaze of rulers and curious "antiquarians," then they stimulated the imagination of today's great anonymous audience. Originally restorative models were preferred, but today descriptive models seem to be more prevalent. Of this last kind were also models created in recent years for large exhibits, like one in Paris in 1989 describing thirty years of archaeological discoveries in France.[14]

The idea of a model of Pompeii was groundbreaking, and served as a constant reflection on how the excavations were progressing. It also captured the structures' conditions when they had just been uncov-ered, which was important because these were inevitably destined to decay. Like a huge puzzle, a bird's-eye view of the city was laid out block after block (*insulae*) for the archaeologists, giving a detailed, yet general image. In reality this did not keep pace with the research, but covered Fiorelli's initial surge and lasted until A. Maiuri's term.

After thorough archival studies by Valeria Sampaolo,[15] there were four stages of modeling that devel-oped over an arc of almost sixty years. Fiorelli relied on a team of technicians: modeling was by the Padiglione brothers, sons of Domenico, who had the task from 1806 to 1828. Antonio Sevillo was definitely one of the painters.

The first five years (1861–65) were especially intense. A large part of Regions 7 and 8 materialized before Fiorelli's eyes. From a technical point of view, this first phase would prove to be the most inspired. The level of city blocks and streets was built from plywood, the raised areas of buildings were made of cork, and the walls were painted directly with the intent of giving a thin preparatory coat of

Above, a design based on the model of Pompeii featured in the work of Johannes Overbeck

Opposite, top, a detail of the Pompeii model that shows Region 8. *Opposite, bottom*, the section of the model con-served in Pompeii's Antiquarium. This section was separate from the main body and features a large stretch of the southern area of the city beginning with the southern end of the Pom-peian Forum. This is a true mosaic of famous buildings: there is the House of Championnet, the Baths of Sarnus, the House of Francesco Giuseppe, and the House of the Doves.

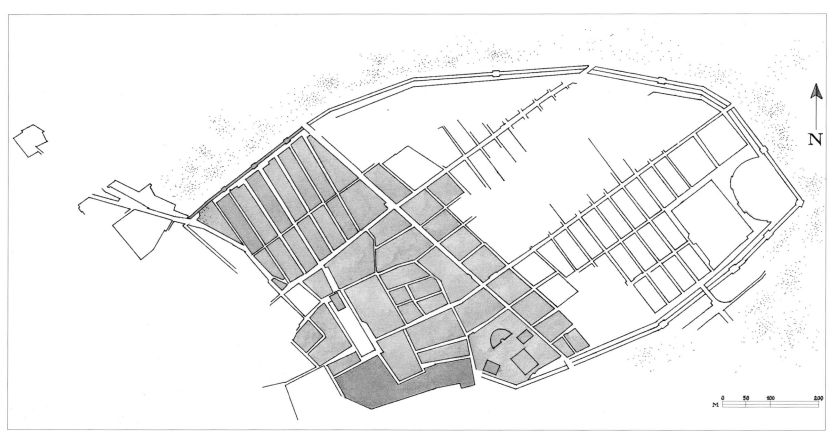

A schematic diagram of Pompeii indicating the housing blocks (*insulae*) recorded in the models. The colors distinguish two distinct models, one in Naples (in ocher), and the other in Pompeii (gray).

whitewash. Meticulous imitation of the ancient floors (mosaics or other types) was done with paper. The ceilings were often removable in order to access the interiors. Architectural details were mostly in stucco or plaster, and at the time, even in bone.[16]

In 1884, when part of the model (the block with the Stabian Baths) was sent to the Esposizione Nazionale in Turin, modeling had already been transferred under the technical guidance of Vincenzo Bramante and his sons, Alessandro and Emilio. According to Sampaolo, the model was mentioned the same year in German archaeological writing, thanks to Johannes Overbeck.[17]

Faced with ministerial worries in 1907 because work had slackened, A. Sogliano formed a new technical team and brought ahead the model. The Bramantes had vacated, and Sogliano entrusted the continuing work to modeler Nicola Roncicchi (1908), the engineer Cozzi, the "artistic head" D'Avino, and the painter Luciano.

The final stage of model construction was accomplished during the 1920s, when it took its present-day form.[18] A report by Della Cort on January 29, 1927 complains about the dearth of work accomplished (for example, Via dell'Abbondanza was incomplete), nevertheless, very few gaps were filled.[19]

During the dark year of 1942 the model was taken apart, and it was only in 1980[20] that a large section was restored, including region 8, block 2. (This had been kept separately at the Antiquarium of Pompeii.) Between 1989 and 1993 the main part of the model, which was kept in Naples, was saved from decay and early aging by restoration work.

Unfortunately, Fiorelli's dream to have the results of all the archaeologists' work in miniature was not possible. Of the nine city regions,[21] the model only partially records three (6–8). Only certain tracts pass beyond the eastern border of Via Stabiana to border with Regions 1, 9, and 5.[22] It should also be said that the model exclusively illustrates the area within the city walls, omitting necropolises and suburban villas like the Villa of Diomedes[23] and Villa of the Mysteries.

Notes

1. F. Barnabei, *Le memorie di un archeologo*, M. Barnabei and F. Delpino, eds., Collana di studi archeologici, vol. 2 (Rome: De Luca, 1991), 86.

2. L. A. Scatozza Höricht, "Giuseppe Fiorelli," in *La cultura classica a Napoli nell'Ottocento*, M. Gigante, ed. (Naples: 1987), 2: 865–80; R. A. Genovese, *Giuseppe Fiorelli e la tutela dei beni culturali dopo l'Unità d'Italia*, Restauro: quaderni di restauro dei monumenti e di urbanistica dei centri antichi, vol. 119 (Naples: Edizioni Scientifiche Italiane, 1992); F. De Angelis, "Giuseppe Fiorelli: la 'vecchia' antiquaria di fronte allo scavo," *Ricerche di storia dell'arte*, vol. 50 (1993), 6–16; G. Fiorelli, *Appunti autobiografici*, (1939; Naples: Di Mauro, 1994).

3. Felice Niccolini contributed in a decisive way to Fiorelli's political and professional rehabilitation: in 1853 he was the friend who introduced Fiorelli to Leopold of Bourbon, the Count of Syracuse, helping Fiorelli exit a tunnel of political persecution that had lasted four years.

4. G. Tascone, *Tabula Coloniae Corneliae Veneriae Pompeiis* (Naples: 1858).

5. F. Parise Badoni, "Tempi e modi della documentazione a Pompei: Dagli scavi borbonici alla campagna fotografica dell'Istituto Centrale per il Catalogo e la Documentazione," in *Un impegno per Pompei* (Milan: Touring Club Italiano, 1983), 13.

6. "Who could ever forget the huge impression everywhere when Fiorelli, guided by his genius to resurrect Roman life in Pompeii, succeeded by attaching plaster to the imprints in the ashes of Pompeians who had fallen while fleeing to obtain their resemblance during their last spasms of agony? Alfonso della Valle di Casanova wrote, 'seeing those entire bodies that had been reconstructed brought on one of the strongest emotions that I had ever experienced in my life.'" From R. De Cesare, *La fine di un regno* (Milan: 1969), 592.

7. Naples, 1860–64.

8. Naples, 1850, 1861–65, 1868–79. See also G. Fiorelli, *Gli scavi di Pompei dal 1861 al 1872* (Naples: 1873). Only when the Pompeian experience could be applied to a commitment on a national scale, when Fiorelli received the charge of Direttore Generale delle Antichità e Belle Arti (1875), did the "Notizie degli scavi di antichità" (News on Excavations of Antiquity) come to light. When he was almost in his twentieth year of work in Pompeii in 1875, Fiorelli published the *Descrizione di Pompei* (Naples).

9. G. Tascone, "Sui lavori geodetici e topografici di Pompei," in *La regione sotterrata dal Vesuvio* (Naples: 1879), 2:3–6; J. A. Overbeck and A. Mau, *Pompeji in seinen Gebäuden, Alterthümern und Kunstwerken* (Leipzig: 1884), 40–41, n. 22; H. Eschebach, "Die Städtbauliche Entwicklung des antiken Pompeji," *Römische Mitteilungen* 17 (1970), 91; F. Parise Badoni, "Tempi e modi della documentazione a Pompei: Dagli scavi borbonici alla campagna fotografica dell'Istituto Centrale per il Catalogo e la Documentazione," in *Un impegno per Pompei* (Milan: Touring Club Italiano, 1983), 13; V. Sampaolo, "La realizzazione del plastico di Pompei," *Il museo* 3 (1993), 79–95; S. De Caro, *Il Museo Archeologico Nazionale di Napoli* (Naples: Electa Napoli, 1994), 105.

10. Ever since the first half of the eighteenth century, mapmaking activity in Naples was accompanied by models in wood, cork, and plaster. These also had special military use. For example, Giovanni Carafa, the Duke of Noja, had models made of castles at Trani, Barletta, Aquila, and Sant'Elmo a Napoli. See also C. De Seta, "Topografia territoriale e vedutismo a Napoli nel Settecento," in *Civiltà del '700 a Napoli: 1734–1799* (Florence: Centro Di, 1980), 2:28. In 1784 King Gustav III of Sweden took advantage of the great ability of local masters (in this case Giovanni Altieri) to create an extraordinary model of the Temple of Isis in cork, one of the most valued monuments of Pompeii during the eighteenth century. See also S. De Caro, "La scoperta, il santuario, la fortuna," in *Alla ricerca di Iside: Analisi, studi, e restauri dell'Iseo pompeiano nel Museo di Napoli* (Rome: ARTI, 1992), 3–21 pass.

11. The museum also displayed the models of the archaeological area in Paestum, the so-called Temple of Serapis in Pozzuoli, the theater of Herculaneum, the church of Saint Mary Major, the Colosseum, and the Temple of Jupiter Stator in Rome. V. Sampaolo, "La realizzazione del plastico di Pompei," *Il museo* 3 (1993), 82–83.

12. See also M. Burri Rossi, *Museo della civiltà romana: Itinerario ragionato per una visita al museo* (Rome: Colombo, 1976), 94–95.

13. Recent attempts have been largely disappointing, such as the model of Archaic Rome (I. Quilici, "Il plastico di Roma arcaica al Museo della Civiltà Romana," *Ocnus* 3 [1995], 143–55) or the entirely dissatisfying one presented for the 1990 exhibit "Milano capitale dell'Impero romano."

14. *Archéologie de la France: 30 ans de découvertes* (Paris: 1989), 286, 384, 425.

15. Sampaolo, "La realizzazione del plastico di Pompei."

16. Valeria Sampaolo's study of the archival records led to the discovery of a list of indispensable materials and tools for the work of the Padigliones and their collaborators, such as choice cork, pins, nails, German glue, paint, brushes, rasps, and files.

17. Overbeck, *Pompeji in seinen Gebäuden*.

18. In this stage A. Carotenuto took the place of Roncicchi as modeler.

19. The last blocks to be completed were Region 4, block 16, and Region 9, block 8.

20. The occasion was for the exhibit on Pompeii. *Pompei, 1748–1980: I tempi della documentazione*, exhibit catalogue (Rome: Mulltigrafica, 1981).

21. The idea to subdivide the city in nine regions had been promoted by Fiorelli since 1858. His proposal, which resulted from recognizing four major road axes, is not necessarily one of the best. In fact, it has overstepped the bounds of simple conventional values to take on an established character that has negatively conditioned urban historical research.

22. The blocks that are represented in the model (less than half of those counted inside the city walls, which total 107) add up to forty-seven: Region 1: 1–5; Region 5: 1; Region 6: 1–16; Region 7: 1–15; Region 8: 3–7; and Region 9: 1–5. Block 2 of Region 8 is kept at the Antiquarium degli scavi di Pompei.

23. The initial choice to exclude the necropolises could have actually come because a model of the Villa of Diomedes and the Herculaneum Gate Necropolis already existed at the museum. The museum displayed a model of the Amphitheater; one photograph shows how, during 1950s reorganization, these could have been juxtaposed with the main model. See also Sampaolo, "La realizzazione del plastico di Pompei," 82.

A GENERAL MAP OF POMPEII

This design schematically illustrates the development of excavations in Pompeii from 1748 to 1923. The monuments and buildings cited in this edition are numbered progressively, and the boundary positions are also indicated, including the region, housing block, and civic address numbers.

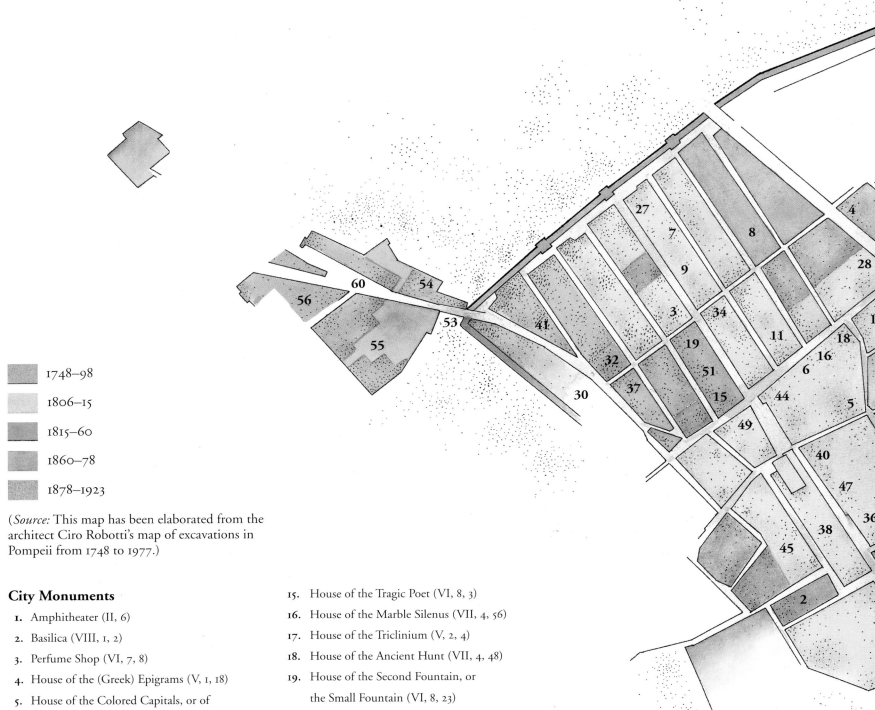

1748–98

1806–15

1815–60

1860–78

1878–1923

(*Source:* This map has been elaborated from the architect Ciro Robotti's map of excavations in Pompeii from 1748 to 1977.)

City Monuments

1. Amphitheater (II, 6)
2. Basilica (VIII, 1, 2)
3. Perfume Shop (VI, 7, 8)
4. House of the (Greek) Epigrams (V, 1, 18)
5. House of the Colored Capitals, or of Ariadne (VII, 4, 31)
6. House of the Sculpted Capitals (VII, 4, 57)
7. House of the Dioscuri, or of Castor and Pollux (VI, 9, 6)
8. House of the Vettii (VI, 15, 1)
9. House of the Centaur (VI, 9, 3)
10. House of the Centenary (IX, 8, 6)
11. House of the Faun (VI, 12, 2)
12. House of Solomon's Judgment (VIII, 5, 9)
13. House of the Gladiator Actius Anicetus (I, 3, 23)
14. Bakery (VII, 3, 30)

15. House of the Tragic Poet (VI, 8, 3)
16. House of the Marble Silenus (VII, 4, 56)
17. House of the Triclinium (V, 2, 4)
18. House of the Ancient Hunt (VII, 4, 48)
19. House of the Second Fountain, or the Small Fountain (VI, 8, 23)
20. House of the Mosaic Doves (VIII, 2, 34)
21. House of the Silver Wedding (V, 2, 1)
22. House of Caprasius Felix and Fortunata (IX, 7, 20)
23. House of Epidius Sabinus (IX, 1, 22)
24. House of Jason (IX, 5, 18)
25. House of L. Caecilius Iucundus (V, 1, 26)
26. House of Marcus Lucretius (IX, 3, 5)
27. House of Meleagrus (VI, 9, 2)
28. House of Orpheus, or of Vesonius Primus (VI, 14, 20)

29. House of P. Vedius Siricus (VII, 1, 47)
30. House of Julius Polybius (VI, 17, 19–26)
31. House of Cornelius Rufus (VIII, 4 15)
32. House of Sallust (VI, 2, 4)
33. Gladiator Barracks (VIII, 7, 16)
34. Tavern on Via di Mercurio (VI, 10, 1)
35. Tannery (I, 5, 2)
36. Eumachia Building (VII, 9, 1)
37. Brickyard (VI, 3, 27)
38. Pompeian Forum and Temple of Jupiter

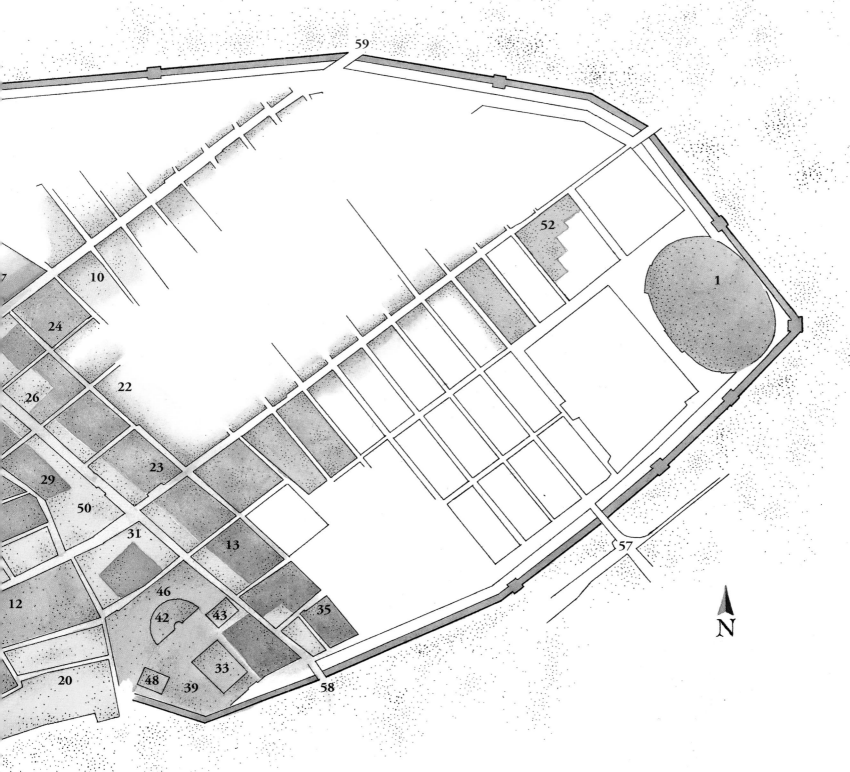

Note

Le case ed i monumenti di Pompeii, disegnati e descritti (Naples: 1854–96).
The Niccolini brothers' four volumes are a collection of a long series of peri-
odicals published separately between 1854 and 1896. In the edition kept in the
Accademia di Brera library, the periodicals are distributed as follows. The first
volume contains *The House of the Tragic Poet, The House of Castor and Pollux,
The House of the Second Fountain, The Temple of Fortuna, The So-Called House
of the Faun, House Number 57 on Strada Stabiana, The House of Siricus, Pan-
theon, The Tomb of Umbricius, The Temple Commonly Called of Mercury, The
House of the Colored Capitals, The Tomb of Naevoleia Tyche, The House of Mar-
cus Lucretius, The Stabiae Gate Baths, Gladiator Barracks, Theaters,* and *The
Temple of Isis.* The second volume contains *The Villa of Diomedes, The House
of the Sculpted Capitals, The Cenotaph of C. Quieto,* and *General Description.*
The third features *The Topography of Pompeii, Amphitheater, Baths Near the
Arch of Fortuna, The Temple of the Triangular Forum, The House of the Banker
L. Caecilius Iucundus, The So-Called House of the Centenary, The House of Block*
*VII in Region IX, The House of Sallust, The Trades and Industries of the
Pompeians, Plaster Forms,* and *Art in Pompeii.* The fourth contains *Graffiti,
Restoration Essays,* and *New Excavations.* A booklet entitled *Supplement* was
also published.

 In order to represent these to the public, certain materials have been
selected here to provide a meaningful sample of the Pompeian context, mate-
rials, and artists. These selections also inevitably represent the tastes of the
Niccolini brothers. The various archaeological contexts have been reorganized
to record the city in terms of urban planning and, naturally, to include
aspects of public and private life. The concluding segment of reconstructions
(*Pompeii As It Was*) selects and reorders the plates that were originally a part of
the so-called restoration essays. Each monument is distinguished in its cap-
tion with its relative position in the city (region, block, and civic address).
*Pier Luigi Ciapparelli and Massimiliano David wrote and edited the plate
legends and captions.*

PLATES

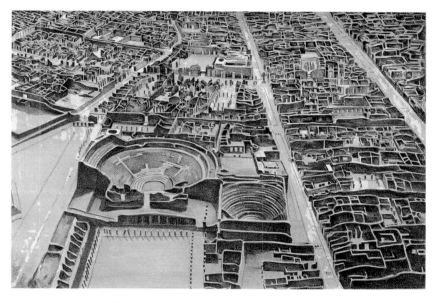

1. De Stefano, *A General View of the Excavations*

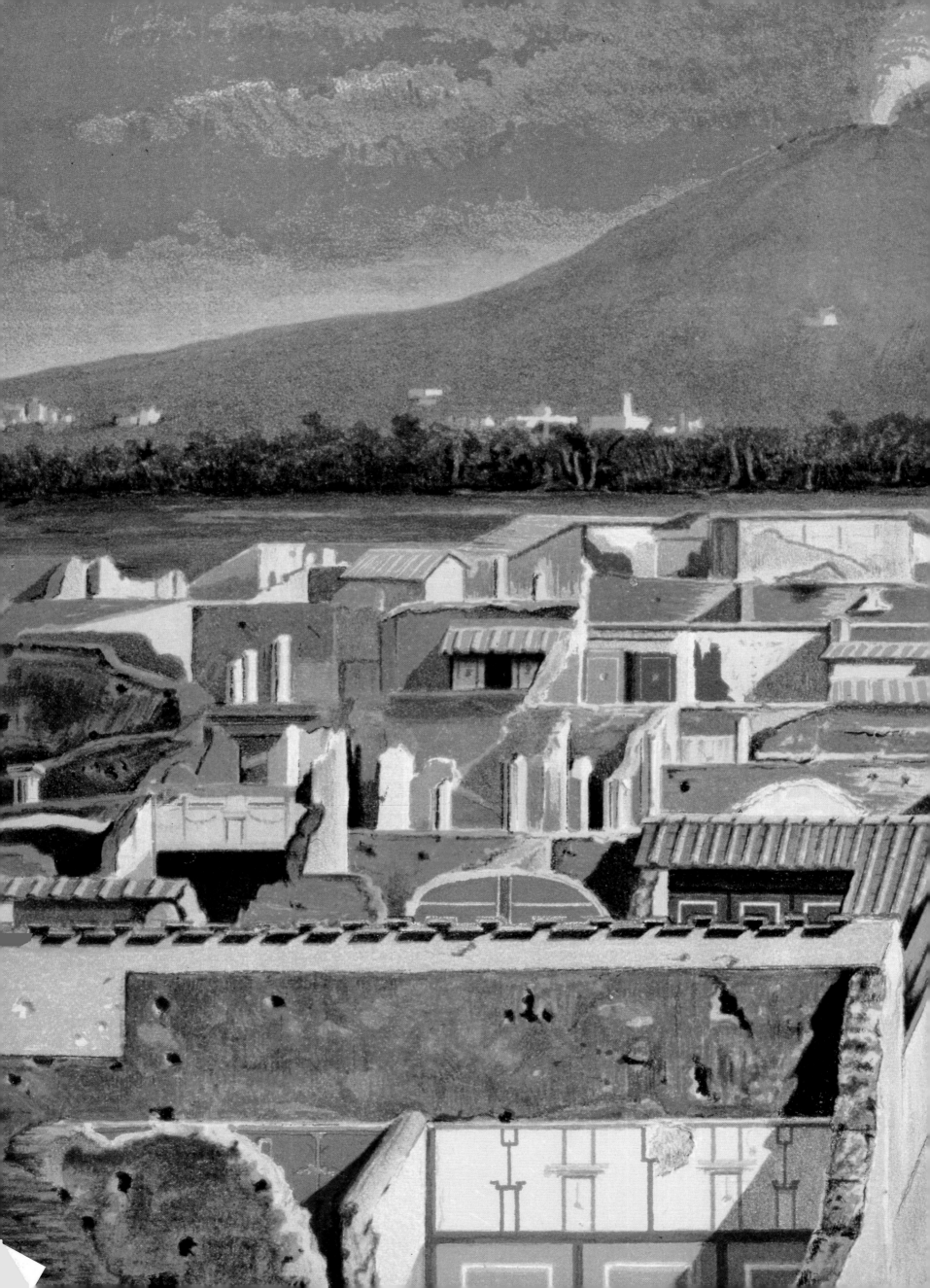

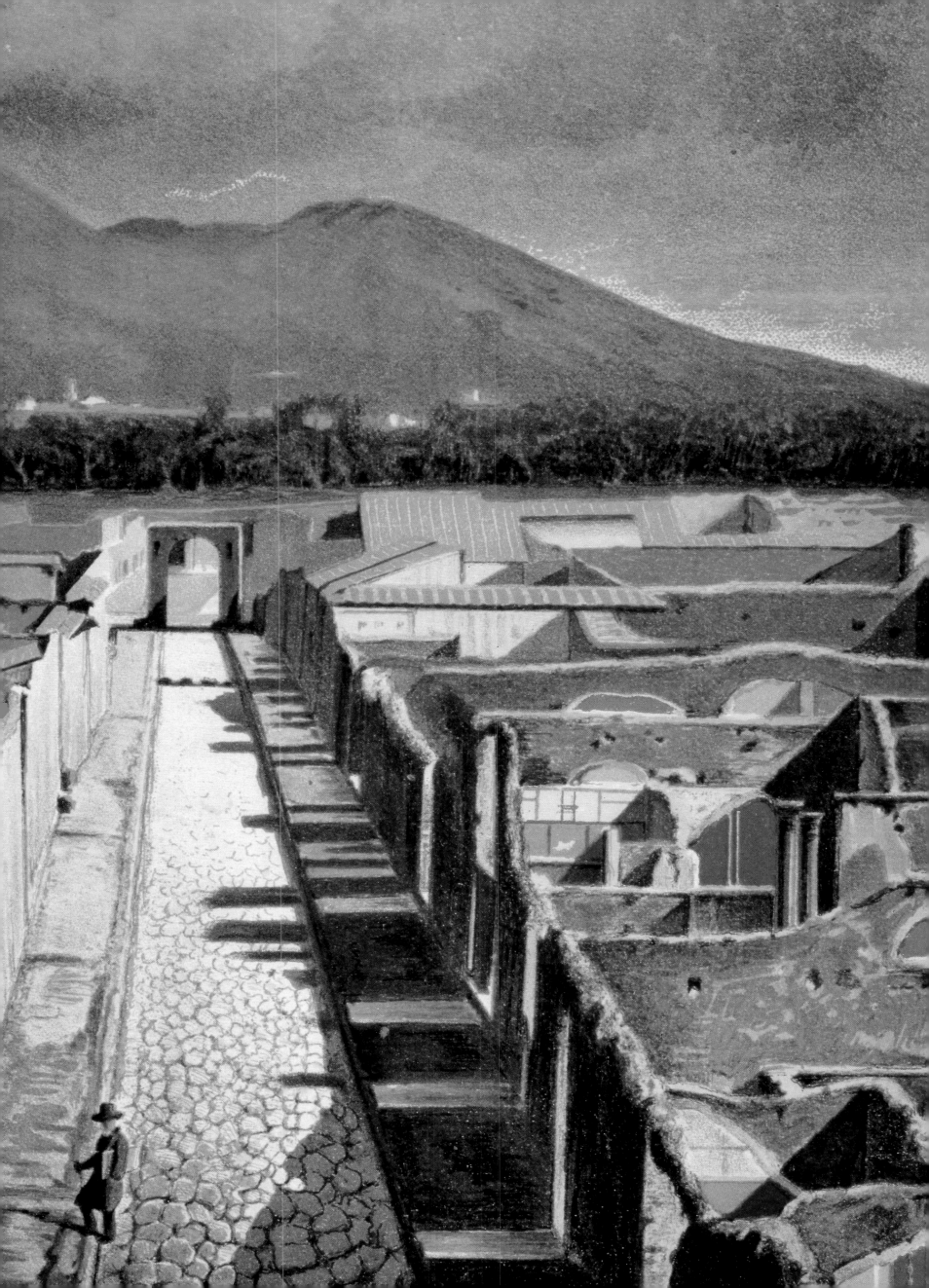

THE TOPOGRAPHY OF POMPEII

On the preceding pages:
2. G. De Simone and D. Capri,
A General View of the Excavations

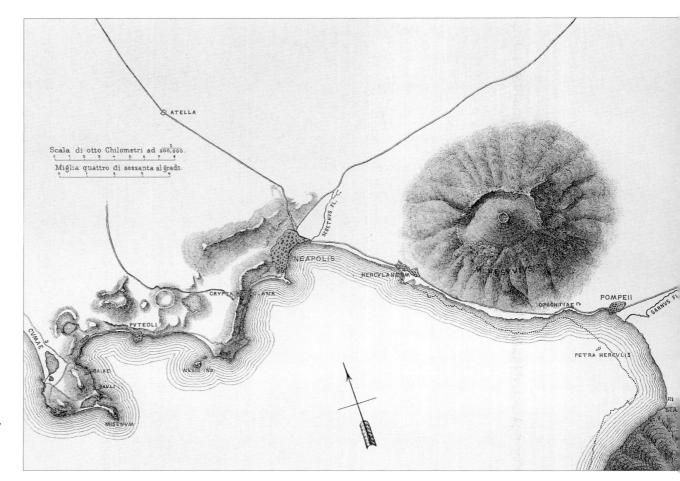

3. A. Carli, *Map of the Gulf of Naples in the Roman Era*
At the right is the topographic configuration of the Gulf of Naples according to the Niccolini brothers' reconstruction, as it must have appeared at the moment of the disaster. Besides Mount Vesuvius and the area of Campi Flegrei, the main coastal cities are recognizable, from the mouth of the Sarno River to the Cumae shore.

4. A. Carli, *General Schematic Map of the City Divided into Regions*
Pompeii was founded on an elevated bluff formed by a prehistoric lava flow. In the complexity of its origins, the city reflects the richness and cultural circles of ancient Campania, a land of Etruscan, Italic, and Greek peoples. During the Social War the city opposed Rome and suffered the siege and occupation at the hands of Roman troops in 89 B.C. The area was named the Colonia Cornelia Veneria Pompeianorum in 80 B.C. Seventeen years before the huge Vesuvian disaster of A.D. 79, an earthquake had a serious effect on the city and caused serious destruction and difficulty, although it gave new impetus to rebuilding and construction.

Here the city appears schematically divided into nine neighborhoods (*regiones*) that are defined by four main thoroughfares that archaeologists have conventionally named Via delle Terme, Via della Fortuna, Via di Nola, Via Marina, Via dell'Abbondanza, Via Stabiana, and Via di Porta Nocera. This partitioning of the city, which was created by Giuseppe Fiorelli, is still used today by scholars.

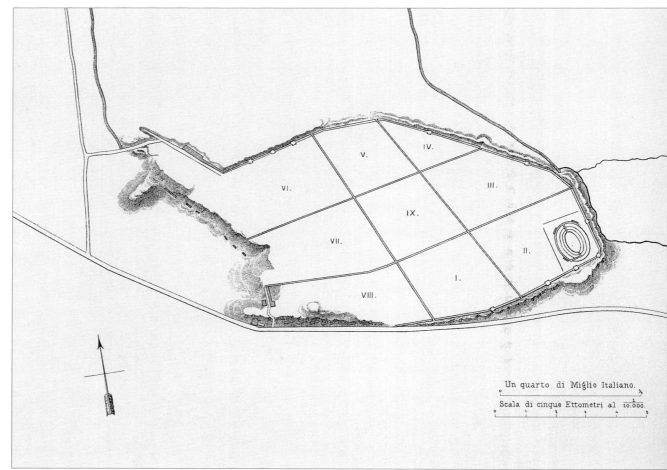

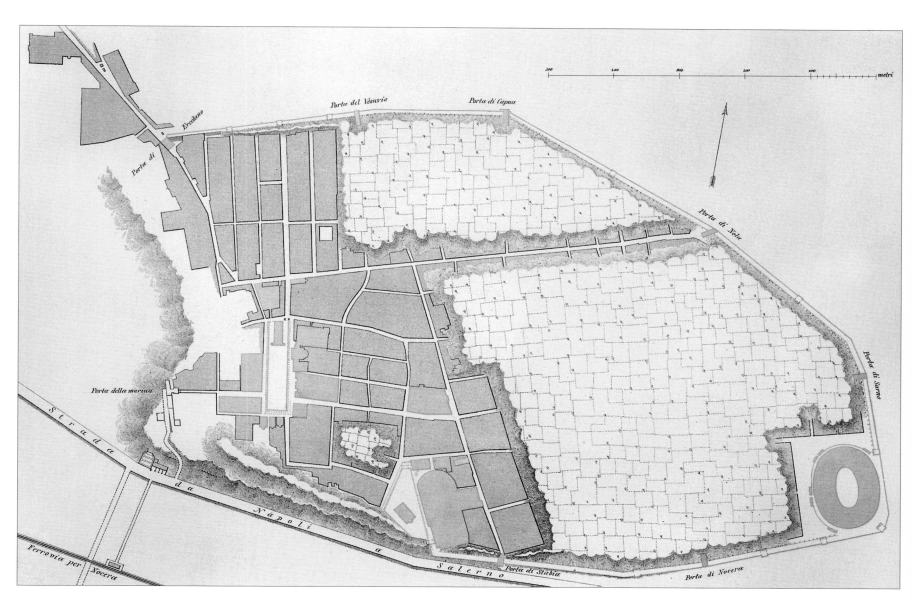

5. A. Carli, *General Map of the Excavated Areas*

This map highlights the excavated areas (in gray), the eight city gates (in orange), and the main public buildings that had emerged, such as the Amphitheater, the theater district (with the Triangular Forum), the Stabian Baths, and the Pompeian Forum complex with its annexed baths. When this map was made (circa 1890), the digging had evidently not reached most of the city's northern (Regions 4, 5, and part of Region 6) or eastern areas (Regions 1, 3, and 9). The isolated points in the northwest corner of Region 7 and the Temple of Venus area do not seem defined in their lines. Blocks (*insulae*) 5 and 6 of Region 8 are in the process of being excavated.

The border of the eastern excavations seems to extend as far as buildings that flanked a stretch of Via Stabiana, and the digging pushed toward the extreme east by following the Via di Nola axis to the gate of the same name. In the southeast corner of the city, the shape of the Amphitheater rises. It was one of the first public buildings to be identified and excavated. Eight city gates are shown: Marina Gate, Stabiae Gate, Nuceria Gate, Sarnus Gate, Nola Gate, Capua Gate (which at the time was only hypothesized about and later proven by excavations to be nonexistent), Vesuvius Gate, and Herculaneum Gate.

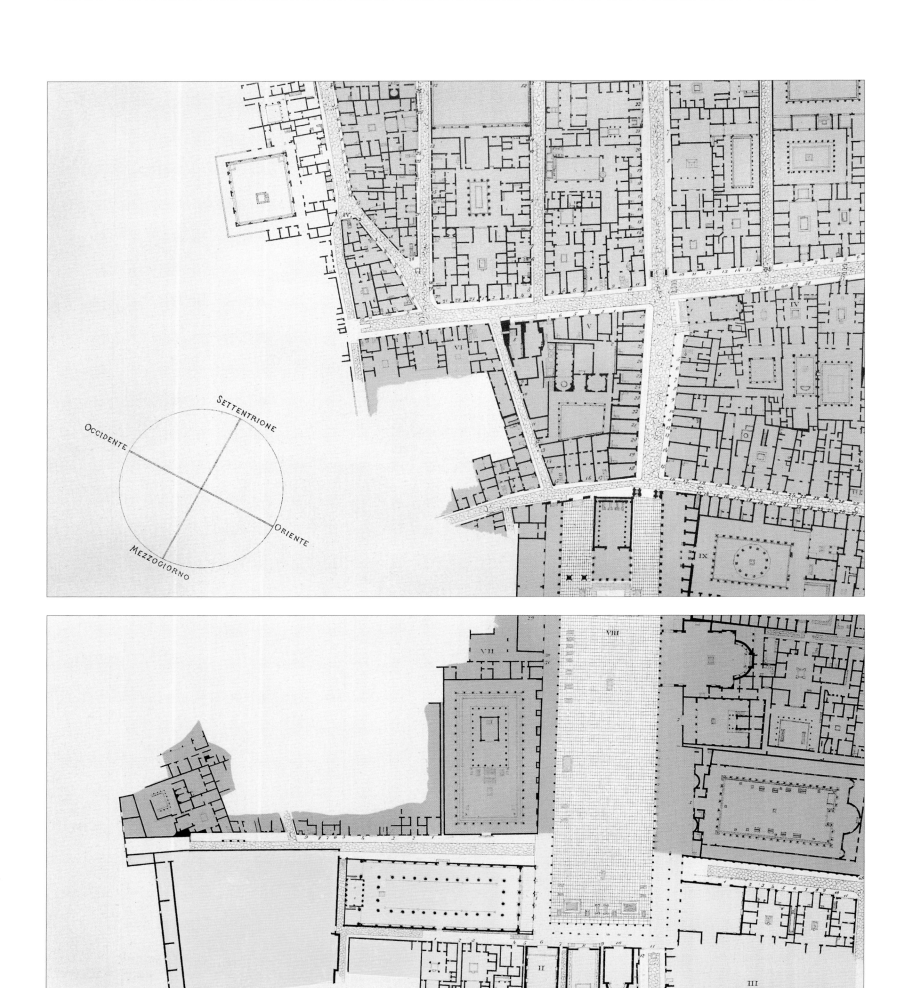

6. R. Sifo, *Map of the Forum Bath Area (Regions 6 and 7)*

7. R. Sifo, *Map of the Forum Area*

8. R. Sifo, *Map of the Region 6 Area*

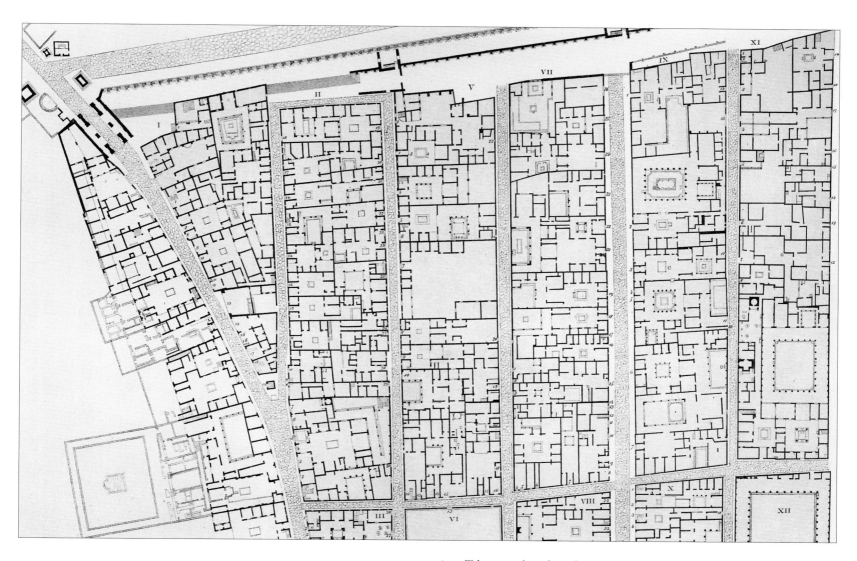

6–13. Taken together, these diagrams reproduce the extent of the city in detail, as it appeared in the mid-nineteenth century. Here the Niccolini brothers relied on the comprehensive projection of Pompeii that had been created by Giacomo Tascone, who had been given the task by Fiorelli.

According to the topographic reconstruction by Fiorelli, ancient Pompeii was divided into nine regions by four main streets. Each region was composed of blocks that were bordered and separated by other streets. However, excavations that were carried out from the second half of the nineteenth century up to the present day brought to light a city that was much more spacious than documented here, although these plates clearly mark the centers where the main public buildings were situated.

Today it is commonly accepted that the oldest part of the entire settlement revolved around the Pompeian Forum, which was hemmed in by four winding streets (Vicolo dei Soprastanti, Via degli Augustali, Vicolo del Lupanare, and Via dei Teatri). During the Roman era the city grew far beyond this original nucleus, yet always within the ample wall enclosure.

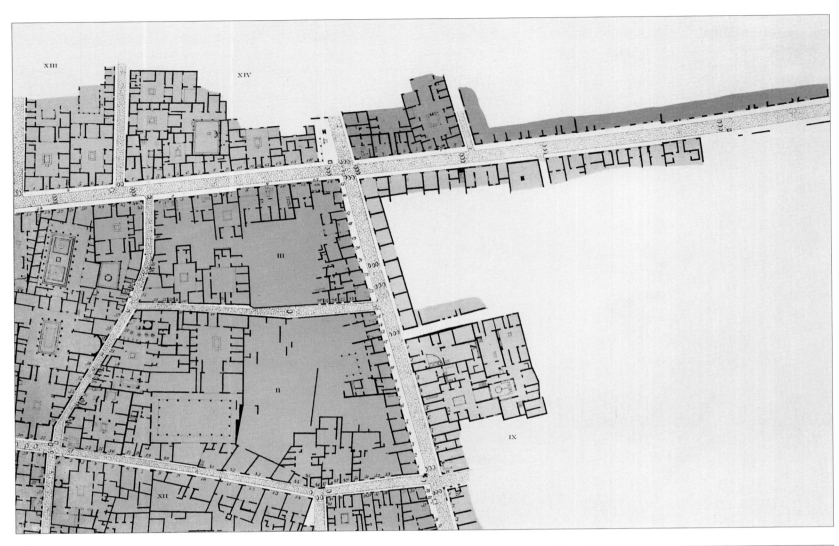

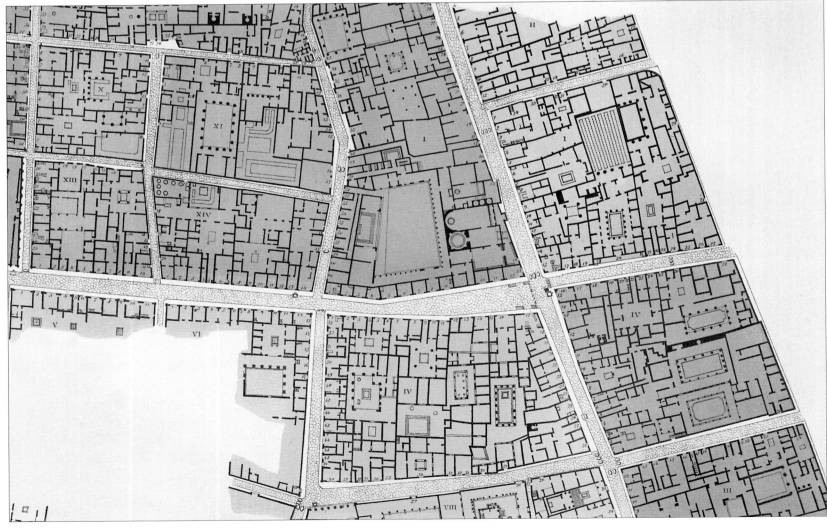

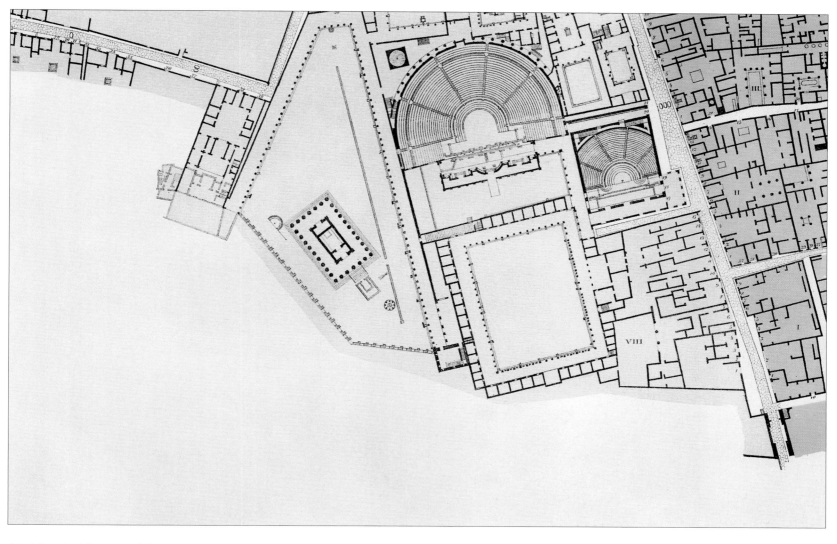

Top left 9. R. Sifo, *Map of the Area at the Crossroads Between Via di Stabia and Via di Nola*

Bottom left 10. V. Loria, *Map of the Stabian Bath Area*

Above 11. V. Loria, *Map of the Triangular Forum Area*

12. V. Loria, *Map of the Amphitheater Area*

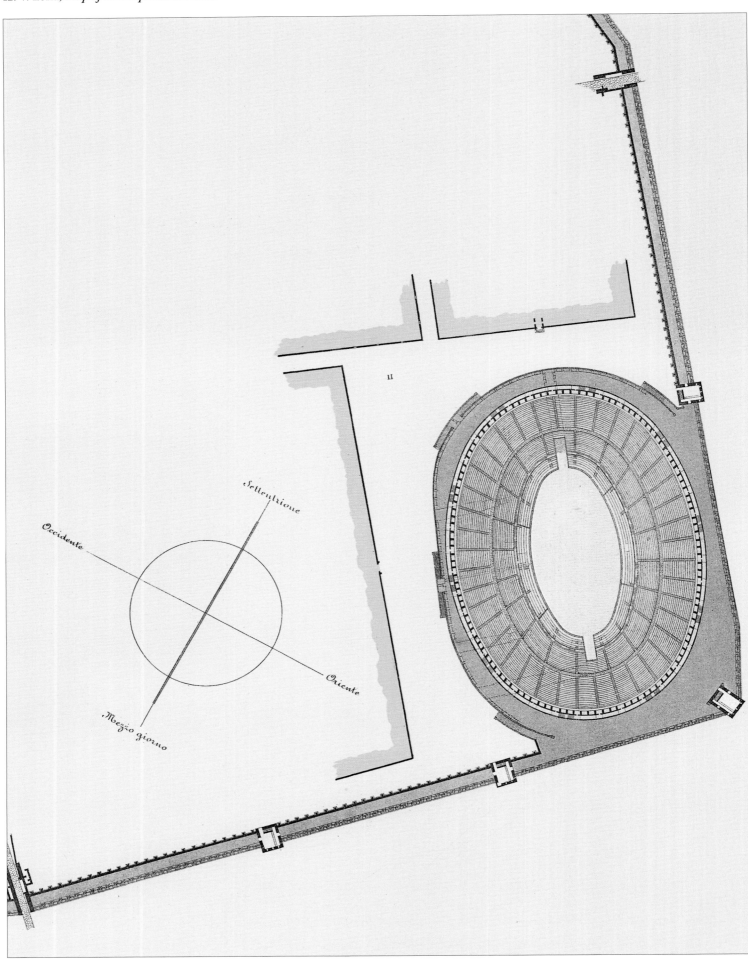

13. A. Carli, *Map of the Via dei Sepolcri Area*

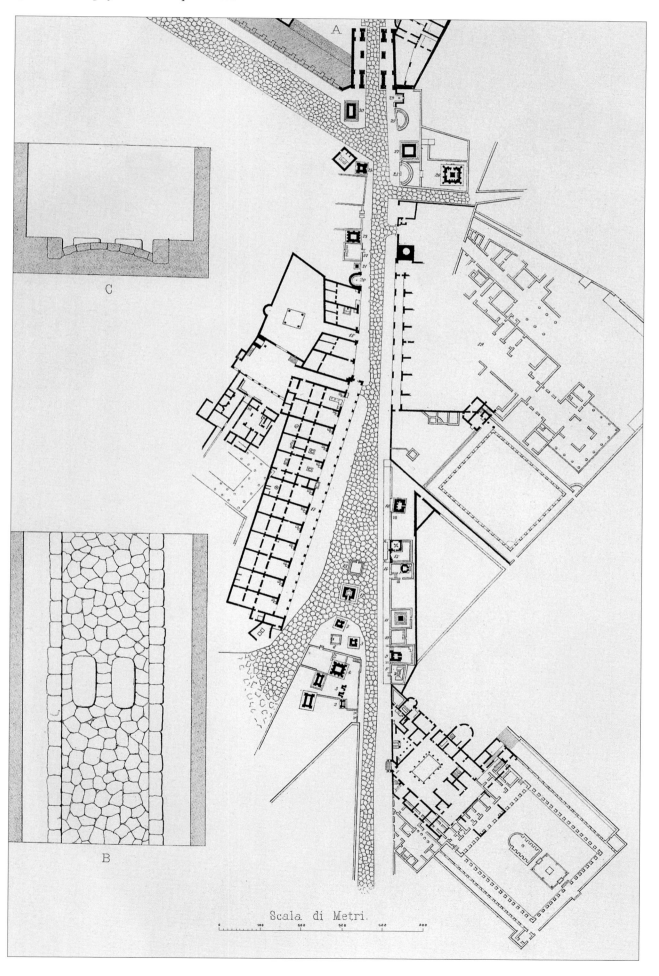

Scala di Metri.

PUBLIC AREAS

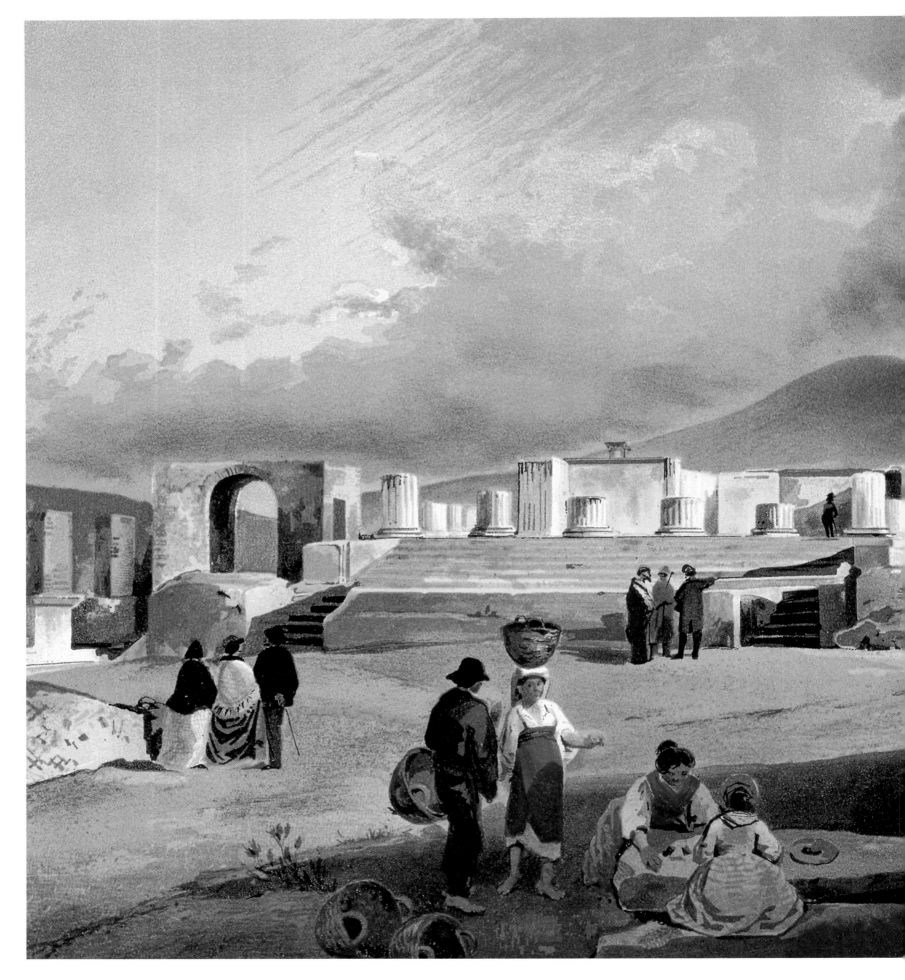

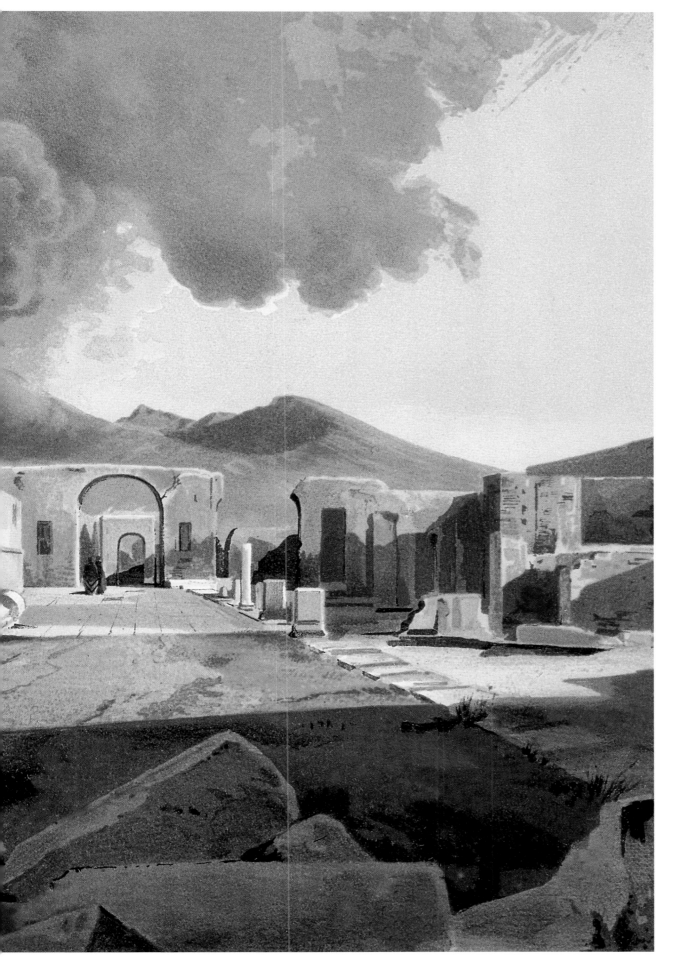

14. Giacinto Gigante, *View of the Forum and Temple of Jupiter* (VII, 8, 1)

14–15. The Pompeian Forum was the center of civil, religious, and commercial life in the city. Some of the most important public buildings of Pompeii faced the square: the Temple of Jupiter, the Treasury (*aerarium*), municipal buildings, the Comitium (assembly), the Basilica, the Eumachia Building, the Temple of Apollo, the Temple of Vespasian, the Public Sanctuary of the Lares (ghosts of the dead), and the provisions market (*macellum*). One of the most extensive bath complexes could be found a short distance away, the so-called Forum Baths (also called the Baths of Fortuna). Monuments to decorated citizens (such as the magistrate Quinto Sallustio) were also erected in the forum, as were honorary arches like one dedicated to Nero. The forum was created as a pedestrian area cordoned off from heavy traffic, as shown by the presence of the U-shaped portico that is higher than the surrounding streets (*left*). The rigidly rectangular shape of the forum is oriented north-south and was the result of restructuring that has been dated to around the end of the second century B.C.

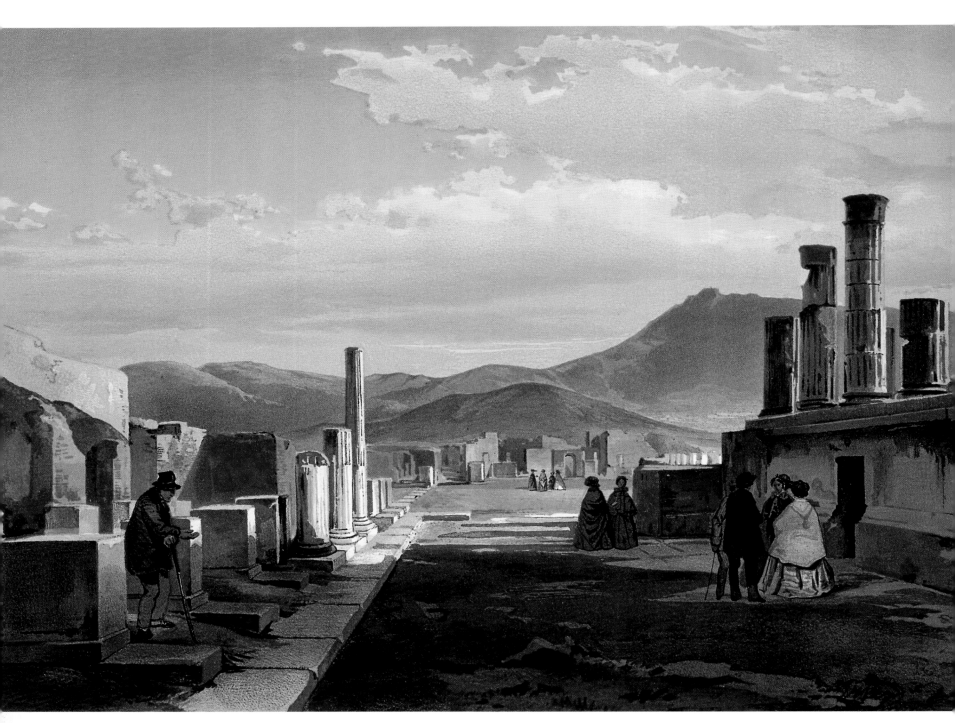

15. Giacinto Gigante, *View of the Forum* (VII, 8)

Opposite, top 16. G. Weidenmüller, *Diagram of the Macellum* (VII, 9, 7–8)
Archaeologists once mistakenly interpreted the twelve-sided structure that
takes up the center of this courtyard as a pantheon, as it was commonly called
in archaeological writing of the nineteenth century. In reality this was the
public provisions market. On the longitudinal axis in front of the entrance
was a tiny chapel.
Opposite, bottom 17. G. Weidenmüller, *Macellum Wall Fresco* (VII, 9, 7–8)

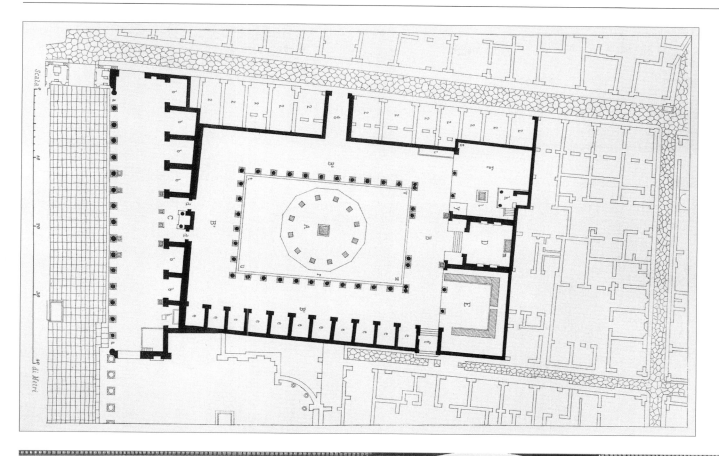

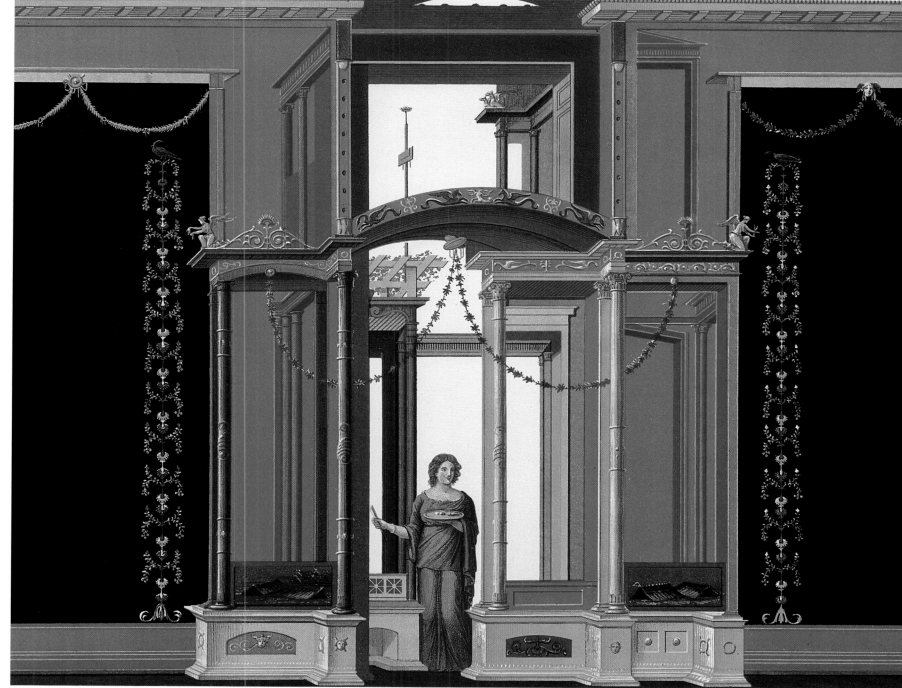

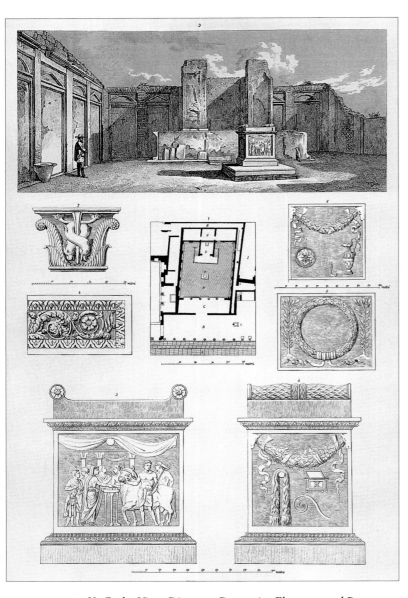

18. K. Grob, *View, Diagram, Decorative Elements, and Perspectives of the Altar at the Temple of Vespasian* **(VII, 9, 2)**
The so-called Temple of Vespasian—some have interpreted this as the Temple of the Genius of Augustus—is composed of a rectangular structure that opens onto the Pompeian Forum through a tiny atrium and colonnade. In the rear of one of the uncovered areas is a tabernacle on a high pedestal, where the ritual statue was found. In front of the cella, in the center of the courtyard, is an altar decorated with marble bas-reliefs. The main façade portrays a sacrifice being celebrated by a priest with his head covered; he is assisted by various others. In the nineteenth century the building was thought to be the Temple of Mercury.

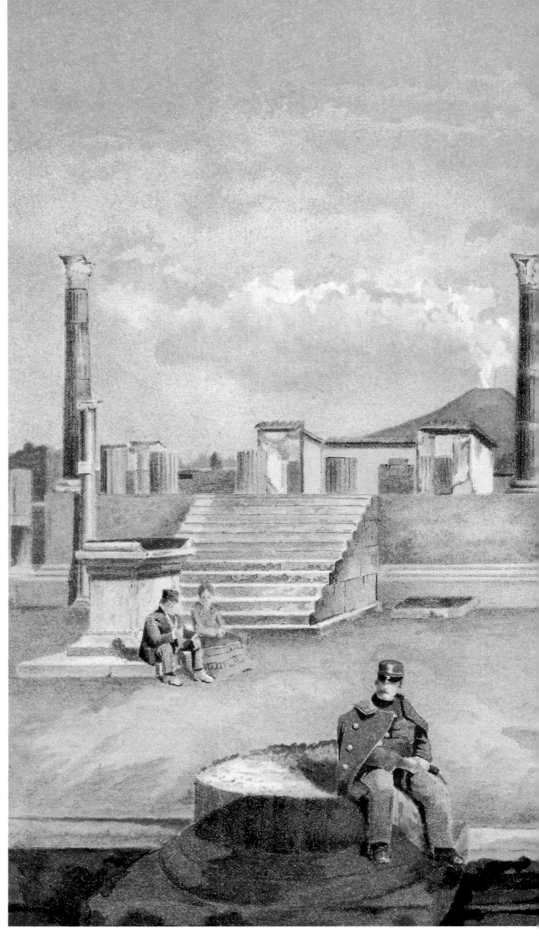

19. Vincenzo Loria, *View of the Temple of Apollo* (VII, 7, 32)
The Temple of Apollo rises within an elegant porticoed court-
yard. It was built in the sixth century B.C. and restored in the
second century B.C. The temple has a row of six columns pre-
ceded by an altar. A bronze statue of the god was situated inside
the peristyle. The sundial to the left of the stairs on a column
(*left*) was a gift of high-level municipal magistrates during the
Imperial period.

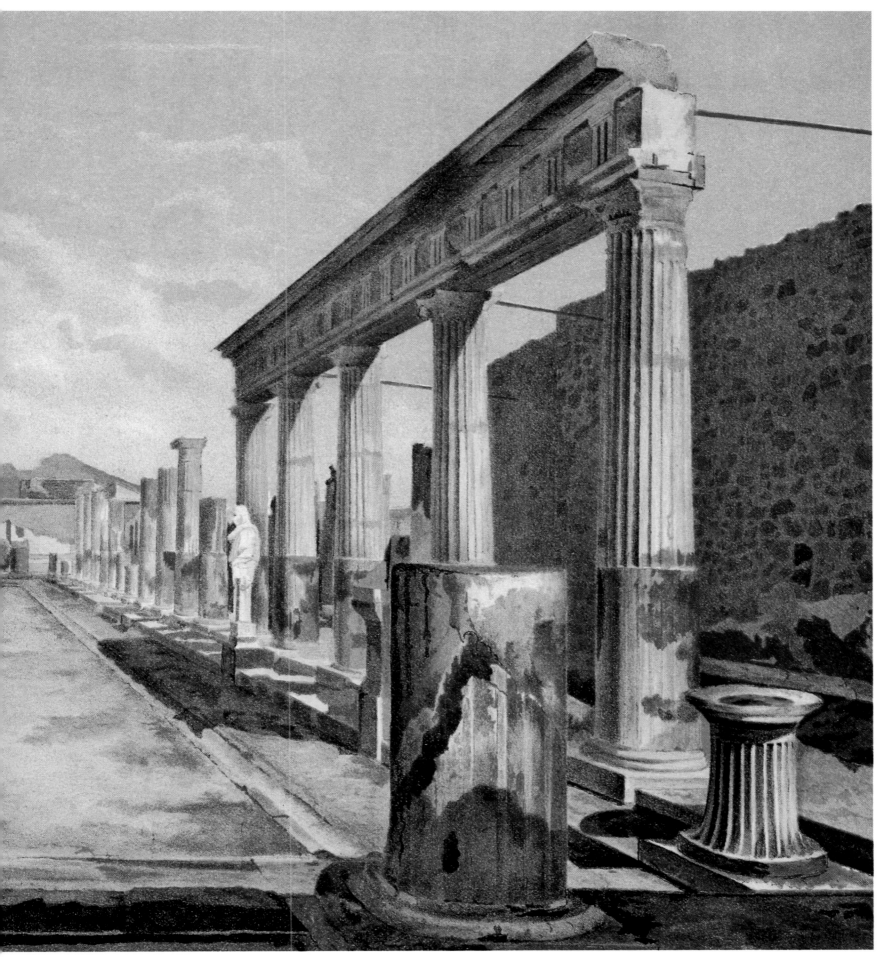

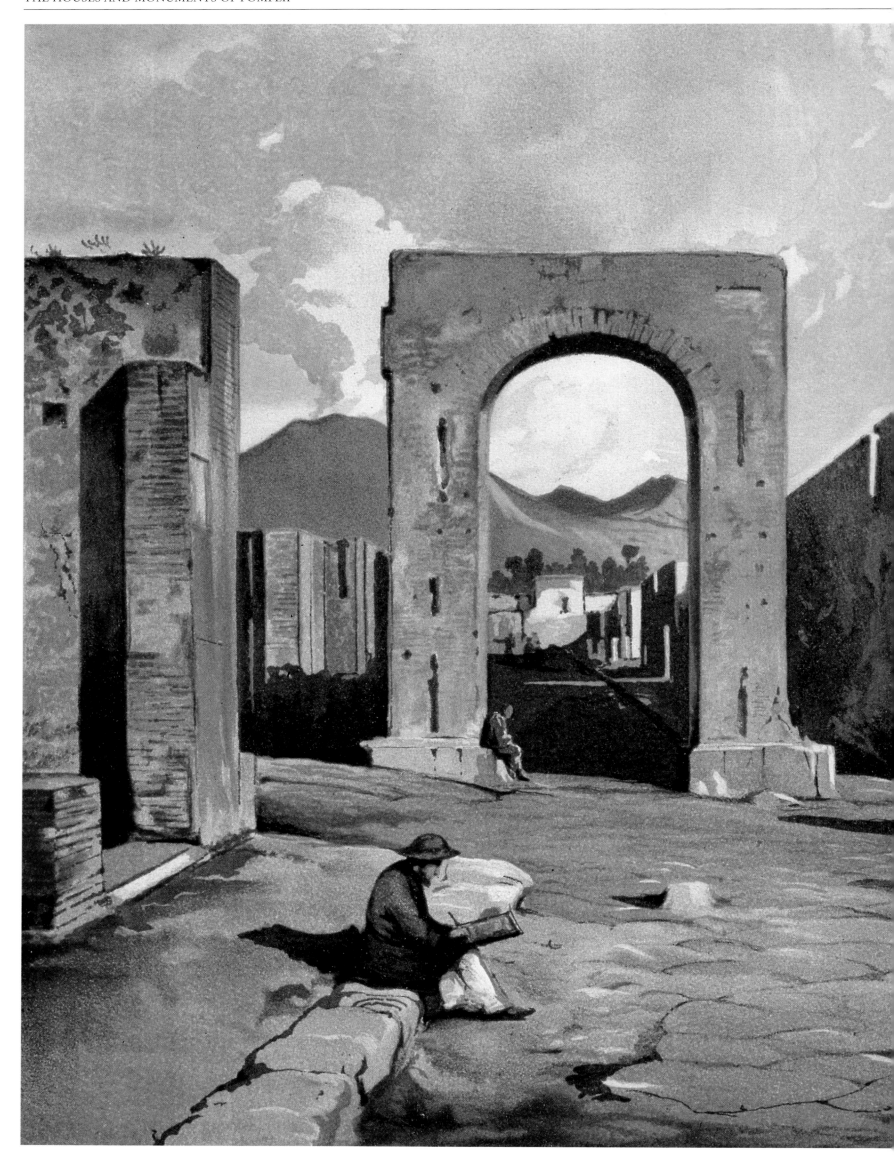

On the preceding pages: **20. Giacinto Gigante,** *View of the Temple of Fortuna Augusta and the Arch of Caligula*

This structure, which is called the Arch of Fortuna because of the nearby temple of the same name, rises at the crossroads of two important city thoroughfares. It introduced the setting of the innermost nucleus of the city and is here depicted with huge stairs adjacent. The arch is well-positioned on the axis of another honorary arch from the Temple of Jupiter (*left*). It defines an effective perspective sequence that seems to allude to other urban solutions in Rome, larger-scale experiments.

Right **21. L. Schioppa,** *Diagram and Architectural Details of the Temple of Fortuna Augusta* (VII, 4, 1)

Opposite, top **22. Giuseppe Abbate,** *Statues of High-Ranking Pompeian Celebrities in the Temple of Fortuna Augusta* (VII, 4, 1)

The Temple of Fortuna Augusta was built by Marcus Tullius on his own land. He was a prominent figure in Pompeii during the early Imperial period, as an inscription uncovered in the cella attests. The tetrastyle (four-pillared) temple had a portico on one side and stairs that were interrupted by a landing with an altar on it. The cella is rectangular with an apse, where the ritual statue of Fortuna could be found. Statues of four high-ranking celebrities, dedicated by ritual ministers, adorned four niches that were dispersed along the perimeter walls on each side of the apse. Two of these statues were uncovered at the beginning of the 1800s.

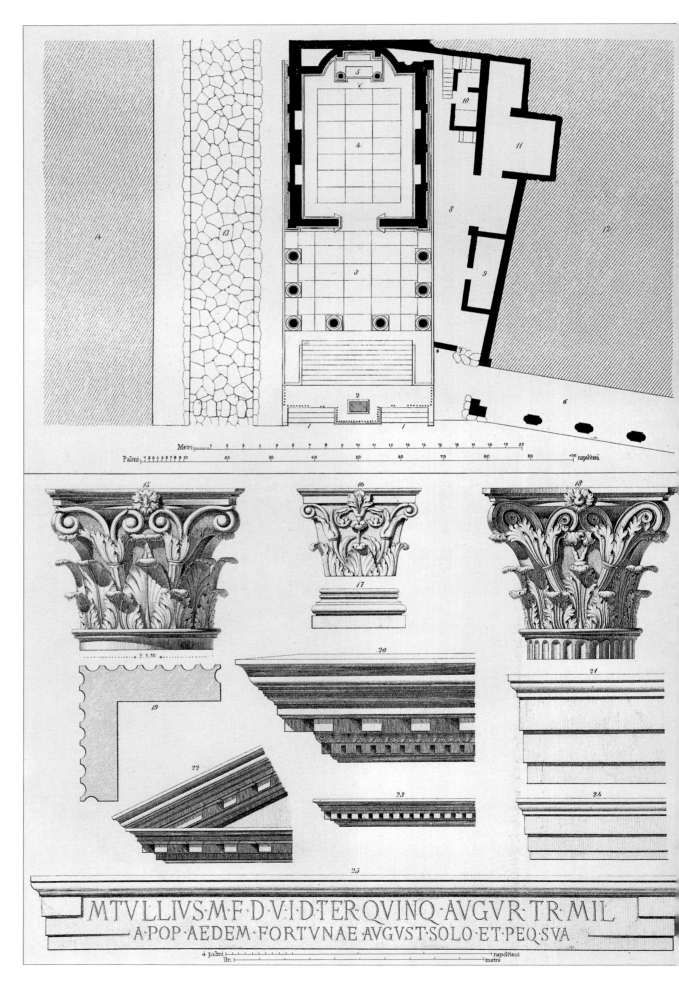

Right 23. A. Magliano and D. Capri, *Diagram and Cross Section of the Doric Temple in the Triangular Forum* (VIII, 7, 30)
The so-called Triangular Forum area is anything but a forum. It was a sanctuary area that was, of course, triangular, and it rose in a panoramic position at the southeast edge of the historical center, which had been occupied since the Archaic period (sixth century B.C.). The ancient sanctuary was the catalyst for an entire neighborhood around it, made up of a sacred area, temples, theaters, a gymnasium, and a large four-sided portico. The architectural characteristics of the temple are scarcely known, and its orientation follows the west (non-porticoed) side of the sacred area. Based on surviving elements, the temple was Doric with a single row of columns. Which divinity it was dedicated to remains uncertain, possibly Minerva and/or Hercules. In the plate the letters *A* and *B* indicate the spaces of the cella and vestibule that were reconstructed based on excavation samples, while the portions of the temple discovered in the nineteenth century are highlighted in red.

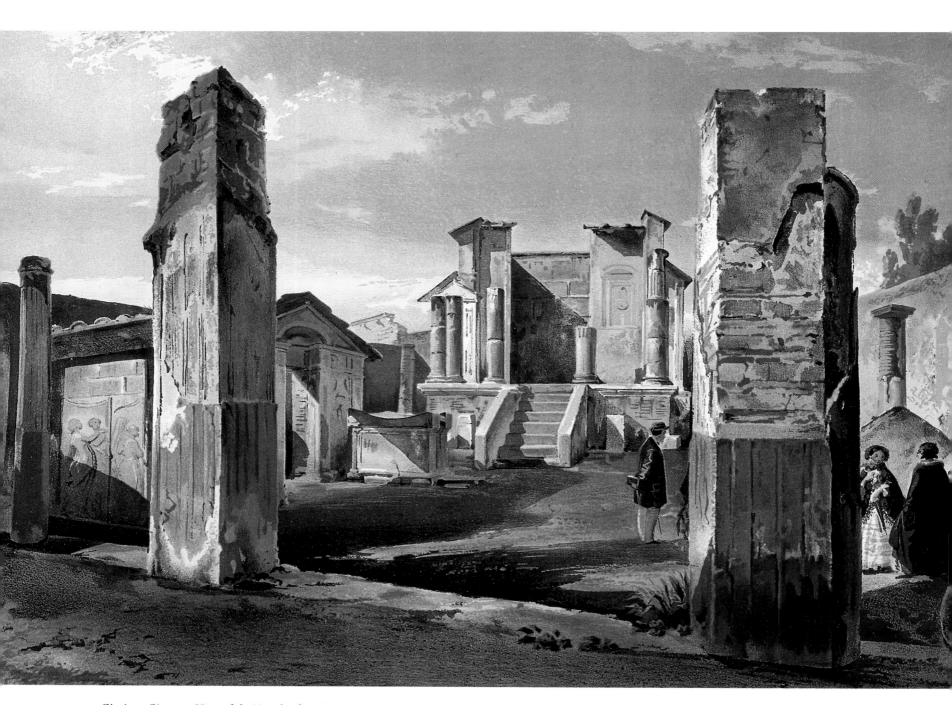

24. Giacinto Gigante, *View of the Temple of Isis* (VIII, 7, 28)

25. K. Grob, *Cross Sections of the Temple of Isis* (VIII, 7, 28)

24–29. One of the most unique religious buildings of the city was located behind the Large Theater. In Rome worship of Egyptian deities was officially introduced in 44 B.C., when triumvirates built the temples of Serapis and Isis after Caesar's death. In Pompeii, the Temple of Isis existed before the earthquake of A.D. 62 and was rebuilt by private funds afterwards. The building is located at the center of a colonnaded courtyard and is somewhat unusual, with an antechamber with four columns in front and two on each side. A hall where the faithful met opens up behind the cella. Two niches with tympanums can be found on each side of the front. Other small buildings that were used for worship were dispersed throughout the courtyard, such as the so-called *purgatorium*, where holy water of the Nile was kept for purification ceremonies. The worship of Isis was especially widespread in Pompeii, as shown by numerous domestic altars that were uncovered inside important residences such as the Villa of Julia Felix or the House of the Gilded Cupids. The discovery of this Iseum at the end of the eighteenth century held great significance for European culture.

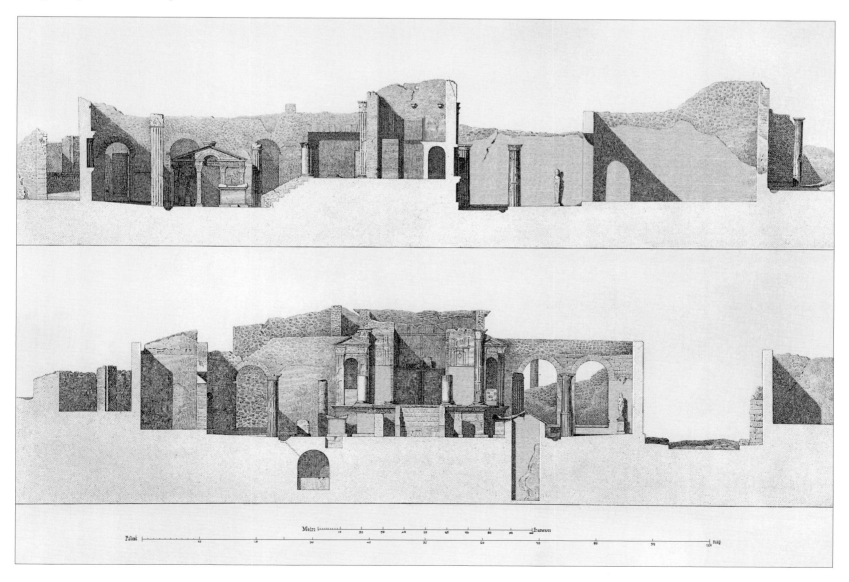

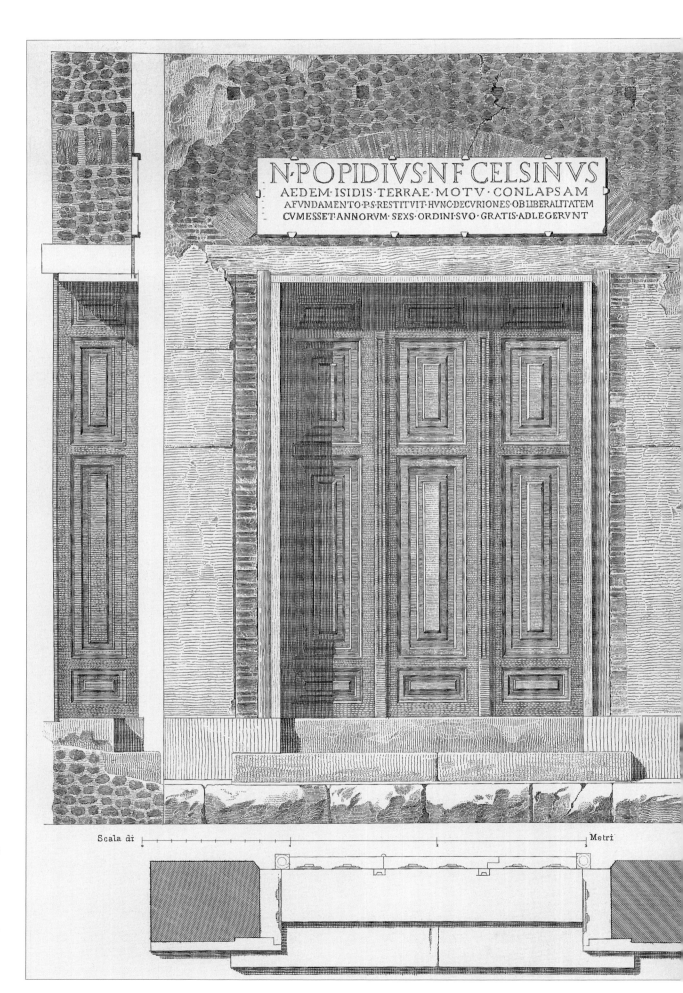

26. K. Grob, *Entry Door to the Temple of Isis* (VIII, 7, 28)

The dedication inscription on the architrave records the name of the rich freed slave N. Popidius Ampliatus. He financed the restructuring of the building to favor his young son Celsinus, who was admitted as a member of the citizens' council as a result.

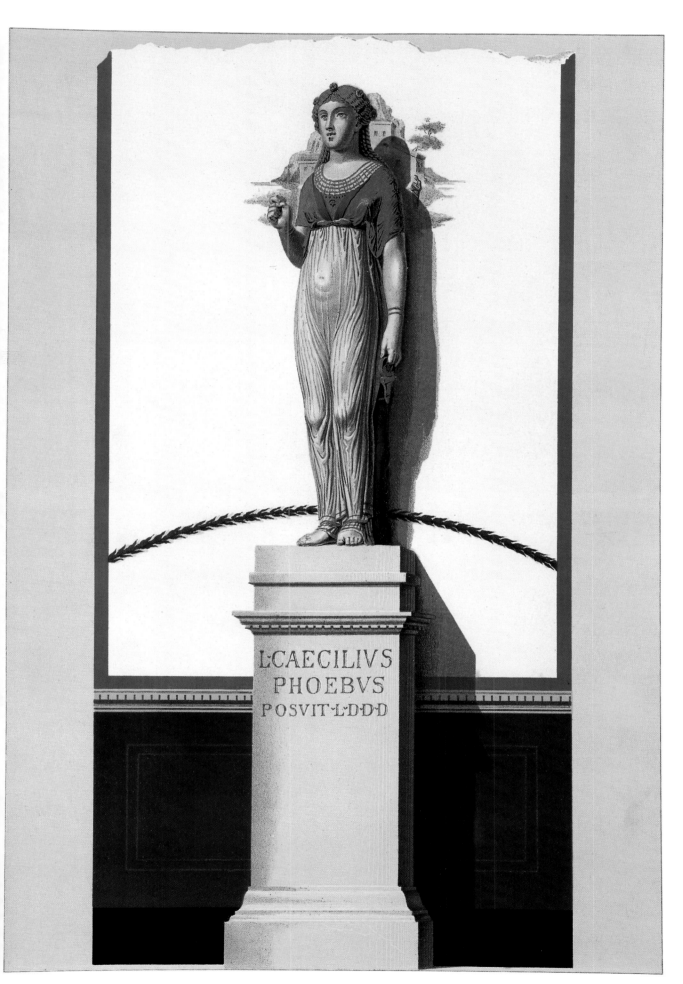

27. K. Grob, *Statue of Isis Dedicated to Lucius Cecilius Febus in the Temple of Isis* (VIII, 7, 28)
This is an image of the goddess represented in an Archaic style. It was placed in the covered area in the west corner of the portico, a place designated by the citizens' council. In fact, the epigraphic abbreviation LDDD can be seen, which stands for *locus datus decreto decurionum* (this place has been given by a decurion decree).

28. Giacinto Gigante, *Frescoes of Naval Battles from the Temple of Isis* (VIII, 7, 28)
The walls of the portico held small pictures of various images of Egyptian influence. These include these naval battle scenes, which took place in view of coasts that held lavish, charming villas.

29. Giuseppe Abbate, *Fresco with Filled-Vine Designs in the Temple of Isis* (VIII, 7, 28)
Above, the central portion of the frieze from the portico wall, where an acanthus shrub originates the scrolling vines. A pygmy is seated on the shrub holding a sistrum and an offering basin between two ibises. The vines shown here hold a bull, a lion, and a racing horse.

32–38. The Stabian Baths—the oldest thermal bath complex of the city—were achieved during the Samnite period in the late second century B.C., although they were rebuilt in later eras. Three main areas are distributed around the central courtyard, which was used for exercise and bordered by an elegant portico. These areas were the public baths themselves, a group of private baths, and spaces for health activities organized around a great open pool. The public baths were located in the eastern wing and contained two separate areas for women and men, divided by a device that provided heat (*praefurnium*). Each side included the usual system in Roman baths: two areas of different temperature (*tepidarium* and *calidarium*) with a changing room (*apodyterium*). On the men's side, there was also an area used for cold-water immersions (*frigidarium*). Before sophisticated heating systems using circulating steam were developed, these areas were heated using bronze braziers, such as one uncovered in the *tepidarium* of the Forum Baths (32a).

33. Giuseppe Abbate, *Frescoes of the Peristyle at the Stabian Baths; Sundial with Oscan Inscriptions* (VII, 1, 8)

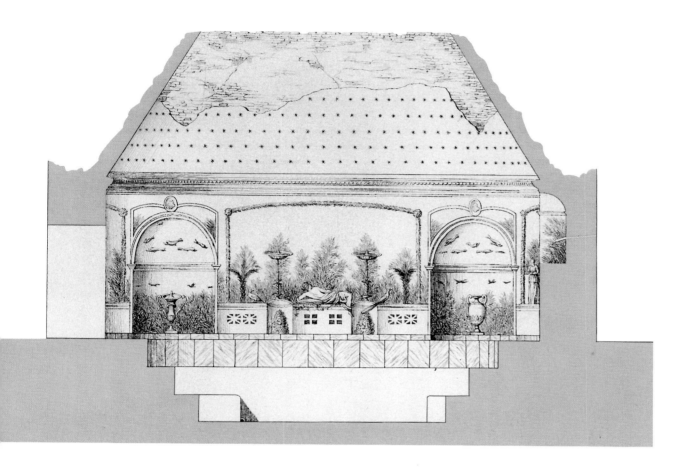

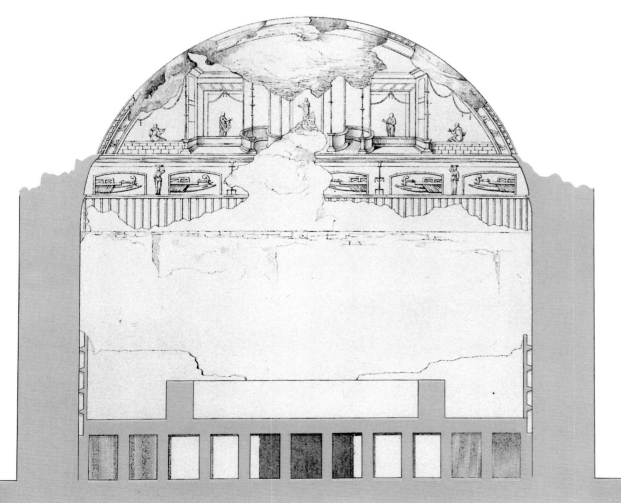

34. Giuseppe Abbate, *Cross Sections
of the Stabian Baths* (VII, 1, 8)

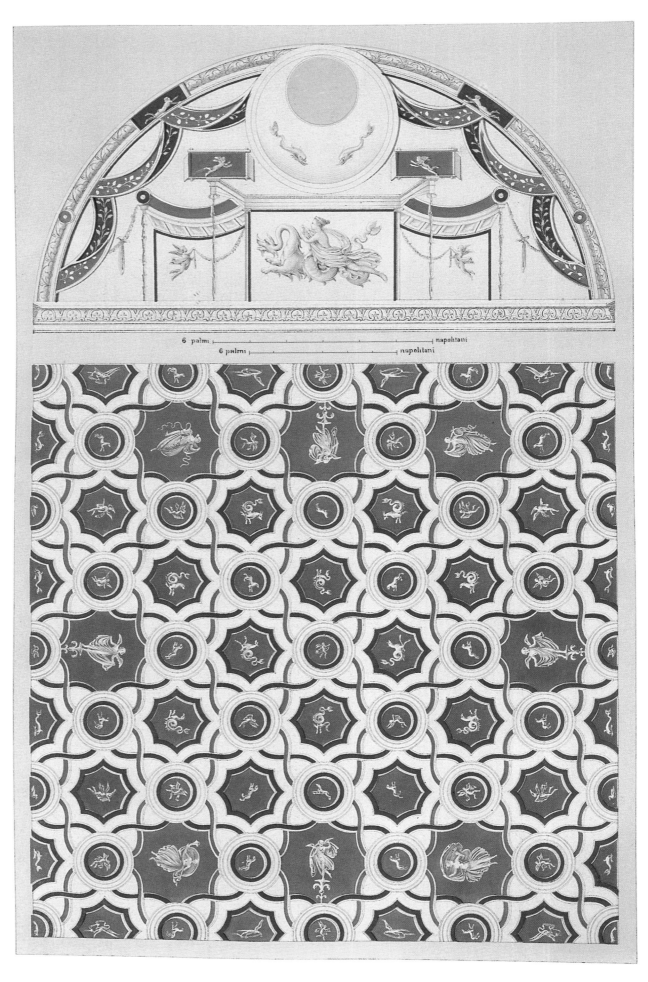

35. Giuseppe Abbate, *Entrance Hall Vault of the Apodyterium and Lunette in the Stabian Baths* (VII, 1, 8)

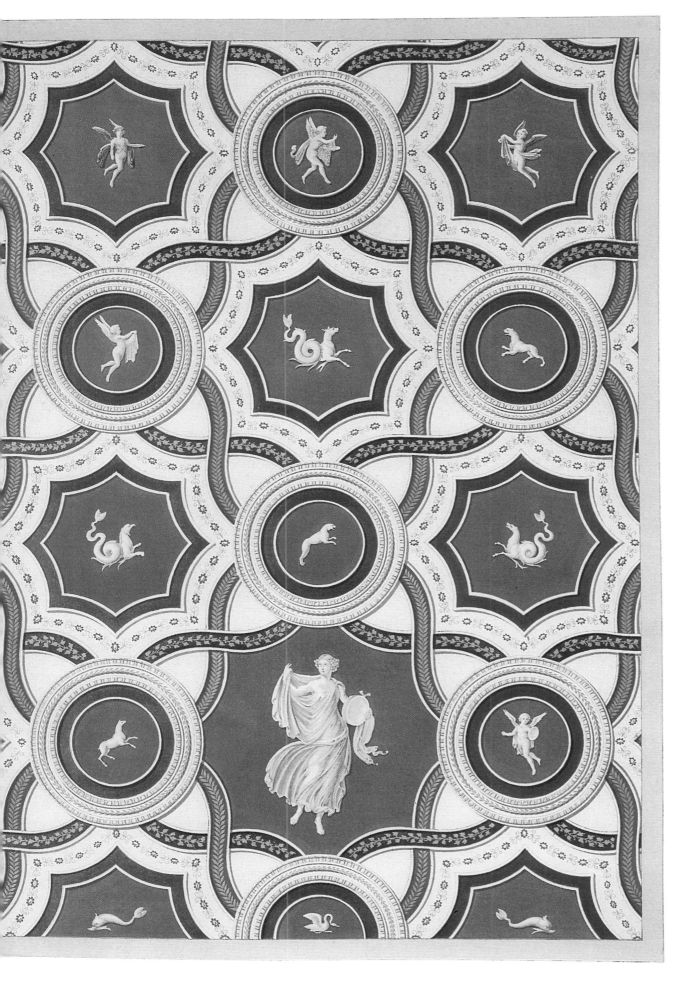

36. Giuseppe Abbate, *Detail of the Entrance Hall Vault of the Apodyterium at the Stabian Baths* (VII, 1, 8)

On the following pages:
Left 37. Giuseppe Abbate, *Frigidarium Interior, Fresco from the East Wall of the Stabian Baths* (VII, 1, 8)

Right 38. Giuseppe Abbate, *Fresco from the West Wall Peristyle of the Stabian Baths* (VII, 1, 8)

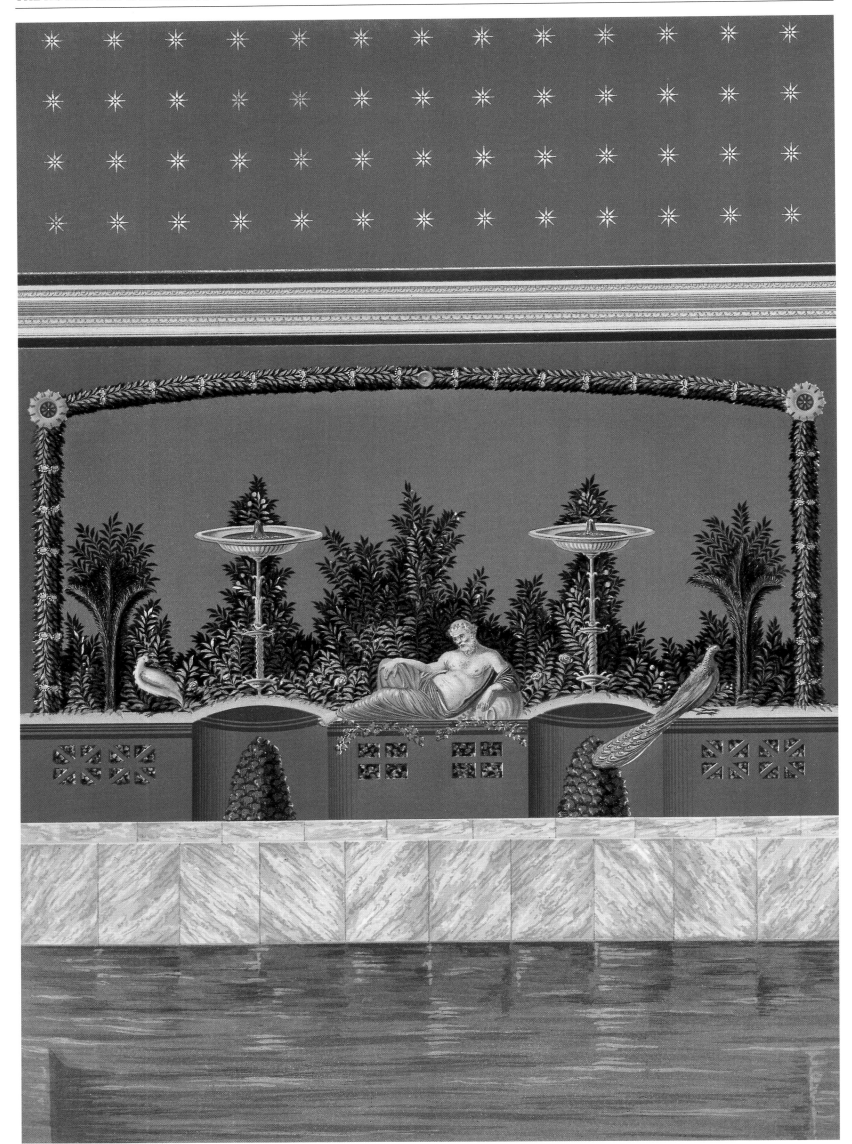

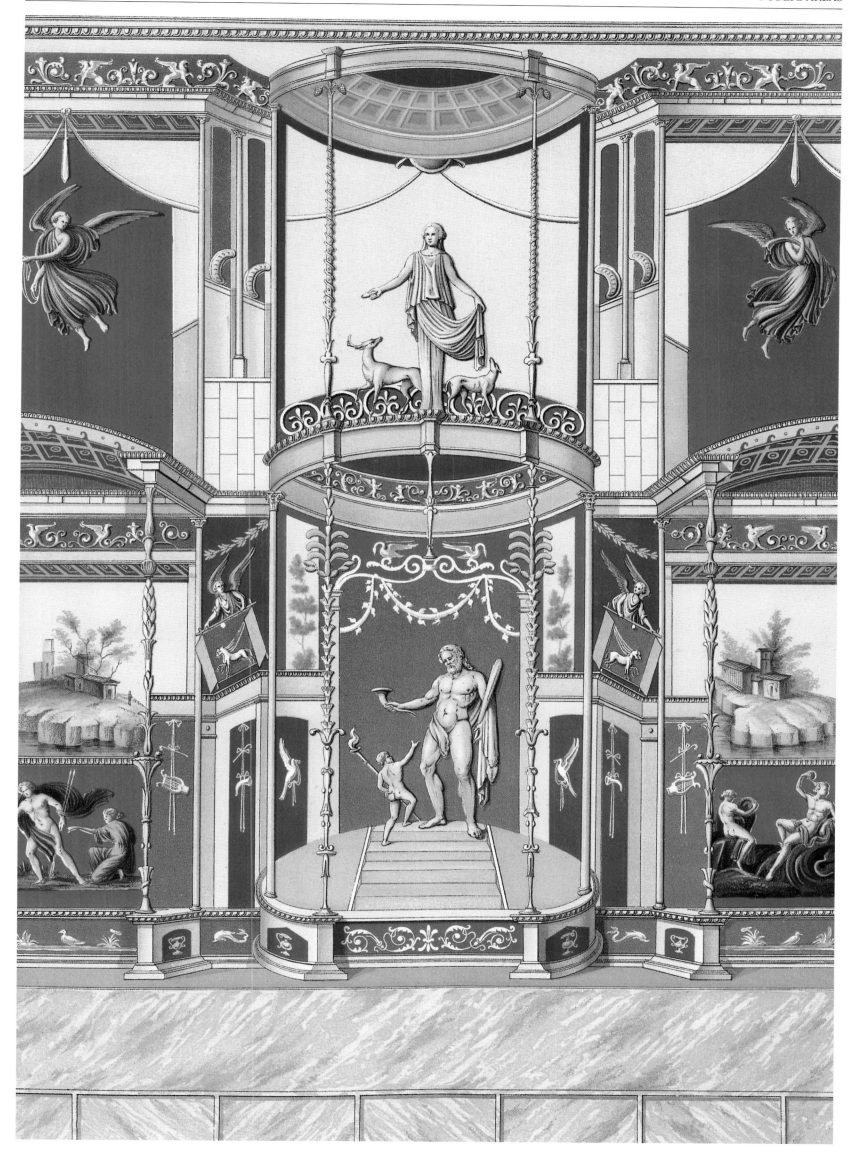

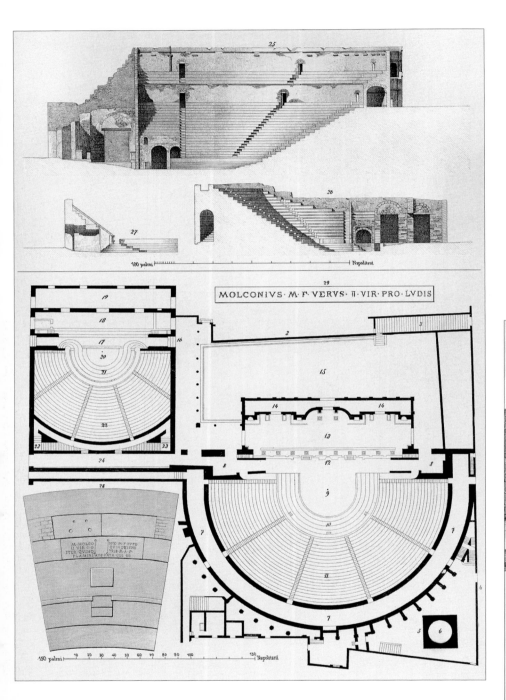

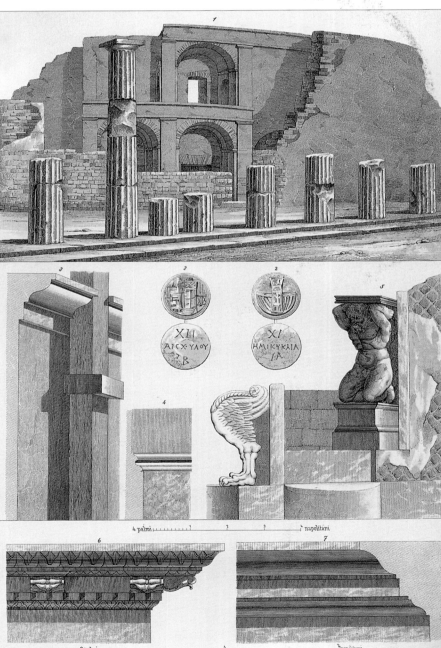

Left **39.** G. Frauenfelder, *Theater Cross Sections and Diagrams with Details of the Steps Where Names of Municipal Magistrates Appear*

Below **40.** Giuseppe Abbate, *View and Decorative Details of the Theater*

39–40. The presence of a natural slope used for the seating tiers (*cavea*) must certainly have influenced the choice of a site for the Large Theater, which was built in the Hellenistic period (second century B.C.). This was adapted to Roman theatrical architecture during the Augustan period thanks to the initiatives of Marcus Holconius Rufus and Marcus Holconius Celerus, who financed the construction of the upper part of the seating tiers (*summa cavea*) and the passageway beneath them (*crypta*). This modernization also included new stone facing inside the building, and this type of architecture matched Vitruvius's theories.

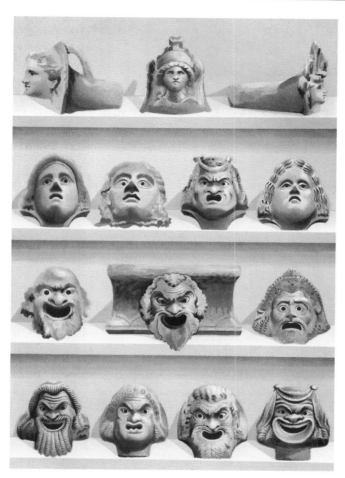

Left 41. Vincenzo Loria, *Terra-Cotta Ornamentation (Mostly Theatrical Masks)*

Below 42. Teodoro Duclère, *View of the Small Theater Interior* (VIII, 7, 19)

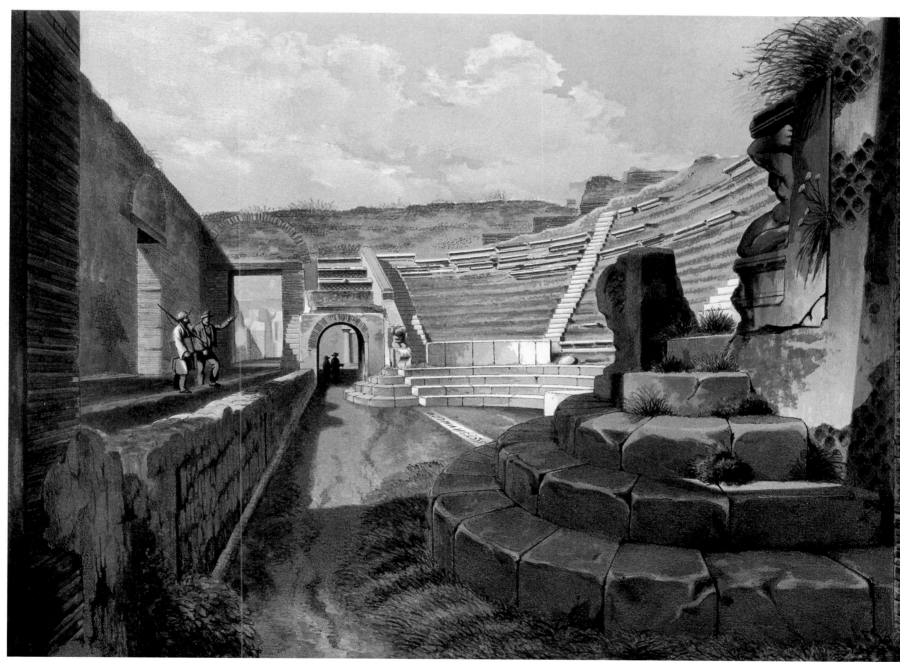

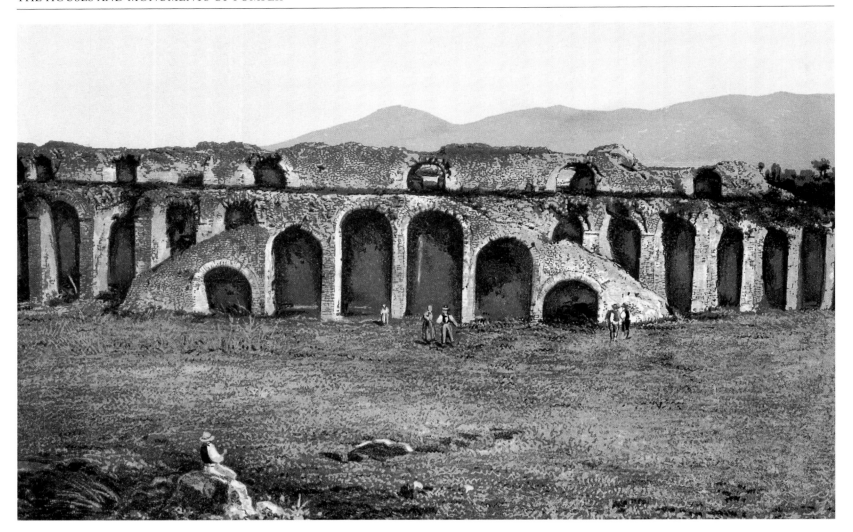

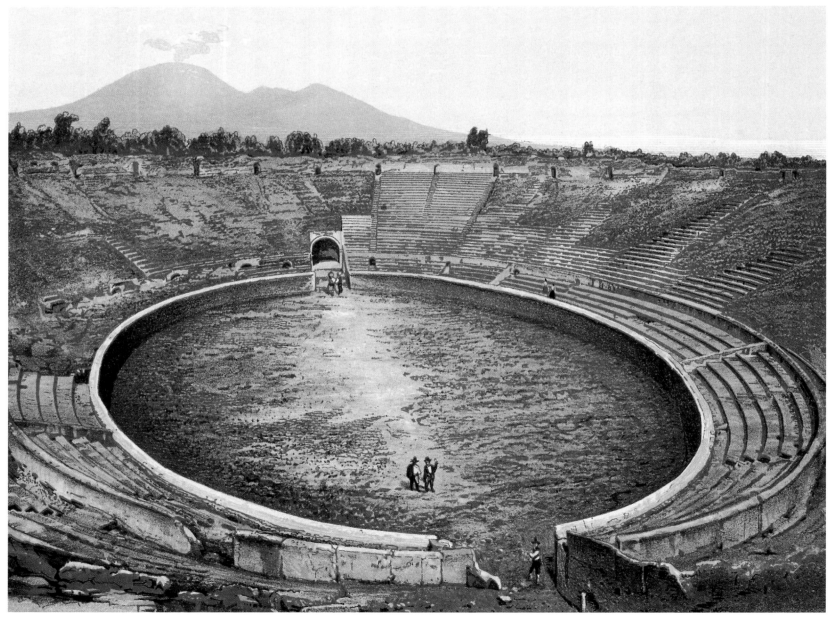

Opposite, top **43.** C. Weidenmüller, *Exterior View of the Amphitheater* (II, 6)

Opposite, bottom **44.** C. Weidenmüller, *Interior View of the Amphitheater* (II, 6)

Below **45.** I. Müsli, *Amphitheater Diagram* (II, 6)

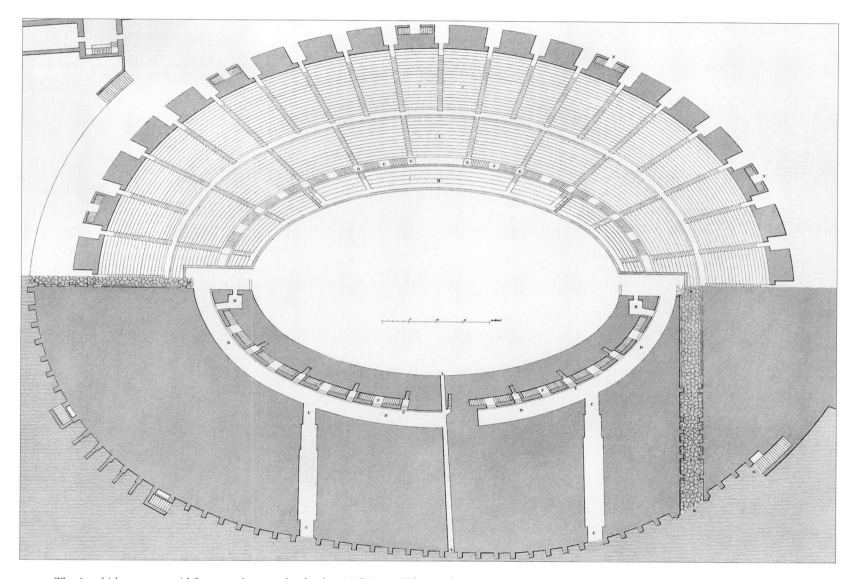

43–45. The Amphitheater was paid for around 70 B.C. by the duoviri Quintus Valgus and
Marcus Porcius, who had given the Small Theater (*Theatrum tectum*) to the city just a few
years before. The Amphitheater has been cited in inscriptions with the names of the games
(*spectacula*) that were held there. It occupied the southeast corner of the city walls, almost at
the extreme opposite of the city's historic center, and is one of the oldest amphitheaters surviv-
ing. Here its paneled shape alternates with other structures that were widespread in the Roman
world: complex systems of foundation walls and underground chambers.

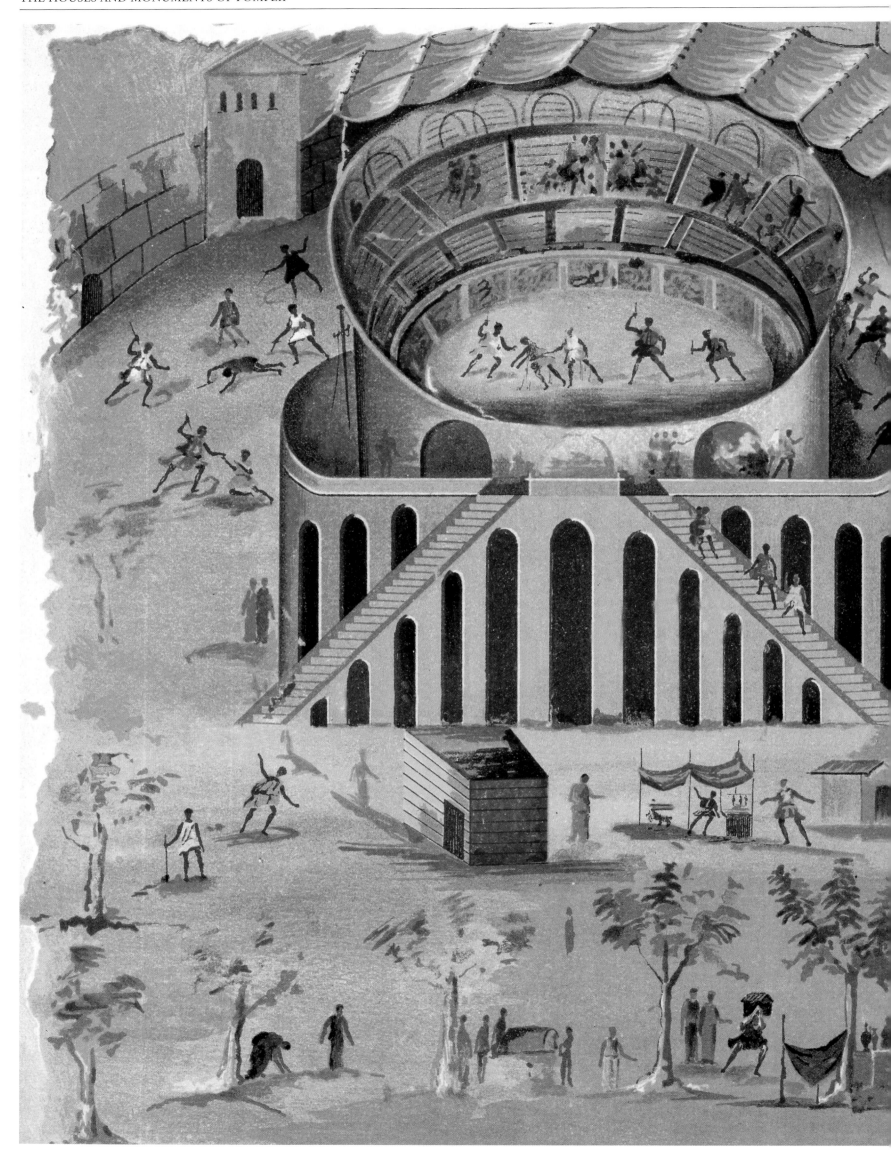

DIVCRETIOHTCH

46. Vincenzo Loria, *Fresco Portraying the Famous Brawl Between the Pompeians and the Nucerians in the Amphitheater Discovered in the House of the Gladiator Actius Anicetus* **(I, 3, 23)**
The bloody riot that occurred between the Pompeians and Nucerians in A.D. 59 happened during a gladiator show in the amphitheater and resulted badly for the guest fans. The episode is referred to by Tacitus and forced the authorities to close the amphitheater for ten years. This fresco re-creates the interior of the amphitheater during the shows in a lively manner, including the surrounding squares that were frequented by strolling vendors.

PRIVATE BUILDINGS AND DECORATIONS

Right 47. G. Frauenfelder, *Diagrams, Columns, and Capital with Figurative Ornamentation in the House of Ariadne, or House of the Colored Capitals* (VII, 4, 31)

Opposite 48. Giacinto Gigante, *Interior View of the House of Ariadne, or House of the Colored Capitals* (VII, 4, 31)

47–49. The entrance to the residence, now better known as the House of Ariadne, only opens onto narrow Via degli Augustali. However, a small, porticoed courtyard (*xystus*) is accessible from Via della Fortuna and is cheered by flowerbeds. In longitudinal order, the large peristyle with Ionic columns follows, then the tablinum, and finally the atrium. The capitals from the peristyle already existed in the Samnite era and were later covered with stucco and painted with multi-color decorations, a detail that inspired the building's name.

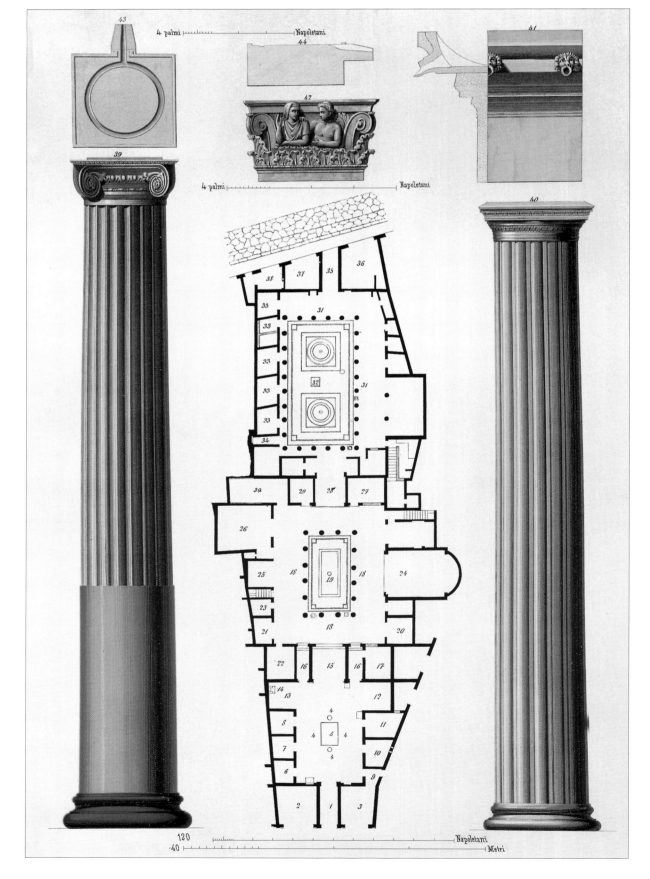

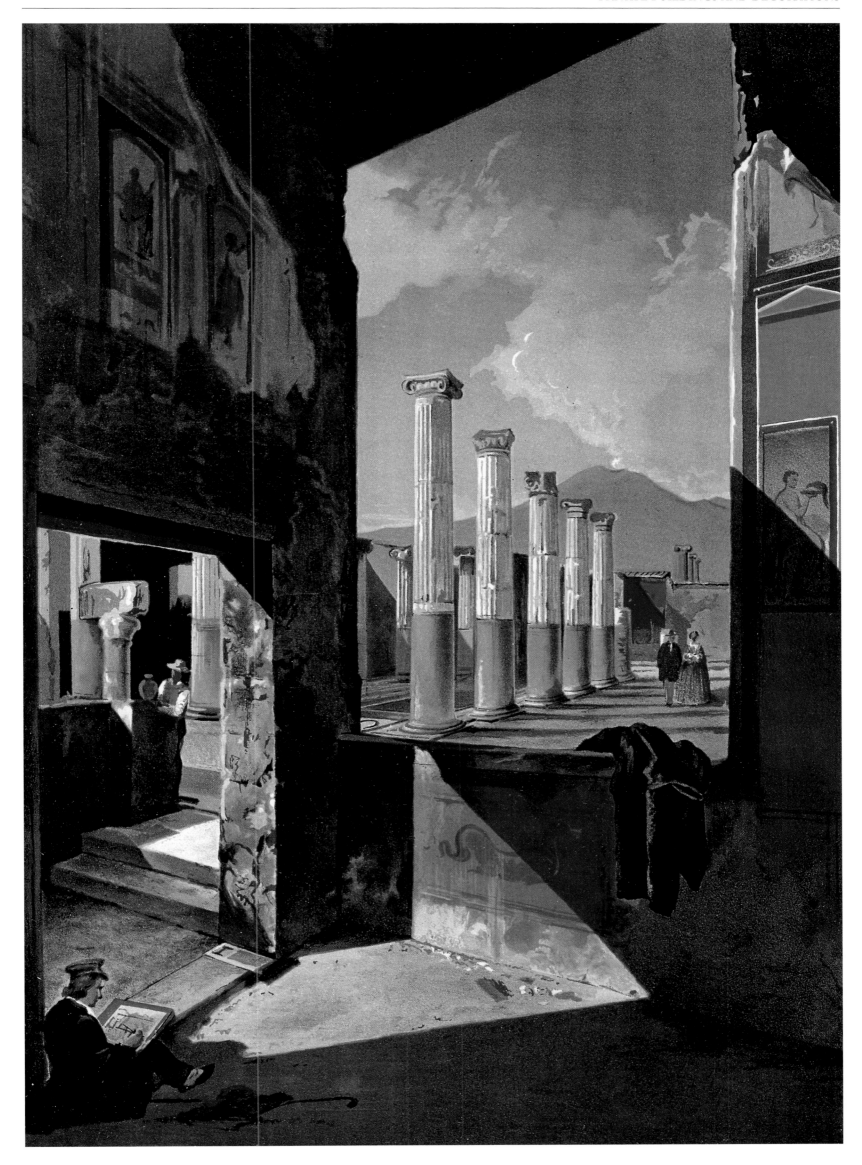

Below **49.** Giuseppe Abbate, *Fresco Portraying Galatea at the House of Ariadne, or House of the Colored Capitals* (VII, 4, 31)

Below **50.** Giuseppe Abbate, *Diagram, Pavement Inscription, and Other Uncovered Materials from the House of P. Vedius Siricus* (VII, 1, 25)

Opposite **51.** Giuseppe Abbate, *Frescoed Wall with a Picture of Aeneas Wounded* (VII, 1, 25)

50–54. The House of P. Vedius Siricus was a large city residence made up of two nuclei with Tuscan atria. The Niccolinis originally understood these as two separate houses, the House of Siricus (VII, 1, 25) and House No. 57 on Strada Stabiana (VII, 1, 47). In contrast, a seal and other wall graffiti uncovered inside the house attribute the entire property to the magistrate P. Vedius Siricus. The pavement at the entrance from Vicolo Lupanare reads *Salve lucru(m)*, or "Greetings, profits!"

Below 52. Giuseppe Abbate, *Diagram and Ornamental Details from the House of P. Vedius Siricus* (VII, 1, 47)

Opposite 53. Giuseppe Abbate, *Armed Victory in Flight; Frieze Portraying Goats from the House of P. Vedius Siricus* (VII, 1, 47)

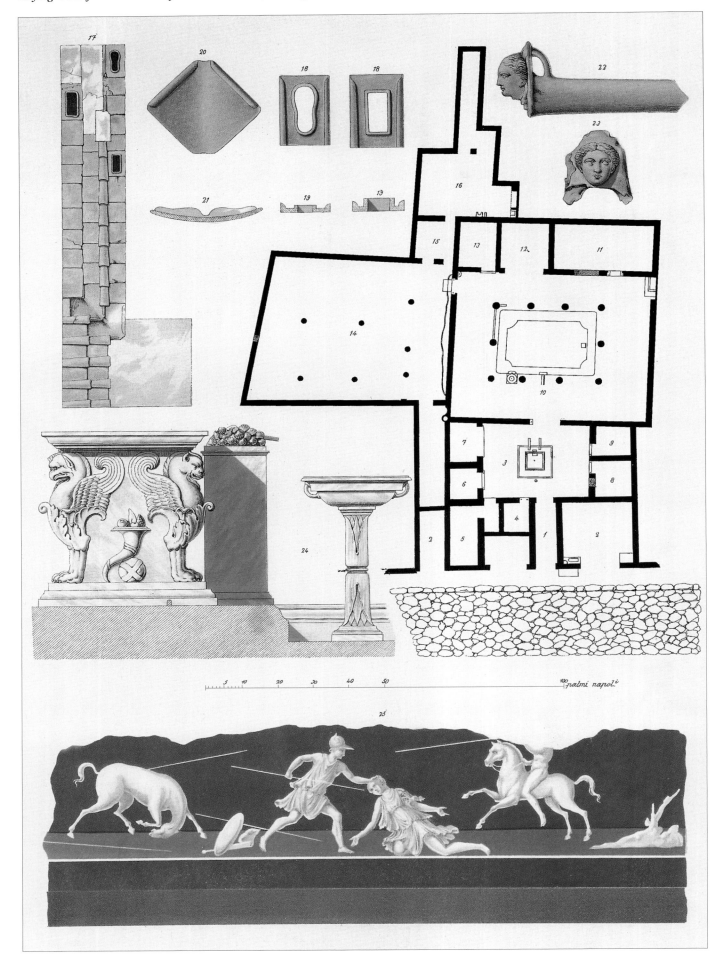

54. Giuseppe Abbate, *Decorative Motifs from a Fresco at the House of P. Vedius Siricus* (VII, 1, 47)

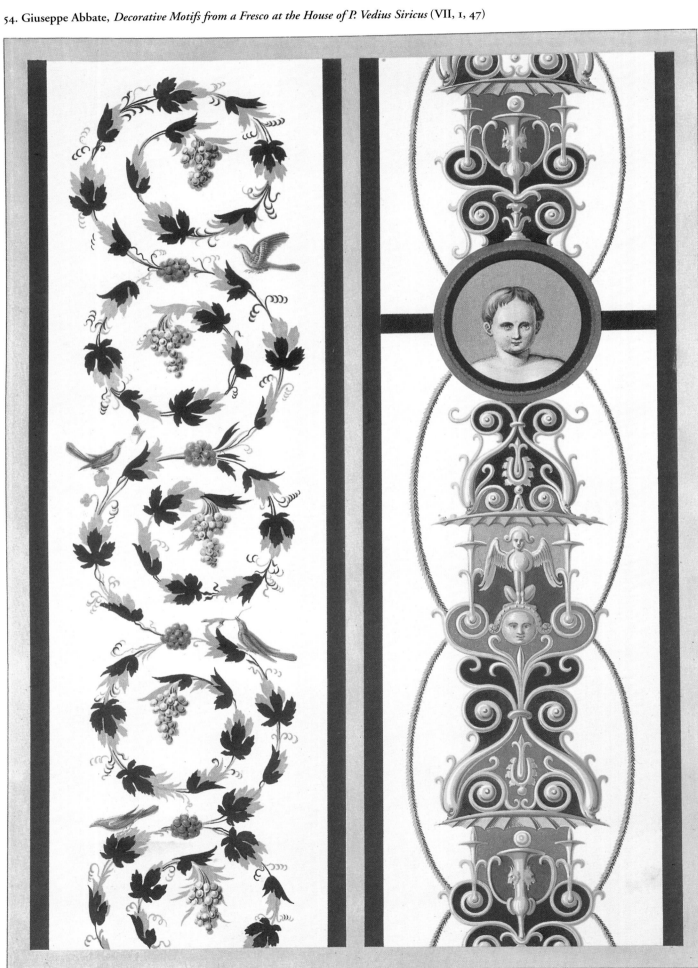

55. F. Tessitore, *Diagram, Capitals, and Other Decorative Elements from the House of the Sculpted Capitals* (VII, 4, 57)
This elegant house dates to the Samnite period and owes its name to the capitals that decorate its entrance. The sides facing the street portray two couples, each a satyr and a maenad, while the interior side holds two couples that participate in a sympo-sium in an amorous pose. These last two have been theoretically interpreted as the owners of the building. More generally, the entire series has been reread as a Dionysian portrayal. In fact, the entire residence reflects an inspiration from Hellenistic models, as the pergola and sundial in the garden show.

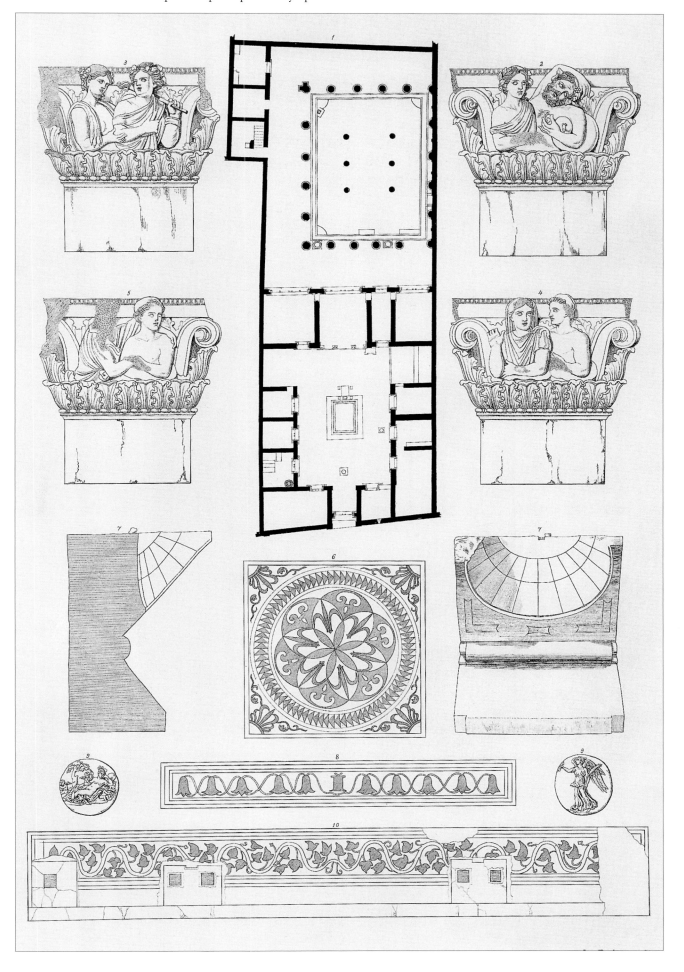

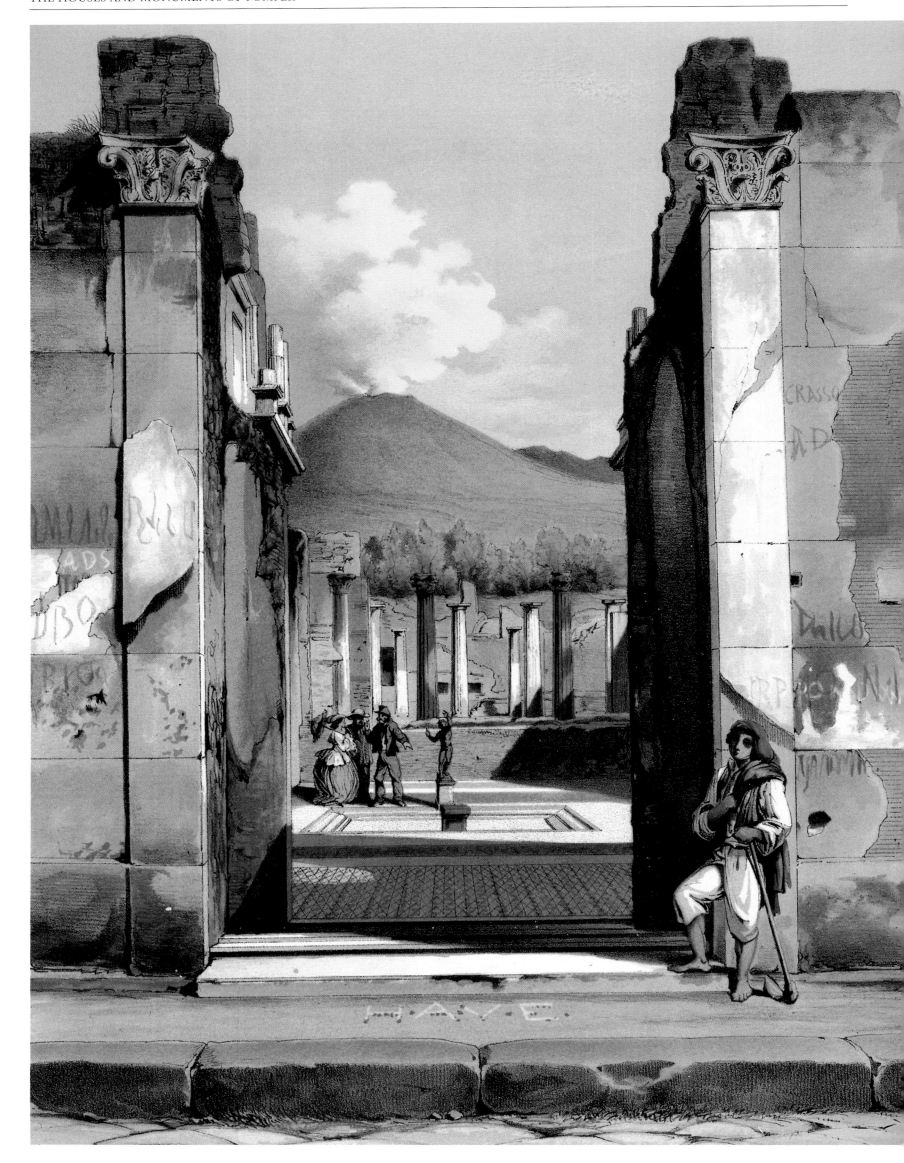

Opposite 56. Teodoro Duclère, *View of the House of the Faun* (VI, 12, 2)

Below 57. **Fausto Niccolini and Felice Niccolini,** *Diagram and Details of the House of the Faun* (VI, 12, 2)

56–62. The House of the Faun was a luxurious private city residence and is perhaps the most famous among the historical buildings of Hellenistic Pompeii. It was discovered in 1831 with numerous furnishings and the celebrated mosaic of Alexander the Great inside. Its exceptional size—it takes up an entire city block—can be compared to residences of Hellenistic royalty, such as the Palace of the Columns at Ptolemais or the palaces at Pella (Macedonia). The usual spaces of the house have been duplicated: two entrances usher in just as many atria (one is

tetrastyle). Four triclinia that faced in different directions once provided pleasant temperatures during all the seasons. The two huge peristyles are quite impressive, and the area reserved for living space has been decreased with respect to reception areas. The pattern of figurative mosaics that adorn the pavement in many areas is also significant, and the house's architectural elegance is revealed in the refined compositions of the interior walls.

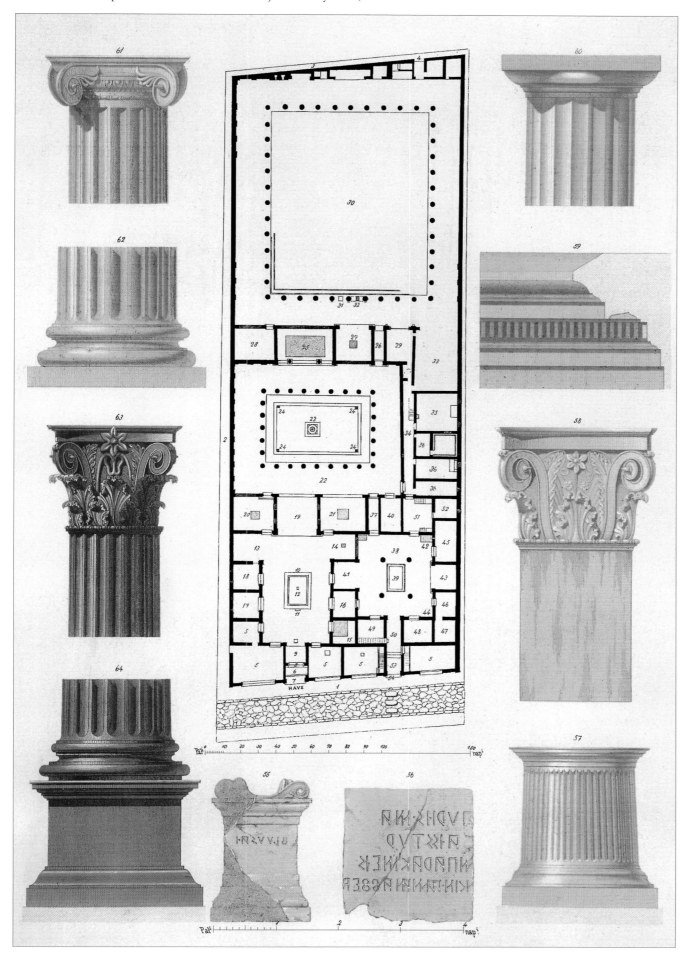

111

Below 58. Giuseppe Abbate, *Projection of the Entranceway and Materials Uncovered Within the House of the Faun: Window; Door; and Bronze, Marble, Terra-Cotta, and Iron Objects* (VI, 12, 2)

Opposite 59. Giuseppe Abbate, *Mosaic Pavement with Panel Portraying the Child Dionysos Riding a Lion* (VI, 12, 2)

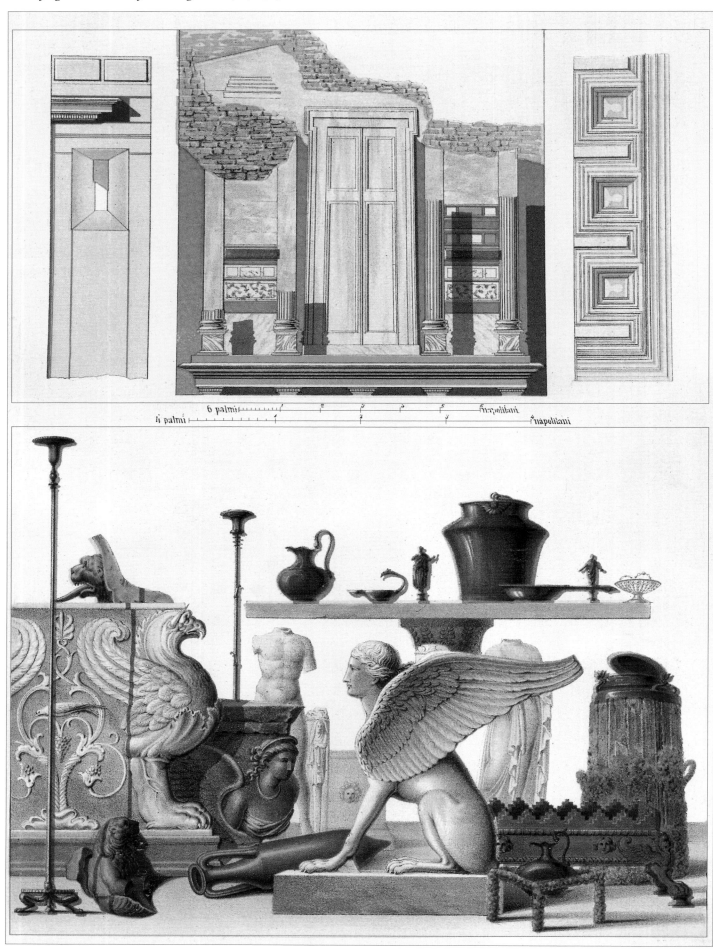

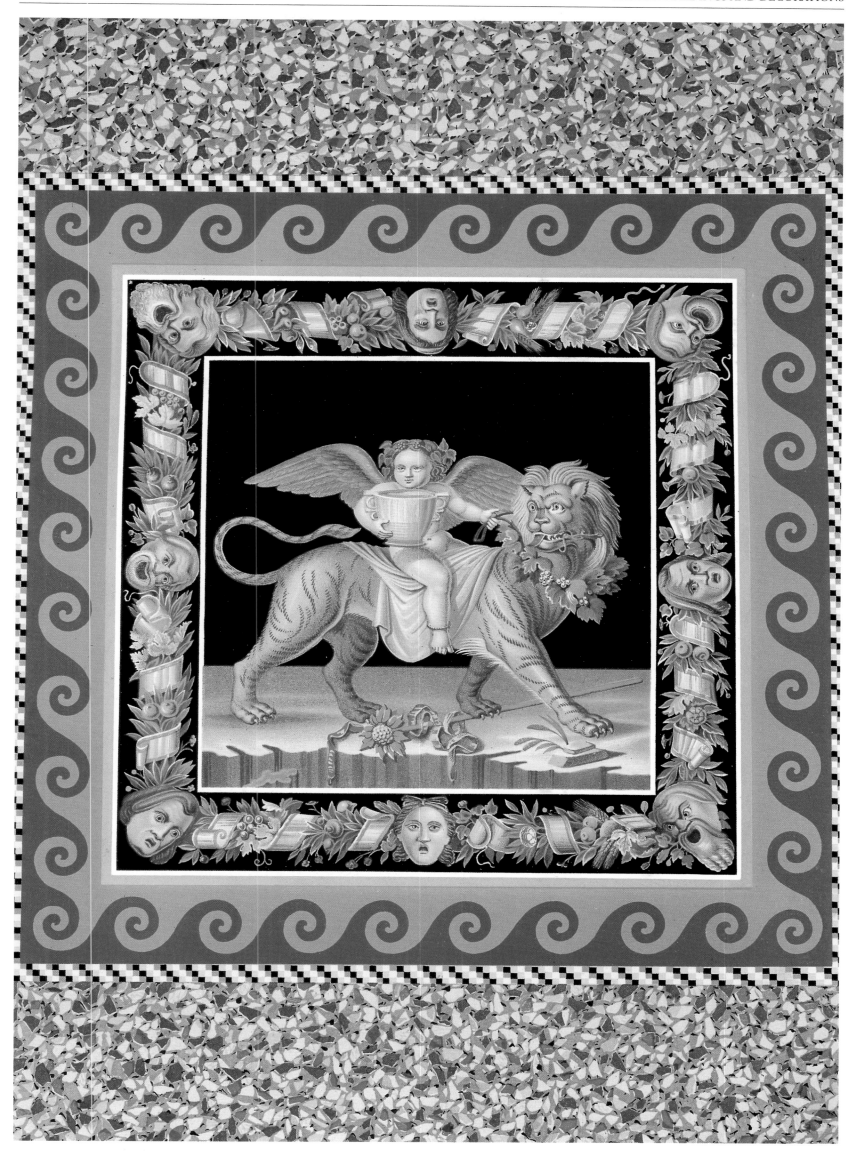

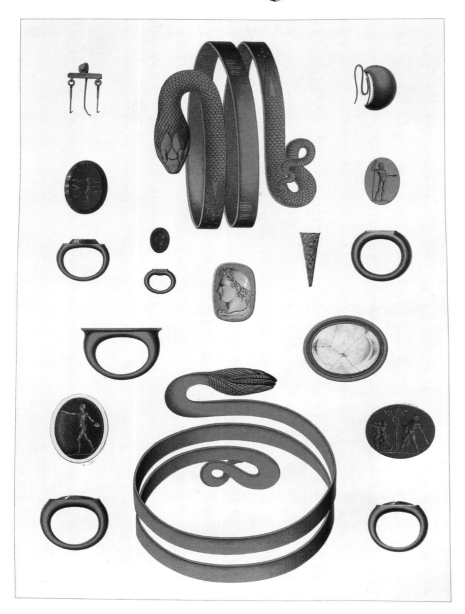

Top left 60. G. Frauenfelder, *Bronze Statue of a Satyr from the House of the Faun* (VI, 12, 2)

Bottom left 61. Giuseppe Abbate, *Jewelry Uncovered in the Tablinum of the House of the Faun* (VI, 12, 2)

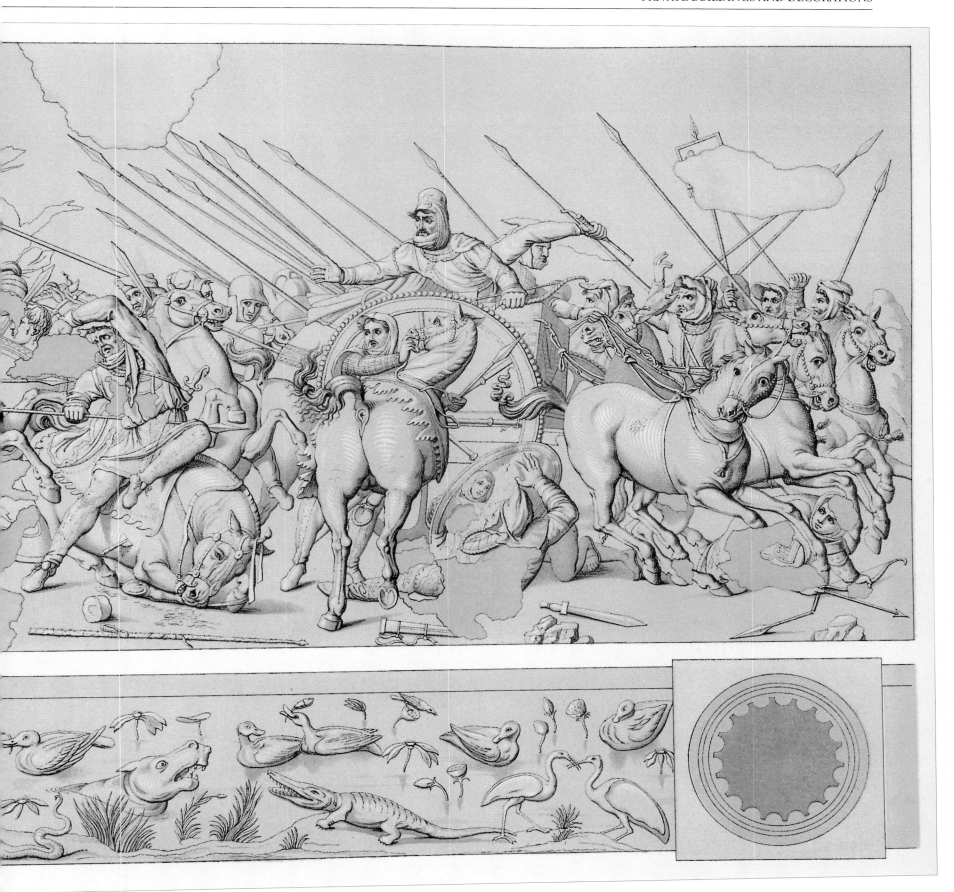

Above 62. G. Frauenfelder, *Mosaic Pavement from the House of the Faun Exedra* (VI, 12, 2)
The great mosaic of Alexander the Great (11.2 ft. × 19.4 ft.) is probably a copy of the famous painting by Philoxenos of Eretria that portrayed a battle between Alexander and Darius. The pavement has not entirely survived, but luckily, the image of Darius on his battle chariot has not been lost. He has been caught in a moment of sheer terror brought on by Alexander, who is depicted killing a Persian knight with a spear.

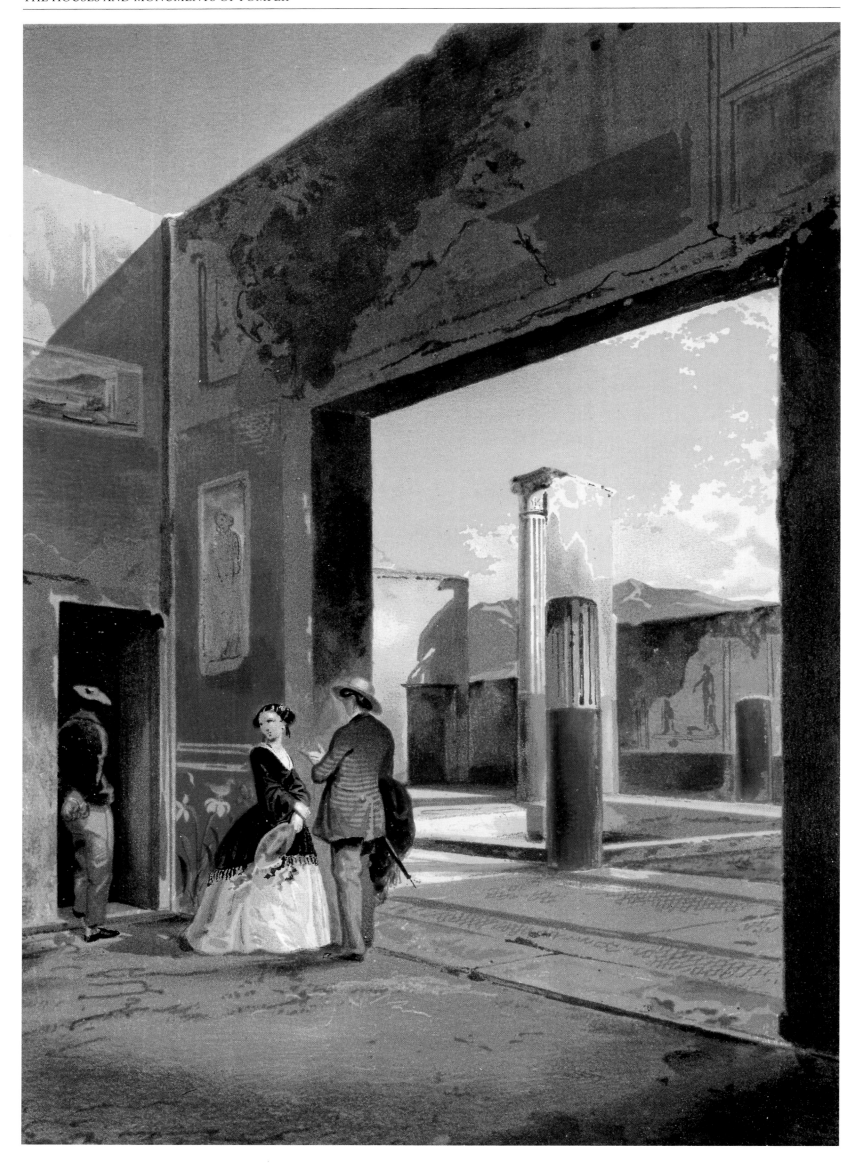

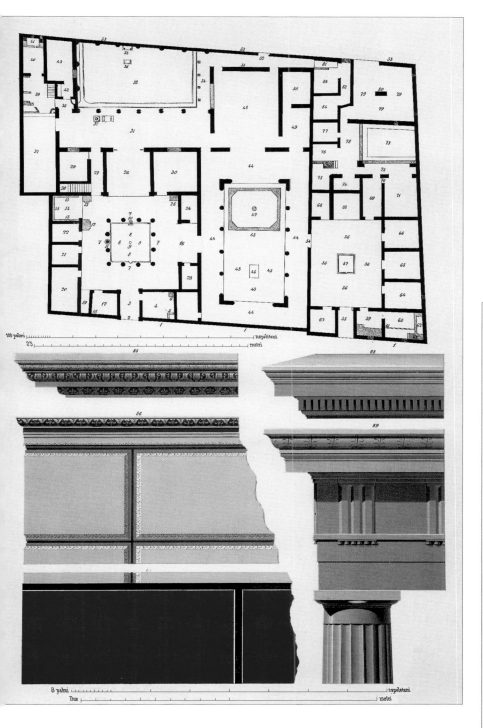

Opposite **63.** Giuseppe Gigante, *Interior View of the House of the Dioscuri* (VI, 9, 6–7)

Left **64.** Giuseppe Abbate, *Diagram and Architectural Details from the House of the Dioscuri* (VI, 9, 6–7)

Below **65.** Giuseppe Abbate, *Wall Frescoes from the House of the Dioscuri* (VI, 9, 6–7)

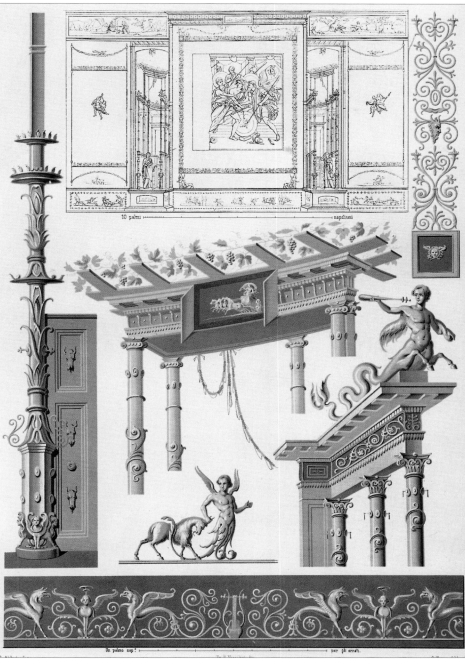

63–68. The House of the Dioscuri, excavated between 1828 and 1829, was named for its depiction of Castor and Pollux in a vestibule fresco. The fresco is especially significant for its rich, fourth-style ornamentation and was later brought to the Museo Nazionale di Napoli. In the Augustan period, the house incorporated three previous residences, whose structures are still recognizable. These contributed two atria and two peristyles each. The placement of the Corinthian atrium is especially interesting. This corresponded to the main entrance, where twelve columns surround the compluvium (a central, open-air area). On the same axis is the Doric portico from one of the two gardens, separated by the tablinum. The second peristyle, located at the center of the residence, also merits special attention for its interesting L-shaped solution of corner pilasters and an octagonal basin.

117

Below 66. Giuseppe Abbate, *Decorative Details of Frescoes at the House of the Dioscuri* (VI, 9, 6–7)

Opposite 67. Giuseppe Abbate, *Fresco Depicting the Scene of Achilles Being Recognized at Skyros from the House of the Dioscuri* (VI, 9, 6–7)

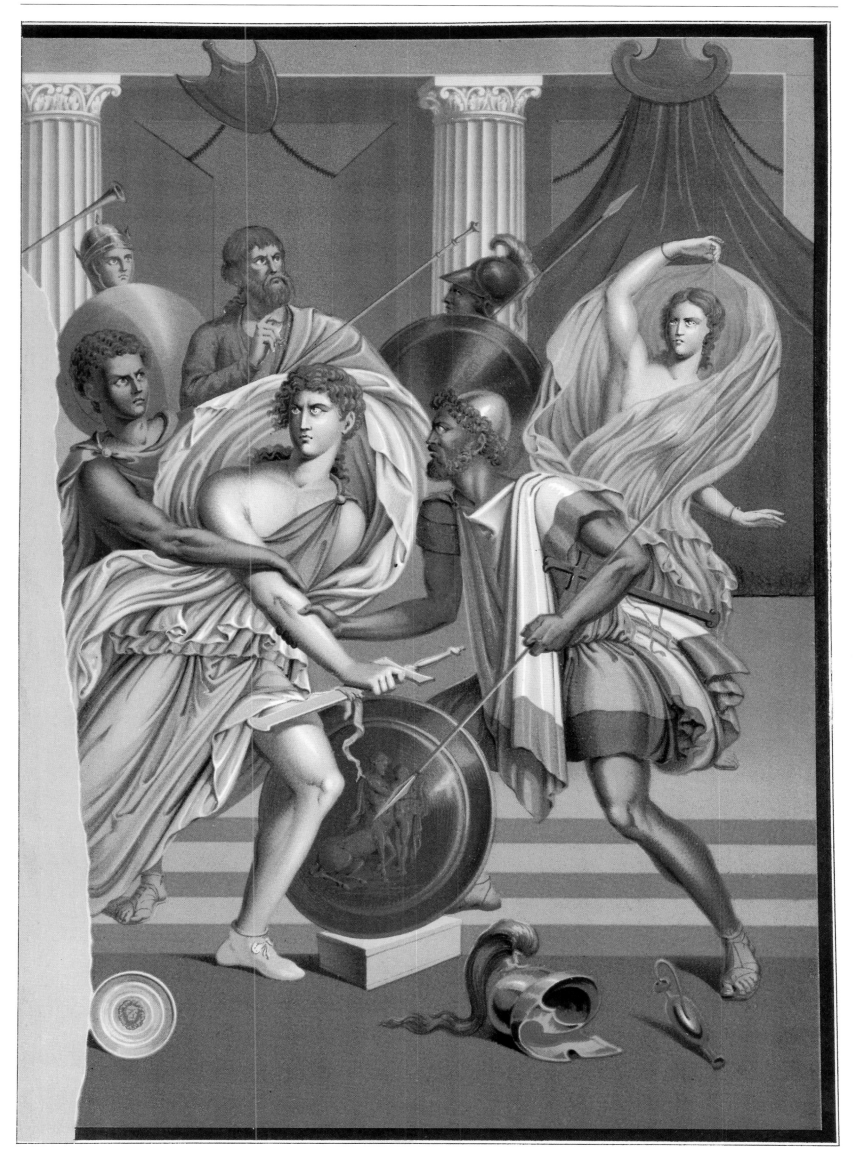

Below 68. Giuseppe Abbate, *Wall Fresco from the Cubiculum at the House of the Dioscuri* (VI, 9, 6–7)

Opposite 69. Vincenzo Loria, *A View of the House of Sallust* (VI, 2, 4)

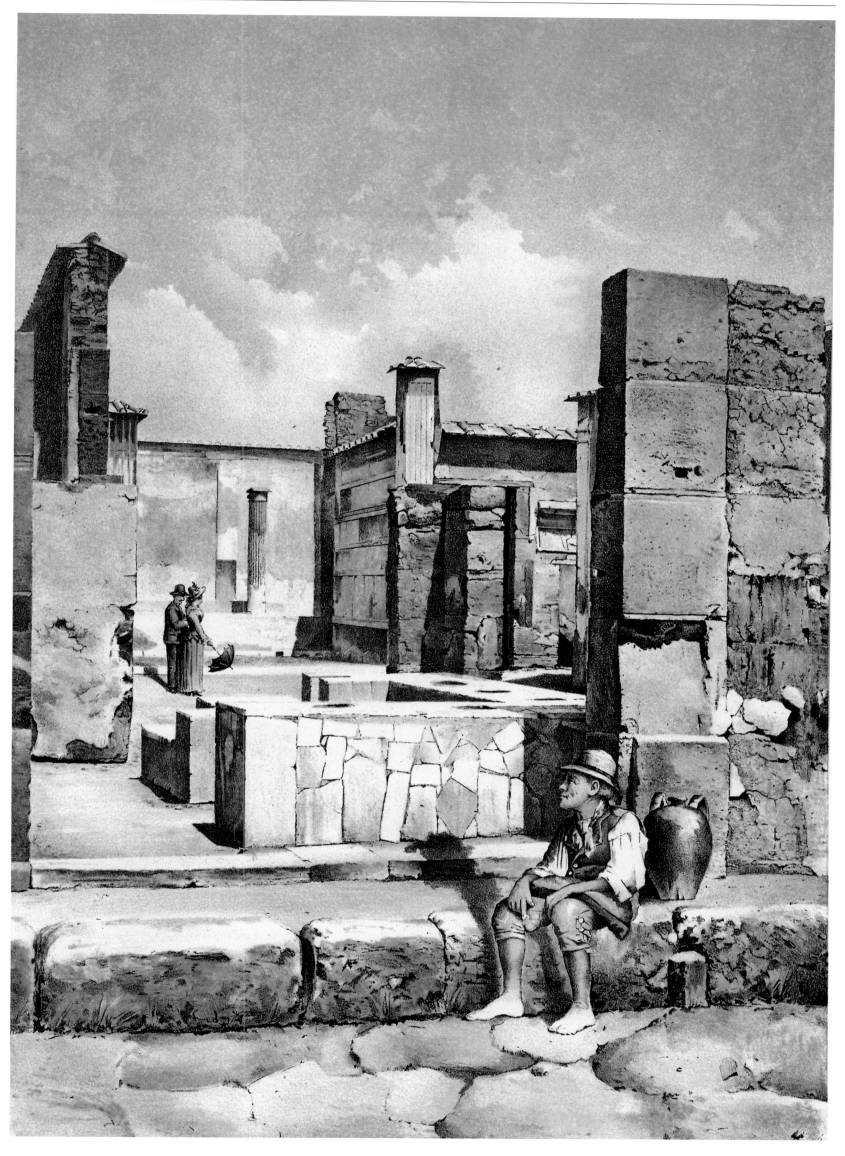

Below 70. **Fausto Niccolini,** *Diagram of the House of Sallust* (VI, 2, 4)

Right 71. **Vincenzo Loria,** *Fresco Portraying the Punishment of Actaeon at the House of Sallust* (VI, 2, 4)

69–71. The original layout of the House of Sallust dates to the Samnite period. It was limited to a central area, where a Tuscan atrium and tablinum were located, and a row of shops on each side of the entrance. The garden (*hortus*) that bordered the house on three sides was later transformed into new living spaces. Among these, the small peristyle placed on the southern side is worth mentioning. Here the ends of the portico concluded with two narrow bedrooms (*cubicula*) with large entrances. This was clearly inspired by the panoramic living rooms (*diaetae*) of large villas. The limited dimensions of the courtyard were a clever illusion simulating greater depth.

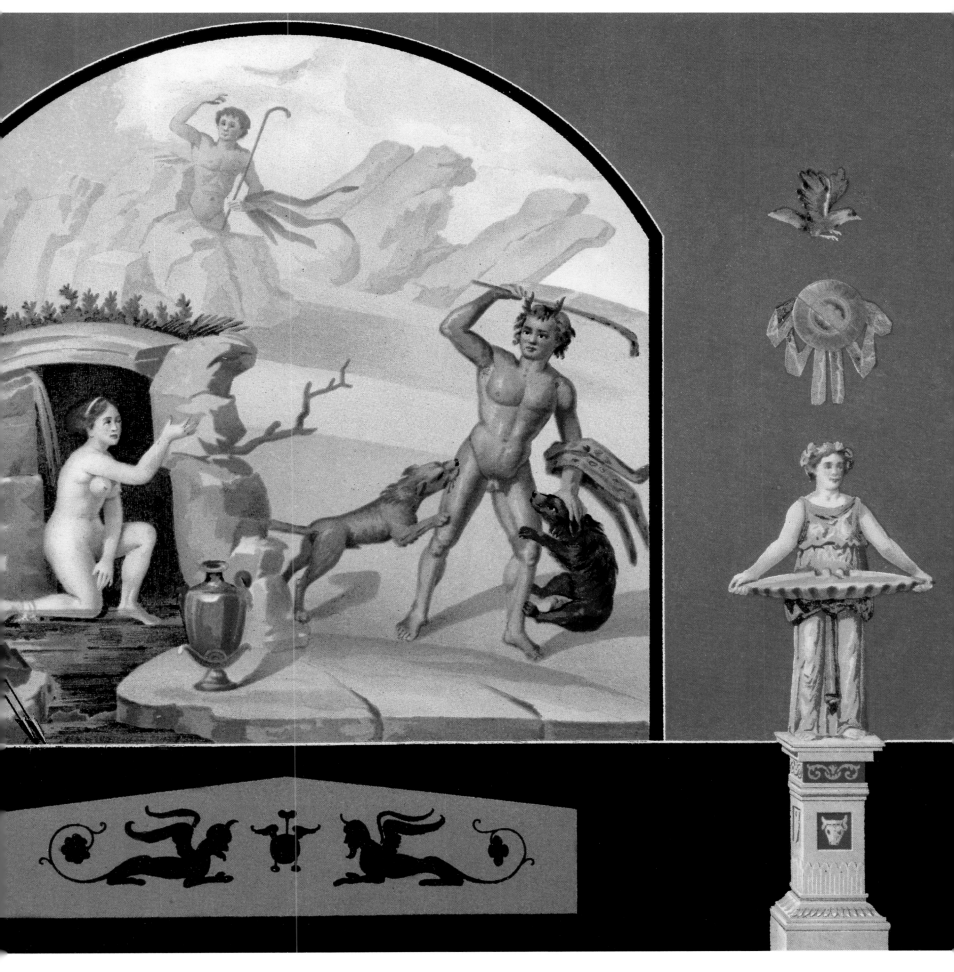

Below **72.** Giuseppe Abbate, *Diagram and Characteristic Elements of the House of the Small Fountain: Electoral Graffiti and Mosaic Pavement* (VI, 8, 23–24)

Opposite **73.** Giuseppe Abbate, *Nymphaeum in the West Wall of the Peristyle at the House of the Small Fountain* (VI, 8, 23–24)

72–75. Two sumptuous nymphaeums (fountains) allowed the discoverers to recognize two connecting houses on the same block, one named House of the First Fountain, the other the House of the Second Fountain. The latter is known today as the House of the Small Fountain. The nymphaeum within is perfectly lined up with the main entrance, having a representa-tional function and acting as the scenic background for the atrium and the tablinum. The building was discovered in 1827 with elegant furnishings and objects inside. One meandering mosaic motif decorated the tablinum floor, and the façade of the building held an election sign promoting Marcus Holconius Priscus.

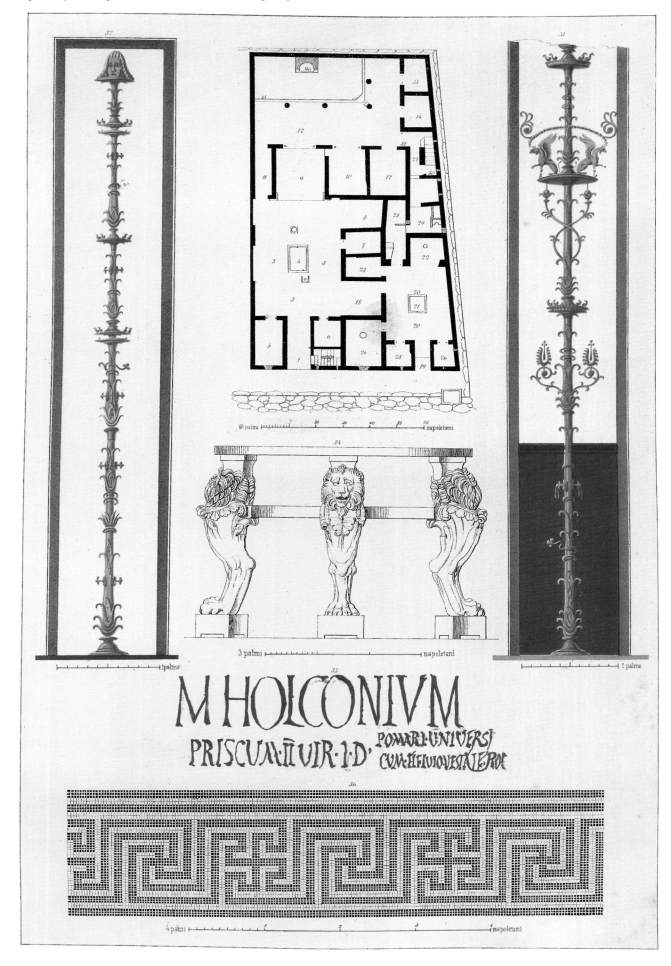

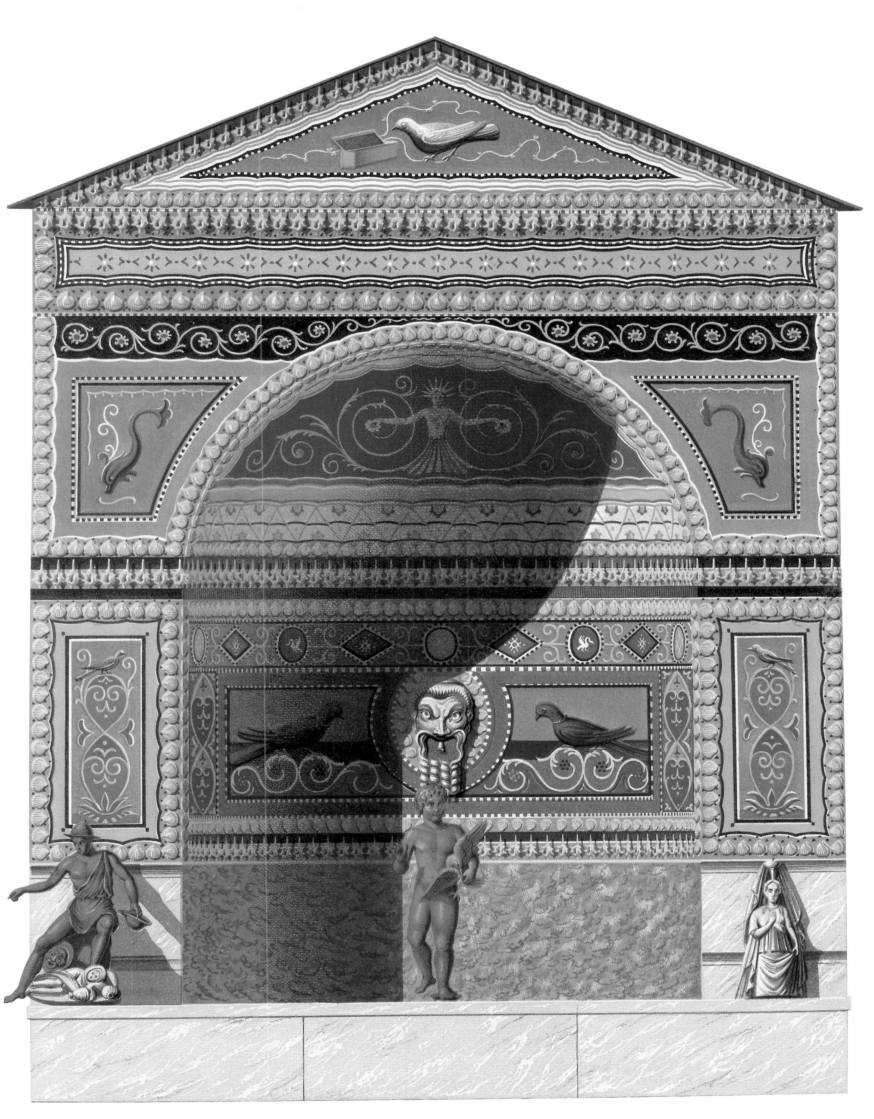

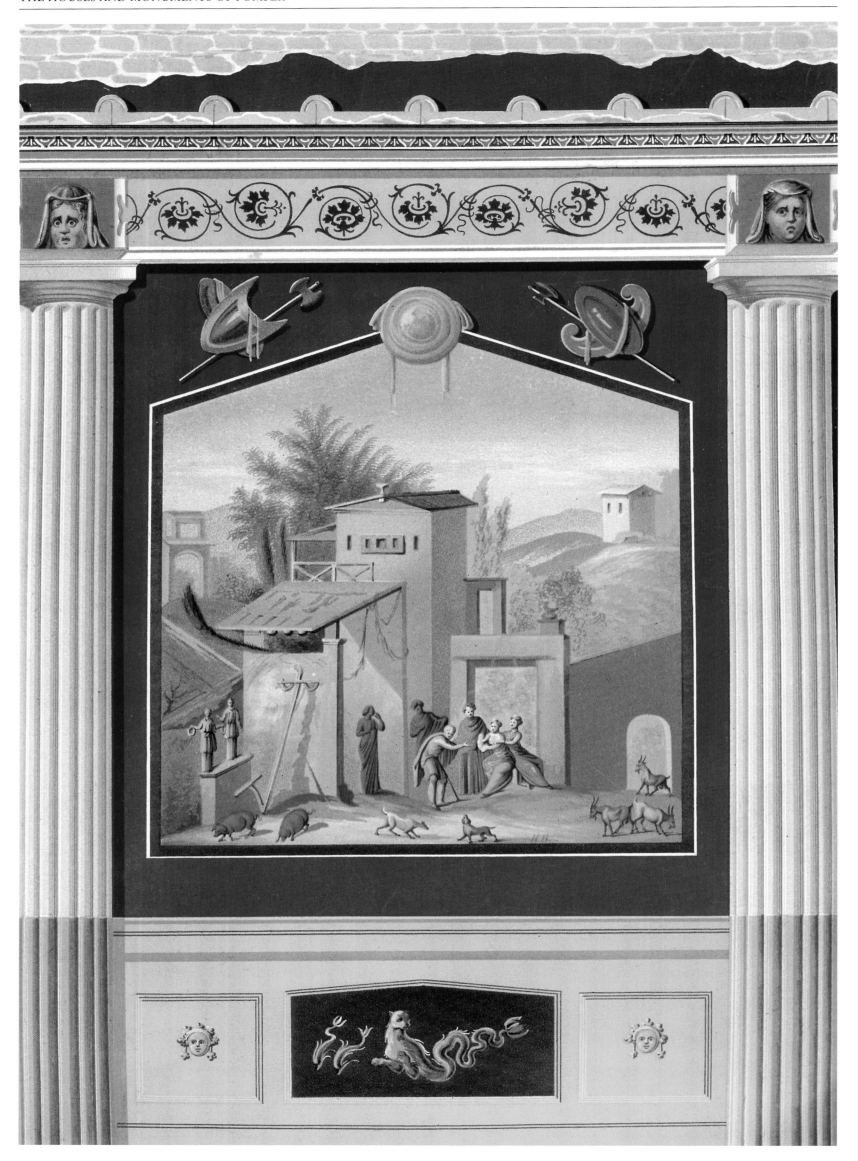

Opposite 74. Giuseppe Abbate, *Fresco of the Countryside on the West Wall of the Peristyle at the House of the Small Fountain* (VI, 8, 23–24)

Below 75. G. Frauenfelder, *Sculpted Candelabras from the House of the Small Fountain* (VI, 8, 23–24)

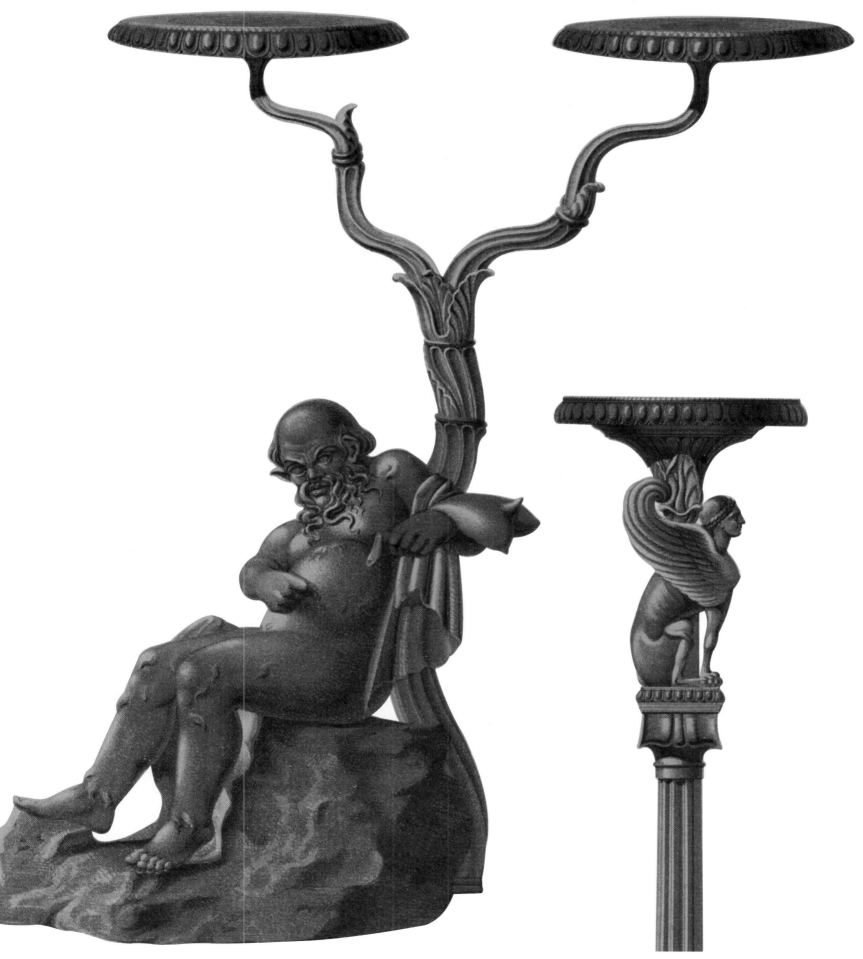

Below 76. L. Schioppa, *Diagram and Architectural Details of the House of the Tragic Poet* (VI, 8, 3–5)

Opposite 77. **Giuseppe Abbate**, *Fresco of the Marriage of Jupiter and Juno at the House of the Tragic Poet* (VI, 8, 3–5)

76–79. The House of the Tragic Poet was excavated between 1824 and 1825 and owes its name to the floor mosaic uncovered in the tablinum portraying a dramatist and a company of actors. The house's fame is linked to an exceptional series of wall decorations discovered in the atrium and triclinium. The presence of two small stairs at the sides of the atrium proves the existence of an upper floor. The House of the Tragic Poet became the setting for the life of Glaucus, the lead character in *The Last Days of Pompeii*, a famous novel by Edward Bulwer-Lytton published in 1834.

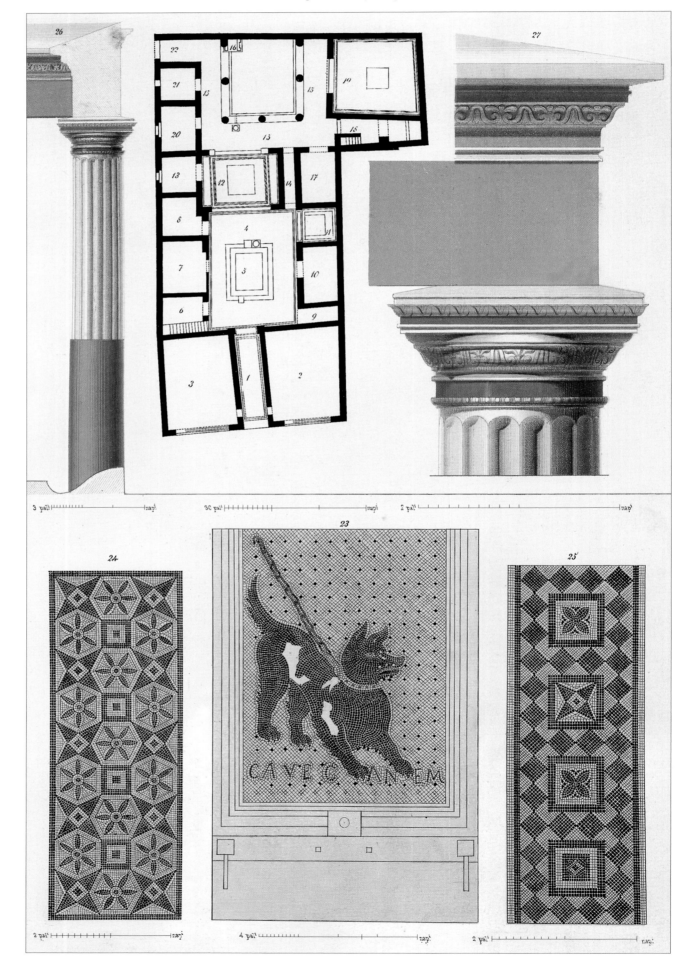

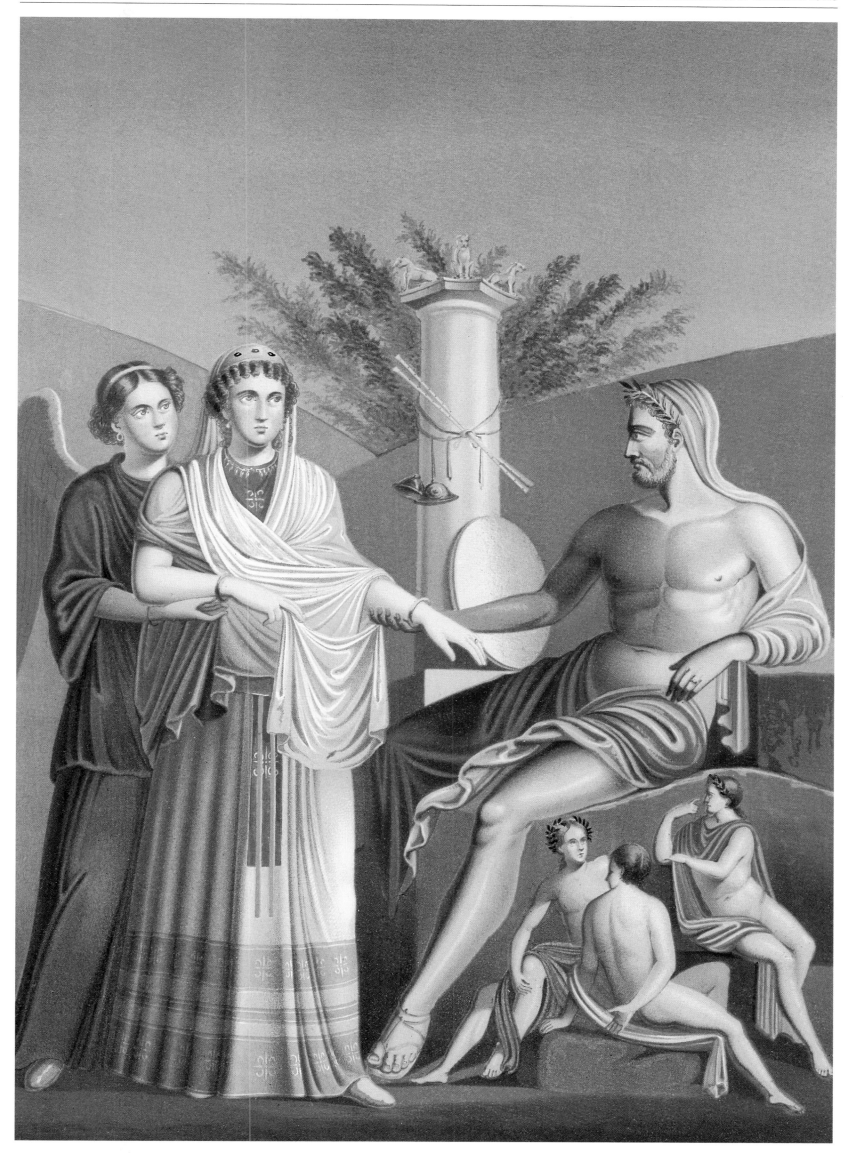

Below 78. Giuseppe Abbate, *Jewelry and Floor Mosaic with an Emblem Depicting a Theatrical Rehearsal of a Satirical Drama from the House of the Tragic Poet* (VI, 8, 3–5)

Opposite 79. Giuseppe Abbate, *Frescoed Wall from the House of the Tragic Poet* (VI, 8, 3–5)

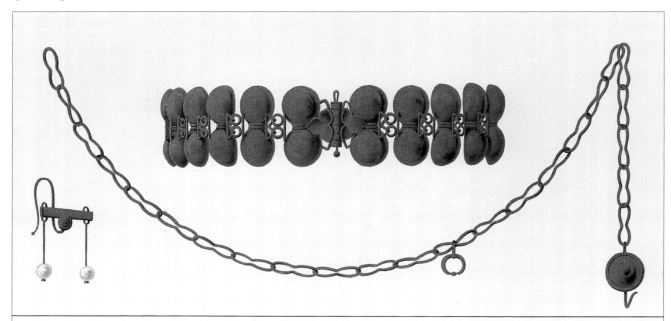

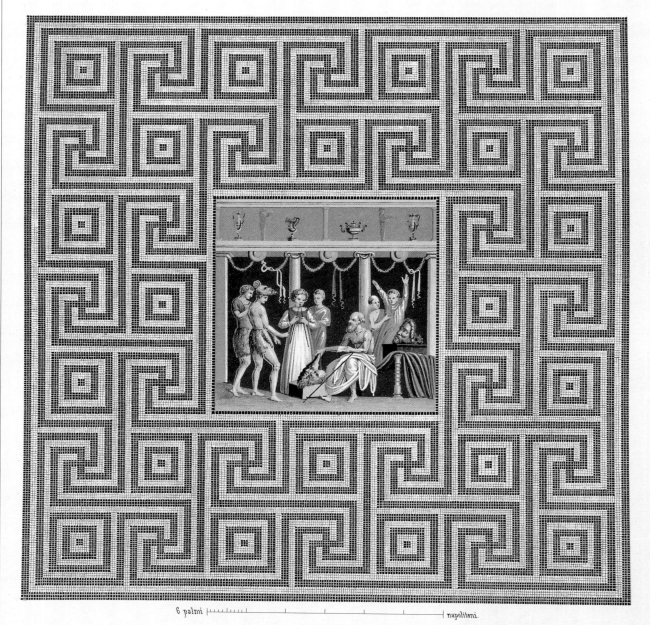

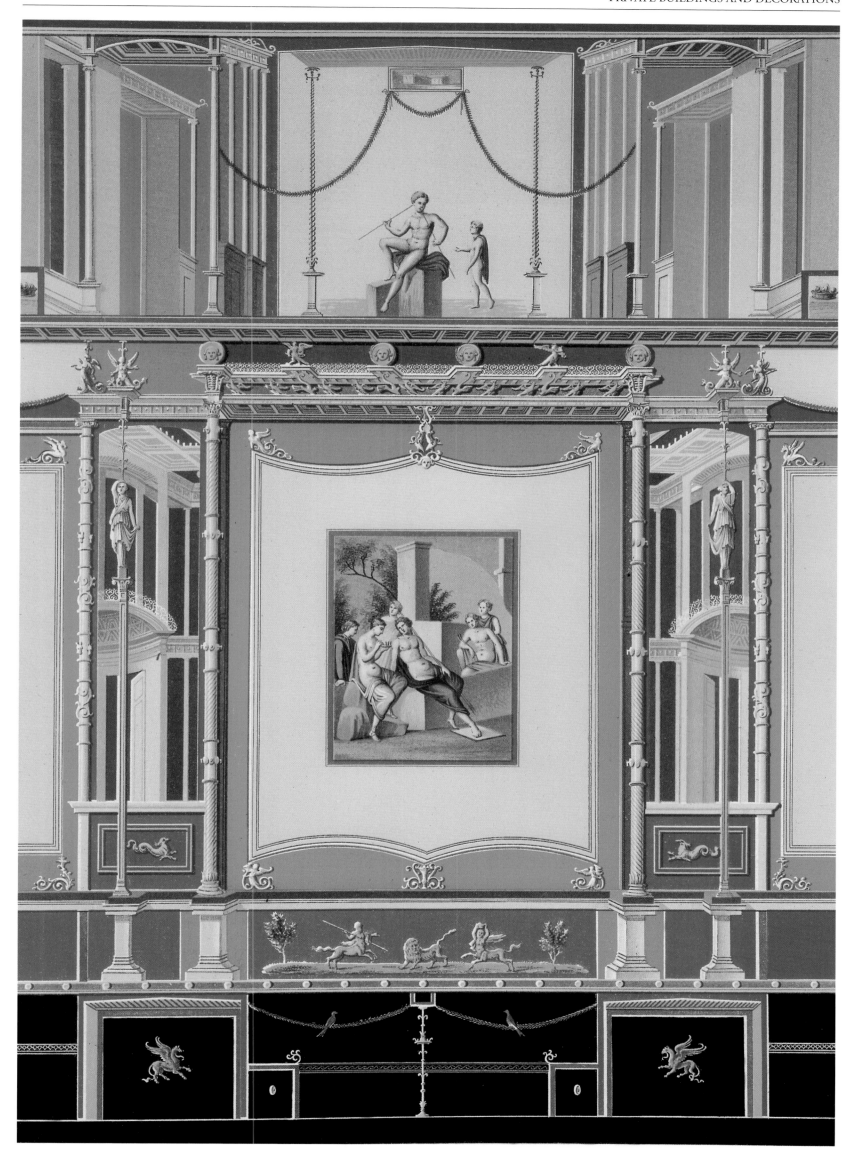

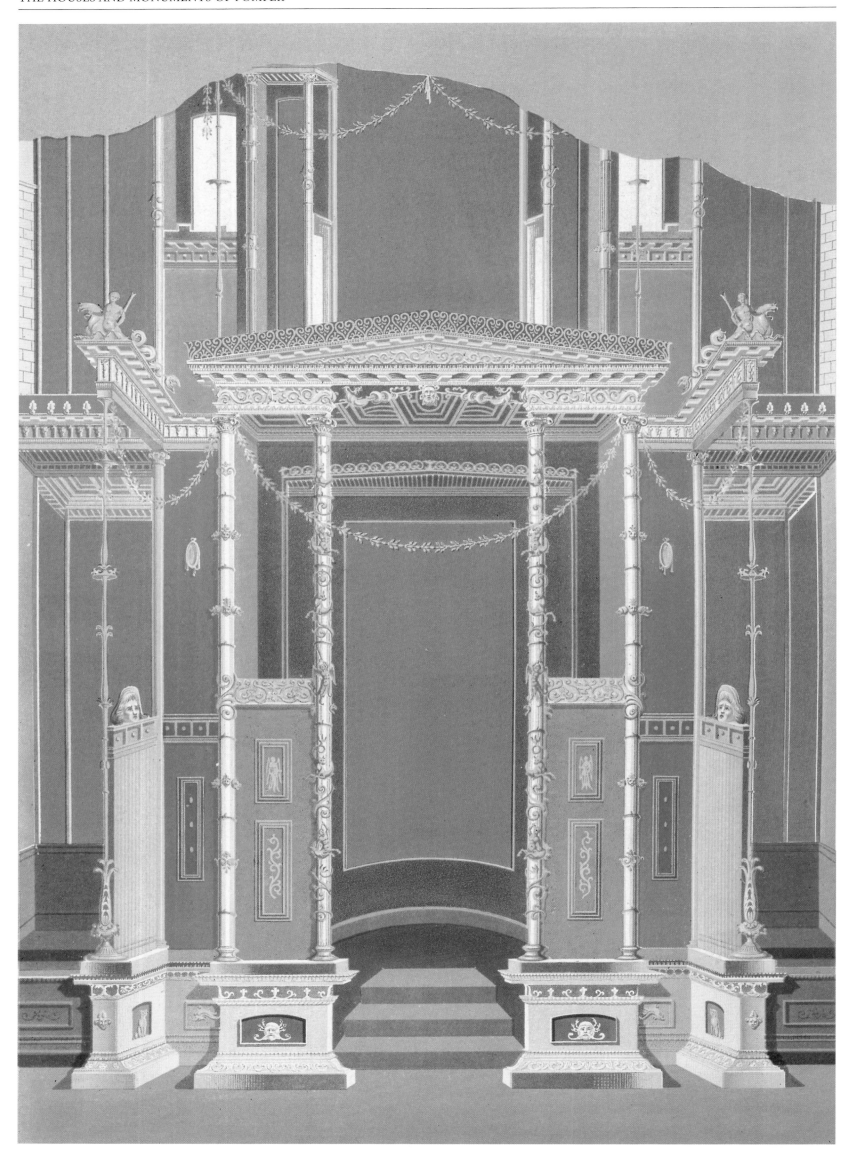

Opposite 80. **Giuseppe Abbate,** *Wall Fresco of a Theatrical Background at the House of Marcus Lucretius* (IX, 3, 5)

Below 81. **Giuseppe Abbate,** *Decorative Motifs in Colored and Gold-Plated Stucco at the House of Marcus Lucretius* (IX, 3, 5)

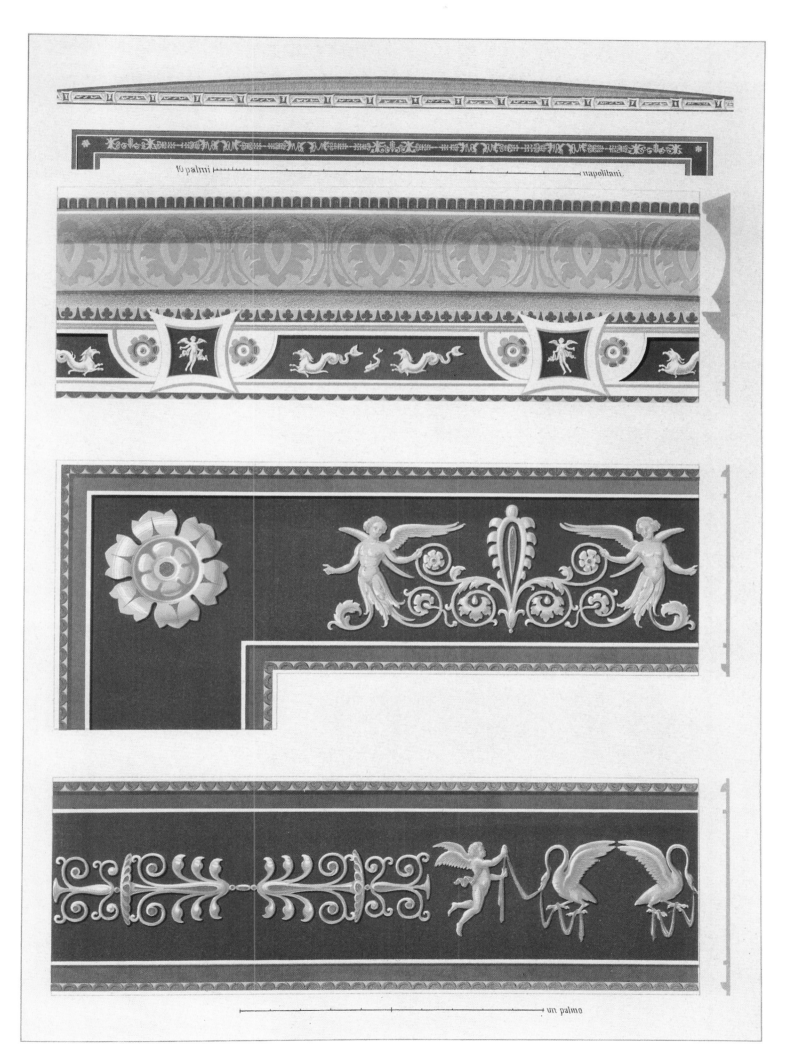

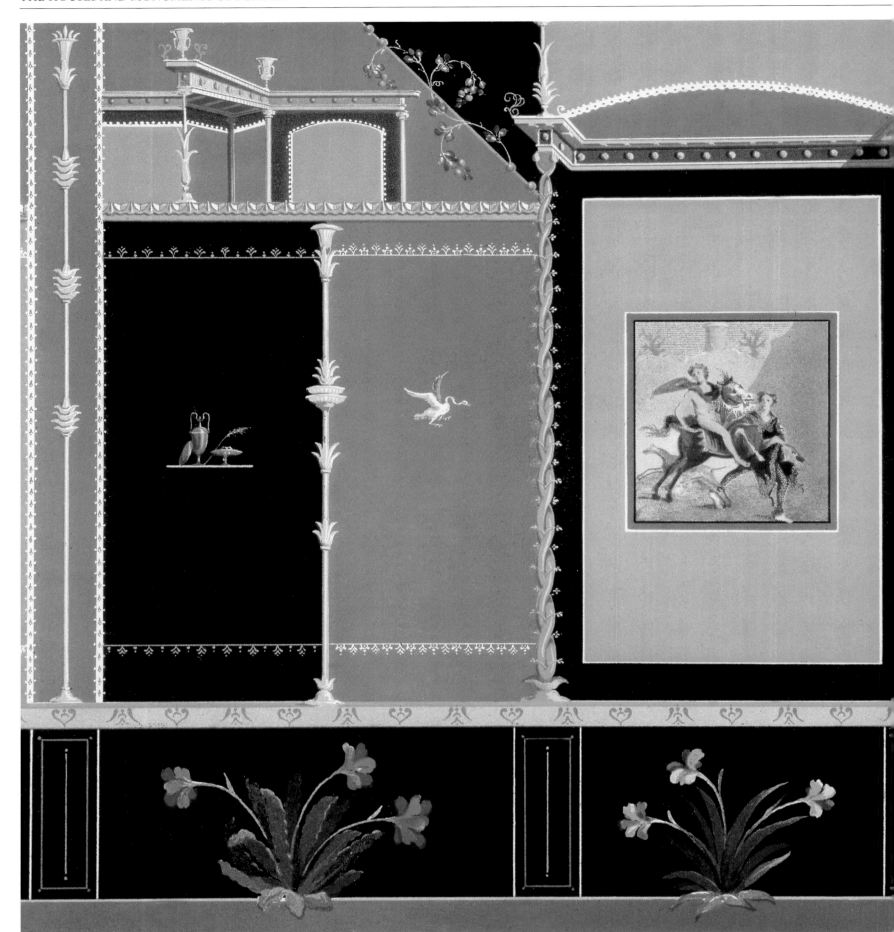

Above **82. Vincenzo Loria,** *Wall Fresco from the House of the Centenary* (IX, 8, 6)

Opposite, top **83. Vincenzo Loria,** *Diagram with a Projection of the Black-and-White Floor Mosaic in the House of the Centenary* (IX, 8, 6)

Opposite, bottom **84. Vincenzo Loria,** *Fresco Portraying Dionysos and the Serpent of Lararius in the House of the Centenary* (IX, 8, 6). The god is shown clothed in a large bunch of grapes at the foot of Mount Vesuvius, as it appeared before the damaging eruption of A.D. 79.

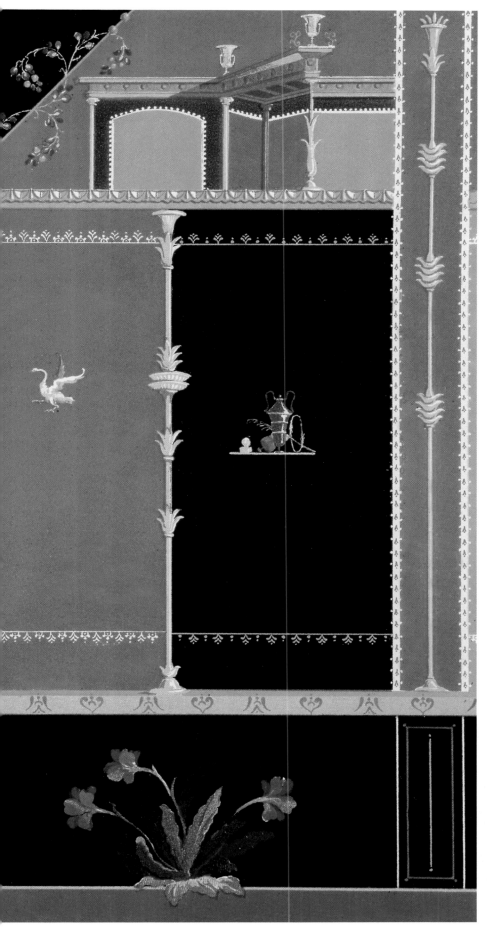

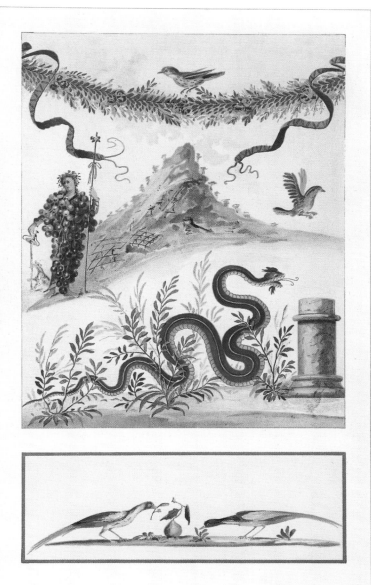

82–84. The House of the Centenary was a luxurious residence that incorporated three previous living quarters. These were transformed in the Augustan period after the earthquake of A.D. 62. It was excavated in 1879, exactly eighteen hundred years after the city was buried. It contains a large peristyle connected to an extraordinary nymphaeum that is decorated with a rich variety of plants and animals. The fountain installed on the back wall must have contributed to the illusion of an open-air garden.

135

Above **85. R. Sifo,** *Diagram of the Villa of Diomedes*

Right **86. C. Weidenmüller,** *A View of the Villa of Diomedes*

85–89. The lavish suburban villa extends along Via dei Sepolcri and was excavated between 1771 and 1774, causing reverberations partly because eighteen victims were discovered in the underground cryptoporticus. The peristyle, which connected directly to the road, is the centerpiece; around it were an elegant private bath, the tablinum, the triclinium, and a great hall with an apse, which was used as an alcove during the day. A huge four-sided portico was positioned on a lower level, with terraces that were directly accessible from the living quarters. The higher level featured two small towers, complete with rooms in which to relax and enjoy the panoramic view. The porticoes, supported by pillars, enclosed the largest Pompeian garden. *At center*, note the remains of a large fountain and a summer triclinium.

Above 87. Vincenzo Mollame, *Fresco Details with Dancers from the Villa of Diomedes*

Right 88. A. Carli, *Painted Ceiling from the Villa of Diomedes*

Opposite 89. A. Carli, *Wall Fresco from the Villa of Diomedes*

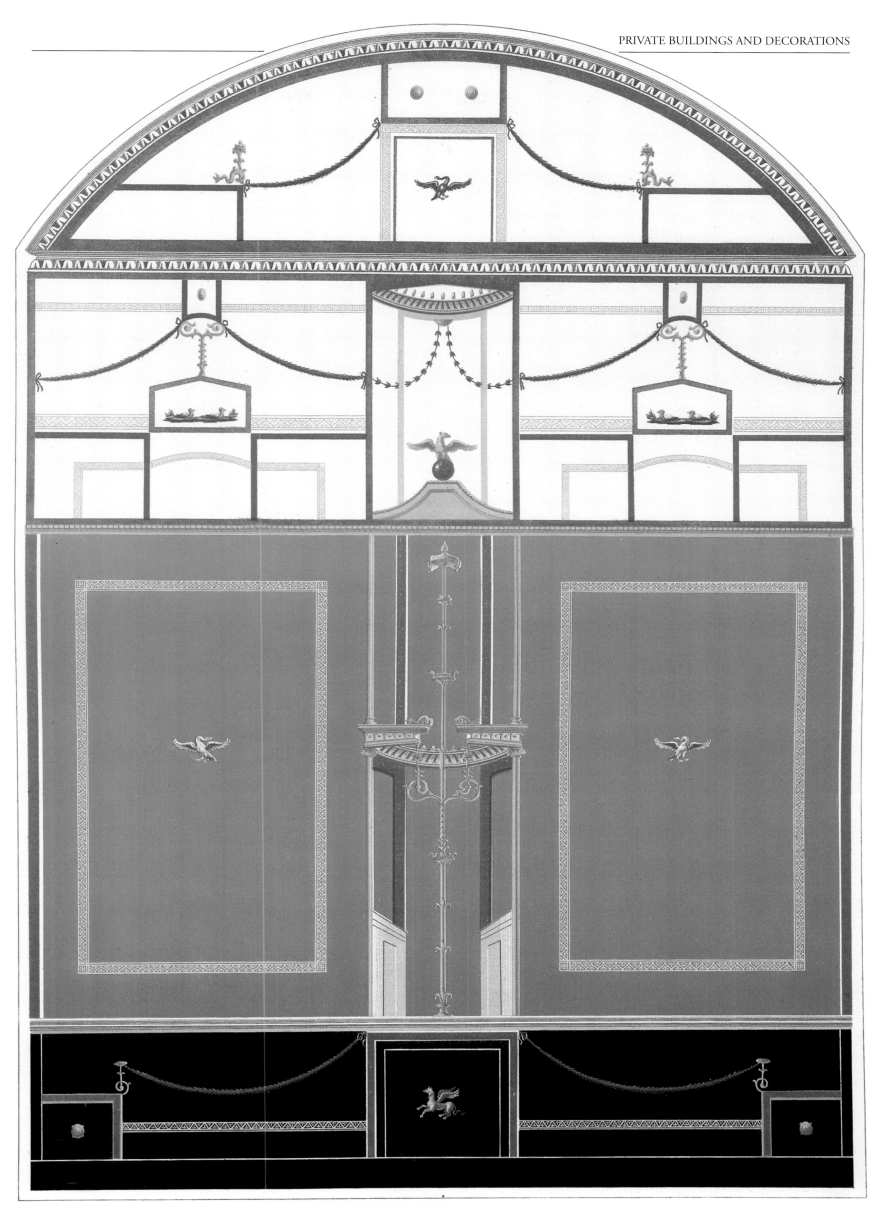

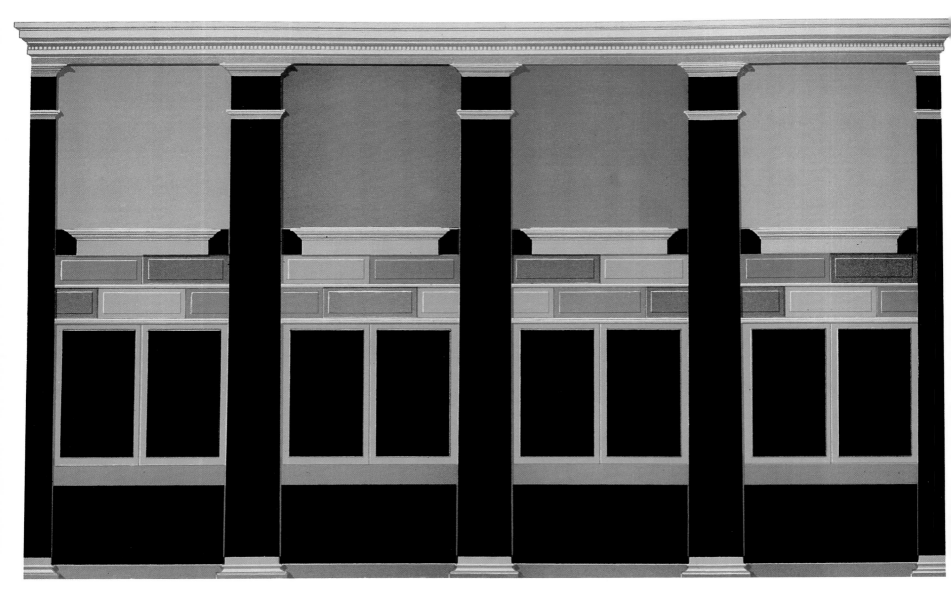

90. G. Discanno and D. Capri, *Wall Frescoed in the First Style*

In 1873 August Mau developed a classification system for Pompeian painting that archaeologists still use today for Pompeii and the entire Mediterranean region. Recent studies have perfected the chronology and the context of these decorative phenomena. The so-called first style is a wall decoration with colored stucco. The wall is subdivided into three areas (baseboard, middle level, and upper level) and imitates walls of equal-sized blocks of a variety of marble. Today it is known that this interior decorative technique was widespread in the Hellenistic world since the fourth century B.C. At the beginning of the first century B.C., by the time Rome had the entire Mediterranean in its direct or indirect control, a radical transformation in decorative techniques for interior architecture was noticeable. The wealth of an ever-growing social class of people brought with it the expansion of companies and artisans who were able to answer their increased demand.

The so-called second style began to spread during this time and introduced the first illusionist painting to Rome. This new taste favored architectural backgrounds that were sometimes quite complex; perhaps this was related to the tradition of theatrical imagery. The second style was not just found in Campania, but also in the rest of Italy and many other parts of the Mediterranean and Europe (France, Germany, Spain, Egypt, Palestine, etc.). The third style asserted itself during the Augustan period and continued through the Julio-Claudian era. It simplified the decoration structure using linear frameworks with figurative pictures inside. When Vesuvius erupted in A.D. 79 near the workshops of Roman painters, the trend of decorating walls with complex architectural scenery had returned into vogue for almost thirty years. This time, however, it was detached from the intent of giving an illusion of a background—a fourth style.

91. A. Magliano and D. Capri, *Second-Style Fresco from the House of the Epigrams* (V, 1, 18)

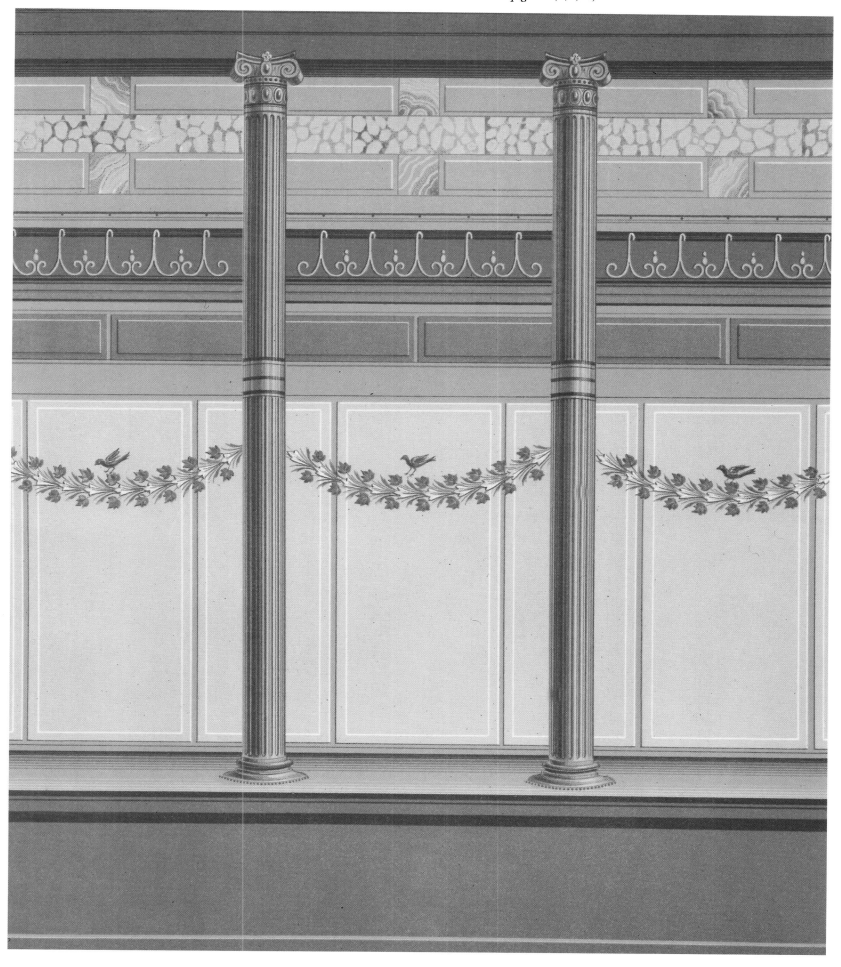

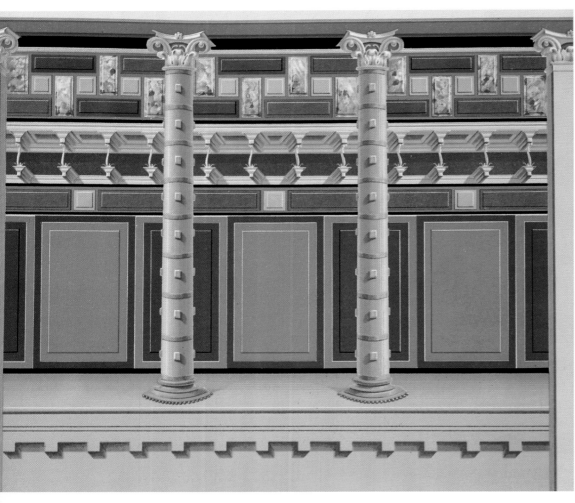

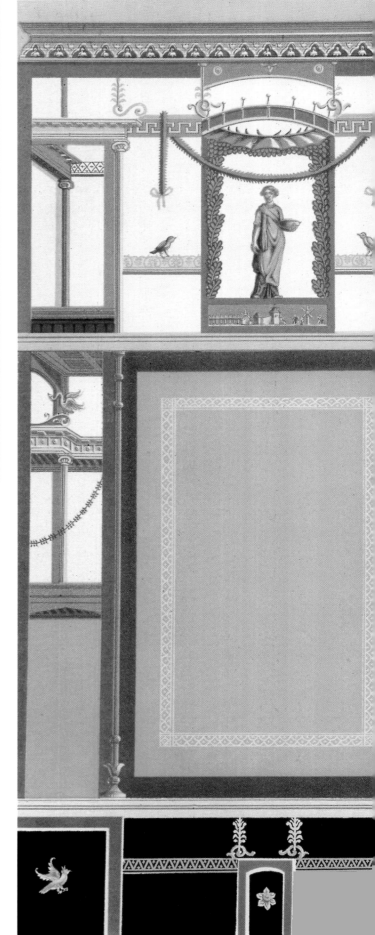

Above 92. G. De Simone and D. Capri, *Second-Style Fresco from the House of the Silver Wedding* (V, 2, 1)

Right 93. A. Carli, *Wall Fresco with Panel Depicting Phrixus and Helle from the House of Marcus Lucretius* (IX, 3, 5)

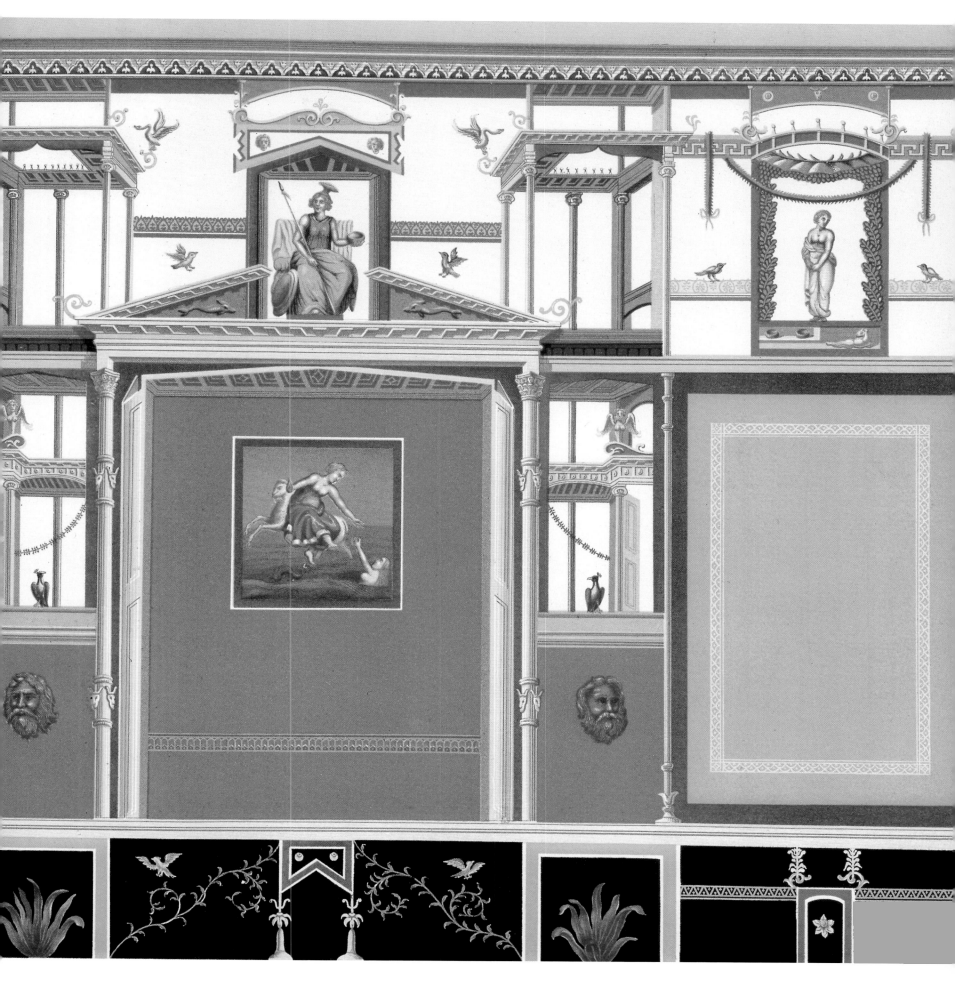

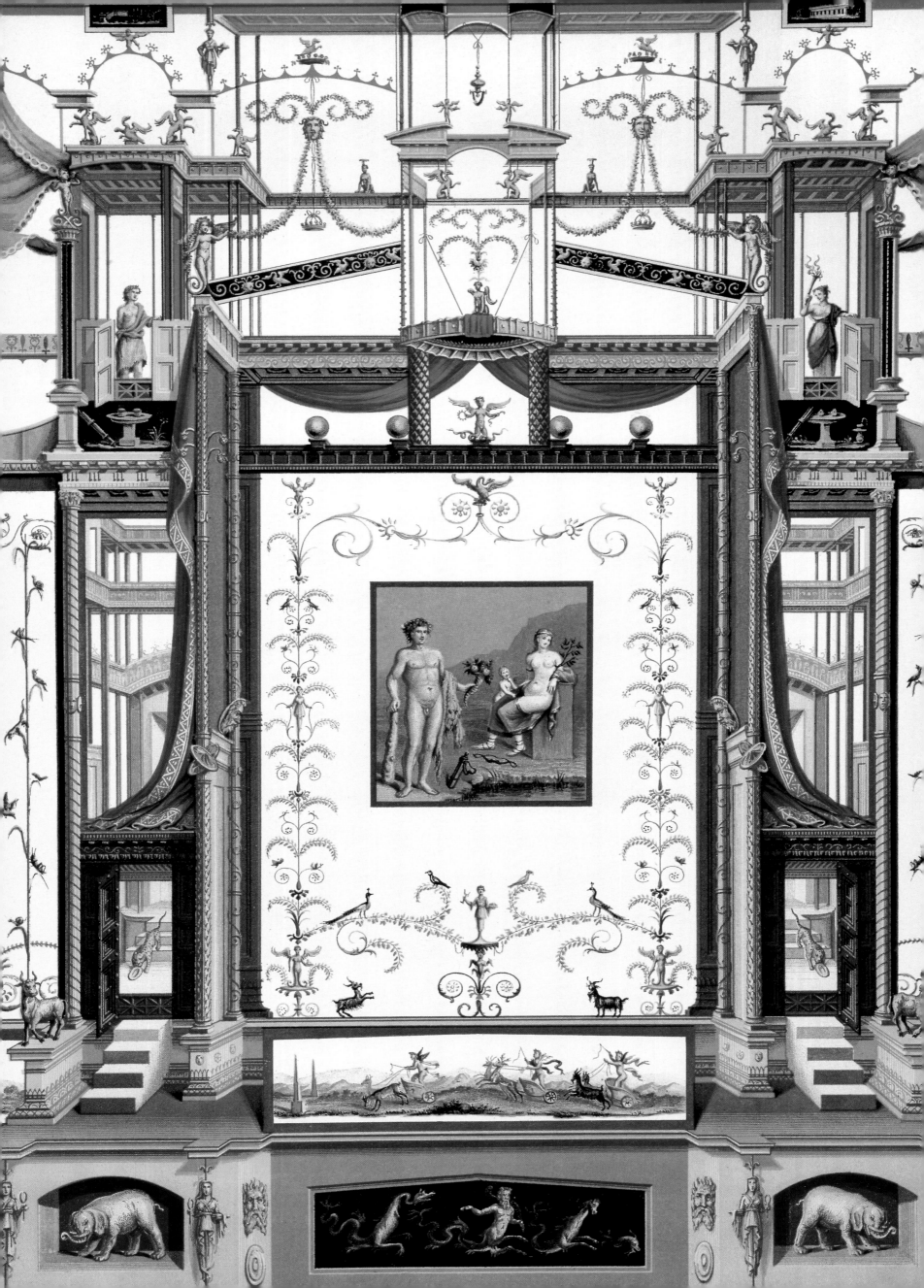

Left 94. C. Weidenmüller, *Fourth-Style Wall Fresco with a Center Picture of Hercules and a Female Character*

Below 95. Vincenzo Loria, *Viridarium Wall Fresco from the House of the Epigrams* (IV, 1, 18)

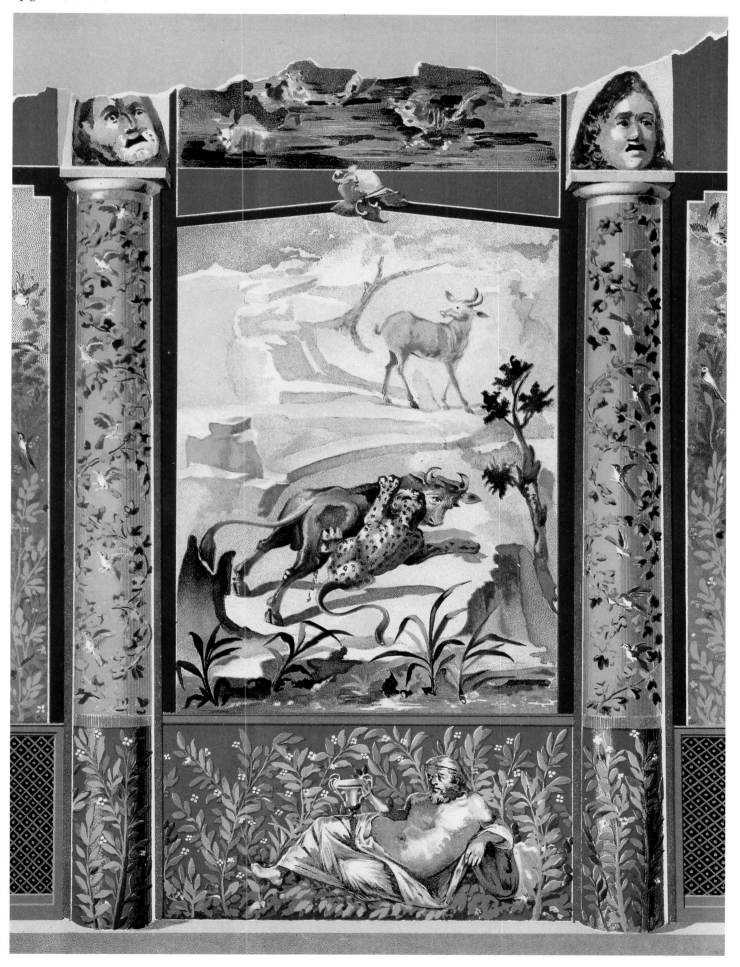

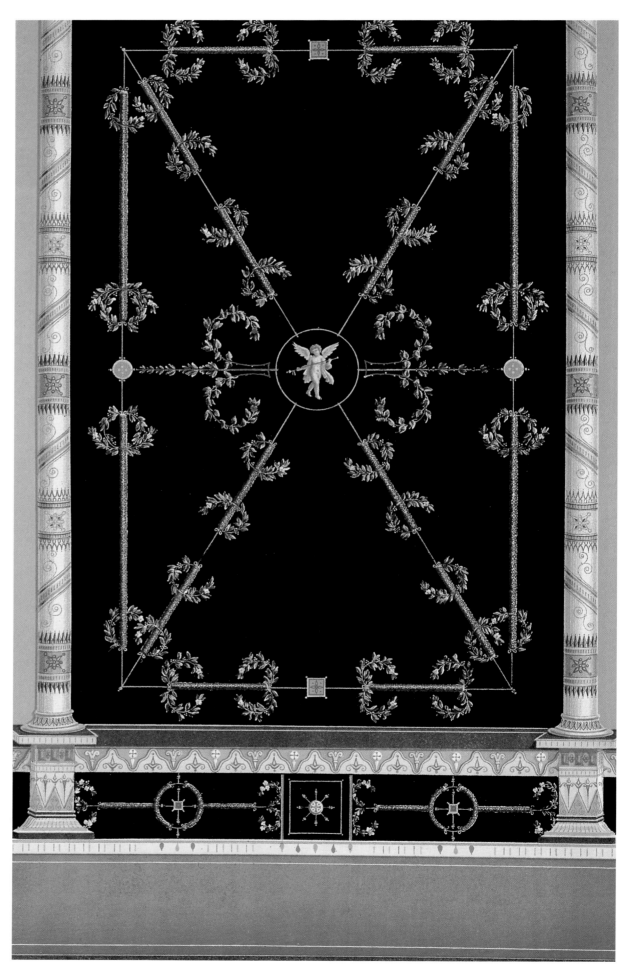

96. D. Capri, *Detail of a Wall Fresco with a Black Background from the House of Epidius Sabinus* (IX, 1, 22)

97. Vincenzo Loria, *Fresco of Hephaistos and Thetis from the House of Meleagrus* (VI, 9, 2–13)

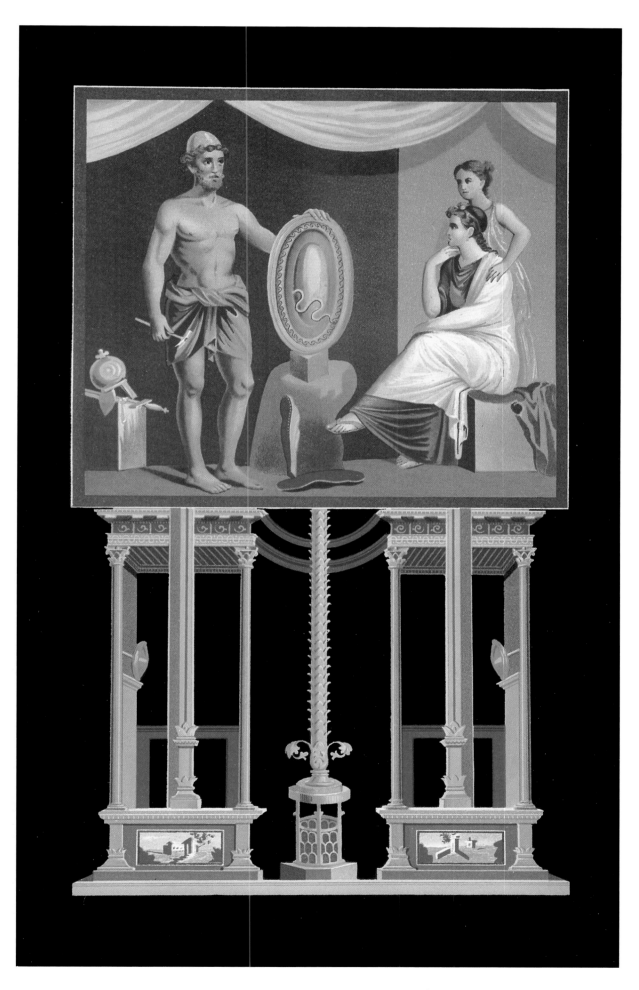

Top 98. G. Discanno, *Frescoes with Neolithic Scenes of Pygmies from the House of Solomon's Judgment* (VIII, 5, 9)

Bottom 99. G. Discanno, *Fresco of the Judgment Scene from the House of Solomon's Judgment* (VIII, 5, 9)

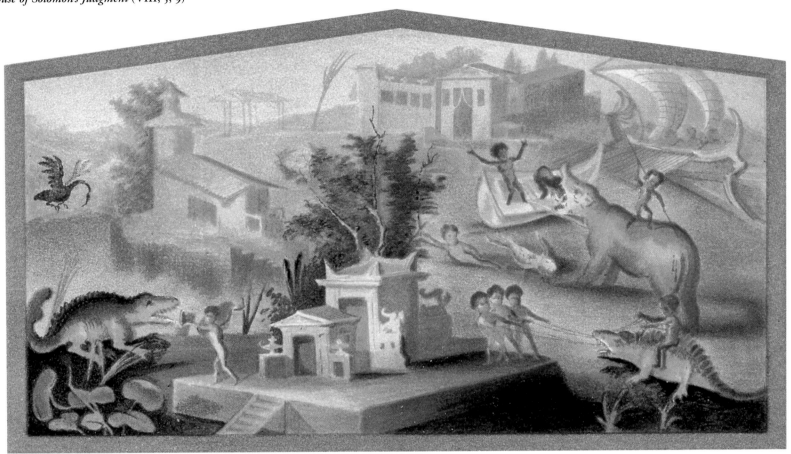

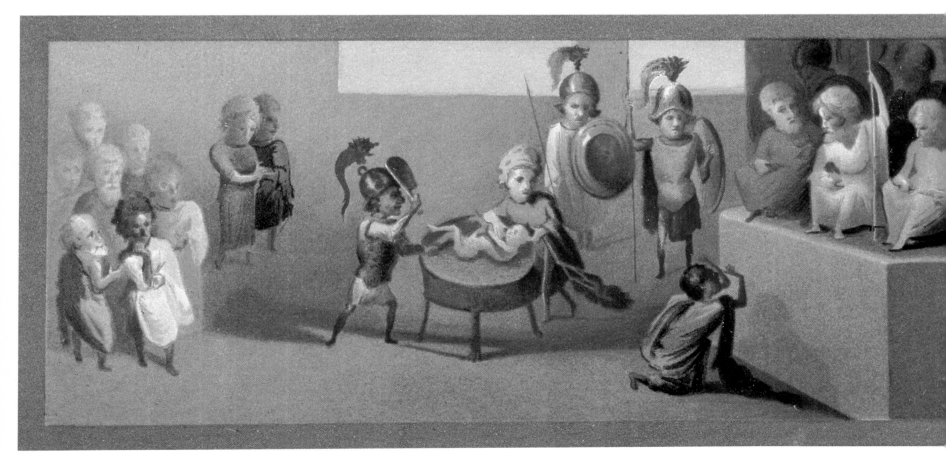

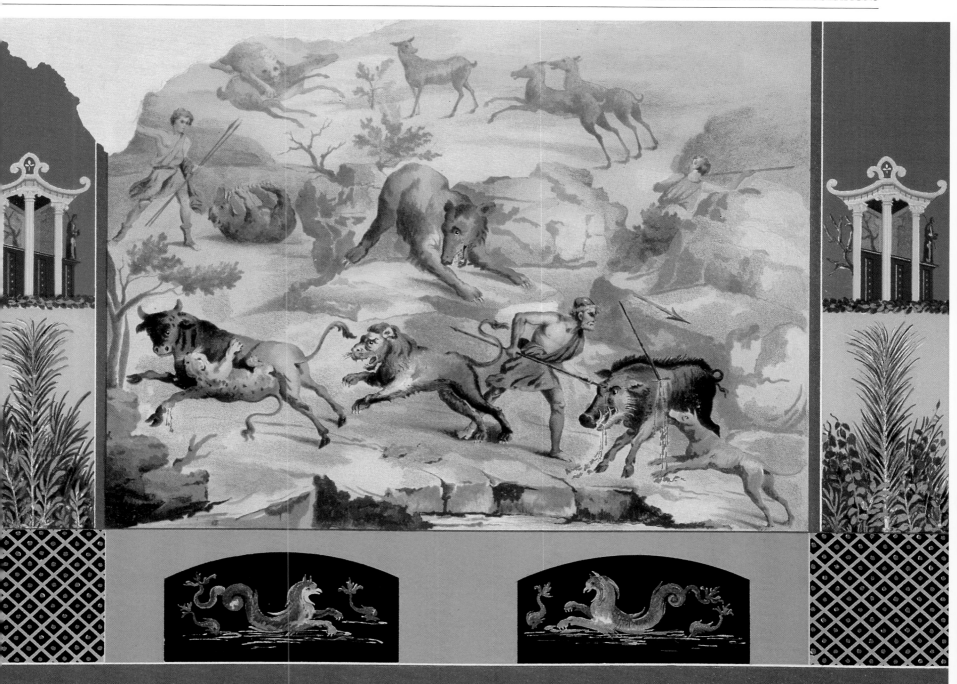

Above 100. Vincenzo Loria, *Fresco of a Hunting Scene from the Viridarium of the House of the Ancient Hunt* (VII, 4, 48)

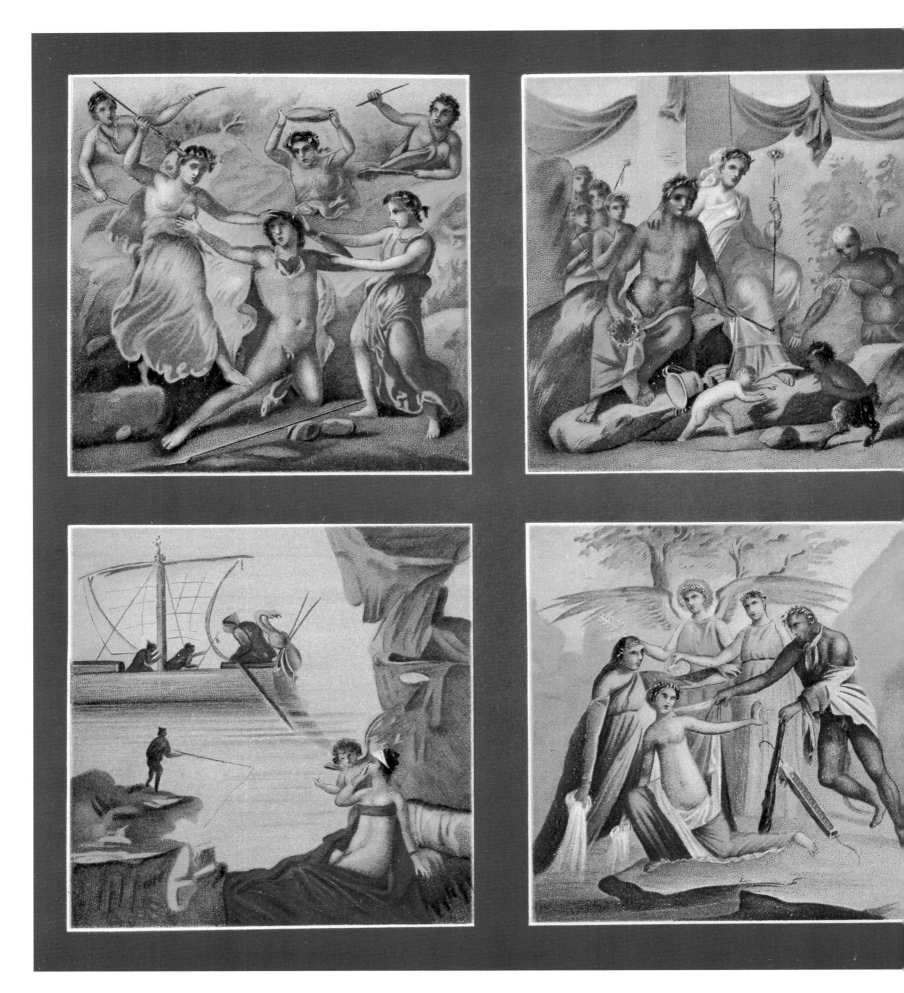

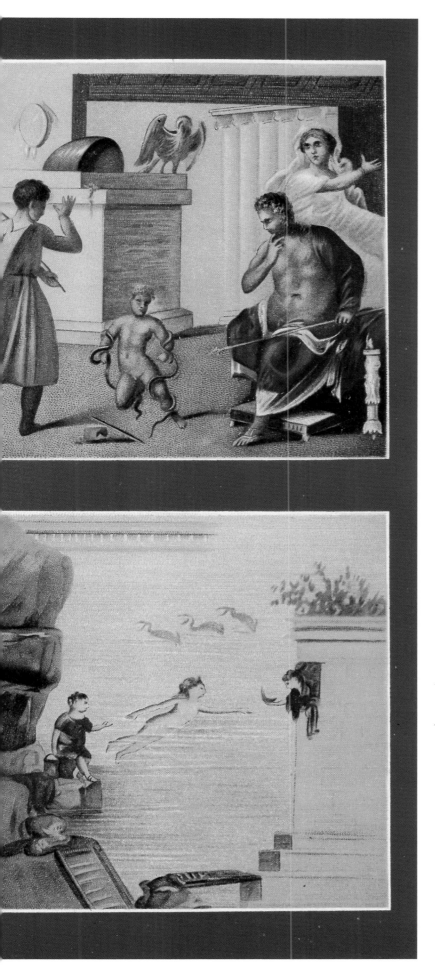

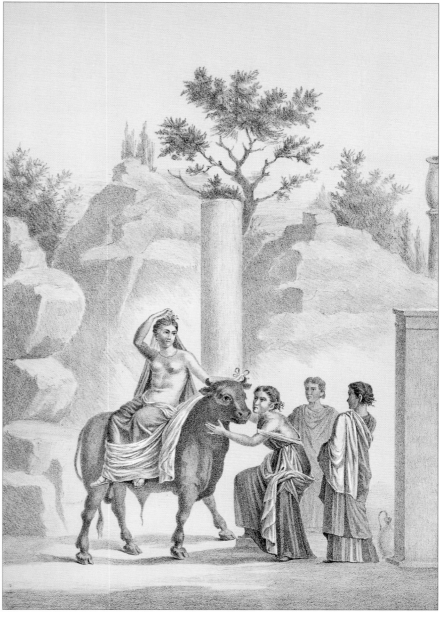

Left 101. G. Cel., *Frescoes of Mythology from the House of the Vettii: The Torment of Pentheus, The Struggle Between Cupid and Pan, The Child Hercules Strangles the Serpents, Ariadne Is Abandoned, Hercules and Augeas, and Hero and Leander* (VI, 15, 1)

Above 102. G. Discanno and D. Capri, *Fresco with Europa on a Bull from the House of Jason* (IX, 5, 18)

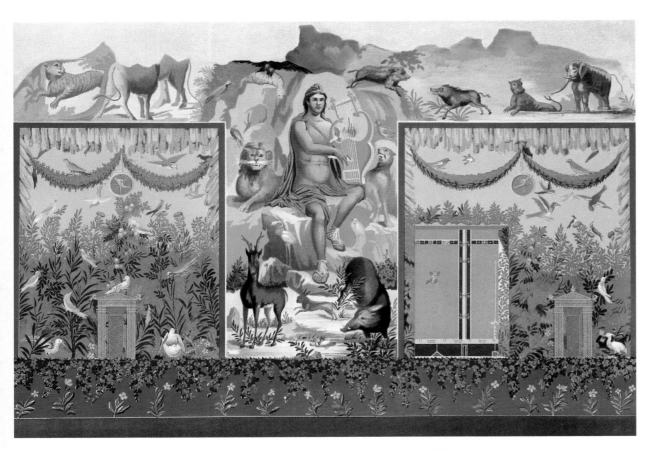

Above 103. Vincenzo Loria, *Frescoed Wall with Orpheus Among Animals from the House of Orpheus or the House of Vesonius Primus* (VI, 14, 20)

Right 104. Vincenzo Loria, *Fresco with a Flowering Garden and Fountains*

Left 105. Vincenzo Loria, *Decorative Motifs from a Fresco*

Below 106. Giuseppe Abbate, *Decorative Motif from a Fresco*

Opposite 107. G. Discanno and D. Capri, *Figures of Satyrs Tightrope Walking from the Villa of Cicero*

Below 108. Giuseppe Abbate, *A Selection of Frescoes with Cherubs, Candelabras, and Frames of Still Lifes*

Opposite, top 109. Vincenzo Loria, *Decorative Motifs from a Fresco*

Opposite, bottom 110. G. Discanno and D. Capri, *Frescoes and Stucco Reliefs*

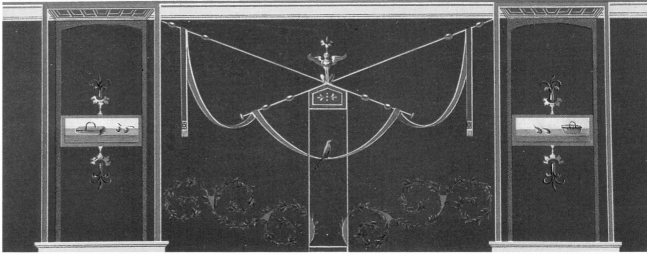

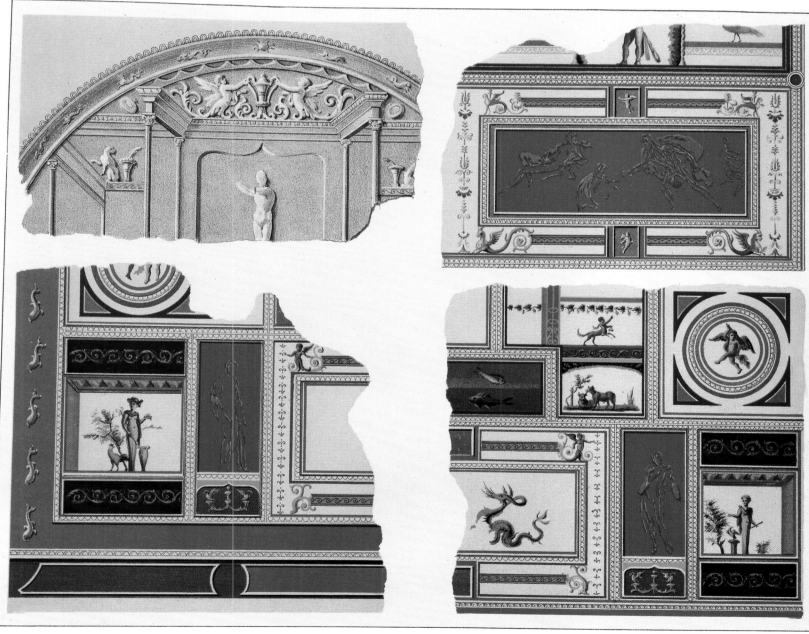

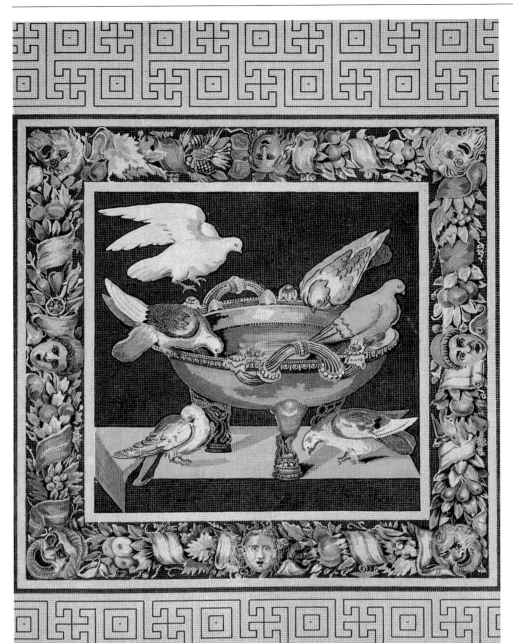

Left 111. G. Discanno and D. Capri, *Floor Mosaic with Doves on a Basin from the House of the Doves* (VII, 2, 34)

Below 112. G. Discanno and D. Capri, *Floor Mosaic with a Central Picture of Actaeon from the House of Julius Polybius* (VI, 17, 19–26)

Opposite 113. Vincenzo Mollame and D. Capri, *Inlay of a Satyr and Maenad Dancing from the House of the Colored Capitals* (VII, 4, 31) *and Floor Mosaic with a Chained Lion and Cherubs from the House of the Centaur* (VI, 9, 3)

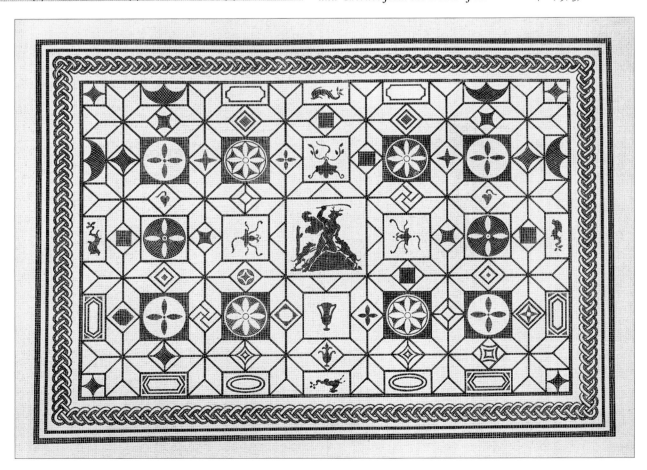

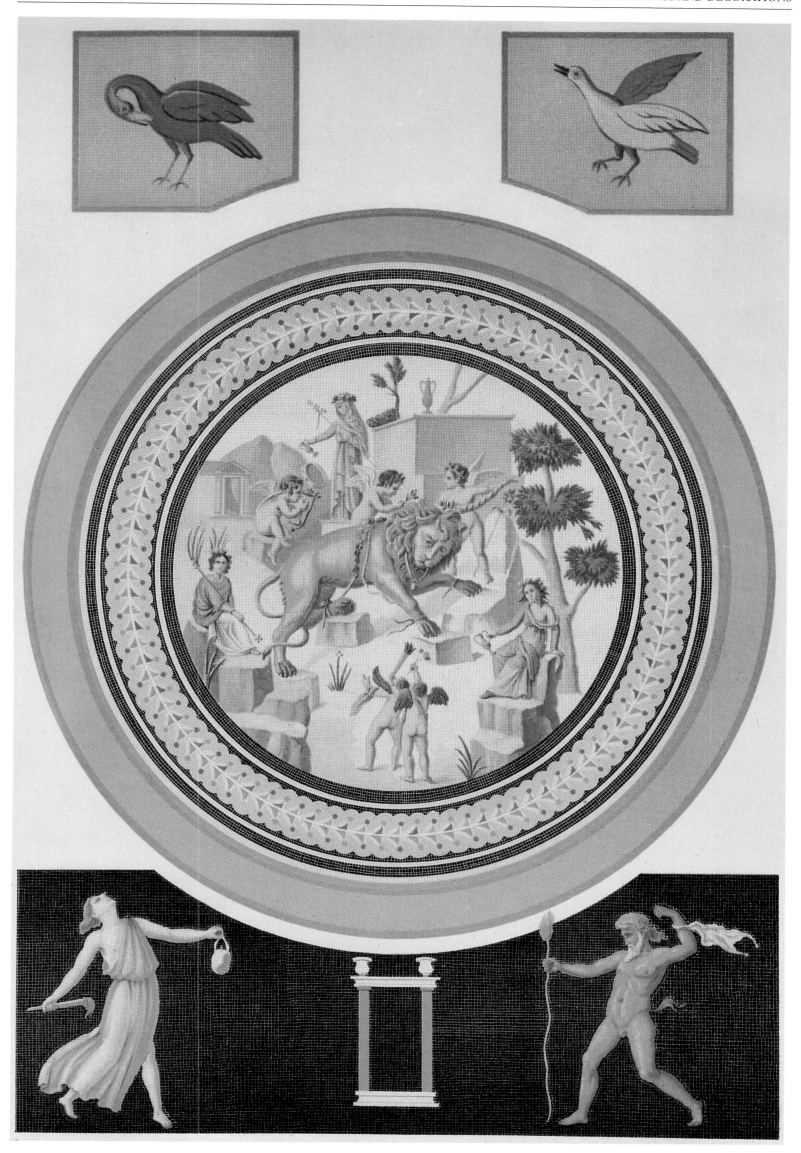

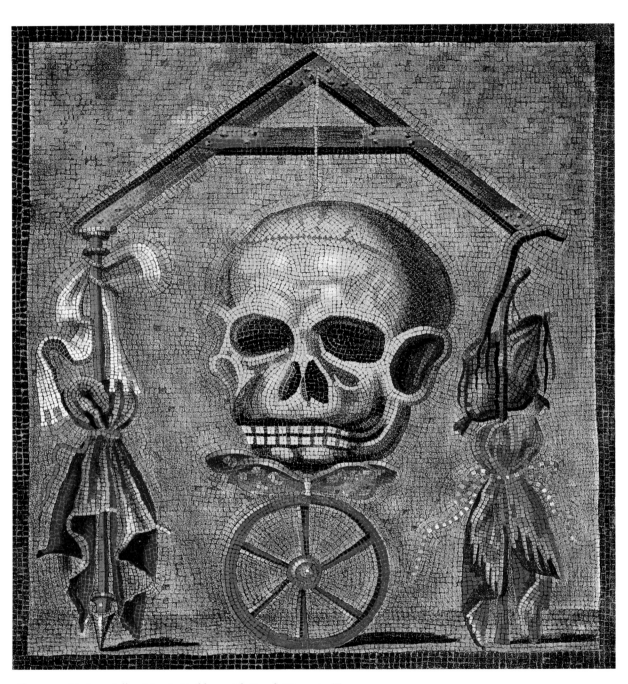

Above 114. G. Autoriello, *Mosaic Emblem with Death Memento-Type Symbols from the Peristyle of the Tannery* (I, 5, 2)

Opposite 115. Vincenzo Loria, *Diagram and Perspective of the Marble Nymphaeum Decorated with Mosaics at the House of the Marble Silenus* (VII, 4, 56)

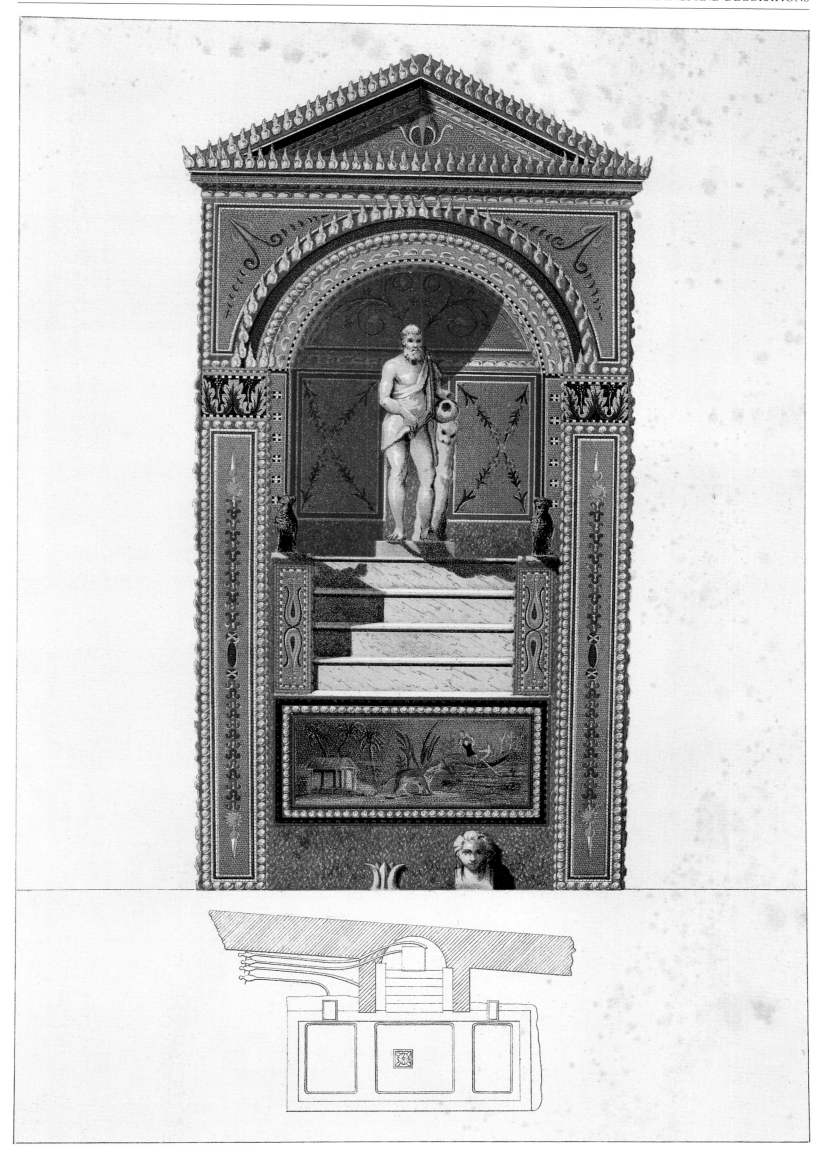

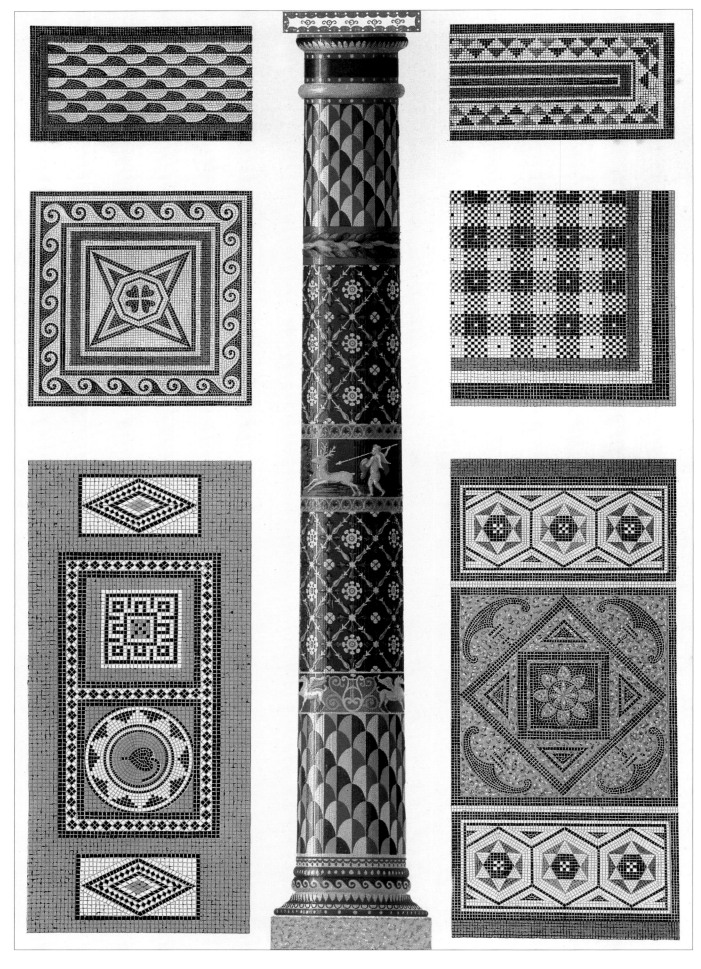

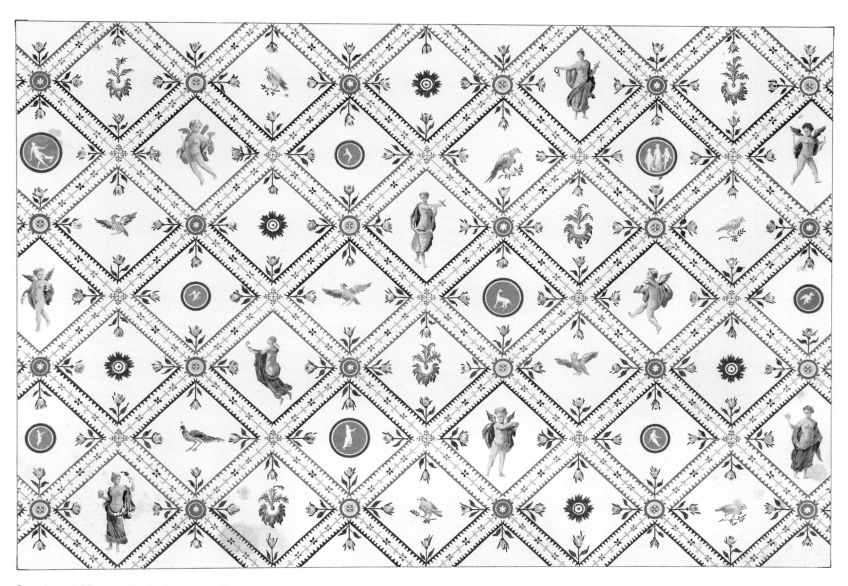

Opposite 116. Vincenzo Loria, *Mosaic Wall Decorations from the Villa of the Columns*

Above 117. Vincenzo Loria, *Ceiling Fresco*

On the following pages: 118. Vincenzo Loria, *View of the Bakery* (IX, 3, 20)

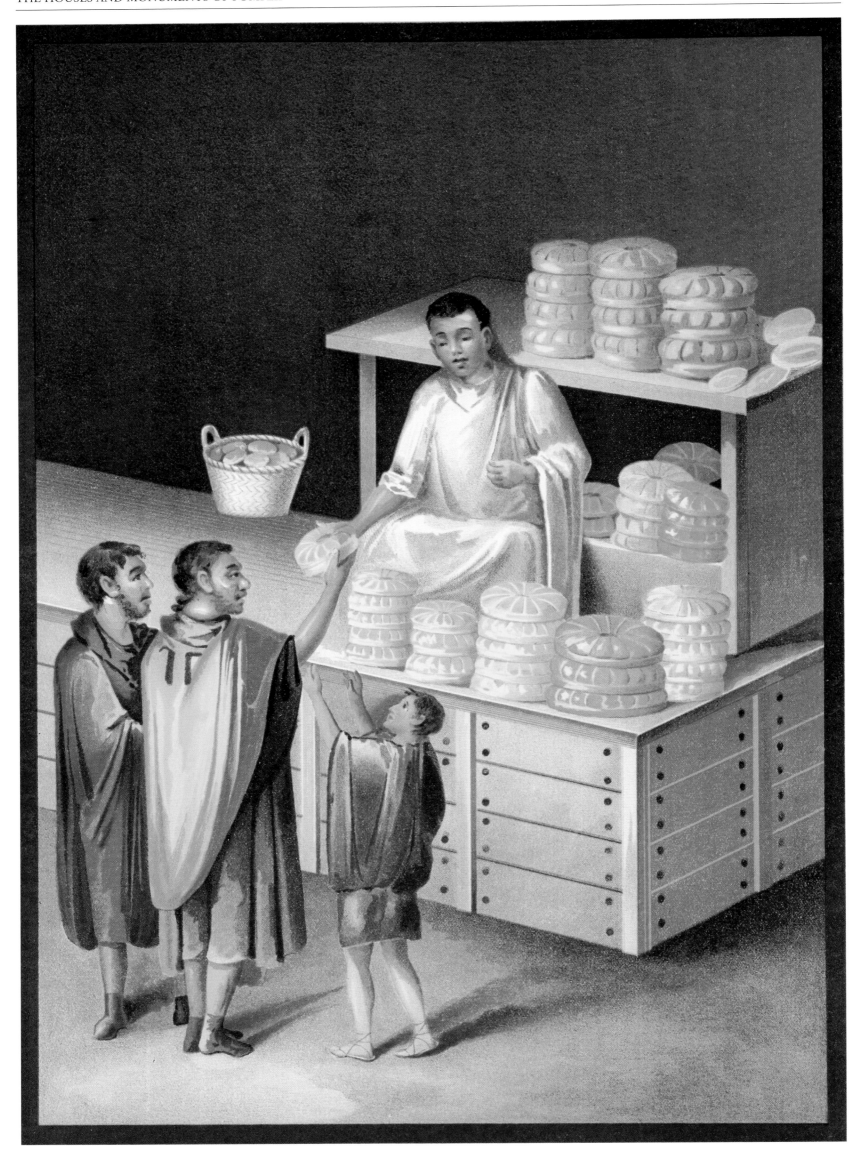

Opposite 119. Vincenzo Loria, *Fresco of a Bakery, also called "Bread Sale," from the Tablinum of the House of the Baker* (VII, 3, 30)

Below left and right 120. Vincenzo Loria, *Frescoes of Fullers and Dyers at Work from the Dye Shop* (VI, 8, 20)

Bottom left 121. G. Discanno and D. Capri, *Fresco of a Procession of Carpenters from the Perfume Shop* (VI, 7, 8–12)

Bottom right 122. G. Discanno and D. Capri, *Fresco from the Tavern Showing the Transfer of Wine from a Wineskin to Amphorae* (VI, 1, 10)

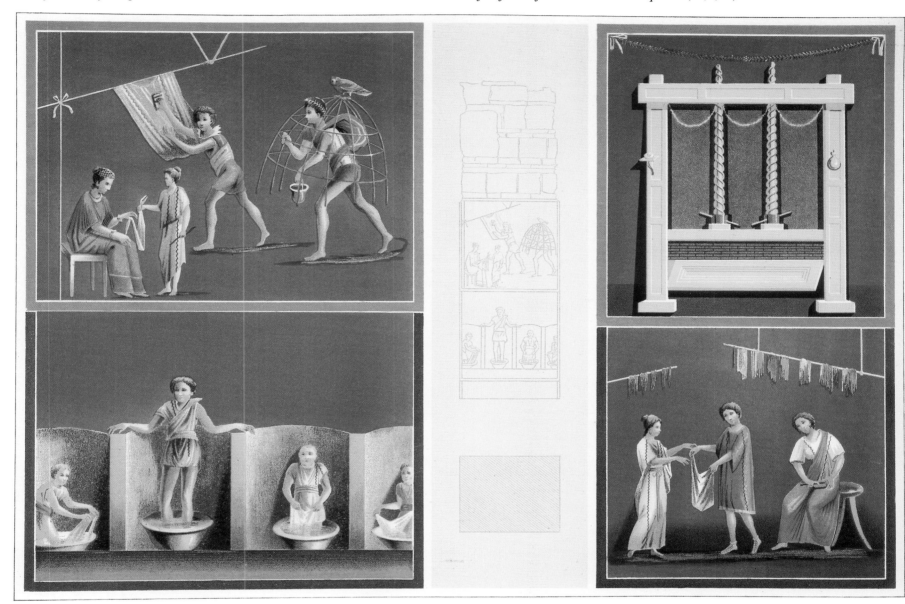

NECROPOLISES

123. Giacinto Gigante, *View of Via dei Sepolcri*

The Herculaneum Gate Necropolis was located along Via dei Sepolcri. This was the most important cemetery of the city, marked by the presence of opulent tombs alternating with luxurious residential complexes such as the so-called villas of Diomedes and Cicero. Besides the usual funerary types of the Roman world, two *schola* tombs can also be found near the gate. A large exedra bench characterized each of these, where travelers could rest.

124. Teodoro Duclère, *View of Tombs Near the Herculaneum Gate on Via
dei Sepolcri*

125. Gaetano Genovese, *Perspective, Cross Section, Diagram, and Projection of Decorative Friezes with Amphitheater Scenes from the Tomb of A. Umbricius Scaurus in the Herculaneum Gate Necropolis*
This was a tomb and an altar on a high, tiered base; its structure contained a square enclosure decorated with stucco figures. The inscription can be translated as follows: *To Aulus Umbricius Scaurus, son of Aulus, of the Menenia tribe, duovir,*

the decurions offer this land for a sepulchral monument, two thousand sesterces for the funeral, and an equestrian statue in the forum. Scaurus the father to the son. The stucco friezes have since been lost. As shown, they presented a lively series distributed over various levels portraying amphitheater shows such as staged hunts and gladiator contests.

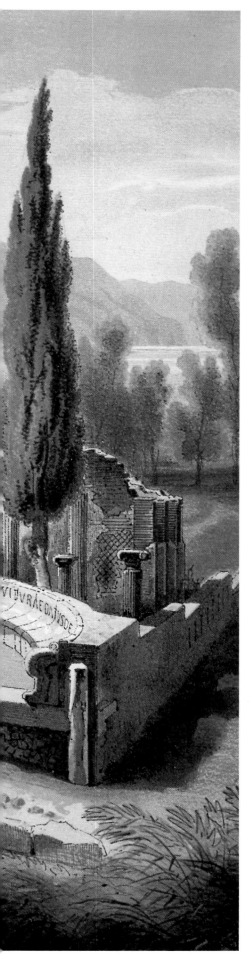

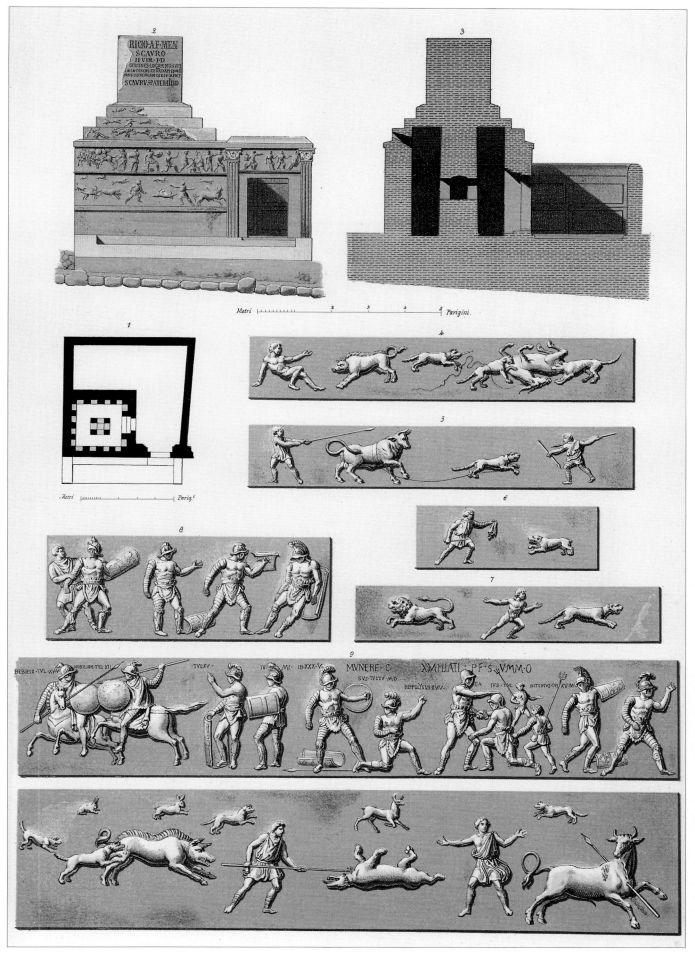

171

126. G. Frauenfelder, *Projection, Cross Section, Diagram, Urn for Ashes, and Decorative Relief Panels from the Tomb of Naevoleia Tyche at the Herculaneum Gate Necropolis*
This was a tomb and altar within an enclosure, similar to that of A. Umbricius Scaurus. On the front of the altar is a small portrait of the deceased, with an inscription and relief depicting a ceremony of public tribute below it. At one end is an image of a ship setting sail, alluding to one of the Roman metaphors of death as voyage. Within the base were a series of niches to hold urns of ashes. At the time the city perished, the prevalent funerary rite was cremation.

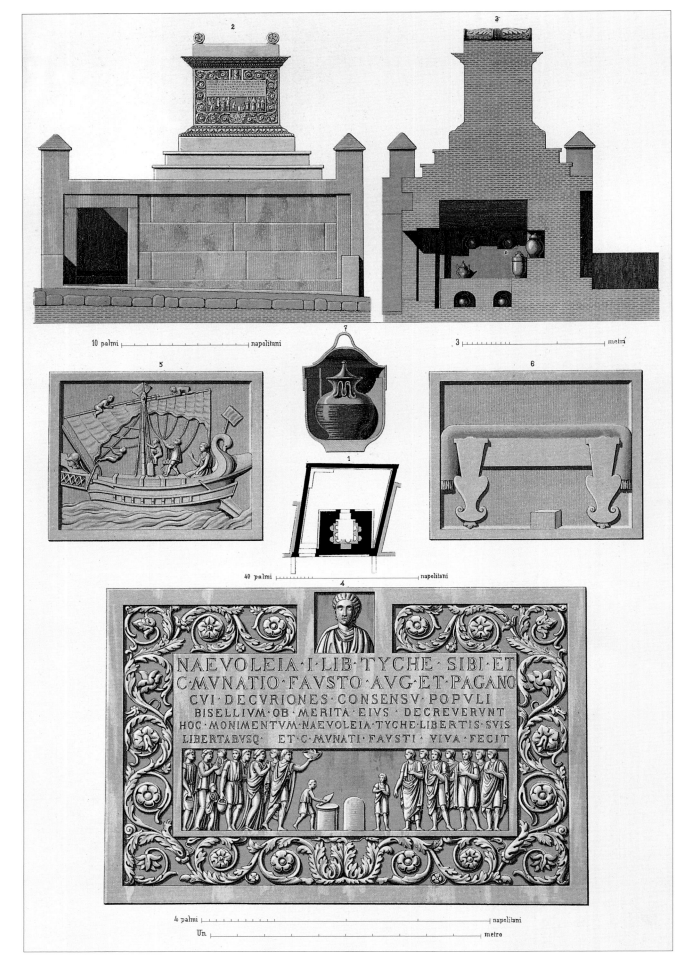

172

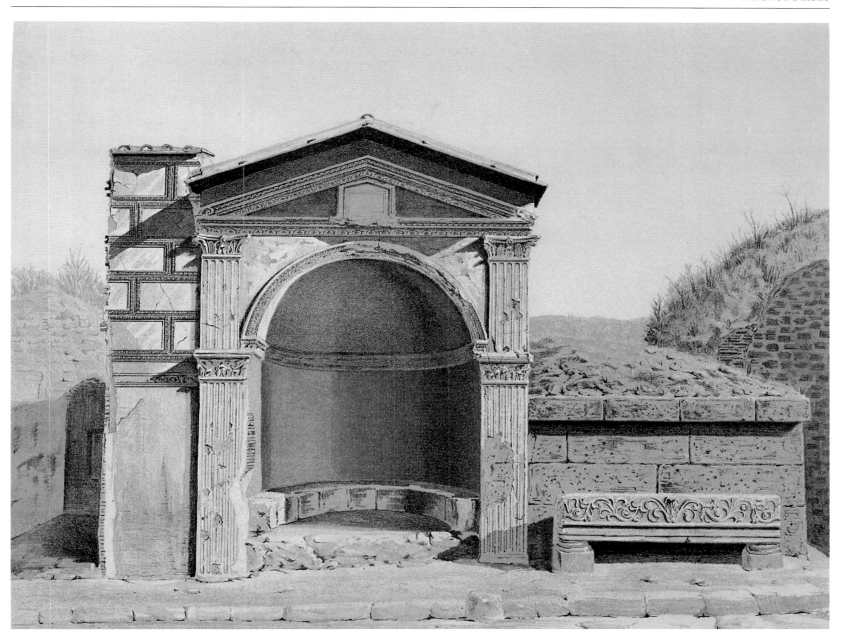

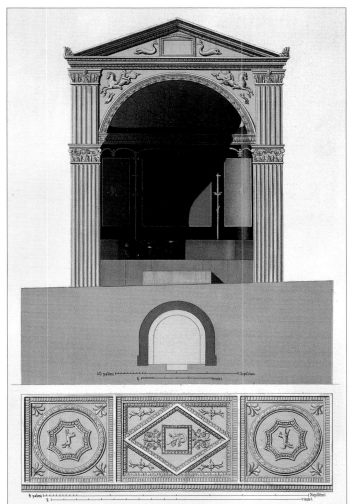

Above 127. A. Magliano and D. Capri, *Monumental Tombs from the Herculaneum Gate Necropolis*

Left 128. Giuseppe Abbate, *Tomb with a Semicircular Niche from the Nola Gate Necropolis*

Above 129. G. Discanno and D. Capri, *Schola Tomb Exedra from the Stabiae Gate Necropolis*

Right 130. G. Discanno and D. Capri, *The Nocera Gate Necropolis After the Excavations of 1886*

HOUSEHOLD OBJECTS

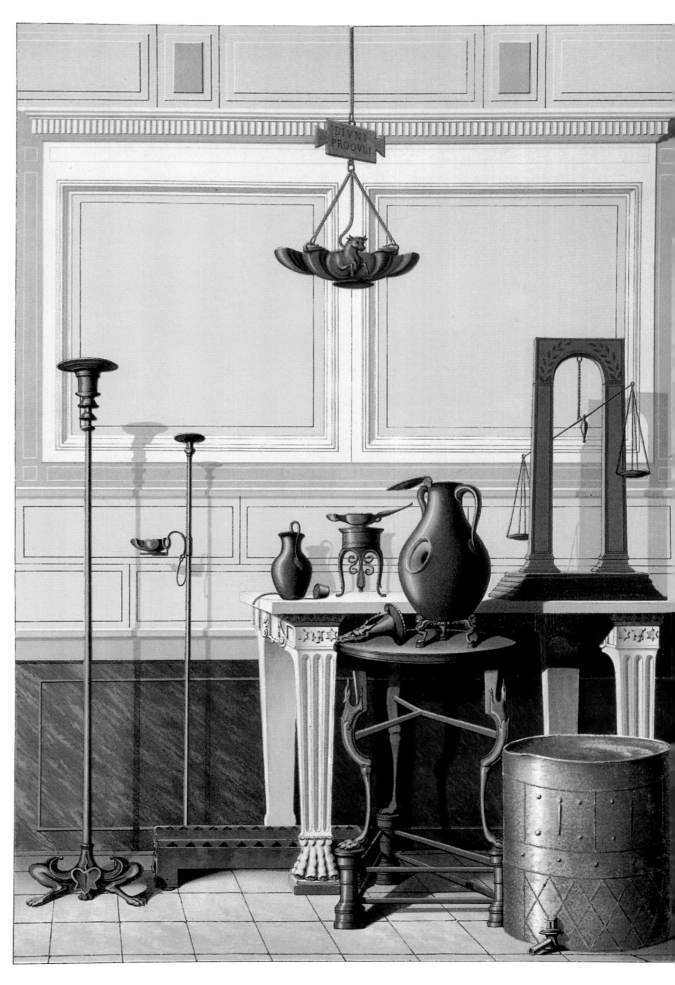

131. Giuseppe Abbate, *Bronze Utensils: a Scale, Lamps, Braziers, Vases, Lamp Stands, and a Lead Tank*

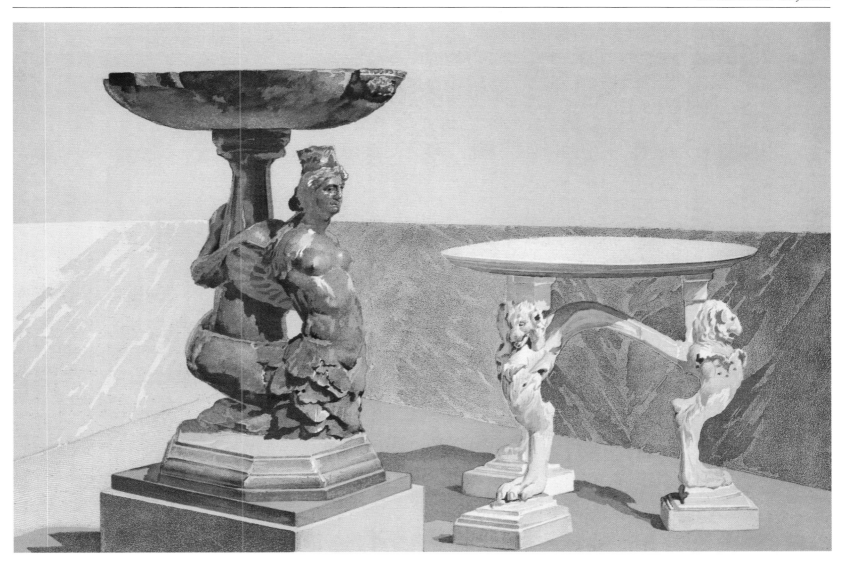

Above 132. A. Carelli and D. Capri, *Marble Furniture*

Left 133. P. Mattej, *Safe with Bronze Knobs and Figurative Ornamentation*

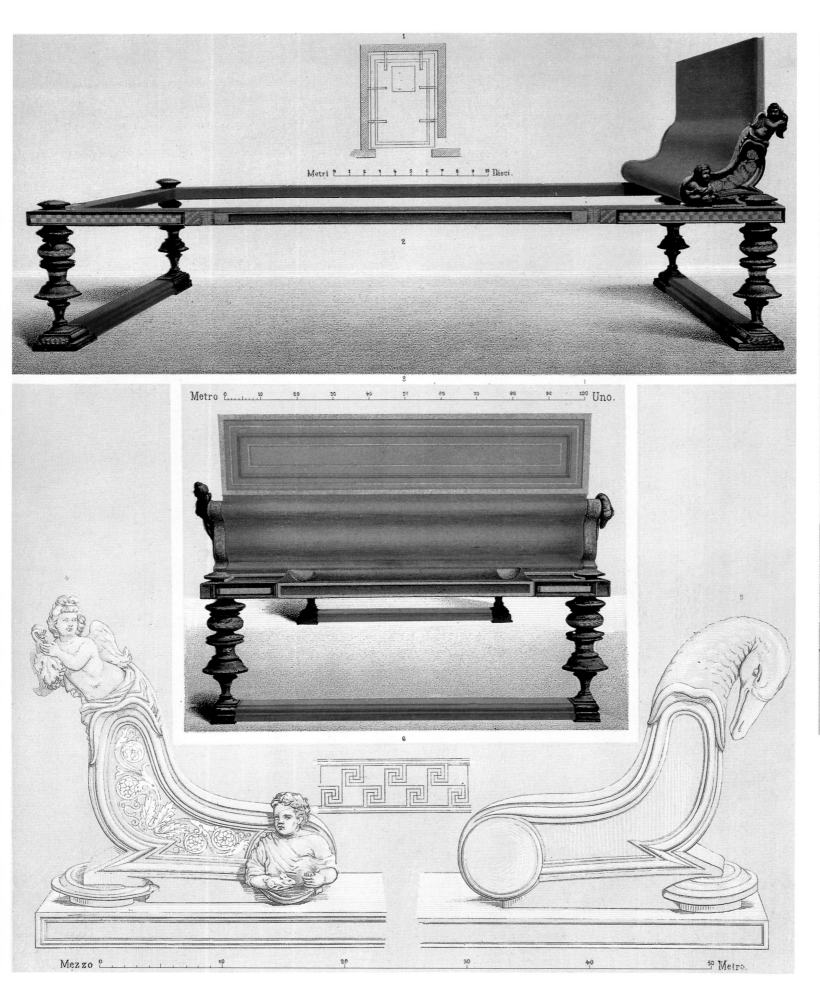

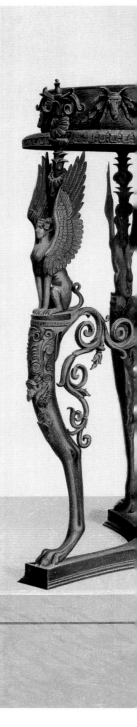

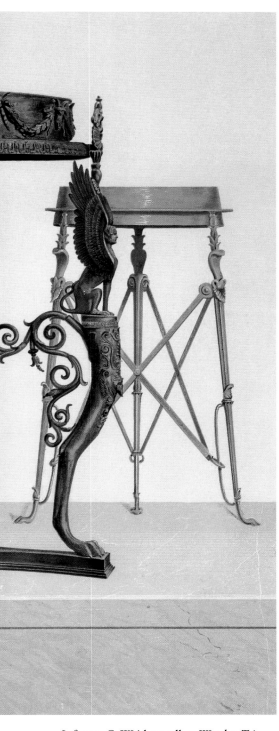

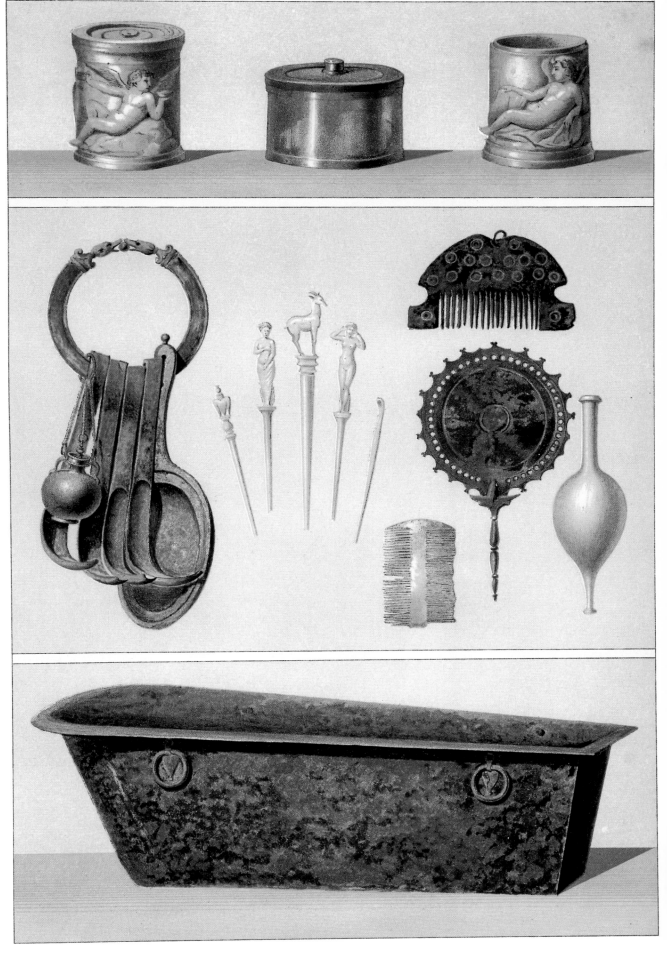

Left 134. C. Weidenmüller, *Wooden Triclinium Bed with Silver-Plated Bronze Decorations*

Above 135. Vincenzo Loria, *Tripods. In front,* a piece originally from the Temple of Isis.

Right 136. Vincenzo Loria, *Bronze Bathtub and Toiletry Objects Made of Bronze or Ivory*

Left 137. Vincenzo Loria, *Common Objects Frescoed as Still Lifes in the Villa of Julia Felix* (II, 4, 3)

Below 138. Vincenzo Loria, *Bronze and Lead Kitchen Objects*

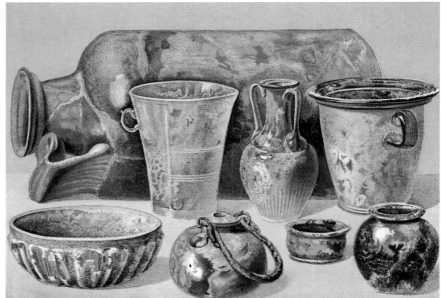

Above left 139. K. Grob, *Keys, Locks, and Bronze Seals,* 1862

Above right 140. Vincenzo Mollame, *Glass Objects*

141. Vincenzo Loria, *Embossed Silver Drinking Cups*

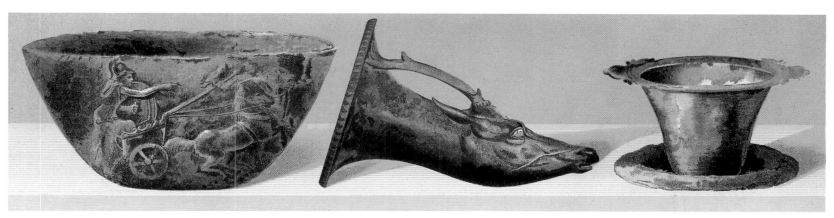

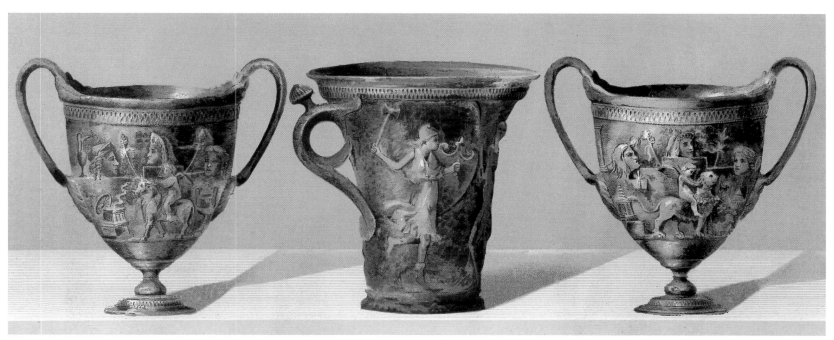

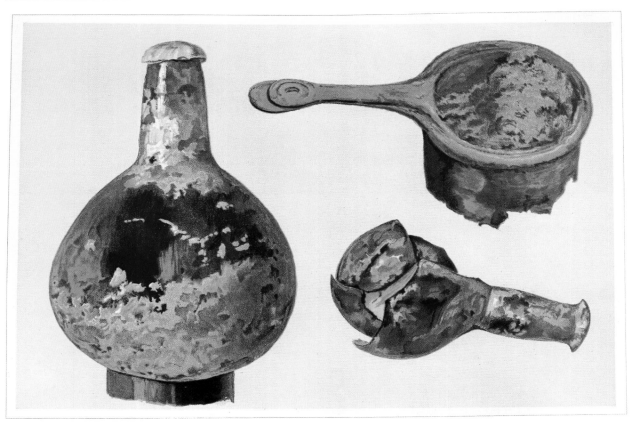

Above 142. Vincenzo Mollame and D. Capri, *Glass Vases*

Right 143. Vincenzo Mollame and D. Capri, *Glass Objects*

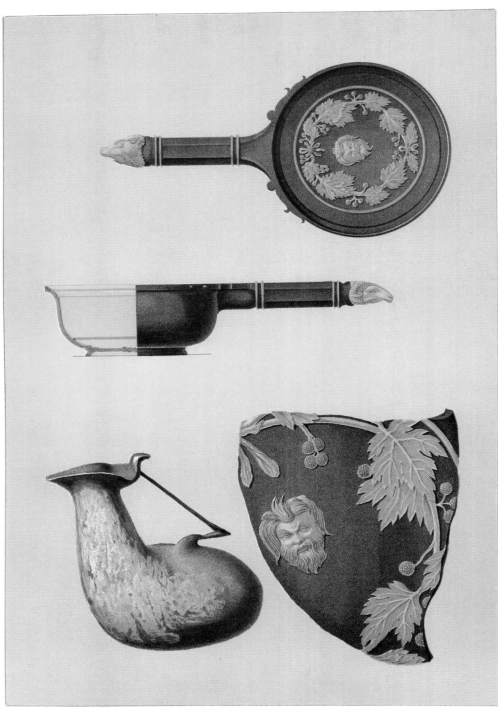

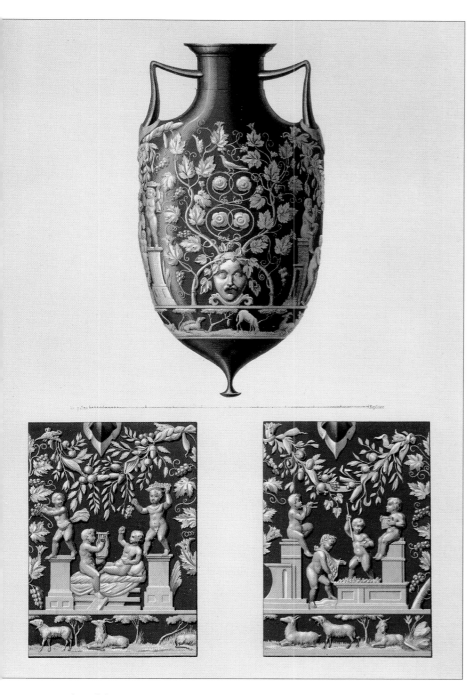

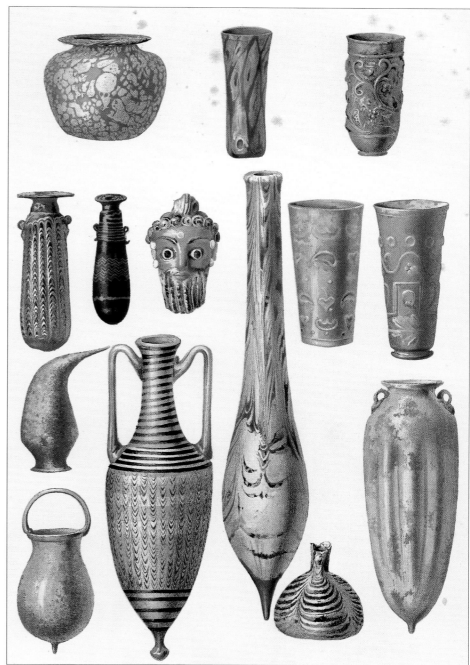

Above left **144. Giuseppe Abbate, *"Blue Vase" from Tomb Eight of the Herculaneum Gate Necropolis***
This vase is one of the most famous pieces ever discovered in the entire city; on a blue background, cherubs picking leaves are portrayed in cameo glass.

Above right **145. Vincenzo Mollame, *Objects Made of Vitreous Paste***

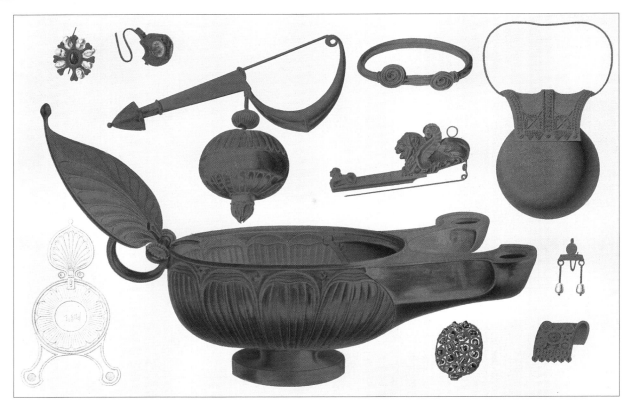

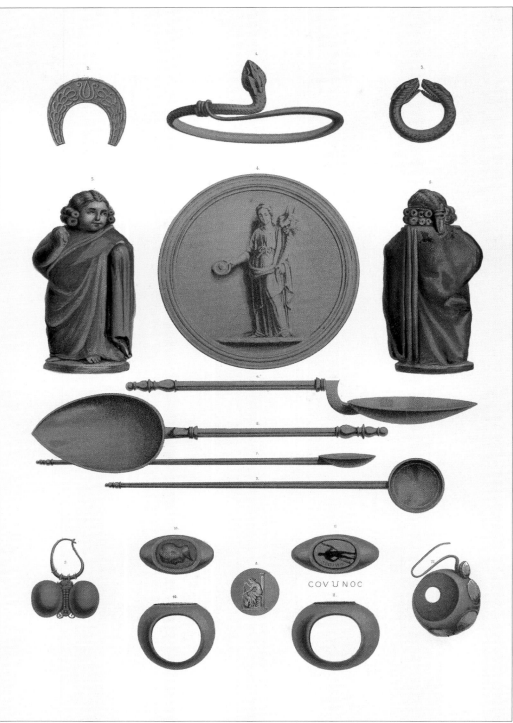

Above 146. Vincenzo Mollame, *Gold Lamps, Seals, Brooches, and Clasps*

Left 147. Vincenzo Mollame, *Precious Objects and Gold Jewelry*

Opposite 148. G. Discanno and D. Capri, *Jewelry*

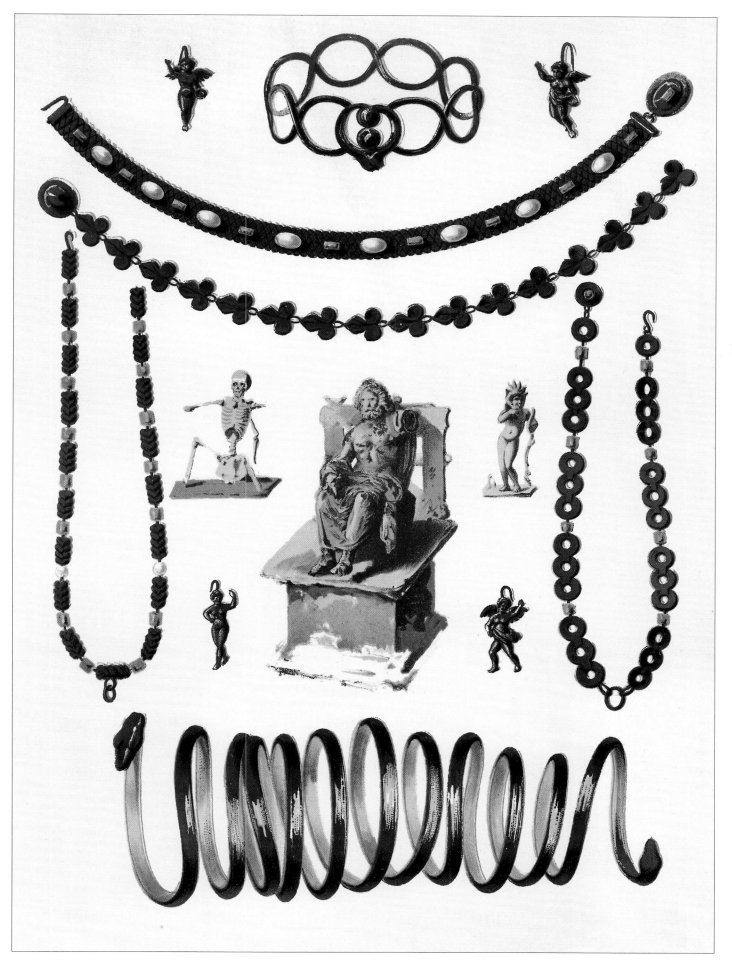

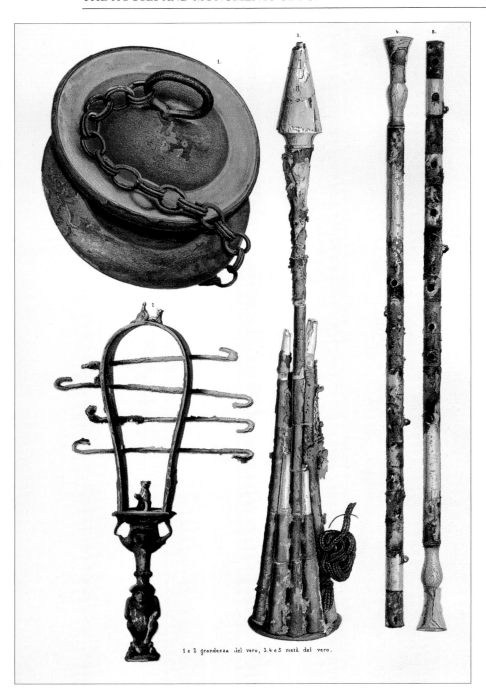

i e 2 grandezza del vero, 3, 4 e 5 metà del vero.

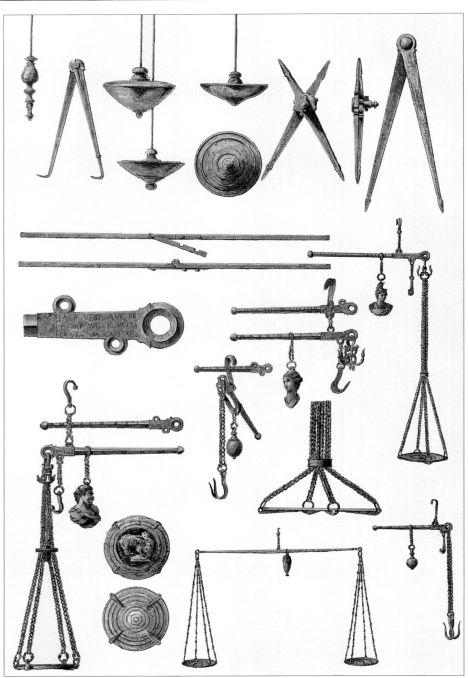

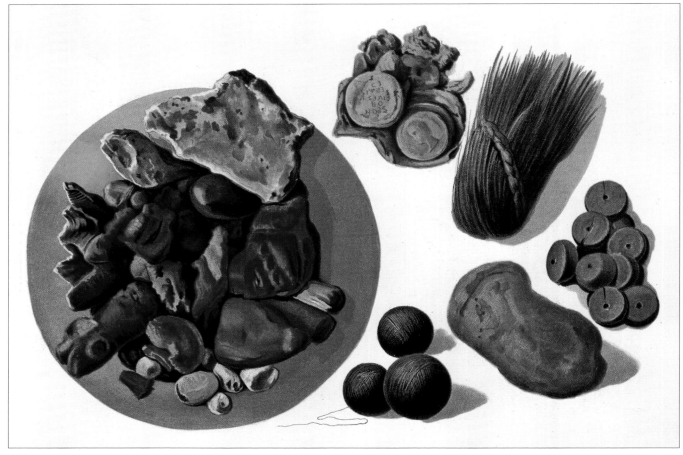

Far left 149. C. Weidenmüller, *Musical Instruments, Including a Sistrum*

Left 150. Vincenzo Loria, *Weights, Calipers, Compasses, and Scales*

Below left 151. Vincenzo Mollame and D. Capri, *Organic Materials*

Below 152. P. Mattej, *Gladiator Display Armor from the So-Called Gladiator Barracks* (VII, 7, 16)

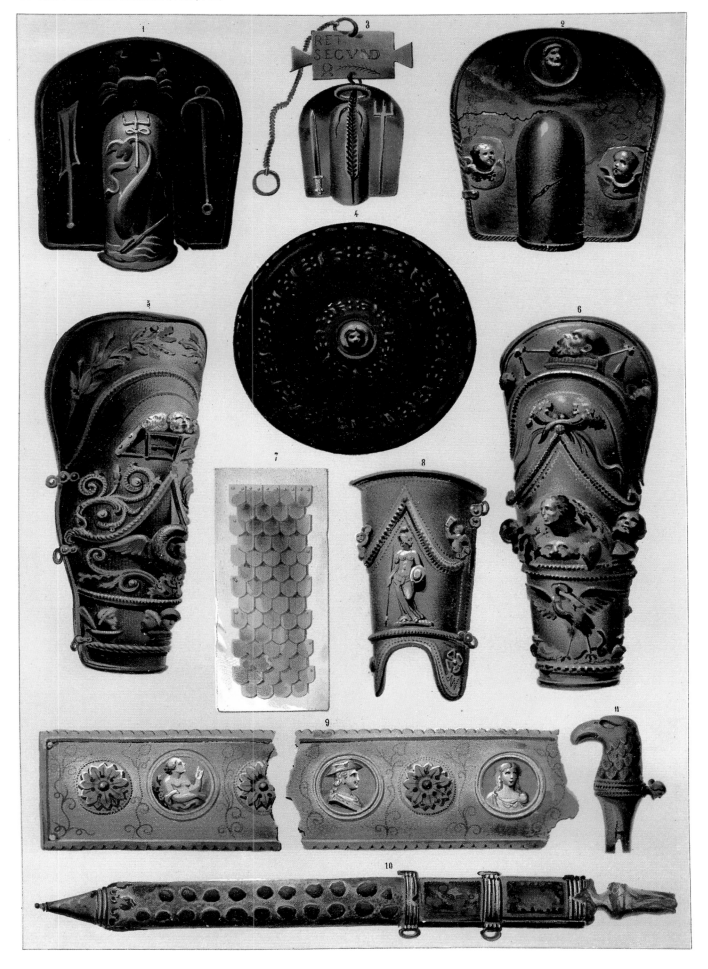

153. K. Grob, *Casts Made for the First Time in February 1863 by Giuseppe Fiorelli*

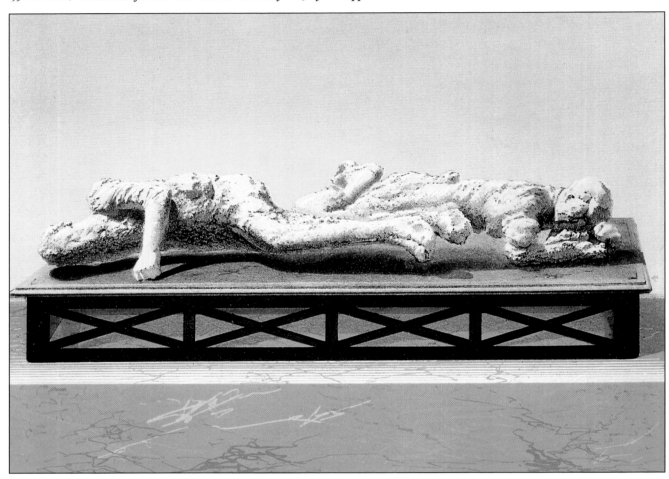

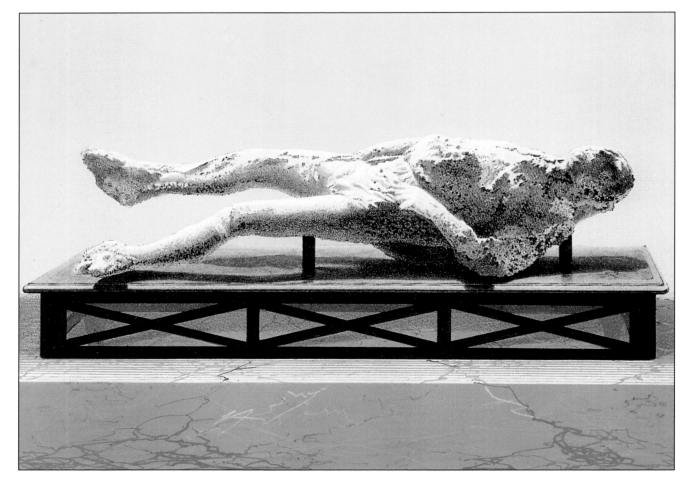

154. G. Discanno and D. Capri, *Plaster Cast of a Body, Door, and Tree Trunk*

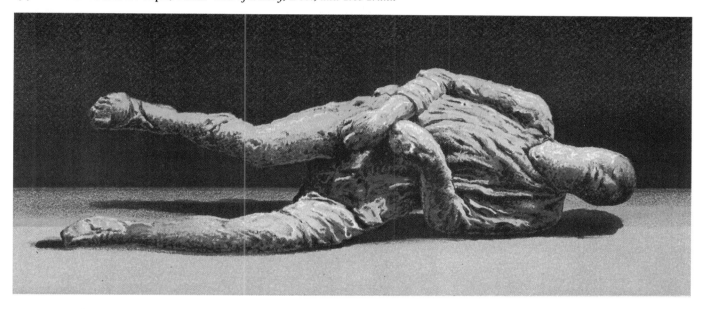

Above 155. G. Autoriello, *A Selection of Electoral Signs Painted on the City Walls*
These are eight inscriptions that publicize the names of Marcus Holconius Priscus and Marcus Cerrinius Vatia, both candidates for aedile (magistrate). The fourth refers to an amphitheater show being held.

Right 156. G. Cialente, *Graffiti with Caricatures and Images of Gladiators from the Theater Hall, the House of the Dioscuri, and from the House of the Labyrinth*
Note the eighth example, which refers to the brawl of A.D. 59 (*Corpus Inscriptionum Latinarum*, 4:1293).

Opposite 157. Fausto Niccolini and Felice Niccolini, *Frescoes with Banquet Scenes and a Painted Inscription from the Triclinium in the House of the Triclinium* (V, 2, 4)

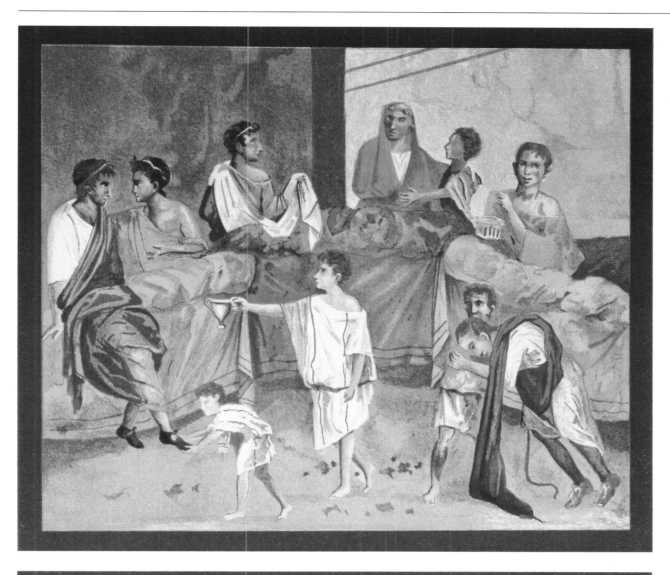

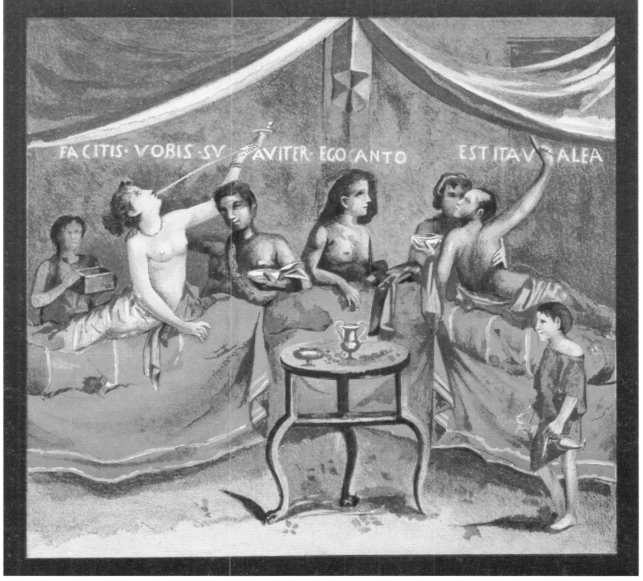

FACITIS·VOBIS·SV AVITER·EGO·ANTO EST ITAV ALEA

POMPEII AS IT WAS

Below 158. G. Autoriello, *House of the Tragic Poet* (VI, 8, 3–5)

Opposite 159. G. Discanno and D. Capri, *Ideal Reconstruction of the House of the Tragic Poet Interior* (VI, 8, 3–5)

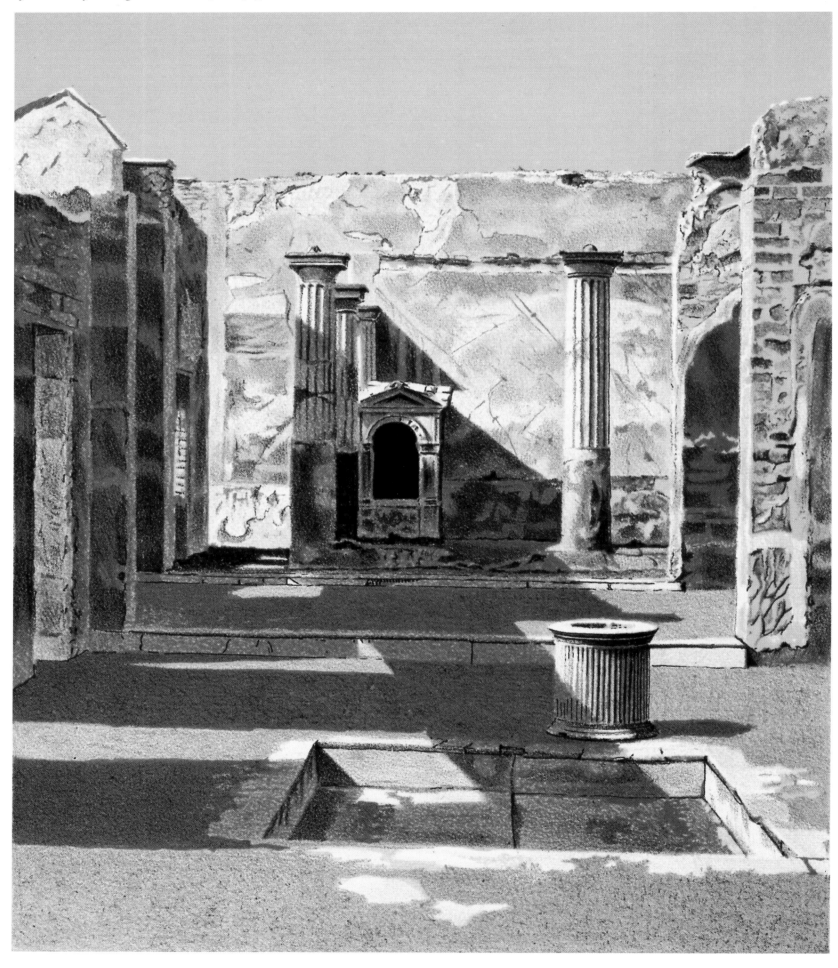

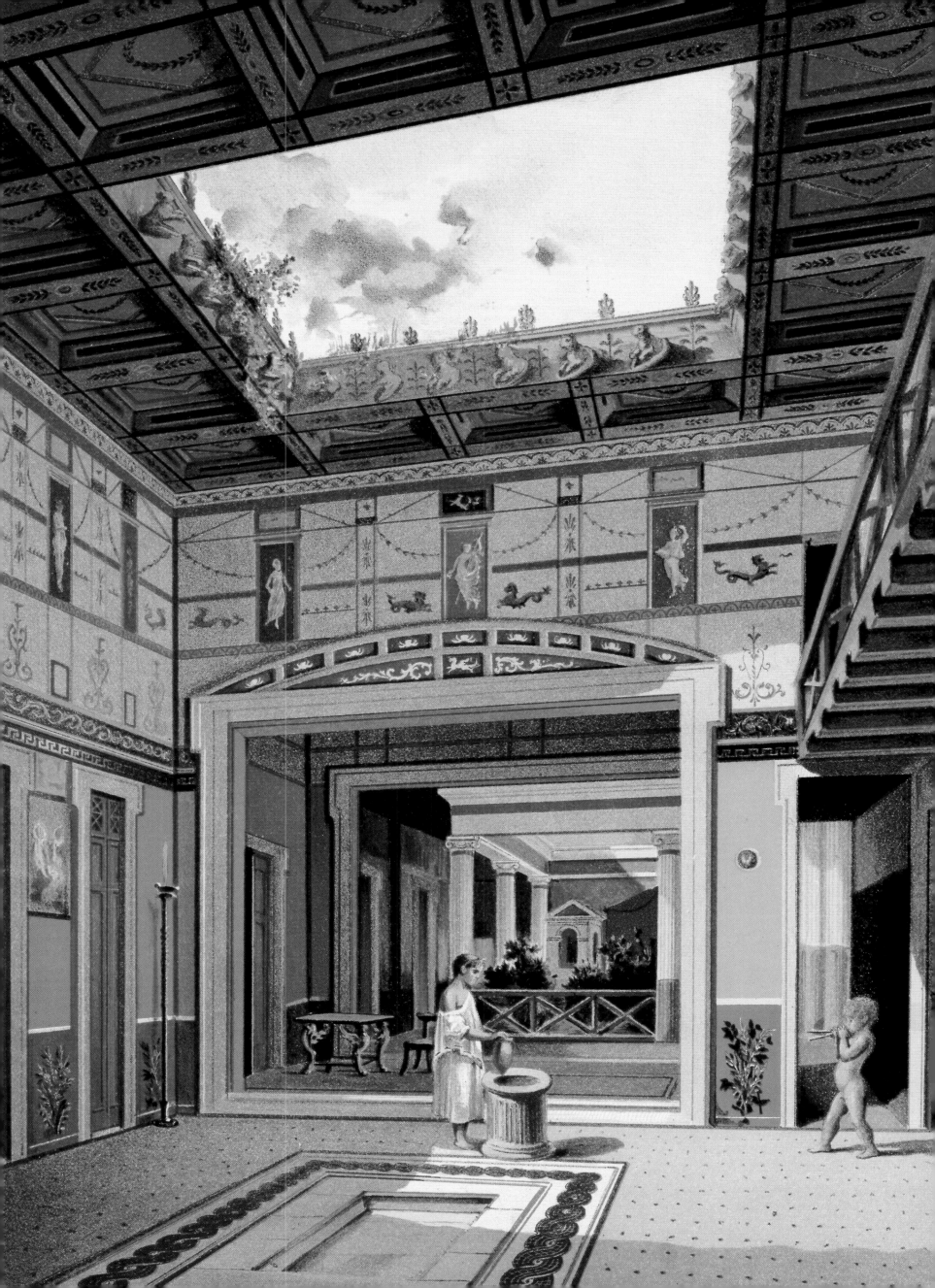

Top 160. G. Autoriello, *Tepidarium Interior from the Forum Baths* (VII, 5, 24)

Bottom 161. G. Discanno and D. Capri, *Ideal Reconstruction of the Tepidarium Interior from the Forum Baths* (VII, 5, 24)

Opposite, top 162. G. Autoriello, *Interior of the House of Marcus Lucretius* (IX, 3, 5)

Opposite, bottom 163. G. Autoriello, *Interior of the House of Marcus Lucretius* (IX, 3, 5)

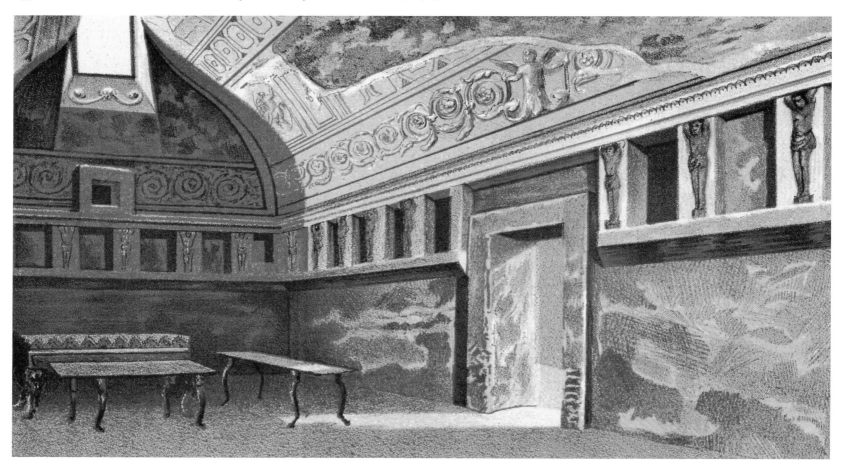

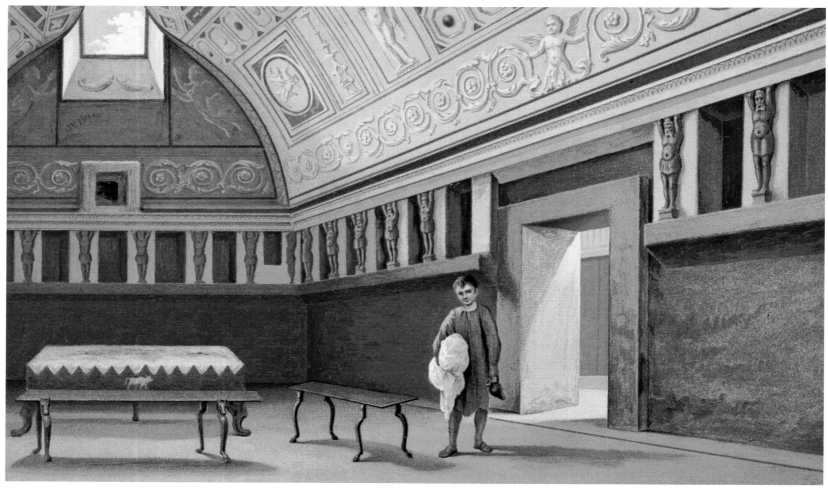

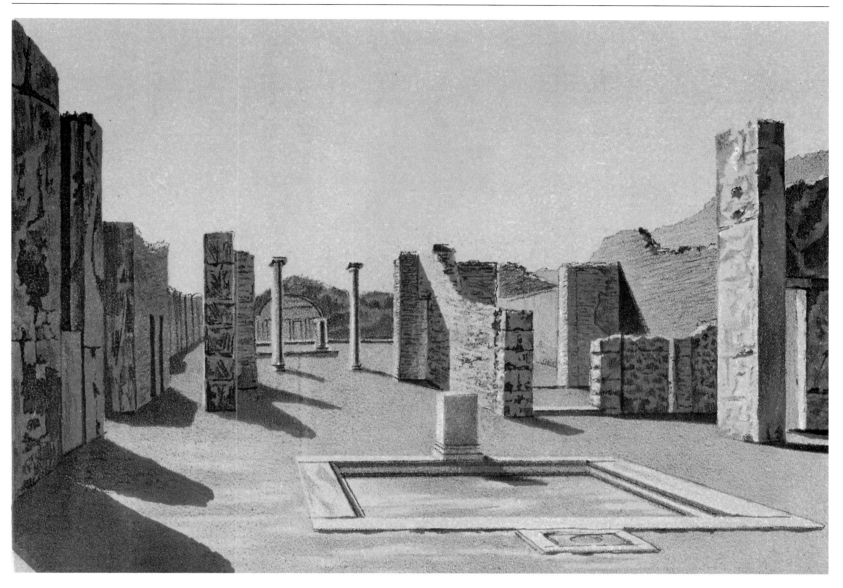

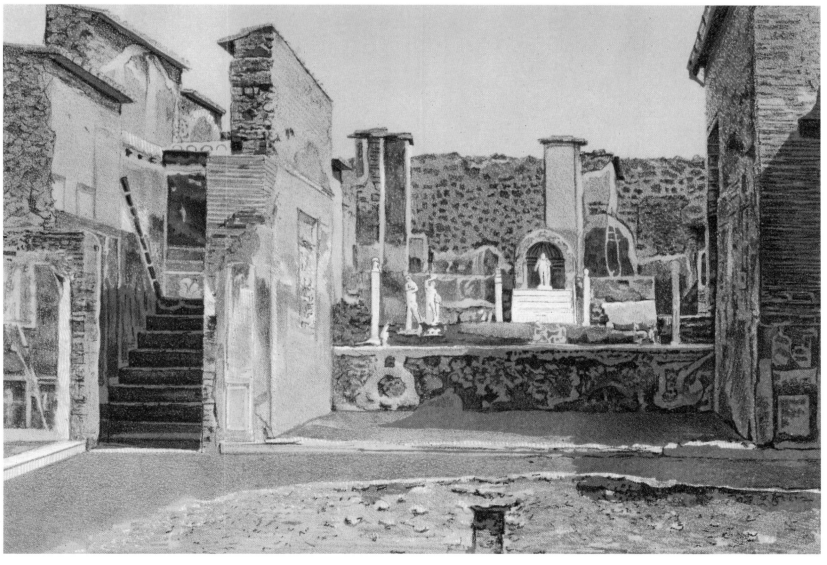

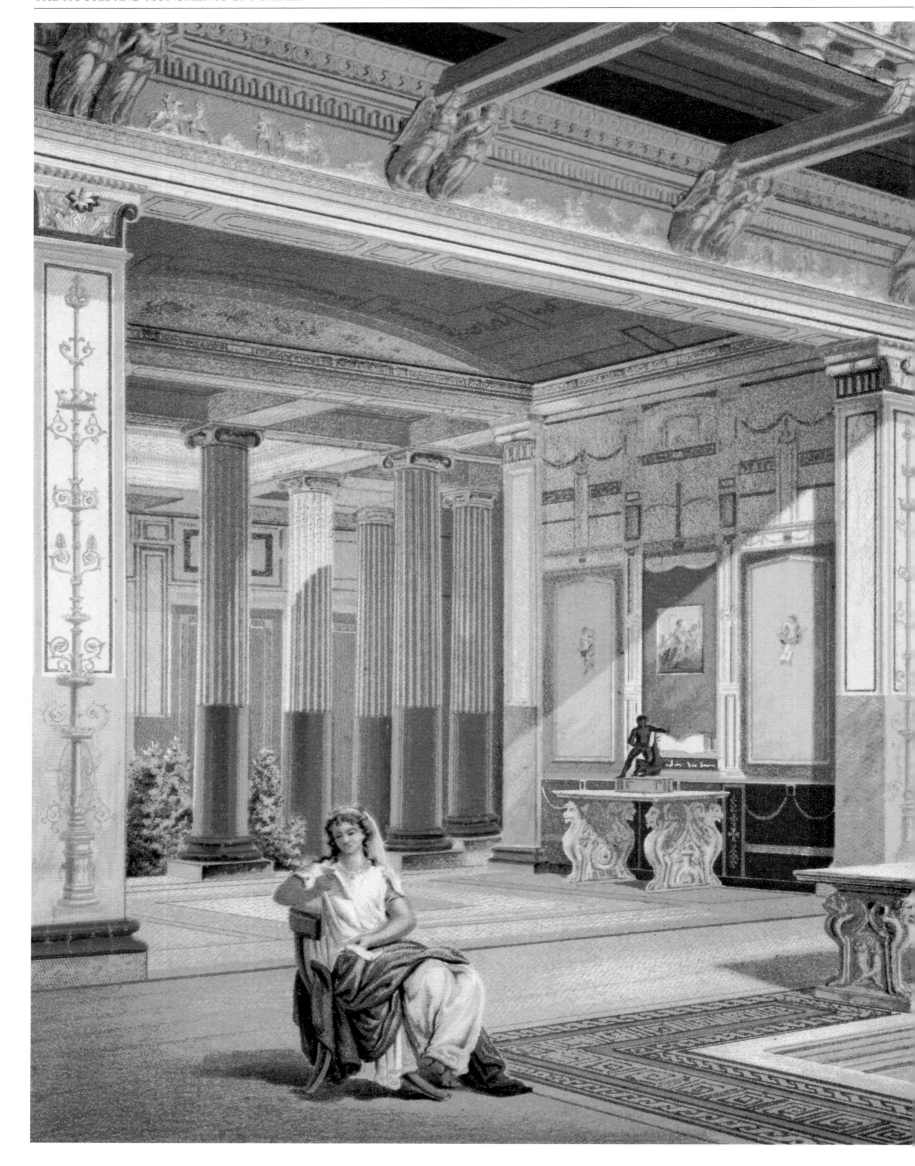

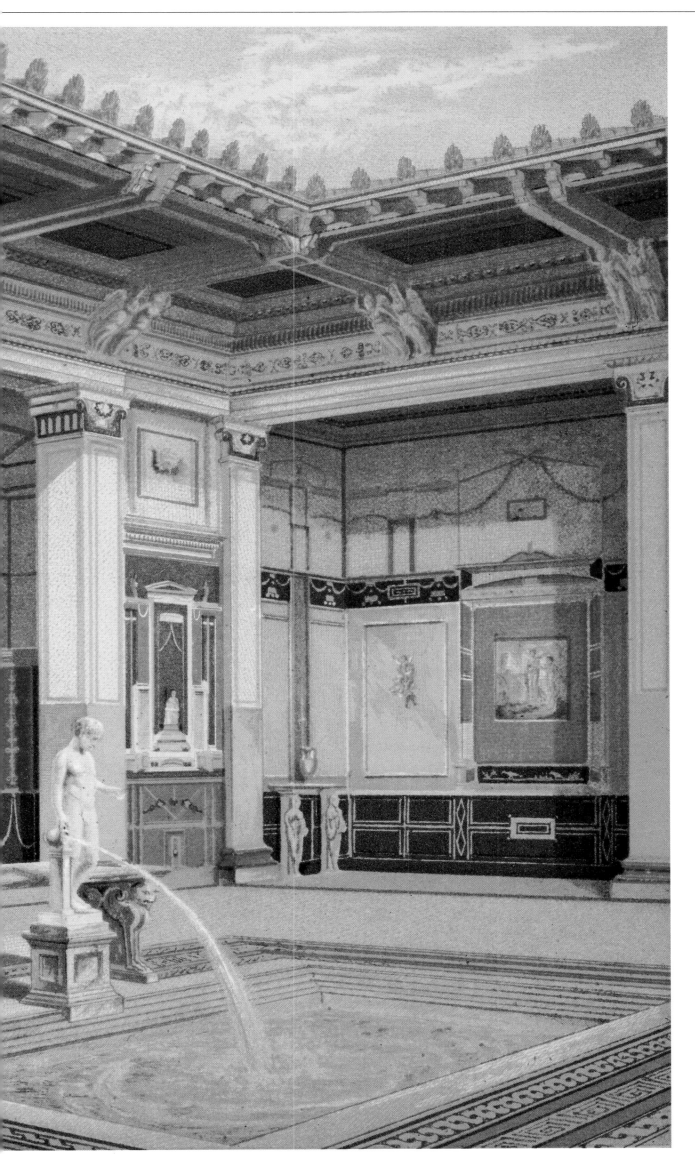

**164. D. Capri, *Ideal Reconstruction
of the House of Marcus Lucretius***
(IX, 3, 5)
Archaeologists discovered the name
of the owner of this house in a room
near the garden. A small fresco por-
trayed a letter addressed to Marcus
Lucretius, a priest of Mars and decu-
rion (assembly member) of Pompeii.
The house is famous for its dynamic
garden, whose centerpiece was a foun-
tain that gushed water from a marble
Silenus. Numerous statues of satyrs
and other busts on columns sur-
rounded it.

Above 165. G. Autoriello, *Frigidarium from the Forum Baths* (VII, 5, 24)

Opposite 166. O. Dressler, *Ideal Reconstruction of the Stabian Baths Frigidarium*

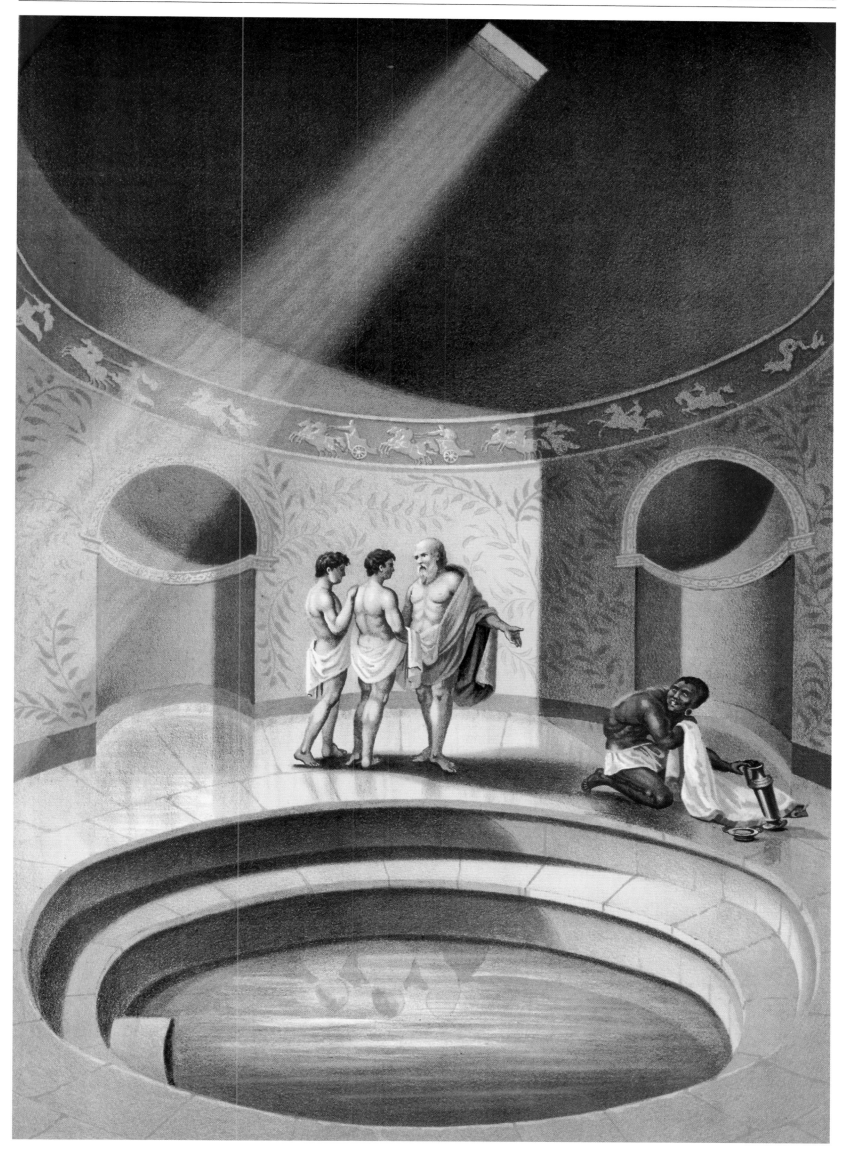

Below 167. G. Autoriello, *House with Overhanging Balcony*

Opposite 168. G. Discanno and D. Capri, *Ideal Reconstruction of an Overhanging Balcony and a Shop*

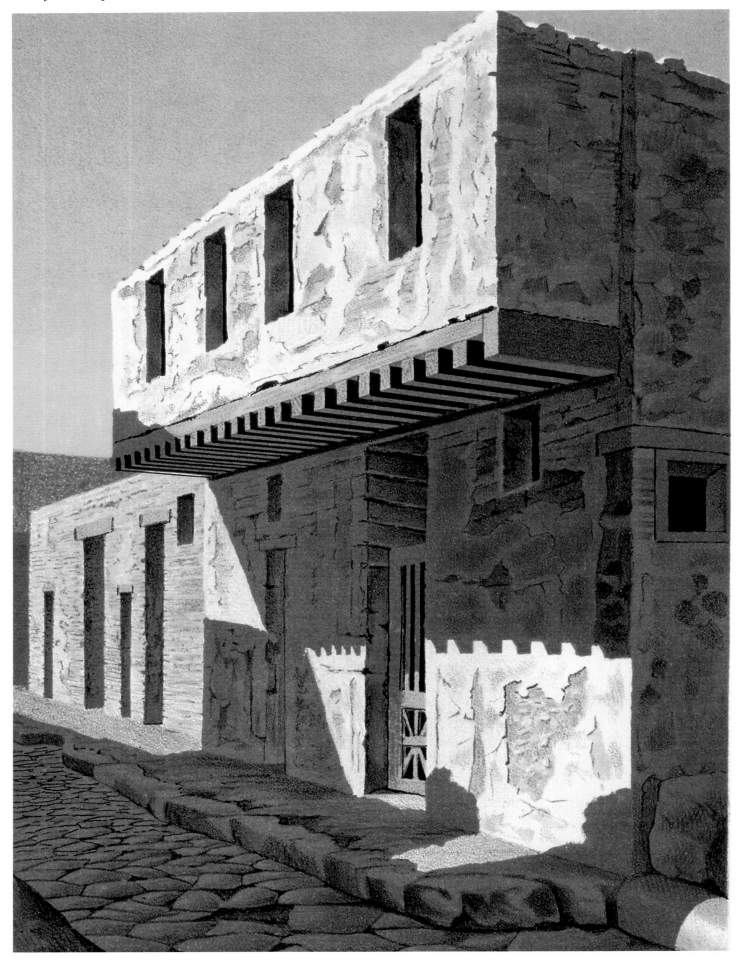

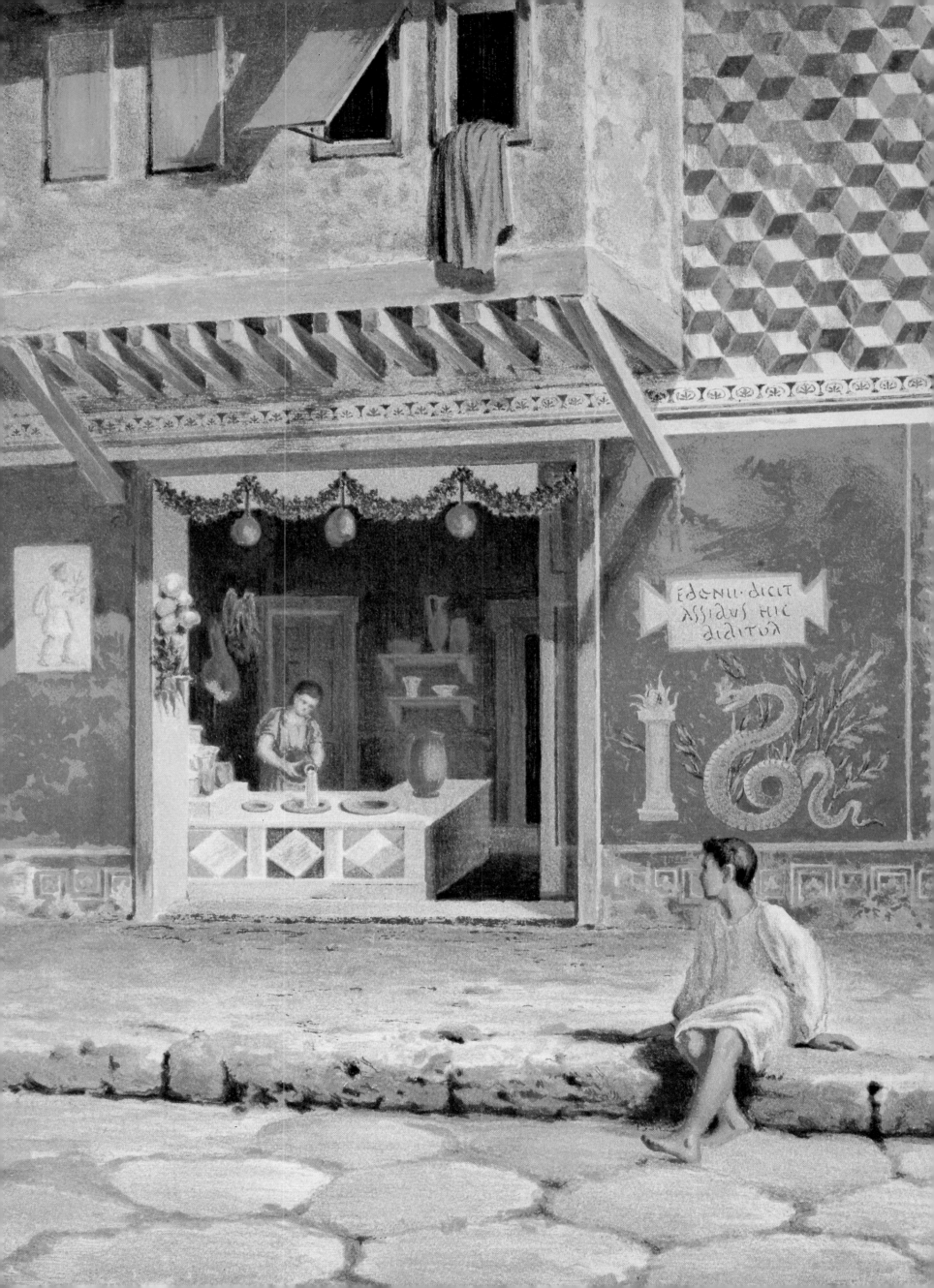

169. G. Cel. And D. Capri, *Ideal Reconstruction of an Amphitheater on Show Day with a Crowd Entering* (II, 6)
This image is especially effective because it makes use of the fresco portraying the brawl that was discovered in the House of Gladiator Actius Anicetus.

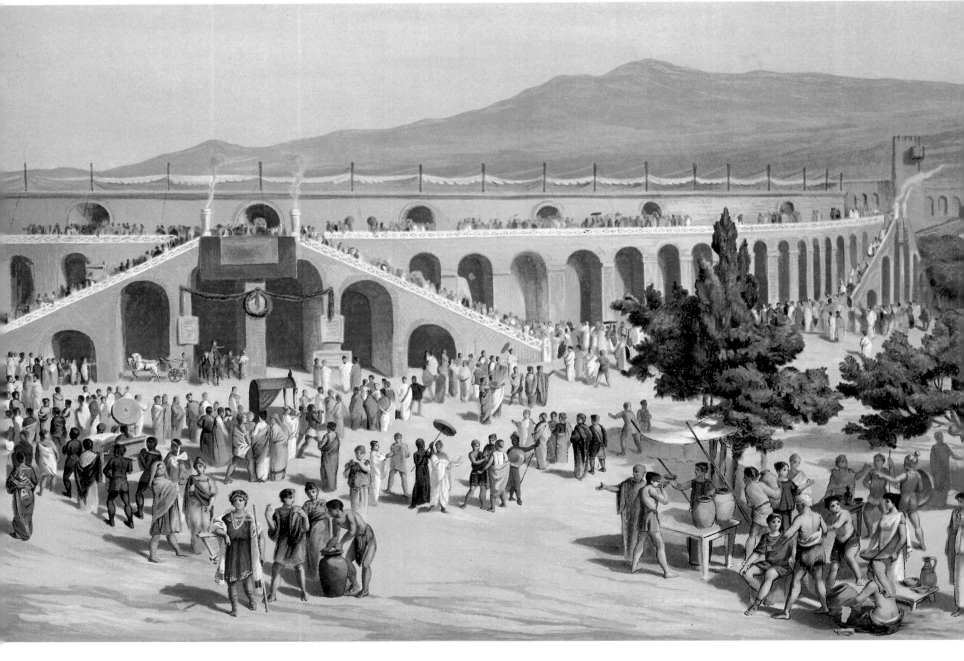

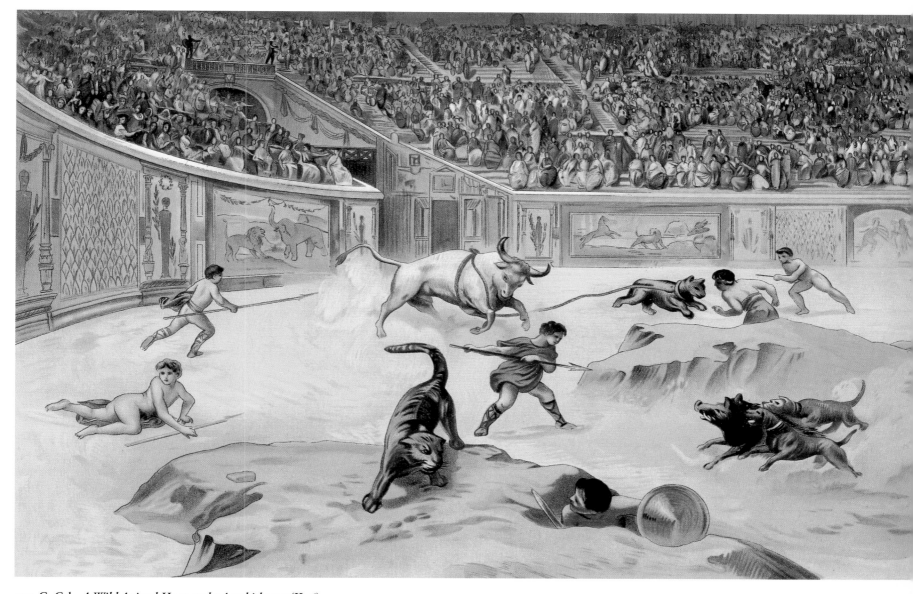

170. G. Cel., *A Wild Animal Hunt at the Amphitheater* **(II, 6)**
This image makes use of many sources to accurately reconstruct the painted friezes
on the arena's enclosure walls and podiums. These have since been lost, although
they had survived up until the first decades of the nineteenth century.

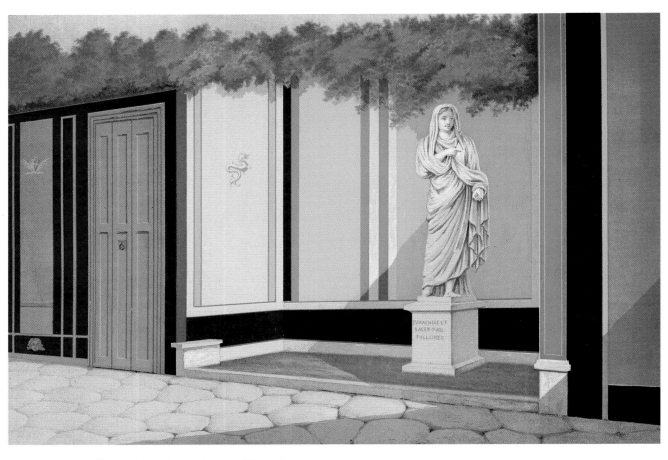

171. Vincenzo Mollame and D. Capri, *Statue of Eumachia in the Eumachia Building* **(VII, 9, 1)**

A private citizen, the priestess Eumachia generously funded one of the monuments facing the Pompeian Forum. Two inscriptions assure the correct identification of the building, which dates from either the Augustan or Tiberian period. One at the entrance at Via dell'Abbondanza states, *Eumachia, daughter of Lucius, public priestess, in her own name and that of her son, Marcus Numistrius Frontone, paid for the building of the vestibule, the covered hallway, and the porticoes; she herself dedicated it to Concordia and Augustan Piety.* The building appears to be a refined and articulated structure, although how it was utilized remains a mystery.

172. G. De Simone and D. Capri, *Ideal Reconstruction of the Temple of Fortuna Augusta (VII, 4, 1) at the Crossroads Between Via del Foro and Via di Nola*

206

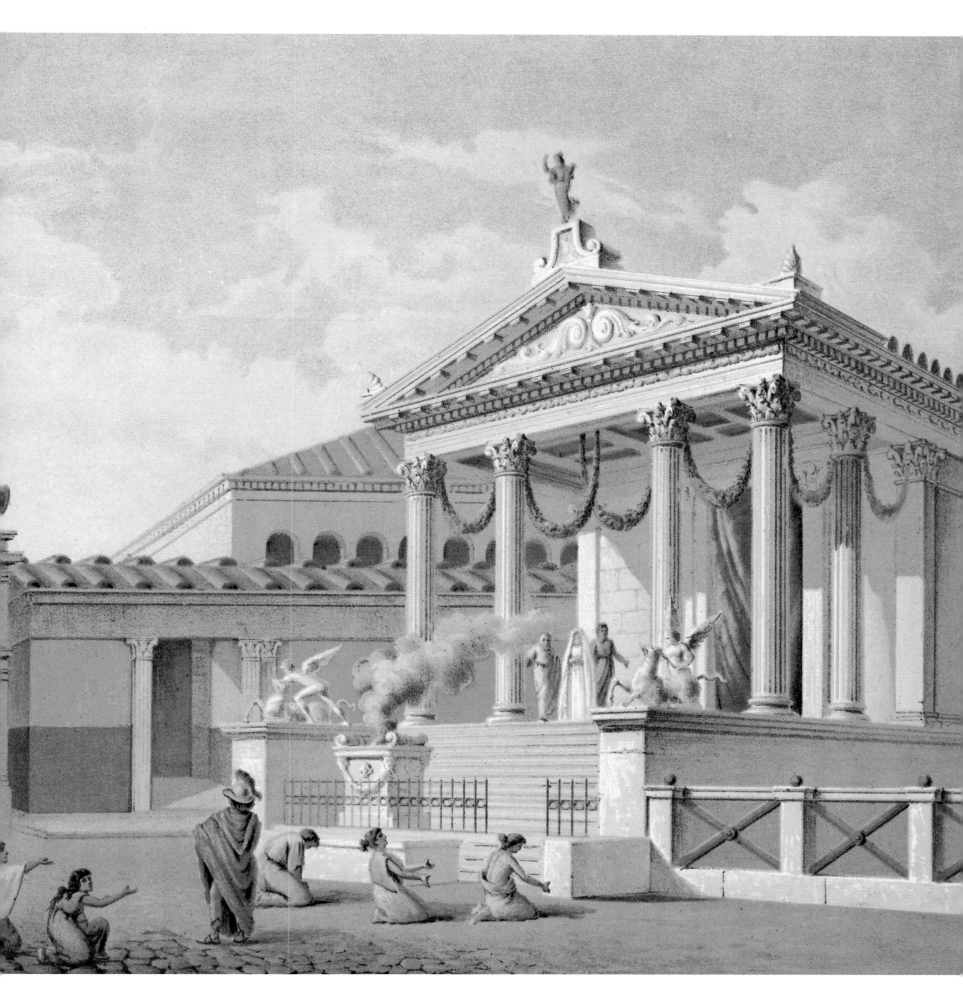

Below 173. G. Cel., *Ideal Reconstruction of the Area in Front of the Large Theater and Statue of Marcellus in the Triangular Forum*

Opposite 174. G. Cel., *Ideal Reconstruction of a Musical Play with Choreography in the Small Theater* (VIII, 7, 19)

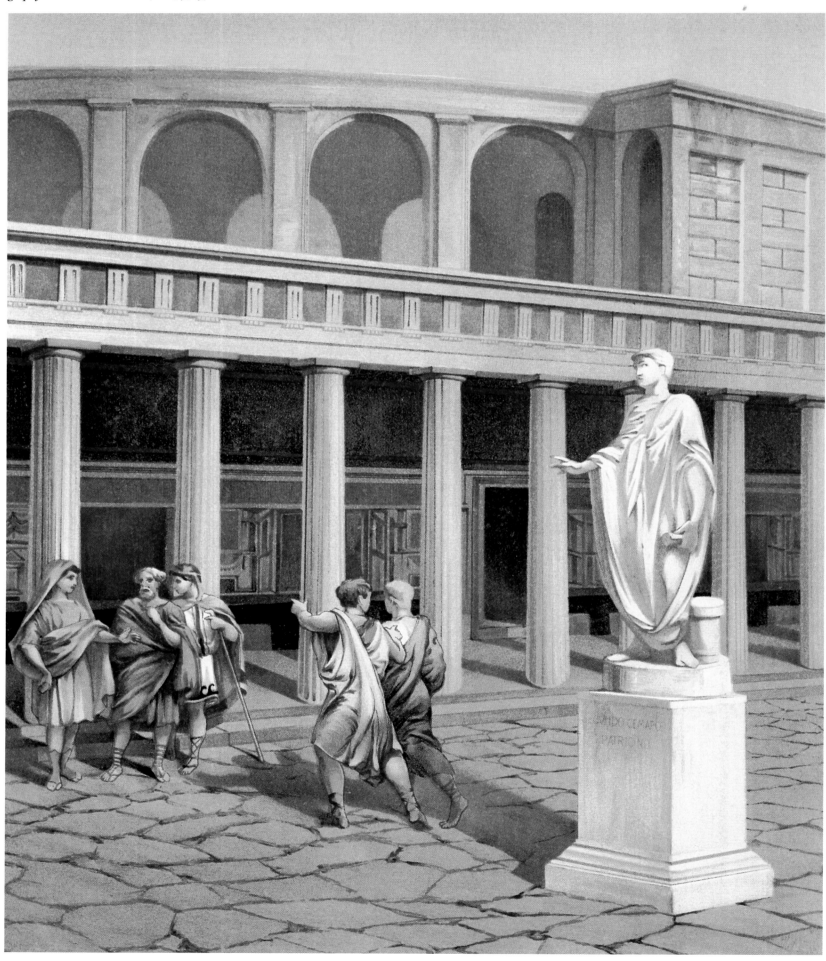

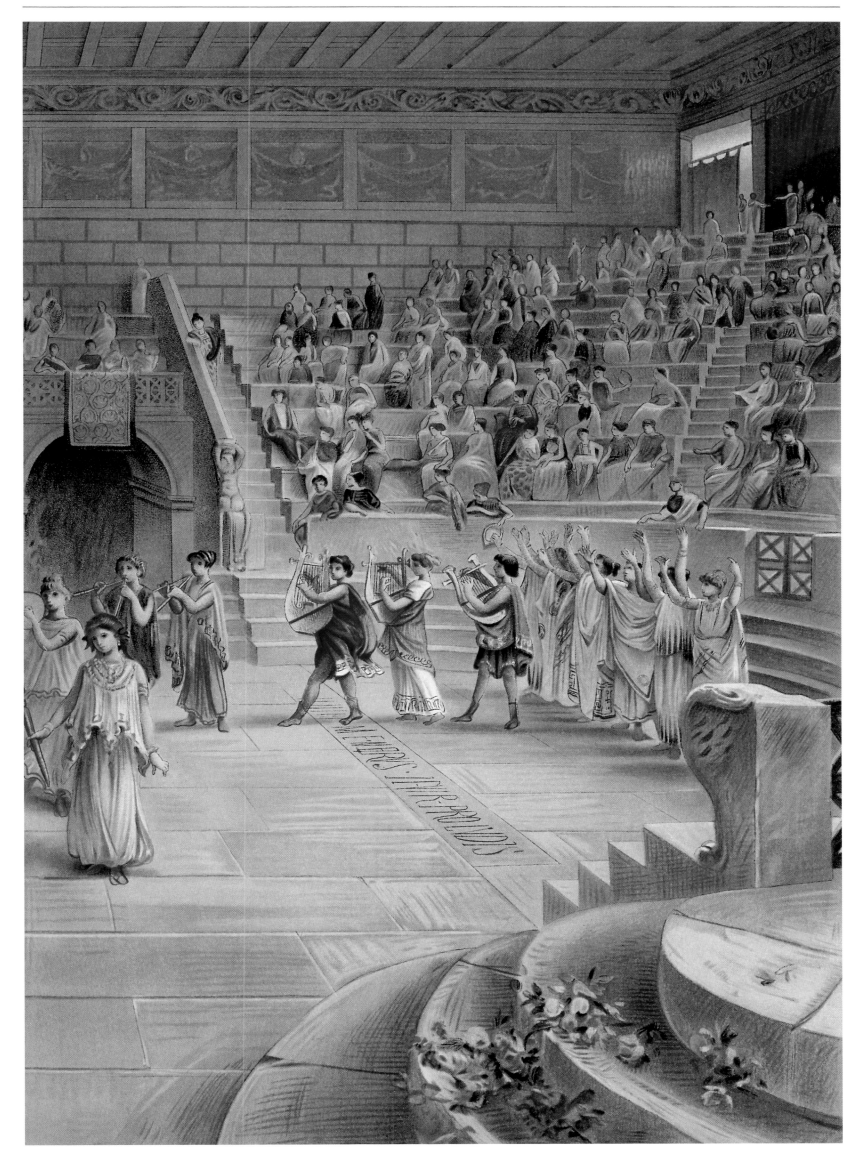

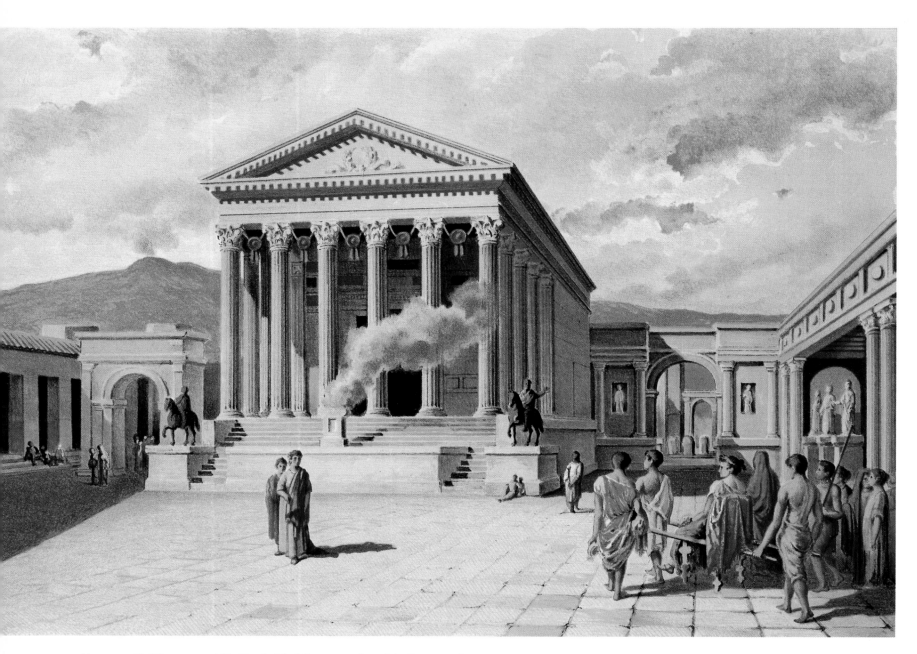

Above 175. G. **Discanno and D. Capri**, *Ideal Reconstruction of the Forum and the Temple of Jupiter* (VII, 8, 1)

Opposite 176. G. **Cel.**, *Ideal Reconstruction of the Basilica Interior as Seen from the Forum* (VIII, 1, 2)

The Basilica of Pompeii is one of the oldest examples of this type of building. It dates to between 130 and 120 B.C. and was built before the city became a colony (the walls of the building show graffiti in the Oscan language). The Basilica was built with a Classical base and had a rectangular shape. It had three entrances; the main access faced the Pompeian Forum and was characterized by a tiny covered portico (*chalcidicum*). A circle of twenty-eight stone columns divided the interior, bordering an ample central space and creating a sort of walkway. The building had two floors and must have been covered by a single two-sided roof. A sort of podium (*tribunal*) was at the western end of the basilica, where the magistrate sat during judicial sessions. The interior walls held semicolumns that were rhythmically coordinated with the exterior colonnade. These were decorated with painted stucco to resemble equal-sized blocks (the first style). The Basilica was utilized quite often and was being rebuilt when the volcano erupted in A.D. 79.

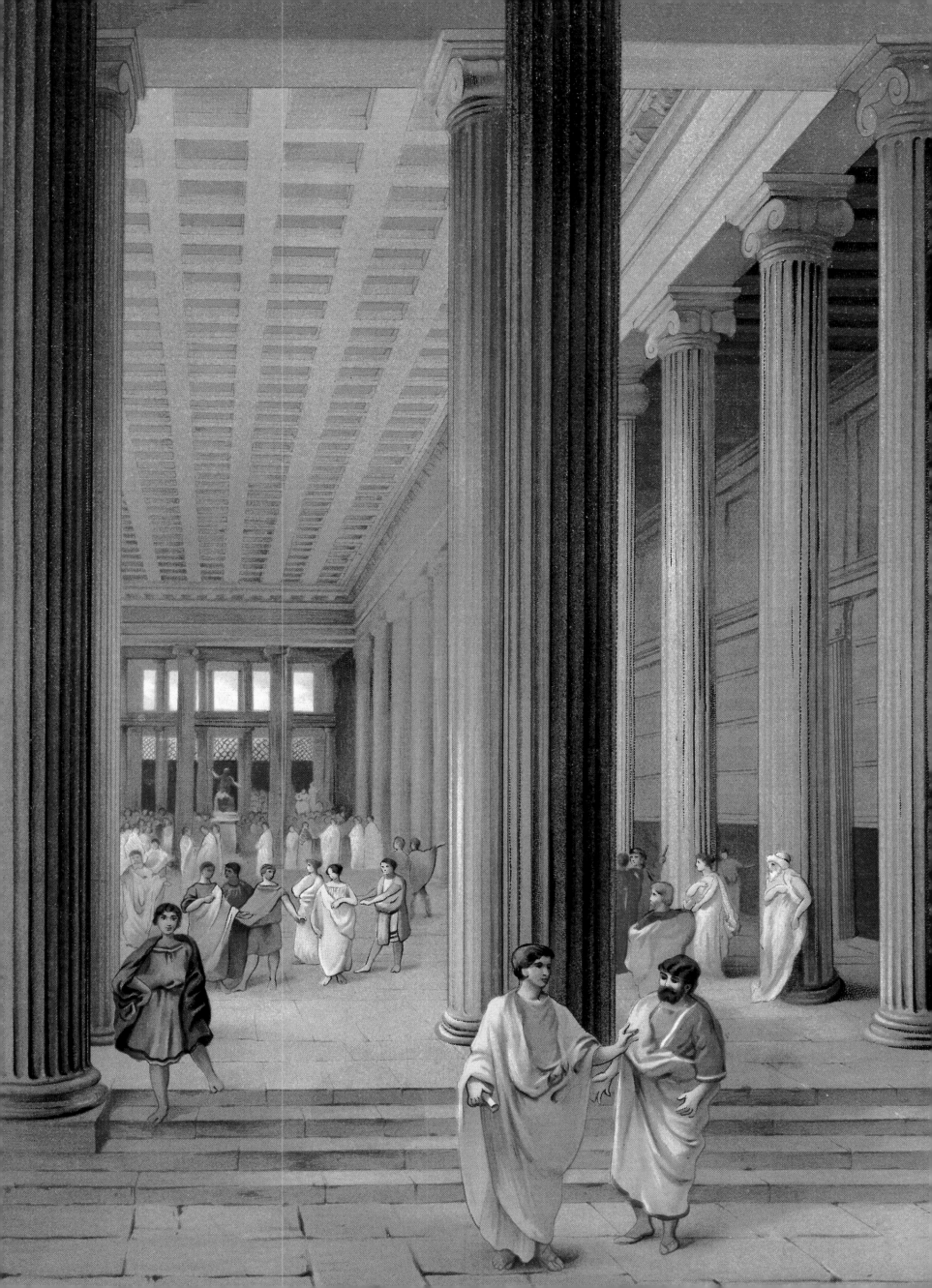

Below 177. O. Dressler, *Ideal Reconstruction of the Tavern (Thermopolium)*
(VI, 10, 1)

Opposite 178. G. Autoriello, *Ideal Reconstruction of the House of the Colored
Capitals or the House of Ariadne* (VII, 4, 31)

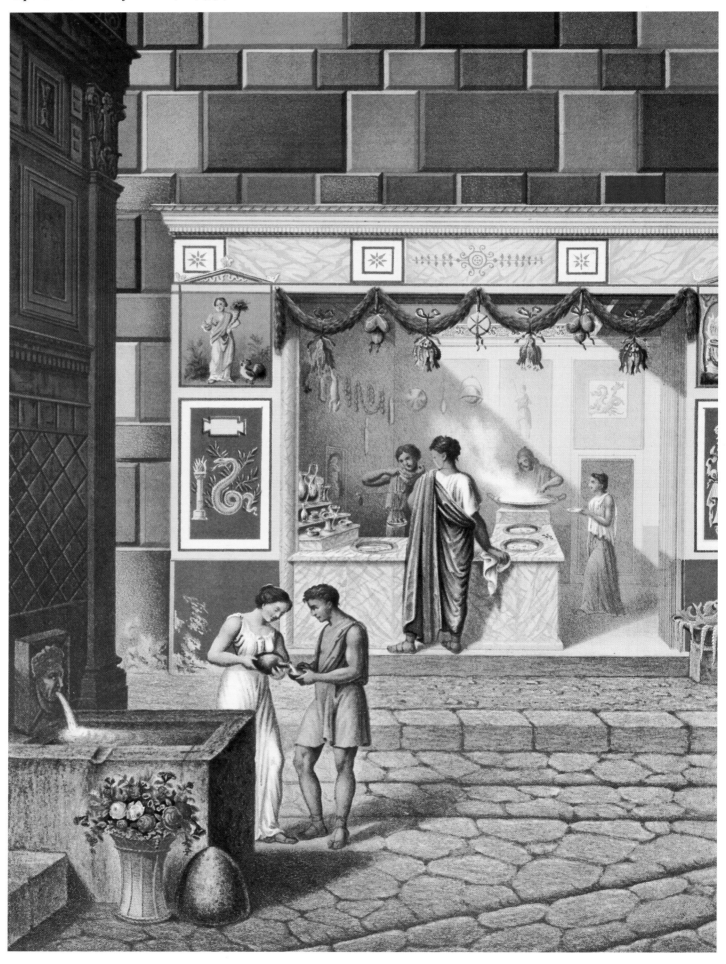

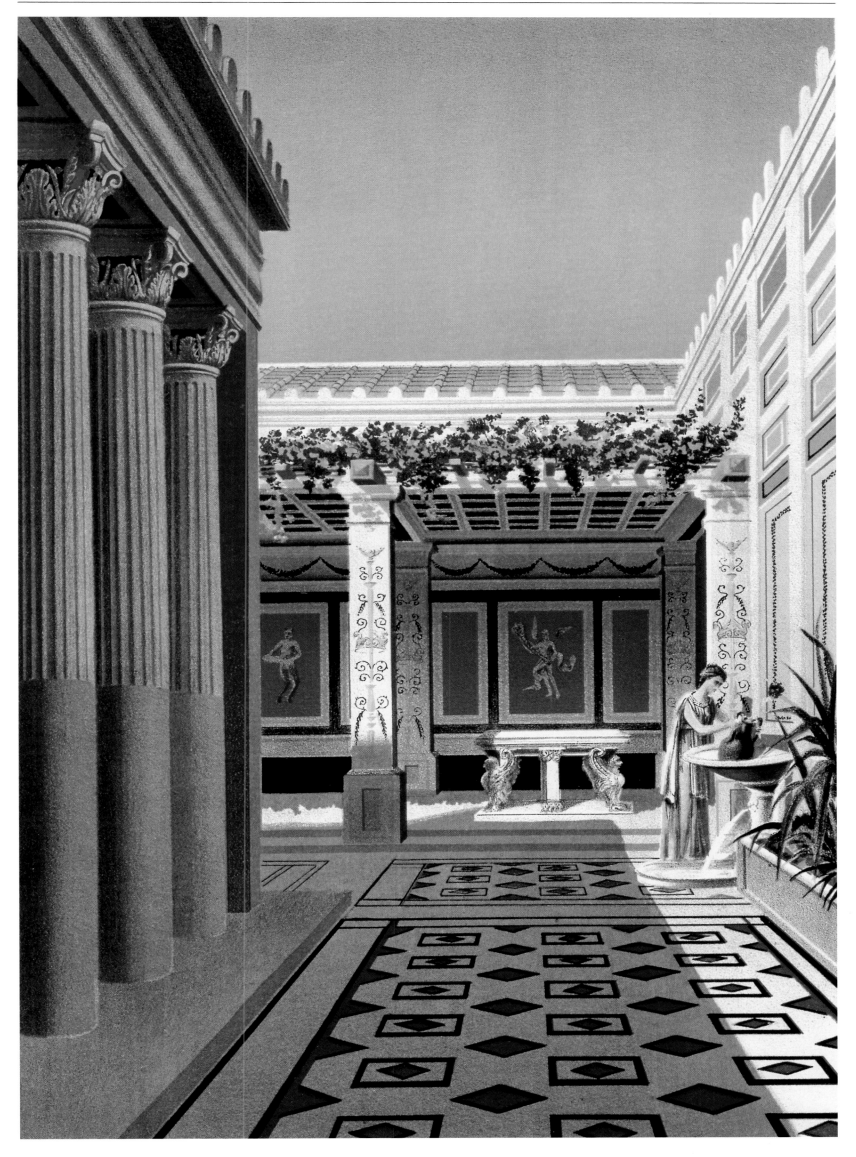

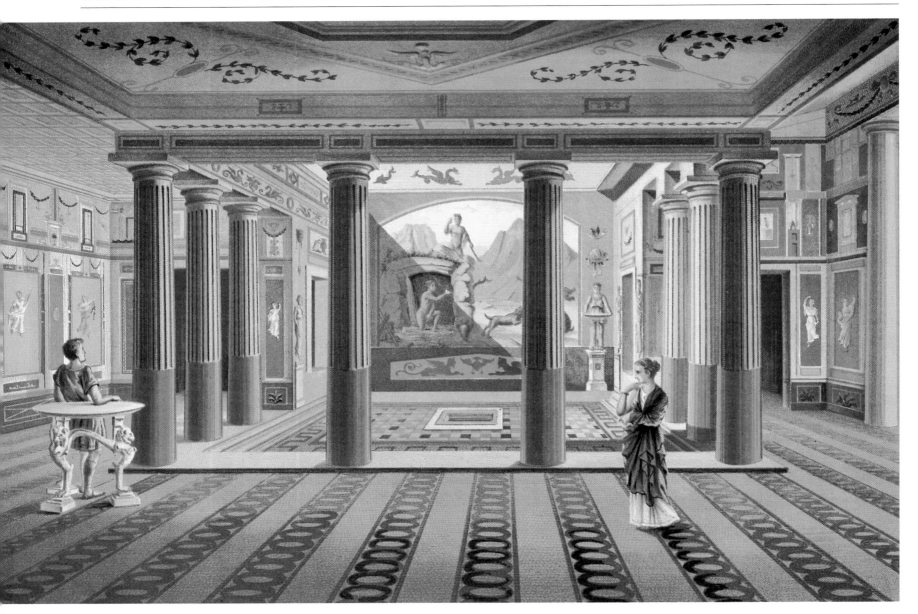

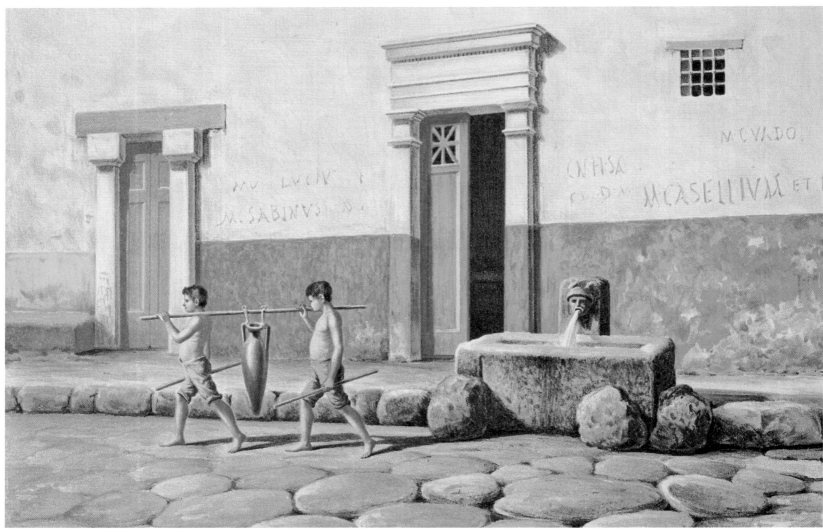

Opposite above 179. D. Capri, *Ideal Reconstruction of the House of Sallust Interior* (VI, 2, 4)

Opposite below 180. D. Capri, *Ideal Reconstruction of a City Street*

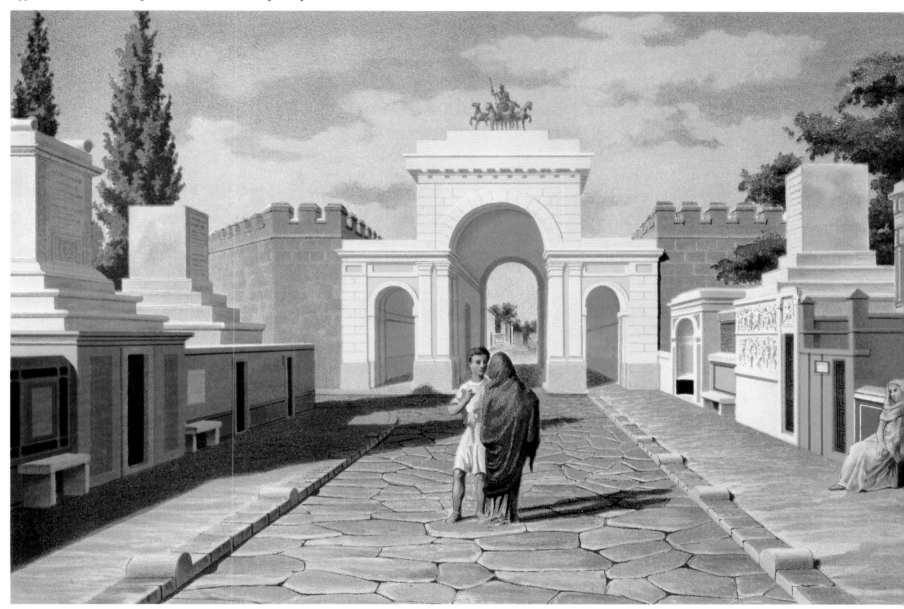

Above 181. G. Autoriello, *Ideal Reconstruction of Via dei Sepolcri with the Tombs on Each Side and the Herculaneum Gate in the Background*

On the following pages: 182. G. Cel., *View of the City of Pompeii on the Fatal Night of August 24, A.D. 79*

215

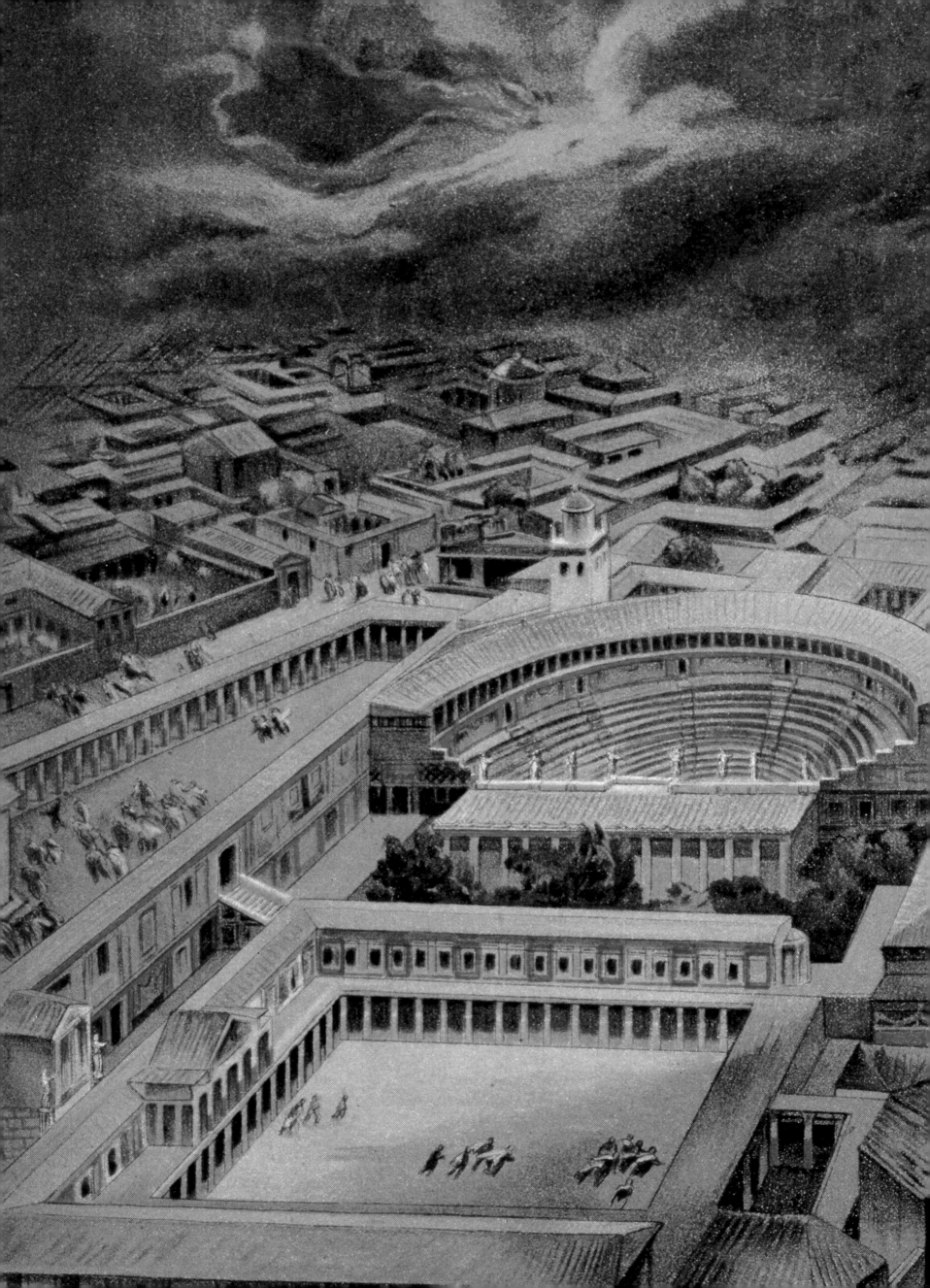

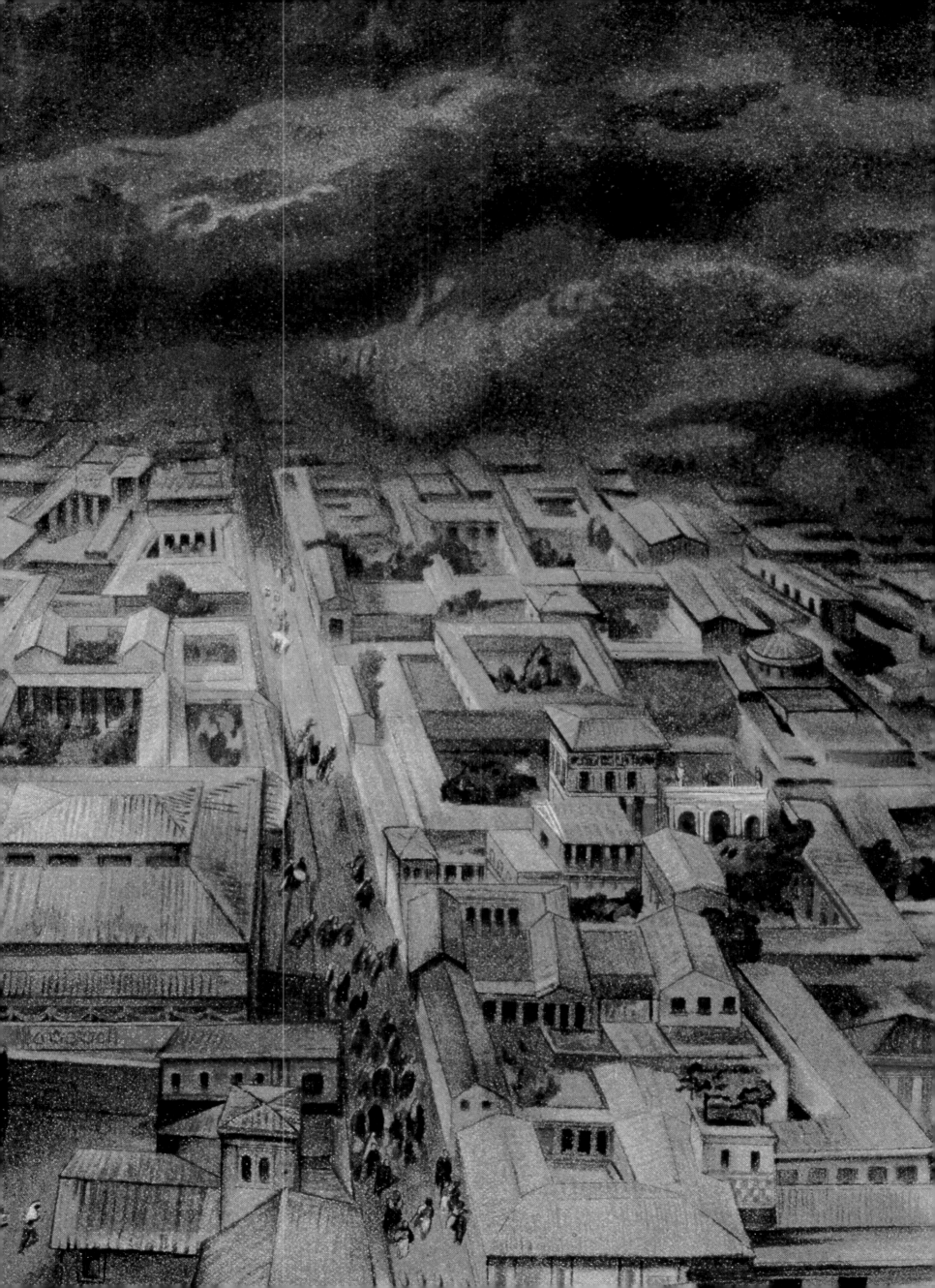

A CHRONOLOGY OF THE EXCAVATIONS IN POMPEII

Edited by Massimiliano David

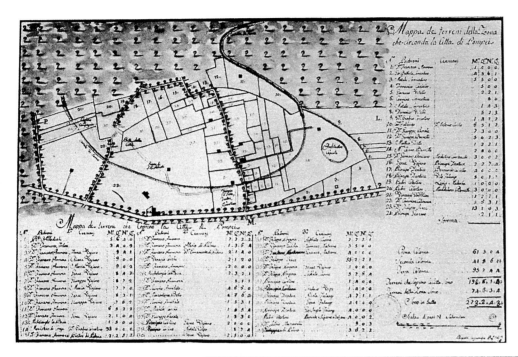

1748–1804 The first phase of the Bourbon excavations, directed by Roque Joachim de Alcubierre and Francesco La Vega. Via dei Sepolcri is followed toward the city interior for the excavations. The Large and Small Theaters, the Gladiator Barracks, and the Triangular Forum are singled out. The discovery of the Temple of Isis is especially revealing, influencing artistic culture. The first maintenance operations are also carried out.

1804–15 The Napoleonic excavations (Pietro La Vega, Antonio Bonucci), and the discovery of the Basilica. Carolina Bonaparte Murat visits the sites.

1812–13 Excavation of the Pompeian Forum. The excavation areas are connected.

1816–60 Second period of Bourbon excavations. Periods of activity alternate with pauses. The Forum Baths, the House of the Tragic Poet, Via della Fortuna, and other residences along Via del Mercurio are all uncovered.

Above **1.** Scognamiglio, 1807

Right **2.** Mazois, 1812

Below **3.** Wilkins, 1819

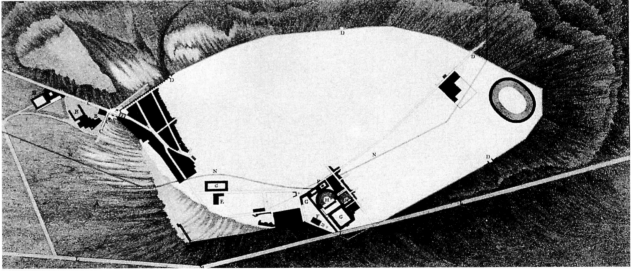

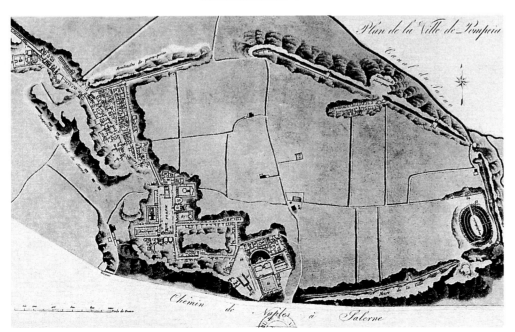

Circa 1830 The discovery of the House of the Faun and its floor mosaics, including one portraying the Battle of Issus.

1847 The discovery of the House of Marcus Lucretius and its refined interior garden.

1860 Giuseppe Fiorelli is named inspector and then excavation director in 1863.

1875 Fiorelli is named General Director of Servizio di Antichità e Belle Arti and is transferred to Rome.

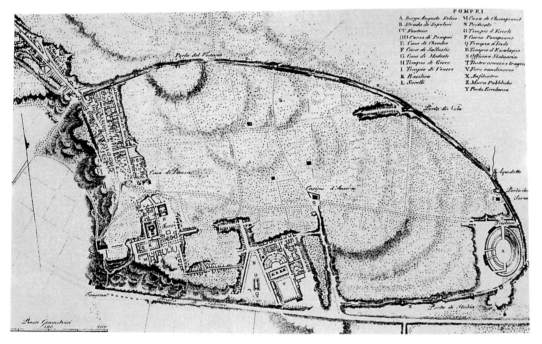

Excavation Directors

1748–80: Roque J. De Alcubierre
1764–1804: Francesco La Vega
1804–6: Pietro La Vega
1807–38: M. Arditi
1839–50: F. M. Avellino
1850–63: S. Spinelli
1863–75: Giuseppe Fiorelli
1875–93: Michele Ruggiero
1893–1901: Giulio de Petra

Left 4. Romanelli, 1817
Below 5. Bibent, 1825
Bottom left 6. Gau, 1837
Bottom right 7. Dufour, 1865

1875–93 Michele Ruggiero is excavation director.

1879–80 The House of the Centenary is discovered, with its splendid architectural structure.

1883–91 The excavation of Region 8 is completed. Detaching and reattaching the wall frescoes at the sites is attempted for the first time.

1893–1901 Giulio de Petra is excavation director.

1894–95 The House of the Vettii is uncovered. De Petra aims at conserving decorations and furnishings at the sites. The upper areas and rooftops are reconstructed after each excavation.

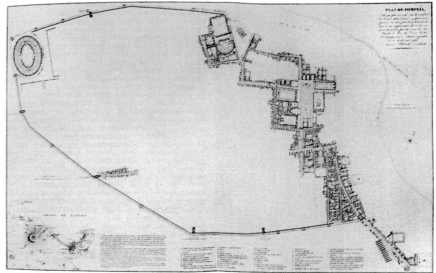

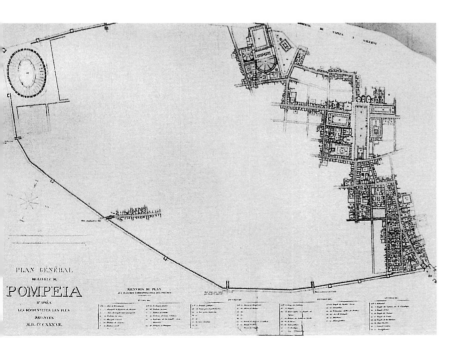

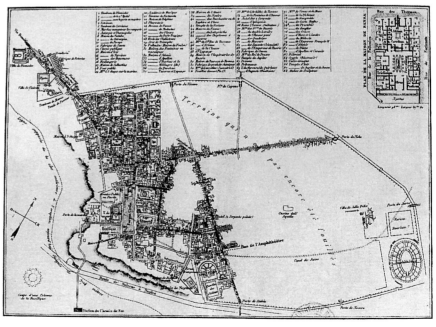

BIBLIOGRAPHY

Edited by Massimiliano David

Alla ricerca di Iside: Analisi, studi e restauri dell'Iseo pompeiano nel Museo di Napoli. Rome: ARTI, 1992.

Andreae, B., and H. Kyrieleis, eds. *Neue Forschungen in Pompeji und den anderen vom Vesuvausbruch 79 n. Chr. verschütteten Städten.* Recklinghausen: Bongers, 1975.

Barbet, A. *La peinture murale romaine: Les styles décoratifs pompeiens.* Paris: Picard, 1985.

Barbet, A. and B. Conticello. *La pittura a fresco al tempo di Pompei.* Paris: 1990.

Bastet, F. L., and M. De Vos. *Proposta per una classificazione del terzo stile pompeiano.* Rome: Nederlands Instituut te Rome, 1979.

Bonghi Jovino, M., ed. *Ricerche a Pompei: L'insula 5 della regio VI dale origini al 79 d.C.* Rome: L'erma di Bretschneider, 1984.

Borriello, M., A. D'Ambrosio, S. De Caro, and P. G. Guzzo, eds. *Pompei: Abitare sotto il Vesuvio.* Catalogue from the exhibit in Ferrara, September 29, 1996–January 19, 1997. Ferrara: Ferrara arte, 1996.

Breton, E. *Pompeia décrite et déssiné.* Paris: Gide et Baudry, 1855.

Brilliant, R. *Pompeii A.D. 79: The Treasure of Rediscovery.* New York, Clarkson N. Potter, 1979.

Carocci, F., E. De Albentiis, M. Gargiulo, and F. Pesando. *Le insulae 3 e 4 della regio VI di Pompei: Un' analisi storico-urbanistica.* Archaeologica Perusina, vol. 5. Rome: Giorgio Bretschneider, 1990.

Causa, R. *Vedute napoletane dell'Ottocento: disegni di Giacinto Gigante.* Naples: 1955.

Causa, R. *La Scuola di Posillipo.* Milan: Fabbri, 1967.

Causa, R., ed. *Acquerelli di Giacinto Gigante.* Naples: 1955.

Chiaramonte Treré, C., ed. *Nuovi contributi sulle fortificazioni pompeiane.* Milan: Cisalpino-Goliardica, 1986.

Ciarallo, A. *Orti e giardini della antica Pompei.* Naples: 1992.

Conticello, B. *Pompei: Guida archeologica.* Novara: Istituto Geografico De Agostini, 1986.

Croisille, J. M. *Les natures mortes campaniennes: Repertoire descriptif des peintures de nature morte du Musée Nationale de Naples, de Pompei, Herculanum et Stabies.* Collection Latomus, vol. 76. Brussels: Latomus, 1965.

Curtis, R. I., ed. *Studia Pompeiana et Classica in Honor of W. F. Jashemski.* New Rochelle: Caratzas, 1988–89.

Curtius, L. *Die Wandmalerei Pompejis: Eine Einführung in ihr Verständnis.* Cologne: 1929.

D'Ambrosio, A., and M. Borriello. *Le terrecotte figurate di Pompei.* Rome: L'erma di Bretschneider, 1990.

De Carolis, E. *Storia degli scavi di Pompei.* Herculaneum: A. Illario, 1994.

De Jorio, A. *Guida di Pompei con appendici nelle sue parti più interessanti.* Naples, 1836.

Della Corte, M. *Case ed abitanti di Pompei.* Naples, F. Fiorentino, 1965.

De Spagnolis Conticello, M., and E. De Carolis, *Le Lucerne bronzee di Ercolano e Pompei.* Rome: 1988.

Domus, viridaria, horti picti. Catalogue from the 1992 exhibit in Naples and Pompeii. Le mostre, vol. 15. Naples: Bibliopolis, 1992.

Dwyer, E. *Pompeian Domestic Sculpture: A Study of Five Pompeian Houses and Their Contents.* Archaeologica, vol. 28. Rome: G. Bretschneider, 1982.

Eschebach, H. *Die Städtbauliche Entwicklung des antiken Pompeji.* Römische Mitteilungen Ergänzungsheft, vol. 17. Heidelberg: Kerle, 1970.

Eschebach, H. *Pompeji: Erlebte antike Welt.* Leipzig: Veb E. A. Seemann, 1978.

Eschebach, H. and L. Eschebach. *Pompeji vom 7: Jahrhundert v. Chr. bis 79 n. Chr.* Cologne, Weimar, and Vienna, Böhlau, 1995.

Eschebach, H., H. Mielsch, M. De Vos, and A. De Vos. *Die Stabianer Thermen in Pompeji.* Denkmäler antiker Architektur, vol. 13. Berlin: De Gruyter, 1979.

Etienne, R. *La vie quotidienne à Pompéi.* Paris: Hachette, 1966 (translated into Italian in 1973).

Fino, L. *Ercolano e Pompei: Vedute neoclassiche e romantiche.* Naples: Electa Napoli, 1988.

Fotografi a Pompei nell'800 dalle collezioni del Museo Alinari. Florence: Alinari, 1990.

Franchi Dell'Orto, L., ed. *Restaurare Pompei.* Milan: Sugarco, 1990.

Frölich, T. *Lararien-und Fassadenbilder in den Vesuvstadten: Untersuchungen zur volkstumlichen pompejanischen Malerei.* Mitteilungen des deutschen archäologischen Instituts: Römische Abteilung Erganzunshefte, vol. 32. Mainz am Rhein: P. von Zabern, 1991.

Gusman, P. *Pompei: La ville, les moeurs, les arts.* Paris: Gaillard, 1899.

I mosaici, le pitture, gli oggetti di uso quotidiano, gli argenti, le terrecotte invetriate, I vetri, I cristalli, gli avori. Le collezioni del Museo nazionale di Napoli, vol. 1. Rome: De Luca-Milano, Leonardo, 1989.

Italienische Reise: Pompejanische Bilder in der deutschen archäologischen Sammlung. Naples: Bibliopolis, 1989.

Jashemski, W. F. *The Gardens of Pompeii, Herculaneum, and the Villas Destroyed by Vesuvius.* New Rochelle: Caratzas, 1979–93.

Kockel, V. *Die Grabbauten vor dem Herkulaner Tor in Pompeji.* Beiträge zur Erschliessung, hellenistischer und Kaiser zeitlicher Skulptur und Architektur, vol. 1. Mainz am Rhein: P. von Zabern, 1983.

Koloski Ostrow, A. *The Sarno Bath Complex.* Cataloghi della Soprintendenza archeologica di Pompei, vol 4. Rome: L'erma di Bertschneider, 1990.

Krauss, T., and L. Von Matt. *Lebendiges Pompeii.* Cologne: 1973.

Lamers, P. *Il viaggio nel Sud dell'abbé de Saint-Non: Il "Voyage pittoresque à Naples et en Sicile": la genesi, I disegni preparatory, le incisioni.* Naples: Electa Napoli, 1995.

La pittura di Pompei: Testimonianze dell'arte romana nella zona sepolta dal Vesuvio nel 79 d.C. Milan: Jaca Book, 1991 (original edition 1990).

La regione sotterrata dal Vesuvio: Studi e prospettive. Atti del convegno internazionale, 11–15 novembre 1979. Naples: Università degli studi, 1982.

La Rocca, E., M De Vos, A. De Vos, and F. Coarelli. *Pompei.* Guide archeologiche Mondadori. Milan: Mondadori, 1994.

Laurence, R. *Roman Pompeii: Space and Society.* London and New York: Routledge, 1994.

Leonhard, W. *Mosaikstudien zur Casa del Fauno in Pompeji.* Naples: 1914.

L'instrumentum domesticum di Ercolano e Pompei nella prima età imperiale. Quaderni di cultura materiale, vol. 1. Rome: L'erma di Bretschneider, 1977.

Maggi, G. ed. *Pompei ed Ercolano attraverso le stampe e gli acquerelli del '700 e '800.* Museo archeologico nazionale di Napoli, September–November 1958. Naples: L'arte tipografica, 1959.

Maiuri, A. *Pompei.* Itinerari dei musei, gallerie, e monumenti d'Italia. Rome: 1964.

Maiuri, A. *Alla ricerca di Pompei preromana: Saggi stratigrafici.* Naples: Società editrice napoletana, 1973.

Maiuri, A. *Pompei ed Ercolano fra case e abitanti.* Florence: Giunti Martello, 1983.

Mayeske, B. *Bakeries, Bakers, and Bread at Pompeii: A Study in Social and Economic History.* Michigan, University of Maryland, 1972.

Mazois, F. *Les ruines de Pompei dessinées et mésurées . . . pendant les années 1809, 1810, 1811.* Paris: Didot, 1812–29.

Mazois, F., M. Gau, L. Barré, C. Artaud de Montor, and M. Quatremere de Quincy. *Les ruines de Pompei.* Paris: Firmin Didot frères, 1824–38.

Neapolis: Progetto-sistema per la valorizzazione integrale delle risorse ambientali e artistiche dell'area vesuviana. Monografie del Ministero Beni Culturali e Ambientali. Soprintendenza Archeologica di Pompei, vol. 7. Rome: L'erma di Bretschneider, 1994.

Neuerburg, F. *L'architettura delle fontane e dei ninfei nell'Italia antica.* Naples, Macchiaroli, 1965.

Noack, F. and K. Lehmann Hartleben. *Baugeschichtliche Untersuchungen am Stadtrand von Pompeji.* Denkmäler antiker Architektur, vol. 2. Berlin and Leipzig: W. de Gruyter, 1836.

Ohr, K., and J. J. Rasch. *Die Basilika in Pompeji,* Berlin and New York: De Gruyter, 1991.

Ortolani, S. *Giacinto Gigante e la pittura di paesaggio a Napoli dal '600 all'800.* Naples: Montanino, 1970.

Overbeck, J. *Pompeji in seinen Gebäuden, Alterthümern und Kunstwerken.* Leipzig: Engelmann, 1875.

Parslow, C. C. *Rediscovering Antiquity: Karl Weber and the Excavation of Herculaneum, Pompeii, and Stabiae.* Cambridge: Cambridge University Press, 1995.

Pernice, E. *Pavimente und figürliche Mosaiken.* Die hellenistische Kunst in Pompeji, vol. 6. Berlin: 1938.

Peters, W. J. T., ed. *La casa di Marcus Lucretius Fronto a Pompei e le sue pitture.* Amsterdam: 1993.

Pompei, 1748–1980: I tempi della documentazione. Rome: Multigrafica, 1981.

Pompei: L'informatica al servizio di una città antica. Rome: L'erma di Bretschneider, 1988.

Pompei: Pitture e mosaici. Rome: Istituto della Enciclopedia italiana, 1990.

Pompei: Pitture e mosaici: la documentazione nell'opera di disegnatori e pittori dei secoli XVIII e XIX. Rome: Istituto della Enciclopedia italiana, 1995.

Pompéi: Travaux et envois des architectes française au XIXe siècle. Paris: Ecole nationale supérieure des beaux-arts, 1981.

Pompeiana: Raccolta di studi per il secondo centenario degli scavi di Pompei. Naples; Macchiaroli, 1936.

Pompeii and the Vesuvian Landscape. Papers of a symposium sponsored by the Archaeological Institute of America. Washington D. C.: Washington Society and the Smithsonian Institution, 1979.

Pompeji: Leben und Kunst in den Vesuvstädten. Katalog der Ausstellung in Villa Hügel, Essen 1973. Recklinghausen: Bongers, 1973.

Presuhn, F. and V. Steeger. *Le più belle pareti di Pompei.* Rome: 1877.

Redi, R., and P. L. Raffaelli, eds. *Gli ultimi giorni di Pompei.* Naples: Electa Napoli, 1994.

Rediscovering Pompeii. Rome: L'erma di Bretschneider, 1990.

Richardson, L. *Pompeii: An Architectural History.* Baltimore and London: The Johns Hopkins University, 1988.

Rizzo, G. E. *Le pitture della Casa del Poeta tragico.* Monumenti della pittura antica, vol. 3. Rome: 1935.

Sasso, C. N. *Il Vesuvio, Ercolano e Pompei.* Naples: 1857.

Schefold, K. *Die Wände Pompejis: Topographischies Verzeichnis der Bildmotive.* Berlin: 1957.

Schefold, K. *La peinture pompéienne: Essai sur l'évolution de sa signification.* Collection Latomus, vol. 108. Brussels: Latomus, 1972.

Seiler, F. *Casa degli Amorini dorati (VI , 16, 7).* Berlin: 1992.

Sommella, P. *Urbanistica pompeiana: Nuovi momenti di studio.* Rome: 1989.

Staccioli, R. A. *Manifesti elettorali nell'antica Pompei.* Biblioteca universali Rizzoli, 890. Milan: Rizzoli, 1992.

Staub Gierow, M. *Casa del Graduca (VIII, 4, 56) e Casa dei Capitelli figurati (VII, 4, 57).* Munich: 1994.

Strocka, V. M. *Casa del Labrinto (VI, 11, 8–10).* Berlin: 1991.

Strocka, V. M. *Casa del Principe di Napoli (VI, 15, 7–8).* Häuser in Pompeji, vol. 1. Tübingen: 1984.

Tassinari, S. *Il vasellame bronzeo di Pompei.* Cataloghi della Soprintendenza archeologica di Pompei, vol. 5. Rome: 1993.

Un impegno per Pompei. Milan: TCI, 1983.

Van Der Poel, H. B. *Corpus topographicum Pompeianum.* Austin: The University of Texas, 1977–86.

Varone, A. *Pompéi.* Paris: Terrail, 1995.

Warsher, T. *Führer durch Pompeji.* Berlin and Leipzig: 1925.

Zanker, P. *Pompei: Società, immagini urbane e forme dell'abitare.* Turin: Einaudi, 1993.

Zevi, F. *La casa reg. IX, 5, 18–21 a Pompei.* Studi miscellanei, vol. 5. Rome: 1964.

Zevi, F., ed. *Pompei 1.* Naples: Guida, 1992.

Zevi, F., ed. *Pompei 2.* Naples, Guida, 1992.

Zevi, F., ed. *Pompei 79: Raccolta di studi per il decimonono centenario dell'eruzione vesuviana.* Naples, Marcchiaroli, 1979.

ARTIST INDEX

This is an index of artists who created the plates in this edition of *Houses and Monuments*, with references to specific plate numbers.

ABOUT THE AUTHORS

Roberto Cassanelli studied art history at the universities of Milan and Pavia. He presently teaches art history at the Accademia Albertina in Turin and coordinates the Centro di Documentazione Storica di Villa Ghirlanda at Cinisello Balsamo. He has been involved with problems of philology and critical editions regarding Roman monuments in Lombardy and Emilia Romagna, extending his interests to the late Middle Ages and fourteenth-century Lombardy. Most recently he has focused on the origins of photography as an artistic technique.

Pier Luigi Ciapparelli earned a degree in architecture from the Università di Napoli, followed by a research doctorate in Architecture History and Criticism from the same institution. He presently teaches art history at the Accademia di Belle Arti in Venice. Specific areas of his research include theatrical architecture and set design, from the Renaissance to the romantic period. Besides numerous essays, he has published a study on theater from the Court of Caserta and a volume on the theaters of Campania. He is a regular contributor to architecture journals.

Enrico Colle is an expert on decorative arts and presently collaborates with the Soprintendenze Fiorentine, studying and cataloguing the furnishings and artistic objects from the Pitti Palace in Florence and the grand-ducal residences. He has led archival research concerning the furniture of the Reggia di Caserta, the Sabaudian residences, and the decór of Palazzo Chigi Saracini in Siena.

Massimiliano David graduated with an arts degree from the Università degli Studi di Milano, having first specialized in archaeology, then ancient art history. His interests have focused on archaeology in urban centers and the countryside, especially on building techniques, and the exploitation, commerce, and use of stone materials in the Roman era. He has either participated in or directed numerous excavations and is the author of a body of work on the ancient floors of Milan.

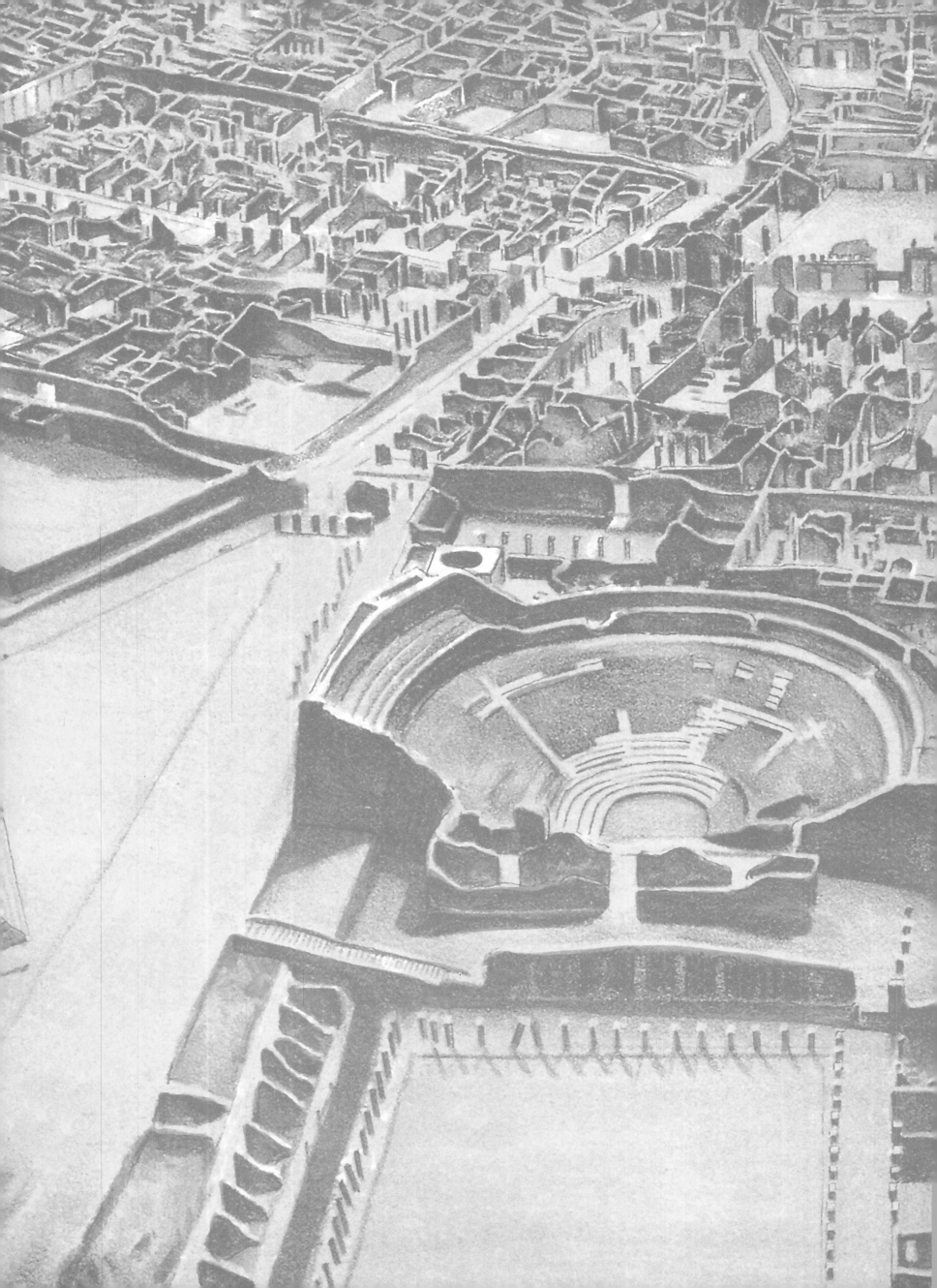